PICTURING
FREDERICK DOUGLASS

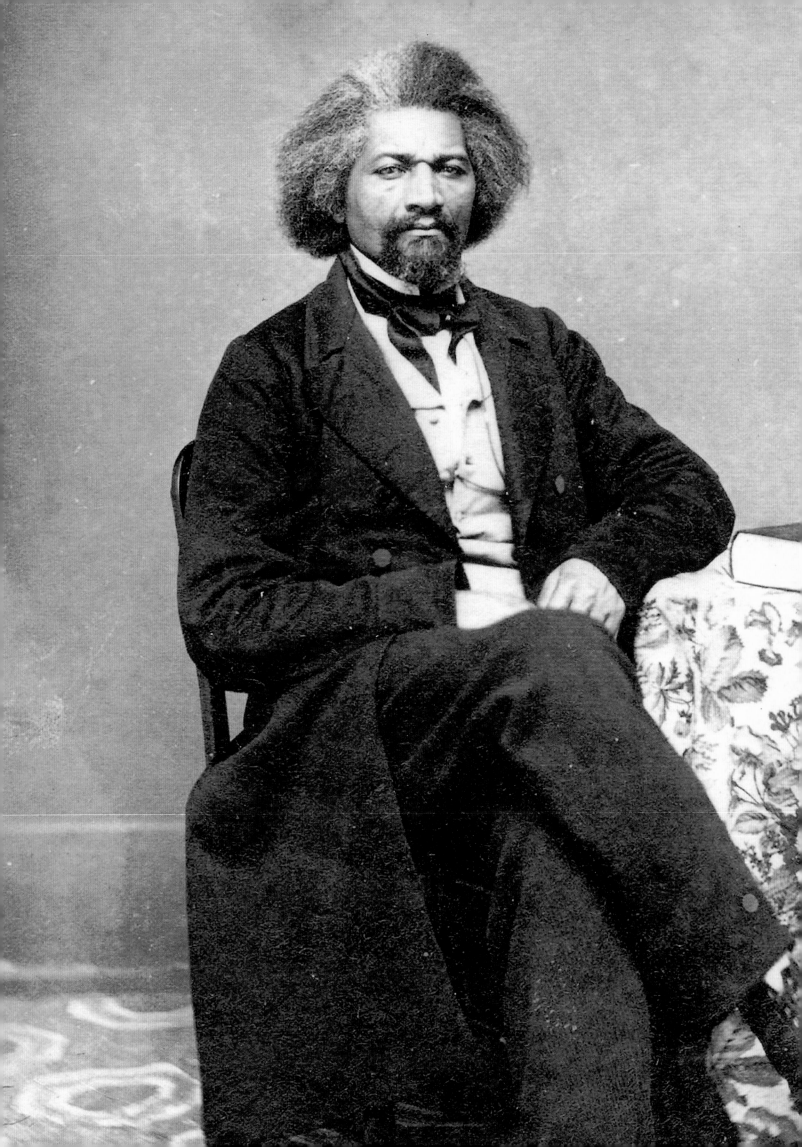

PICTURING
FREDERICK DOUGLASS

An Illustrated Biography of the Nineteenth Century's
Most Photographed American

JOHN STAUFFER, ZOE TRODD,
AND CELESTE-MARIE BERNIER

LIVERIGHT PUBLISHING CORPORATION

A Division of W. W. Norton & Company

New York • London

For information about permission to reproduce selections from this book,
write to Permissions, W. W. Norton & Company, Inc.,
500 Fifth Avenue, New York, NY 10110

For information about special discounts for bulk purchases, please contact
W. W. Norton Special Sales at specialsales@wwnorton.com or 800-233-4830

Manufacturing by Asia Pacific Offset
Book design by Ellen Cipriano
Production manager: Anna Oler

ISBN 978-0-87140-468-8

W. W. Norton & Company, Inc.
500 Fifth Avenue, New York, N.Y. 10110
www.wwnorton.com

W. W. Norton & Company Ltd.
Castle House, 75/76 Wells Street, London W1T 3QT

1 2 3 4 5 6 7 8 9 0

For

Nettie Washington Douglass
Alan Trachtenberg
Donna Wells

Contents

Introduction

Frederick Douglass was in love with photography. During the four years of civil war, he wrote more extensively on photography than any other American, even while recognizing that his audiences were "riveted" to the war and wanted a speech only on "this mighty struggle."[1] He frequented photographers' studios and sat for his portrait whenever he could. As a result of this passion, he also became the most photographed American of the nineteenth century.

It may seem strange, if not implausible, to assert that a black man and former slave wrote more extensively on photography, and sat for his portrait more frequently, than any of his American peers. But he did. Douglass gave four separate talks on photography ("Lecture on Pictures," "Life Pictures," "Age of Pictures," and "Pictures and Progress"), whereas Oliver Wendell Holmes, the Boston physician and writer who is generally considered the most prolific Civil War–era photo critic, penned only three.[2] We have also identified, after years of research, 160 separate photographs of Douglass, as defined by *distinct poses* rather than multiple copies of the same negative.[3] By contrast, scholars have identified 155 separate photographs of George Custer, 128 of Red Cloud, 127 of Walt Whitman, and 126 of Abraham Lincoln.[4] Ulysses S. Grant is a contender, but no one has published the corpus of Grant photographs; one eminent scholar has estimated 150 separate photographs of Grant.[5] Although there are some 850 total portraits of William "Buffalo Bill" Cody and his Wild West Show, and 650 of Mark Twain, no one has analyzed how many of these are distinct poses, or photographs as opposed to engravings, lithographs, and other non-photographic media. Moreover, Cody and Twain were a generation younger, and many if not most of their portraits were taken after 1900, when the Eastman Kodak

snapshot had transformed the medium, bringing photography "within reach of every human being who desires to preserve a record of what he sees," as Kodak declared.[6] In the world, the only contemporaries who surpass Douglass are the British royal family and other British celebrities: there are 676 separate photographs of Princess Alexandra, 655 of the Prince of Wales, 593 of Ellen Terry, 428 of Queen Victoria, and 366 of William Gladstone.[7]

Douglass's passion for photography, however, has been largely ignored.[8] He is perhaps most popularly remembered as one of the foremost abolitionists, and the preeminent black leader, of the nineteenth century. History books have also celebrated his relationship with President Lincoln, the fact that he met with every subsequent president until his death in 1895, and that he was the first African American to receive a federal appointment requiring Senate approval. His three autobiographies (two of them bestsellers) helped transform the genre and are still read today.[9] Yet, because his photographic passion has been almost completely forgotten, historians have missed an important question: why was a man who devoted his life to ending slavery and racism and championing civil rights so in love with photography?

The first part of the answer is that Douglass embraced photography as a great *democratic* art. More than once he praised Louis Daguerre, the founder of the first popular form of photography, the daguerreotype, and hailed him as "the great discoverer of modern times, to whom coming generations will award special homage. . . . What was once the special and exclusive luxury of the rich and great is now the privilege of all. The humblest servant girl may now possess a picture of herself such as the wealth of kings could not purchase fifty years ago."[10]

He wrote this after he and photography had come of age together. Born in February 1818, Douglass escaped from slavery on September 3, 1838, a year before Daguerre and Henry Fox Talbot created the first forms of photography. For the rest of his life, he would mark his new birth of freedom by celebrating it in place of his unknown birthday. He began his career as an abolitionist orator in 1841, just as technical improvements reduced exposure times, enabling the proliferation of daguerreotype portraits. Portraits fueled the demand for photography and constituted over 90 percent of all images in the medium's first five decades.[11]

He first sat for a photograph, a daguerreotype, around 1841 (see plate 1). After publishing his best-selling autobiography, *Narrative of the Life of Frederick Douglass*, in 1845, he lectured throughout the British Isles for two years. There he received his legal freedom and was introduced to the *Illustrated London News*, the world's first (and hugely suc-

cessful) pictorial weekly. The *Illustrated* disseminated photographs and sketches by cutting engravings from them, enabling readers to receive the news visually for the first time. In 1846, Douglass was twice featured in the paper (see plates 2.3 & 2.4), and when he returned to the United States in 1847 to launch his own newspaper, *The North Star*, it was increasingly common for books to be illustrated with frontispiece engravings cut from photographs. Four years later, the American illustrated press was launched in Boston with *Gleason's Pictorial Drawing-Room Companion*, followed by the wildly popular *Frank Leslie's Illustrated Newspaper* in 1855 and *Harper's Weekly* in 1857. By then, there were photographic studios in every city, county, and territory in the free states, and new forms of photography to choose from, notably the tintype and ambrotype. Virtually every Northerner could afford to have his or her portrait taken.[12]

From the 1850s on, the free states enjoyed a love affair with photography that surpassed every other nation on earth. The American South, however, lacked the cities, roads, entrepreneurship, and other aspects of a capitalist infrastructure that enabled photography to flourish in the North. Moreover, in their efforts to defend slavery, Southerners suppressed freedoms of speech, debate, and the press, including photography and visual images.[13]

Douglass quickly recognized this close connection between photography and freedom. He defined himself as a free man and citizen as much through his portraits as his words. The democratic art of photography echoed the freedom articulated in the nation's founding document. His own freedom had coincided with the birth of photography, and he became one of its greatest boosters.

The second reason for Douglass's love of photography is that he believed in its truth value, or objectivity. Much as his Bible referred to an unseen but living God, a photograph accurately captured a moment in time and space. Even more than truth-telling, the truthful *image* represented abolitionists' greatest weapon, for it gave the lie to slavery as a benevolent institution and exposed it as a dehumanizing horror. Like slave narratives (Douglass was a master of the genre), photographic portraits bore witness to African Americans' essential humanity, while also countering the racist caricatures that proliferated throughout the North.

Douglass paid close attention to such caricatures. He noted with scorn in 1872: "I was once advertised in a very respectable newspaper under a little figure, bent over and apparently in a hurry, with a pack on his shoulder, going North." And he was all too familiar with the wider tendency toward racist depictions of African Americans: "We colored men so often see ourselves described and painted as monkeys, that we

think it a great piece of good fortune to find an exception to this general rule," he wrote in 1870.[14]

Photographers recognized that their medium lied—many self-consciously manipulated the image, solarizing it, airbrushing out unwanted subjects, or distorting it in other ways. But Douglass and most patrons of the art believed that the camera told the truth. Even in the hands of a racist white, it simultaneously created an authentic portrait and a work of art. Neither Douglass nor his peers recognized any contradiction between photography as an art and as a technology.[15]

Thirdly, Douglass believed that photography highlighted the essential humanity of its subjects. This was because of the medium's ability to produce portraits for the millions. Influenced by Aristotle's *Poetics* and the writings of Ralph Waldo Emerson and Thomas Carlyle, Douglass argued that humans' proclivity for pictures is what distinguished them from animals: "Man is the only picture-making animal in the world. He alone of all the inhabitants of earth has the capacity and passion for pictures."[16] He summarized the significance of a photograph of Hiram Revels, the first African American senator, by saying: "Whatever may be the prejudices of those who may look upon it, they will be compelled to admit that the Mississippi Senator is a man."[17]

Emphasizing the humanity of all people was central to Douglass's reform vision, since most white Americans believed that blacks were innately inferior, lacking in reason and rational thought. Furthering that view were the ethnologists (precursors of anthropologists), who argued that blacks had smaller craniums, and brains, than whites, and thus lacked whites' cognitive abilities. In an 1854 speech, "Claims of the Negro Ethnologically Considered," Douglass engaged ethnologists' methods of comparing craniums and blacks' and whites' comparative capacities for reason, but with limited success. After his "awakening" to the philosophical power of photography, however, he dismissed the ethnologists' methods out of hand. "Dogs and elephants are said to possess reason," he says. But they lack "imagination," the realm of thought enabling humans to create pictures of themselves and their world. Douglass exposed the ethnologists' faulty method of analysis: they "profess some difficulty in finding a fixed, unvarying, and definite line separating . . . the lowest variety of our species, always meaning the Negro—from the highest animal." The line separating humans from other animals was quite clear, Douglass emphasized, as philosophers from Aristotle forward had acknowledged: "man is everywhere a picture-making animal and the *only* picture-making animal in the world. The rudest and remotest tribes of men manifest this great human power and thus vindicate the brotherhood of man." The picture-making power was "a sublime, prophetic, and all-creative power."[18]

The fourth reason for Douglass's love of photography is that it inspired people to eradicate the sins of their society. The power of the imagination allowed people to appreciate pictures as accurate representations of some greater reality. It helped them try to realize their sublime ideals in an imperfect world. As Douglass put it in an adage inspired by his reading of Carlyle: "Poets, prophets, and reformers are all picture-makers—and this ability is the secret of their power and of their achievements. They see what ought to be by the reflection of what is, and endeavor to remove the contradiction." Douglass considered himself all three: a poet, prophet, and reformer. So did most other abolitionists. As a group, abolitionists and antislavery advocates, from Douglass and Lincoln to Whitman and Sojourner Truth, had their portraits taken with greater frequency, distributed them more effectively, and were more taken with photography, than other groups. Photography inspired them to remove the contradictions between what ought to be and what was.[19]

Douglass recognized, however, that the power of photography depended upon its circulation in the public sphere. Photographs, like writing, needed to be published in books, newspapers, broadsides, and pamphlets in order to be disseminated. Whereas a daguerreotype or ambrotype offered a private viewing experience, its publication sent it into the world and made it public. Through the dissemination of his image and word, Douglass photographed and wrote himself into the public sphere, became the most famous black man in the Western world, and thus acquired cultural and political power. Indeed, his portraits and words sent a message to the world that he had as much claim to citizenship, with the rights of equality before the law, as his white peers. He knew, as James Russell Lowell put it, that "[t]he very look and bearing of Douglass are eloquent, and are full of an irresistible logic against the oppression of his race."[20] His likeness embodied his cause of racial equality. This is why he always dressed up for his sittings with photographers, appearing "majestic in his wrath," as one admirer said of his portrait, and why he labored to speak and write with such eloquence. He was widely considered one of, if not the, greatest orators in the Civil War era, more eloquent even than Lincoln or Emerson. It was through his images and words that he "out-citizened" white citizens, at a time when most whites did not believe that African Americans should be citizens.[21]

Douglass made every effort to circulate his photographs. He shared them with absent family members and close friends. In 1863, his son Charles requested a few autographed Douglass photos for himself and a friend. That same year, Julia Griffiths wrote Douglass from England to ask for a likeness to put in her new photo album.[22] Douglass also gave

his portraits as gifts to new friends, for example to Susan B. Anthony (see plate 3).

His gifted photographs adorned the walls of homes for decades. In 1937, the educator Josephine Turpin Washington explained that she would show visitors a photograph she had kept since Douglass gave it to her as a birthday gift (presumably when she clerked for him in the Recorder of Deeds office during summer breaks from Howard University in the early 1880s).[23] So ubiquitous was Douglass on people's walls, even before his death, that artists depicted rooms with framed Douglass images. In 1889, the African American artist Henry Jackson Lewis, a cartoonist for the *Indianapolis Freeman*, made a sketch of his editor, Edward Elder Cooper, at work in his study. Above Cooper's desk are two portraits, one of himself and one of Douglass. Another drawing by Lewis featuring Douglass on the wall was published in *The Freeman*, as was one by Moses Tucker.[24]

Douglass used his photographs to garner subscriptions to his own newspaper, thereby disseminating them further. In late 1873, his *New National Era* repeatedly advertised the "inducement" of a "fine photograph" of himself, sized at 14 × 20 inches, to any new subscriber.[25]

His photographs also helped promote individuals and organizations devoted to black rights. In 1846, the Anti-Slavery Bazaar offered for sale an "excellent Daguerreotype of Frederick Douglass." Two years later, Ephraim Williams, a shoemaker, and James Knight, a porter, told Douglass that they had commissioned lithograph portraits of him (and other black abolitionists) "to be hung up in our parlors and the parlors of all men who are true to the bondman" as a way to pay tribute to "the reformers who have marched in the forefront, battling for our rights as men and as Americans." In October 1894, the black photographer James E. Reed agreed to sell photographs from a recent sitting—the last in Douglass's life—to the public, and give the profits to Douglass's "Southern school" (see cat. #157–158).[26]

Douglass's photographs helped promote his talks, too. After the Civil War he became a speaker with the Redpath Lyceum Bureau, based in Boston and organized by the abolitionist James Redpath. The bureau used a lantern slide of Douglass (cat. #89) to advertise his affiliation to the agency.

But Douglass faced a problem in trying to disseminate his portrait on a mass scale. The halftone process, which enabled photographs to be mass-produced, would not be perfected until the twentieth century. Although he had to rely instead on engravings cut from photographs for book and newspaper illustrations, he did not have quite the same faith in the objectivity of an engraver (or painter) as he did of a camera. In

1849 he discovered an engraving of himself, cut from another engraving that possibly stemmed from a painting, in *A Tribute for the Negro*, by the British abolitionist Wilson Armistead (see plate 2.6). The engraver had portrayed Douglass with a slight smile. Douglass was outraged, and in his newspaper he noted that his portrait had "a much more kindly and amiable expression than is generally thought to characterize the face of a fugitive slave." Although he was no longer a fugitive, he wanted the look of a defiant but respectable abolitionist. He then attacked the fallibility of engraving and painting: "Negroes can never have impartial portraits at the hands of white artists," he stated. "It seems to us next to impossible for white men to take likenesses of black men, without most grossly exaggerating their distinctive features. And the reason is obvious. Artists, like all other white persons, have adopted a theory respecting the distinctive features of Negro physiognomy." The vast majority of whites could not create "impartial" likenesses because of their preconceived notions of what African Americans looked like.[27]

Douglass's criticism of white artists highlights why he was so taken with photography. As an art and a technology, photography overcame whites' "preconceived notions" of African Americans; the camera, unlike an engraving or painting, represented them accurately. Douglass surmounted the problem of disseminating his photographs using an unreliable medium by hiring engravers he could trust. John C. Buttre was his preferred engraver.[28]

Still, even a faithful engraving lacks the extraordinary detail of the photograph on which it was based. In fact, engravings may appear to us today as crude representations. But they and lithographs were the only available processes for disseminating a photograph in books and print media. Significantly, most Americans treated engravings cut from *photographs* as objective or "authentic," much as most people today interpret a halftone photograph in *The New York Times* as truthful. So did Douglass; if the engraving in Armistead's book had in fact been drawn from a painting, then there are no known instances of Douglass critiquing an engraving cut from a photograph of himself. The illustrated press, from the *Illustrated London News* to *Frank Leslie's* and *Harper's Weekly*, referred to engravings cut from photographs in their pages as "photographs," whereas engravings from sketches were called "sketches." Editors simply ignored the transfer process necessary to mass-produce an image. While the truthfulness of sketches from "eyewitness" artists was challenged, virtually no one "questioned the veracity of a photograph," or an engraving cut from it.[29]

By resolving the problem of circulating his "impartial" likeness, Douglass authorized millions of portraits to be sent into the world.

With very few exceptions, these were public portraits—designed to bolster his public persona. For Douglass, photography was not a personal or sentimental tool, a way to visualize family relationships or friendships. The only photograph that falls into the category of private memento is a honeymoon shot from 1884 with his second wife Helen Pitts (cat. #109). The photographs of Douglass with friends visiting Mount Vernon in Virginia (cat. #111–114) may also have been mementos, but these photographs may have been taken at the behest of a group member rather than Douglass himself.

The only body of work that captures something of his private life are the photos of Cedar Hill, his home in Anacostia, Washington D.C., after Reconstruction. He posed several times for photographs on his porch (see cat. #123, 124, 142); in his library (cat. #143–145); and walking around the grounds (cat. #138–141). But he was rarely photographed with family members. There are no clearly identified images of Douglass with his first wife, Anna, or with any of his children. He was photographed with his second wife, Helen, seven times (see cat. #109, 110, 116, 118, 137, 138, 140). The only grandchild who features in any photographs with Douglass is Joseph, of whom Douglass was particularly fond.[30] Even here, the photographs with Joseph reflect a professional collaboration. The two performed together in Boston in May 1894, Douglass giving a speech and Joseph performing violin solos before and after his grandfather's remarks. They sat for photographs during that Boston trip, then again in New Bedford after performing together. The photographs include Joseph playing his violin, and in one of these Douglass holds a piece of paper, perhaps related to the speech he was giving that day. The only known photographs of Douglass with any blood relative, then, are depictions of a professional and artistic collaboration as much as family portraits.

The sheer number of these public portraits, from his earliest known photograph as a young man with an Afro, circa 1841, to the postmortem portrait fifty-four years later, conveys not only Douglass's faith in photography but his understanding of the public identity he was crafting. By continually updating his public persona, he embraced what might be called a protomodernist conception of the self that paralleled his radical egalitarianism. Just as he rejected fixed social stations and rigid hierarchies, so too did he repudiate the idea of a fixed self. He imagined the self as continually evolving, in a state of constant flux, which exploded the very foundations of both slavery and racism. Of course slavery and racism both depend upon some individuals being "fatally fixed for life." Slavery creates a low ceiling above which no one can rise, and racism reflects the belief that some people are *permanently* superior to other people. Douglass's fluid conception of the self conjoined art and politics. He went so

far as to say that "the moral and social influence of pictures" was more important in shaping national culture than "the making of its laws."[31]

⁓

Douglass embraced almost all forms of photography, a truth that is evident from the archive, which includes virtually every format of nineteenth-century photography. There are nine daguerreotypes and four ambrotypes (plus two copy prints and one engraving from lost daguerreotypes or ambrotypes); one lantern slide and one salt print, which are comparatively rare; along with stereographs, cartes-de-visite, cabinet cards, wet-plate albumen prints, dry-plate prints, and postcards. The only major forms not present in the archive are the British calotype—which was quite rare in America and circulated primarily among the British aristocracy—and the tintype, the cheapest and least vibrant form of nineteenth-century photography.[32]

As Douglass posed for all these varied kinds of photographs, he sat frequently for fellow activists, such as the Philadelphia abolitionist Benjamin F. Reimer (plate 16), the abolitionist Thomas Collins of Westfield, Massachusetts (plate 22), and Robert Cargo of Pittsburgh, an operator on the Underground Railroad (cat. #17). He also rewarded loyalty. For example, in 1859 the Philadelphia photographer John White Hurn worked as a telegraph operator, and aided Douglass's escape after news broke of John Brown's capture at Harpers Ferry. Douglass was in Philadelphia, and Hurn suppressed the delivery of a message to the sheriff ordering Douglass's arrest as a conspirator in Brown's raid. He then warned Douglass, who left Philadelphia immediately and reached safety first in Rochester, then in Canada and England. When Douglass returned to Philadelphia in 1862, he sat for Hurn, and he did so again in 1866 and 1873. Hurn produced a total of nine extant photographs, the most by any Douglass photographer.[33]

But the photographers of Douglass were a varied group, comprising women and men, whites and blacks, Southerners and Northerners. This diversity is partly due to the fact that most of his portraits were taken on the road, amid speaking tours. The sheer number of different photographers also reveals the comparative openness of the photographic profession. There were few barriers to entry for aspiring artist-entrepreneurs. Start-up costs were modest, and it took only a few months to learn the basic process.[34]

At a time when "professional" implied men, Lydia Cadwell, an accomplished Chicago photographer, inventor, and gallery owner, created four stunning images of Douglass during his Western tour in the

winter of 1874–75. Amid the guerrilla warfare of Reconstruction, Carl Giers, a German immigrant who settled in Nashville, photographed Douglass in 1873 during his trip to address the Tennessee Colored Agricultural Association. Then too, many of the nation's best known photographers, from Mathew Brady and Alexander Gardner (figures 1 & 2) to George Schreiber, John Howe Kent, and George Kendall Warren, also photographed Douglass. Gardner inadvertently includes Douglass (and John Wilkes Booth) in his famous photograph of the Second Inaugural; Douglass stands directly in front of Lincoln, and Booth in the balcony above him (figures 3 & 4).[35]

Four black photographers portrayed Douglass. Cornelius Battey, born in Augusta, Georgia, in 1873, established a successful studio in New York with a white partner. Battey photographed Douglass in 1893, before becoming the instructor of photography at Tuskegee Institute in Alabama. James Reed formed another interracial partnership, teaming up with the white artist Phineas Headley, in New Bedford, Massachusetts, where Douglass had lived for three years as a fugitive. In 1894, Reed created two of the most beautiful portraits of Douglass as an older man. James Hiram Easton operated a studio in Rochester, Minnesota, from 1862 until the late 1880s, with his wife as his photographic partner. He photographed Douglass during a speaking tour through the Midwest in 1869. And James Presley Ball (figure 5), one of the nation's preeminent photographers, portrayed Douglass in two 1867 cartes-de-visite.[36]

Ball's Cincinnati studio, in operation from 1851 to the 1870s, became known as the "Great Daguerreian Gallery of the West." In 1854, *Gleason's Pictorial* featured Ball's gallery and declared that Ball photographed "with an accuracy and a softness of expression unsurpassed by any establishment in the Union" (figure 6). The gallery's north, or left, wall displayed several paintings from Robert Duncanson, the African American landscape painter who worked in Ball's studio, hand-tinting Ball's prints. Below Duncanson's paintings is a large selection of Ball's photographs. And on the south, or right, wall are the Goddesses of poesy (creativity), music, science, religion, purity, and beauty—the sources of great photography. The walls themselves are bordered with gold leaf and flowers. "Scarcely a distinguished stranger" who came to Cincinnati did not "seek the pleasure of Mr. Ball's artistic acquaintance," *Gleason's* noted.[37]

Douglass was apparently so taken with Ball that he featured the *Gleason's* article, with an engraving of the gallery, on the front page of his newspaper, *Frederick Douglass' Paper.* Ball's gallery indicated that American visual art stemmed as much from African Americans as whites. It offered up a microcosm of what America could be: an inte-

grated place where patrons like Douglass could mingle, listen to music, and feel ennobled by the art as they waited for their portraits. True art could indeed break down racial barriers.[38]

For Douglass, the diversity of photography reflected the diversity of humanity. "There have been many daguerreotypes taken of life," he said in an 1860 speech on "Self-Made Men." "They are as various as they are numerous. Each picture is coloured according to the lights and shades surrounding the artist" and sitter. The sailor, farmer, architect, and poet each viewed the world differently. Humanity was a "vast school," and thus daunting to understand: "those who learn most seem to have most to learn." Photography brought "focus" to the subject through its accurate portrayal of people. "The proper study of mankind is man," he said, quoting Alexander Pope.[39]

It was as though Douglass viewed the world as a vast picture gallery, which highlighted both the common humanity and sublime uniqueness of each person. In this, he seemed to echo Walt Whitman's unpublished poem "Pictures," written in the 1850s:

> In a little house I keep many pictures
> > hanging suspended—It is not a fixed house,
> It is round—it is but a few inches from one side of it to the other side,
> But behold! it has room enough—in it, hundreds and thousands,—all
> > the varieties;
> —Here! do you know this? This is cicerone himself;
> And here, see you, my own States—and here the world itself,
> > bowling
> > > through the air;
> > rolling

There is room enough in Whitman and Douglass's "little house" for all the varieties of humanity. Like Cicerone, they are guides, showing visitors the fluid, all-embracing nature of photography and democracy.[40] Douglass, even more than Whitman, was one of America's great evangelists of the eye, introducing his viewers, readers, and listeners to a vision of interracial democracy in which everyone was a citizen with equal rights before the law. His picture gallery was all-inclusive.

Douglass recognized, too, that his relationship with the camera and photographer contributed to the transformative power of the medium. His portraits suggest that he understood his role as an artist or performer, part of a *pas de trios* with the photographer and camera. With that role, he acknowledged the challenges of sitting for a portrait: the "photographic process" was one of "stern serenity," which tended to pro-

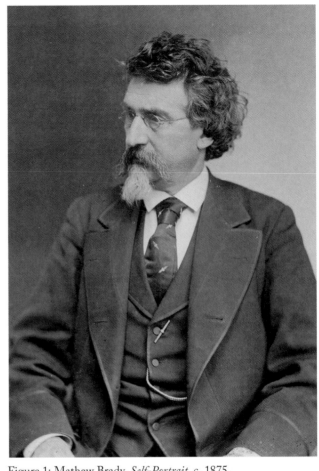

Figure 1: Mathew Brady, *Self-Portrait*, c. 1875.
Library of Congress

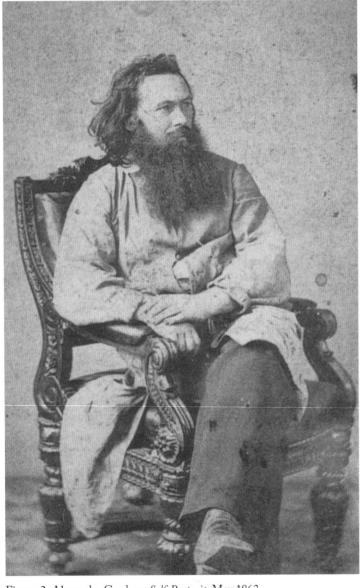

Figure 2: Alexander Gardner, *Self-Portrait*, May 1863.
Library of Congress

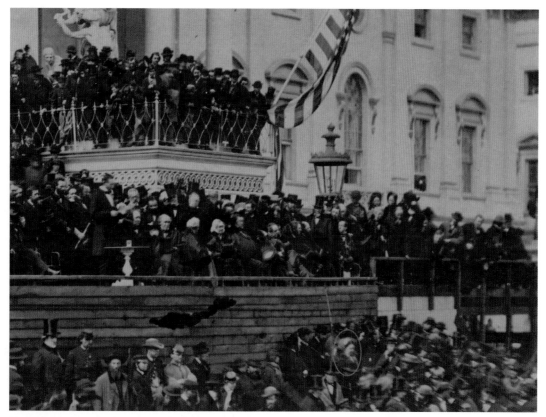

Figure 3: Alexander Gardner, *Lincoln's Second Inaugural*, 1865, detail (Frederick Douglass circled).
Library of Congress

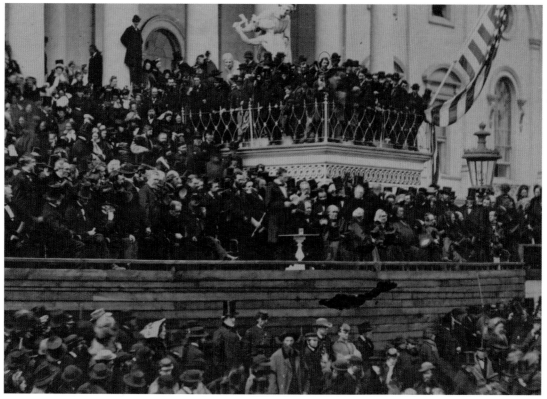

Figure 4: Alexander Gardner, *Lincoln's Second Inaugural*, 1865, detail (John Wilkes Booth circled).
Library of Congress

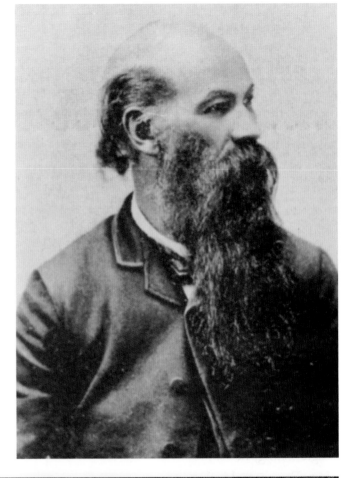

Figure 5: James P. Ball, *Self-Portrait*, c. 1880. Esther Hall Mumford, *Seattle's Black Victorians, 1852–1901* (Seattle: Ananse Press, 1980)

Figure 6: S. C. Peirce, "Ball's Great Daguerreian Gallery of the West," c. 1854. *Gleason's Pictorial Drawing-Room Companion* 6.13 (April 1, 1854): p. 208.

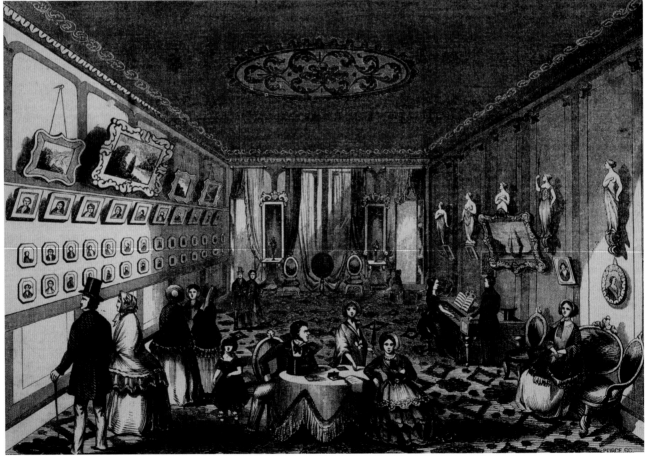

duce "something statue-like" in subjects, he said. The process required the sitter to be absolutely still for several seconds (much longer in the 1840s). Such a process might "deter some of us" from having their photograph taken, he added.[41] And so he confronted the challenge much as a dancer did: by *performing* for the photographer, and appreciating the crucial role of timing, lighting, and set design.

Eventually, Douglass developed his own aesthetic. In his *oeuvre*, the vast majority of his portraits are closely cropped or vignetted. The effect draws attention to Douglass himself. There are comparatively few props to distract the viewer. He rejected the usual nineteenth-century studio practice of using elaborate backdrops: painted scenes of ornate columns and landscapes. Such objects detracted from his solemn, dignified performance of black masculinity and citizenship. On the rare occasion that he used a prop, he made sure it was significant: Lincoln's cane (see plate 32); a book or newspaper (see plates 18, 30, 49); and a lion's head chair, an acknowledgement of his own leonine mythology as "The Lion of Anacostia" at the "sunset" of his life (see plate 57).[42] In other sittings, he was clearly experimenting with different angles, adjusting his clothing, and even trying out varied gestures.[43]

In addition, as is now clear from the clusters of images taken at a single sitting, he worked with the photographer to obtain the "perfect" shot. For example, there are three similar photographs from a sitting with John Howe Kent in early 1874. In one (cat. #81), Douglass's overcoat is undone, hanging loosely. In another (cat #80), the overcoat is fastened but creased. In a third (cat. #79), he has straightened out his coat. It is the image with the straightened coat that exists in multiple archives, suggesting this is the one that Douglass authorized for sale and circulation, perhaps even signed as a carte-de-visite.[44]

This experimentation and artistry is reflected in the compelling force of his portraits. Understandably, photographers sought him out and apparently loved working with him. One friend owned "more than twenty pictures of him," and in 1870 noted that "the photographers are running after him to sit for them." Even now, save for a few isolated shots, his portraits consistently command our attention.[45]

Douglass had clear favorites. For example in the 1890s, Douglass used the photograph by Charles Bell (see plate 48) as the letterhead on his correspondence. He was likely also pleased with the photographs by Samuel Montague Fassett in 1864 and John Howe Kent in 1874, as he returned to Fassett for more photographs in 1878 and to Kent in 1882.

It is significant that Douglass's photographic self, much like his persona as an orator and writer, continually evolved. The earliest three photographs suggest that he was exploring this new medium, searching for

an appropriate pose or "visual voice." The act of posing was political, and it marked a break from his experience as a slave. In 1847, he told a British audience: "dissatisfaction was constantly manifesting itself in the looks of a slave. [I have] been punished and beaten more for [my] looks than for anything else—for looking dissatisfied because [I] felt dissatisfied—for feeling and looking as [I] felt at the wrongs heaped upon [me]." Now Douglass had to turn those facial expressions into sources of power.[46]

In the first known image, a daguerreotype from around 1841, he appears dazed, or "statue-like," as he would have said (see plate 1). No doubt this was partly because exposure times in 1841 lasted several minutes, as opposed to several seconds a few years later. In an 1843 daguerreotype the camera is positioned at the level of his chest, and he looks above it and to one side. This was the pose recommended by photographic manuals. "The eyes should be fixed on some object a little above the camera, and to one side, but never into, or on the instrument," instructed the photography teacher Henry Snelling. The look evoked a statesman or visionary, as Alan Trachtenberg has noted.[47] But Douglass was still a fugitive and not yet comfortable with his visual persona. In the daguerreotype, his eyes seem only half open and partially shrouded in shadow (especially his right eye), thus complicating a visionary gaze (see plate 2).[48] In an 1848 daguerreotype by the Edward White Gallery, he looks askance, with his head down, as if unwilling to trust the camera or the photographer (see plate 3).

These three images indicate uncertainty about his early 1840s visual persona. Such uncertainty is reflected in a letter he wrote in 1846 to a fellow fugitive: "I got real low spirits a few days ago, quite down at the mouth. . . . I looked so ugly that I hated to see myself in the glass."[49] What he sought was a look that could lay claim, for himself and other African Americans, to respect and dignity, in essence the right of citizenship—a visual voice of radical democracy.

Douglass seems to have found that look in 1847, revealed in an 1850 daguerreotype that is a copy of one (now lost) from 1847 (see plate 4). He stares sternly into the camera lens in a dramatic and crafted pose. It sent a message of artful defiance or majestic wrath, and with minor variations, it became his visual voice from the late 1840s through the Civil War. The frontispiece of his best-selling, second autobiography, *My Bondage and My Freedom* (1855), resembles the 1850 daguerreotype and similarly evokes artful defiance (see plate 9). Based on another lost photograph, it too draws attention to his physical strength and aggression, depicting as it does a broad-shouldered young man in a pugilistic pose, with furrowed brows and firm lips. Owing to the popularity of *My Bondage*, the frontispiece was probably the most widely disseminated portrait of Douglass in America until after the Civil War.[50]

The origins of Douglass's look of artful defiance can be seen even earlier. He looks directly into the camera lens in his first known photograph, from around 1841. And in the frontispiece to his 1845 *Narrative* (see plate 2.2), he again stares at the viewer. But the look of defiance is offset by his reclining torso and arms that lay relaxed against his thighs. Appropriately, the engraver left the portrait unfinished. There are few details below his shoulders, as if to illustrate that his visual persona was still being formed.

In the 1850s, Douglass began fashioning for himself another, even more dramatic pose: the profile portrait. It was limited chiefly to distinguished men and women, and in the antebellum era there are only five known profile portraits of Douglass. They generally evoke majesty rather than defiance. In the 1870s, after he became a distinguished statesman, the profile portrait became one of his favorites.

Douglass's mastery of the art of the photographic subject is revealed in several group portraits. In Ezra Greenleaf Weld's 1850 daguerreotype of abolitionists gathered outdoors in Cazenovia, New York (see plate 5), Douglass is one of the few figures sitting still enough for the camera to appear unblurred. In other images, he often appears to be the only person who understands the relationship between subject, camera, and photographer. For group portraits, sitters were instructed to look at or near the camera. But in an 1892 image of the directors of the Alpha Life Insurance Company (see plate 53), most of the men seem to have no idea where the camera is. Some look off to one side, some to the other side, and still others act as if the camera were a gun. Douglass alone addresses the camera in his majestic pose. It is the pose of an elder statesman and citizen, a portrait of radical democracy.

As a photographic subject, Douglass tried to articulate his vision of this radical democracy. Among the 160 distinct poses, three central themes stand out. First, he almost never showed a smile, with the notable exception of an 1894 cabinet card six months before he died (see plate 59).[51] Almost to the end of his life, he refuted the racist caricatures of blacks as happy slaves and servants. Second, he presented himself, in dress, pose, and expression, as a dignified and respectable citizen. Third, his visual persona continually evolved, which undermined the foundations of slavery and racism. The photographs are then a kind of visual autobiography. If Douglass wrote himself into public existence with his narratives, he also photographed himself into public existence, evolving across the years as a freedom fighter, steely visionary, wise prophet, and elder statesman.

For example, he made a shift in his persona after the Civil War and Emancipation. Before the war, Douglass's fists are sometimes clenched, as though in the act of fighting. In a stunning 1855 profile daguerreo-

type, he did just that in a look of majestic defiance (see plate 10; also plates 9 & 13). In another pre-Emancipation photograph, he folds his arms across his chest in an aggressive pose (see plate 14). After Emancipation, the fist unclenches and the arms unfold.[52]

In a second shift, before the war Douglass often makes direct eye contact, staring challengingly back at the viewer. After Emancipation, he tends to use a classic statesmanlike three-quarter pose. Of the 38 photographs taken before the end of the war, 17 feature Douglass staring back at the camera—nearly half. Of the 122 photographs taken after the end of the war, 21 feature the direct stare (not including large group or crowd shots)—less than 20 percent. Douglass the fighter and fugitive transforms into Douglass the citizen and great American. As Douglass himself phrased it in the title to his second autobiography, it is a transition from bondage to freedom.

Perhaps the most noticeable visual marker of Douglass's continual evolution is his facial hair. Although nineteenth-century men experimented with hirsute faces, few did so as frequently as Douglass. He tracked, and often led, the prevailing fashion. In the 1840s, "a clean-shaven look was most prevalent," writes Joan Severa. Douglass, too, was clean-shaven. He grew chin whiskers in the early 1850s (see plate 7) that evolved into a cropped fringe of muttonchop whiskers along the chin and jawline, also a trend at the time (plate 9). By the mid-1850s he became a trendsetter, with a full beard coupled with side hair that covered his ears, a look that was not popular until late in the decade (plate 11). He then began sporting a goatee, which he kept until about 1861 (plates 13–14), when he grew a Lincolnesque beard for a year before resuming the goatee (plate 16). In January 1864, he anticipated another trend with a sporty walrus mustache, which would not become common for another two decades (see plate 21). Around 1865 he coupled his walrus mustache with a short ponytail (see cat. #42). He kept his mustache until about 1873, at which point he briefly grew a full beard (plate 38). Within a year, however, he shaved his chin whiskers, while retaining bushy sideburns that looped up to connect to his mustache (see cat. #79–83). In 1875, he maintained a neatly groomed full beard, anticipating a look "affected by authority figures in the 1880s," according to Severa. His beard and hair gradually lengthened and whitened until his death in 1895 (see plate 60).[53]

Douglass may have even revised his look with the publication of each new autobiography, knowing that the first page of the book would feature a frontispiece portrait. The Douglass of the *Narrative* era is clean-shaven with a side parting. When he published *My Bondage and My Freedom* in 1855, he grew a goatee and replaced the side-parted hair with a larger Afro-like style. This version of Douglass is the one asso-

ciated with his most radical years, when he advocated violent resistance to slave catchers. In the late 1870s, soon before he published his third autobiography, *The Life and Times* (1881), he reinvented himself one last time and grew a full beard and longer hair. This leonine persona lasted until his death. The autobiographies therefore date the different visual eras of Douglass as the fugitive slave era of the *Narrative* (1840s), the abolitionist firebrand era of *My Bondage* (1850s and 1860s), and the elder statesman era of *The Life and Times* (1880s and 1890s).

The evolution of his appearance indicated his status as a "self-made man." The appellation encapsulated his rise up from slavery; his abolitionism; his love of photography; and his faith that true art could break down racial barriers. "Self-Made Men" became for Douglass one of his signature speeches and a key phrase denoting not riches but radicals who sought to eradicate the sins of their society as they evolved. The black abolitionist and physician James McCune Smith called Douglass an emblematic self-made man because he had "passed through every gradation of rank comprised in our national make-up and bears upon his person and his soul everything that is American." Lincoln said something similar; after his first meeting with Douglass at the White House, he called him "one of the most meritorious men, if not the most meritorious man, in the United States."[54]

Douglass's portrait gallery contributed to this persona as one of the nation's preeminent self-made men. In certain respects it resembled the nation: both had come out from slavery and revolution to become a respected statesman or state. Then, too, Douglass and his nation were both aspirational; they saw what "ought to be by the reflection of what is." But unlike Douglass, most American statesmen did not seek to remove the contradiction between what was and what ought to be. While Douglass's portrait gallery was all-embracing, America's was narrow and petty. It continued to define itself as white. As a result, Douglass's portraits would serve as an important legacy in the twentieth century, inspiring art that could break down racial barriers.

The photographs' afterlife began in the days after Douglass's death, when dozens of newspapers published obituaries that included lithographs of photographic portraits. Then in 1896, just a year after Douglass died, the civil rights activist John Edward Bruce copyrighted an unglazed earthenware pitcher that featured Douglass's head, based on a photograph taken by Brady in 1877 (plate 44). The following year, John Hay Industrial School was dedicated in Alexandria, and the committee sealed into

the cornerstone a photograph of Douglass, along with a Bible and other images and mementos. At the same time, the Douglass monument committee, which raised money for the statue erected in Rochester in 1899, offered an 8 × 10 inch photograph of Douglass to anyone who sent a dollar or more to the statue fund. John Wesley Cromwell launched a business to sell steel engravings of Douglass and other black figures in 1898, and his brother, Levi Cromwell, planned to give away thousands of copies. Farther south, Henry Stanley Newman described the black settlement of Warnersville, North Carolina, where on the walls of the small parlors were portraits of Douglass. This vision of Douglass-on-the-wall endured. Brother Tarp in Ralph Ellison's novel *Invisible Man* (1952) hangs a portrait of Douglass above the narrator's desk, and Ernest Gaines describes a photo-collage of Douglass, Lincoln, and Booker T. Washington hanging over the mantel in his novel *A Lesson Before Dying* (1992).[55]

Douglass had predicted as much, observing in 1870 in a published letter to a leading printer and lithographer:

> Heretofore, colored Americans have thought little of adorning their parlors with pictures. . . . Pictures come not with slavery and oppression and destitution, but with liberty, fair play, leisure, and refinement. These conditions are now possible to colored American citizens, and I think the walls of their houses will soon begin to bear evidence of their altered relations to the people about them. . . . Every colored householder in the land should have one of these portraits [of a black leader] in his parlor, and should explain it to his children, as the dividing line between the darkness and despair that overhung our past, and the light and hope that now beam upon our future as a people.[56]

Douglass's portrait was its own dividing line between past and future. It appeared not only on the walls of black and white homes but also on the walls of at least 110 murals in black and white neighborhoods, community centers, churches, and parks. Artists summoned his portrait from photographs for their murals, drawings, and magazine covers to protest lynching and segregation, to lobby for civil rights, and to celebrate Black Power. Douglass's awareness of the possibilities of imagery to shape public opinion, coupled with his ability to control and circulate his own image, shaped one of the great battles in American history—a battle between racist stereotypes and dignified self-possession. Across fifty years of photographs, Douglass fought for the public image of African Americans. Across the next century, in his visual afterlife, the photographs fought on.

PICTURING
FREDERICK DOUGLASS

PART I
The Photographs

Photographs of Douglass are rare works of art and important historical documents. In this "gallery" we showcase 60 of the 160 separate poses, most of them published here for the first time. We also feature a selection of engravings and lithographs, cut from the photographs, that reveal how the print media disseminated Douglass's photographic image and made him instantly recognizable to millions.

The images are sequenced chronologically and span half a century, from the first known photograph of the young Douglass, circa 1841, to a "deathbed" photo taken shortly after he died in 1895. Along this arc, we see Douglass first searching for an appropriate pose, then acquiring postures of a defiant citizen, and finally settling into elder statesman. Throughout this evolution he continually experimented with poses, gestures, and styles.

Our selection highlights not only the artistry of the photographers, engravers, and of Douglass as subject, but also his catholic preferences for photographers and formats. He sat for women and men, African Americans and whites, Southerners and Northerners. The range of formats mirrors the evolution of photography: the earliest images are daguerreotypes, followed by ambrotypes, a salt print, then cabinet cards, albumen prints, and postcards.

The vast majority of these "top 60" images are solo portraits. They capture Douglass close up, offering us subtleties of expression, texture, and mood. But there are also some group portraits that include family members, and the only known photograph of Douglass delivering a speech. In four cases the original photograph has been lost, and in its place we include a photographic copy of the original, a copy print, or a detailed engraving that suggests something of the original's power.

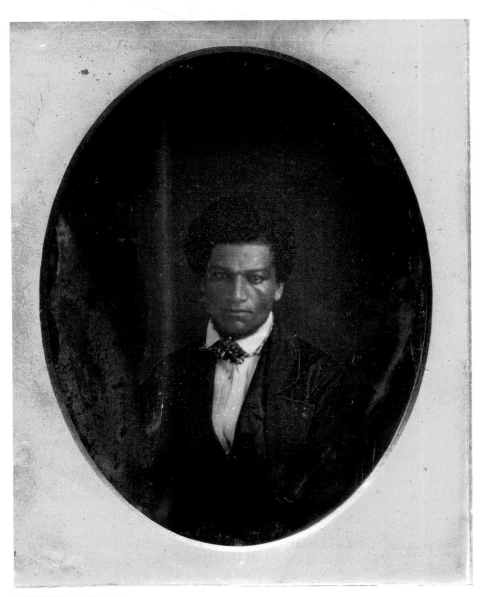

Plate 1 (cat. #1)
Unknown photographer
c. 1841
Sixth-plate daguerreotype (2¾ × 3¼ in.)
Collection of Greg French

Douglass likely sat for this photograph when he visited Syracuse between
July 30 and August 1, 1843.

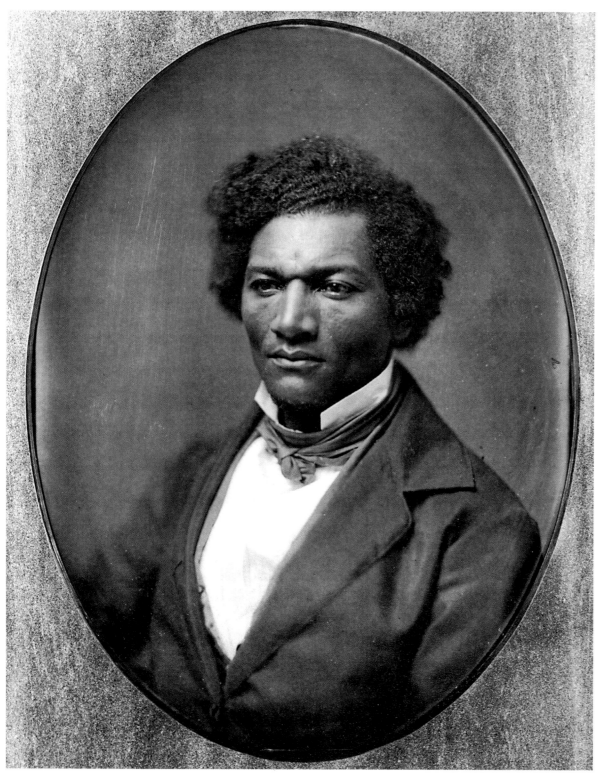

Plate 2 (cat. #2)
Unknown photographer
July–August 1843
Syracuse, NY
Whole-plate daguerreotype (6½ × 8½ in.)
Onondaga Historical Association

John C. Buttre was a steel-plate engraver and lithographer who went on to publish the three-volume *American Portrait Gallery* (1880–81).

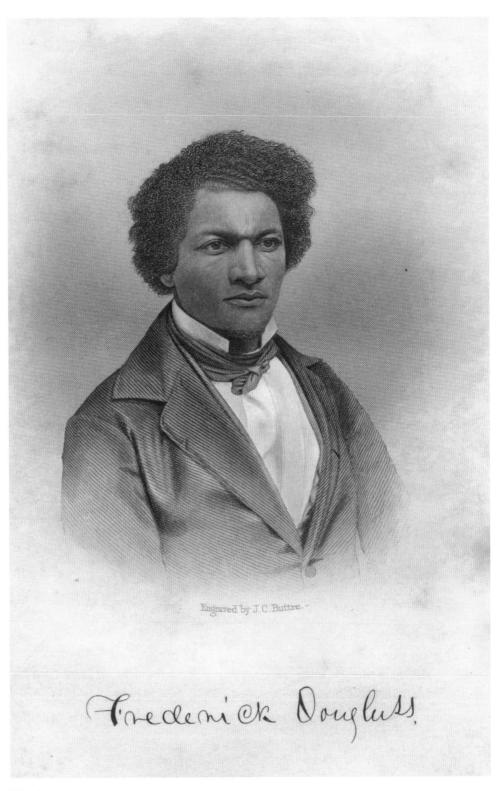

Engraved by J.C.Buttre.

Frederick Douglass.

Plate 2a
John Chester Buttre (1821–1893)
c. 1854
Engraving published in Julia Griffiths, ed., *Autographs for Freedom* (1854), p. 251
Author's collection

Douglass likely sat for this photograph when he visited New York for the American Anti-Slavery Society's annual meeting between May 9 and 11, 1848, also speaking at Convention Hall on Wooster Street, not far from White's studio. According to a note that Albert Cook Myers placed inside the case, Douglass gave this photograph to Susan B. Anthony, whose niece gave it to Myers, who gifted it to the Chester County Historical Society in 1955.

Edward White was a daguerreotypist and daguerreian plate and case manufacturer in New York City. He operated a portrait studio at 175 Broadway known as the United States Daguerreian Gallery from 1843 until at least 1847. In 1846 he also took over Johnson's Southern Daguerreotype Portrait Gallery in New Orleans, and in 1848 he moved to 247 Broadway and advertised a free exhibition of "over 1000 Daguerreotype Miniatures from life, of nearly all our eminent men." He retired from the profession in 1851.

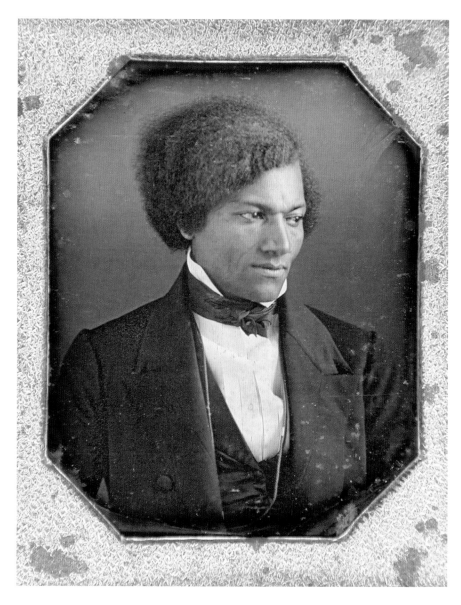

Plate 3 (cat. #3)
Edward White Gallery
May 1848
247 Broadway, New York City
Sixth-plate daguerreotype (2¾ × 3¼ in.)
Albert Cook Myers Collection, Chester County Historical Society

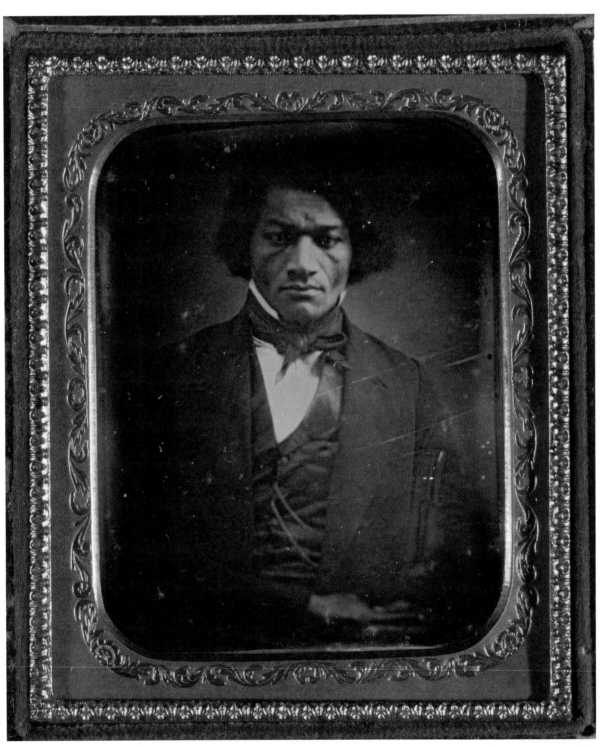

Plate 4 (cat. #4)
Unknown photographer
c. 1850 (copy of lost c. 1847 daguerreotype)
Sixth-plate daguerreotype (2¾ × 3¼ in.)
National Portrait Gallery, Smithsonian Institution

Ezra Greenleaf Weld took this photograph at the Cazenovia Fugitive Slave Law Convention, which met in abolitionist Grace Wilson's apple orchard on its second day because delegates had endorsed the public "Letter to the American Slave from those who have fled from American Slavery," which prompted angry local churches to close their doors. Douglass is seated, with Theodore Dwight Weld (the photographer's brother) sitting in front of him and Gerrit Smith, the speaker, standing behind. Mary Edmonson is to Smith's left and Emily Edmonson to his right; George W. Clark is over Emily Edmonson's shoulder. Theodosia Gilbert sits next to Douglass and Joseph Hathaway is taking notes at the table. Samuel J. May is behind Hathaway. William Chaplin, in prison for helping slaves escape, received the daguerreotype as a gift.

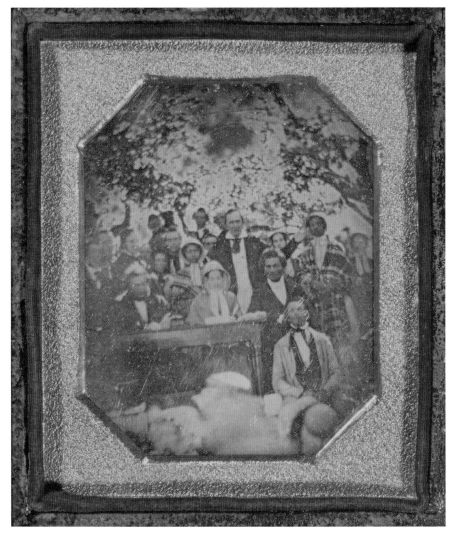

Plate 5 (cat. #5)
Ezra Greenleaf Weld (1801–1874)
August 22, 1850
Cazenovia, NY
Sixth-plate daguerreotype (3⅛ × 2¾ in.)
J. Paul Getty Museum. (Also held by Madison County Historical Society; and Collection of Mr. & Mrs. Set Charles Momjian, on loan to the National Portrait Gallery.)

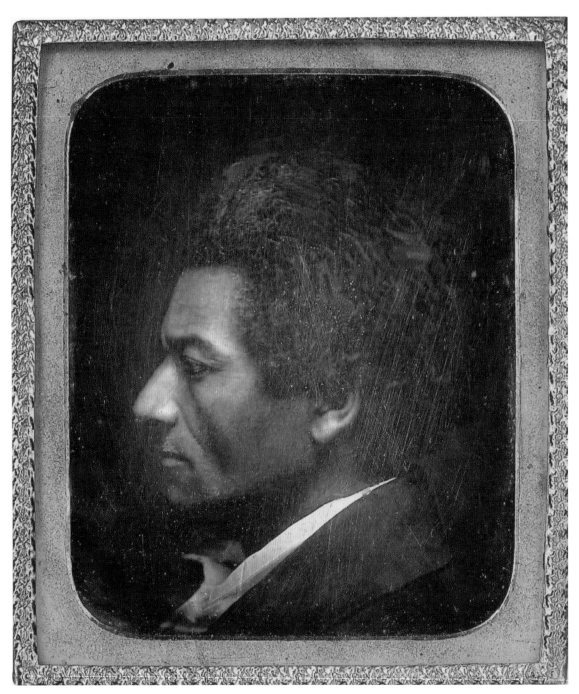

Plate #6 (cat. #6)
Unknown photographer
c. 1850
Quarter-plate daguerreotype (3¼ × 4¼ in.)
Moorland-Spingarn Research Center, Howard University

Douglass likely sat for this photograph when visiting nearby Salem, Ohio, between August 21 and August 23, 1852, for the Western Anti-Slavery Society annual meeting. Samuel J. Miller was active in Akron from 1849 to 1857 and also photographed John Brown in the early 1850s. He was working in New York City by 1863.

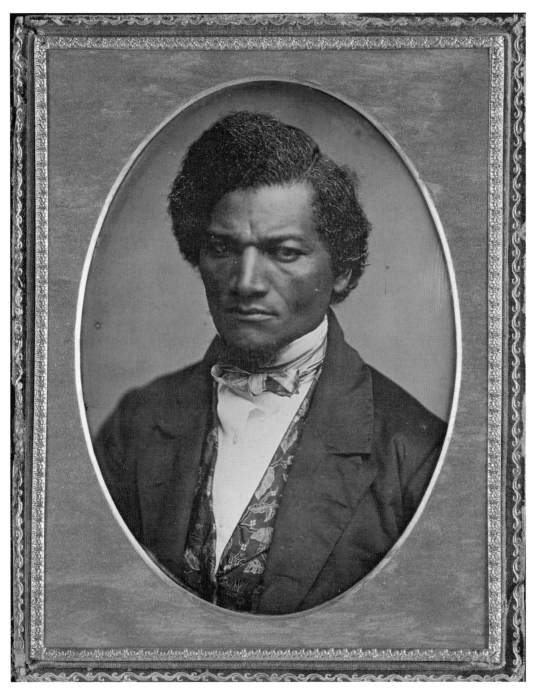

Plate 7 (cat. #7)
Samuel J. Miller (1822–1888)
August 1852
Akron, OH
Half-plate daguerreotype (4¼ × 5½ in.)
Art Institute of Chicago

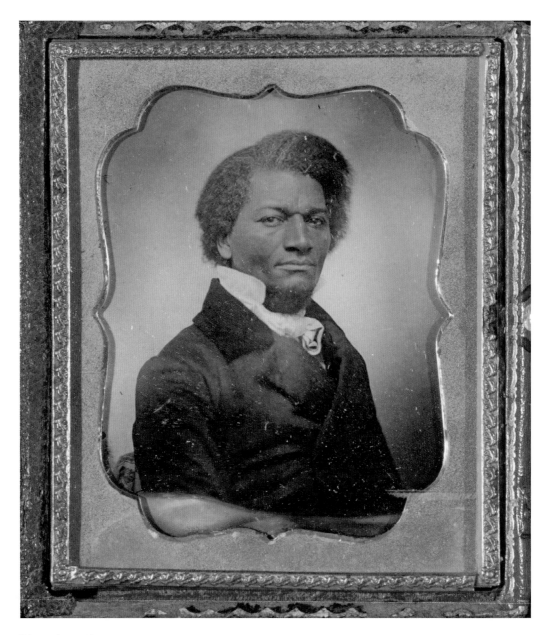

Plate 8 (cat. #8)
Unknown photographer
c. 1853
Sixth-plate daguerreotype (3⅛ × 2¾ in.)
Metropolitan Museum of Art

This engraving accompanied Douglass's obituary, along with another engraving based on the Charles Bell photo, c. 1881 (see plate 48). The *Evening Star* did not normally include images; of the eleven pages in this issue, there was only one other engraving—of Charles V. The obituary gives a lengthy sketch of Douglass's life, including his "active part in inducing President Lincoln to arm the slaves."

Plate 9a
Unknown artist
c. 1895
Washington Evening Star,
February 21, 1895, p. 9.
Frederick Douglass Papers,
Library of Congress

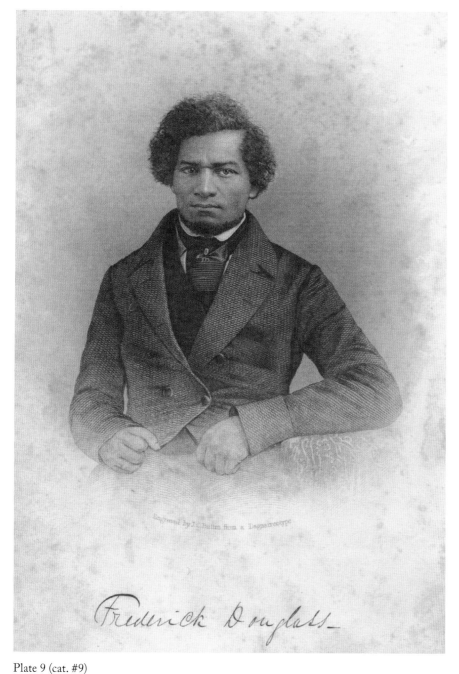

Plate 9 (cat. #9)
John Chester Buttre
c. 1855
Engraving from a lost daguerreotype, published as the frontispiece to Douglass's *My Bondage and My Freedom* (1855) (5 × 3 in.)
Author's collection

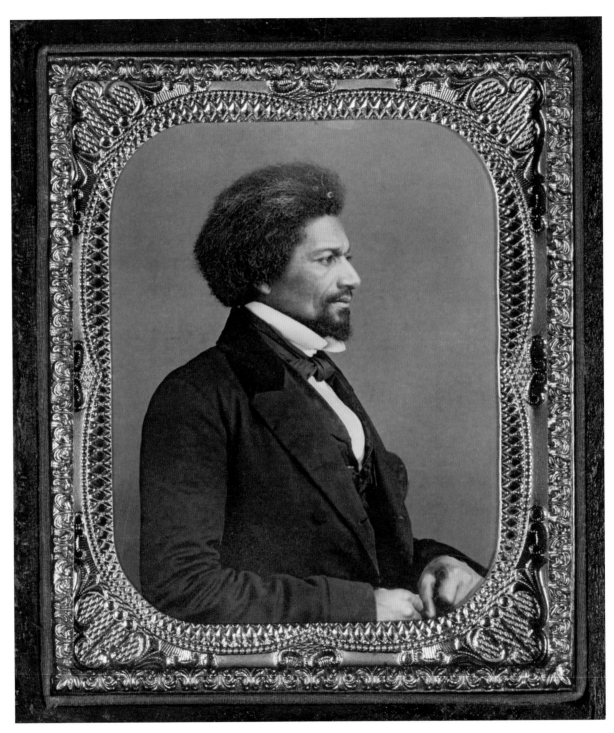

Plate 10 (cat. #10)
Unknown photographer
c. 1855
Sixth-plate daguerreotype (2¾ × 3¼ in.)
Nelson-Atkins Museum of Art

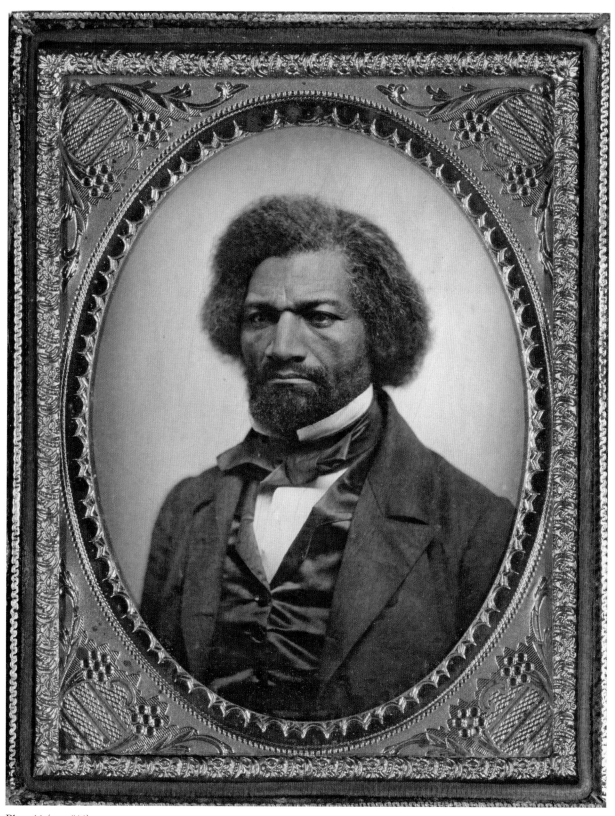

Plate 11 (cat. #11)
Unknown photographer
c. 1856
Quarter-plate ambrotype (4¼ × 3¼ in.)
National Portrait Gallery, Smithsonian Institution

The photograph exists in a scrapbook along with portraits of Lowell Mason, John Saxe, Henry Clay, Bayard Taylor, George Prentice, Zachary Taylor, Henry Longfellow, and Dr. Elisha Kane.

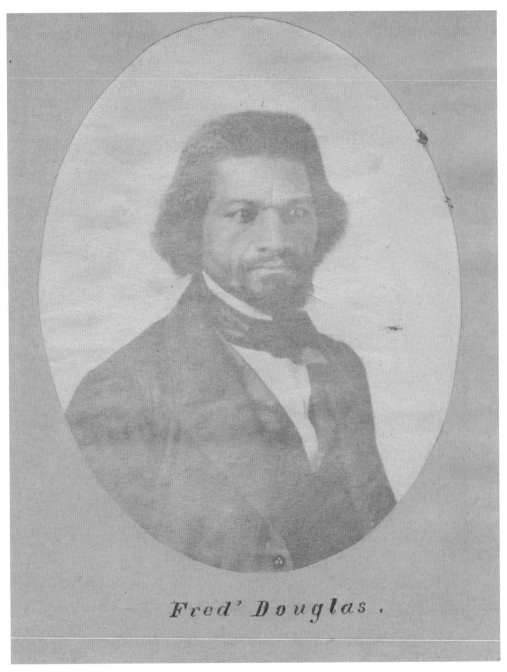

Plate 12 (cat. #12)
Unknown photographer
c. 1857
Copy print from a lost daguerreotype or ambrotype (2 × 3 in.)
Clements Library, University of Michigan

The only extant copy of this photograph has two black lines across it.

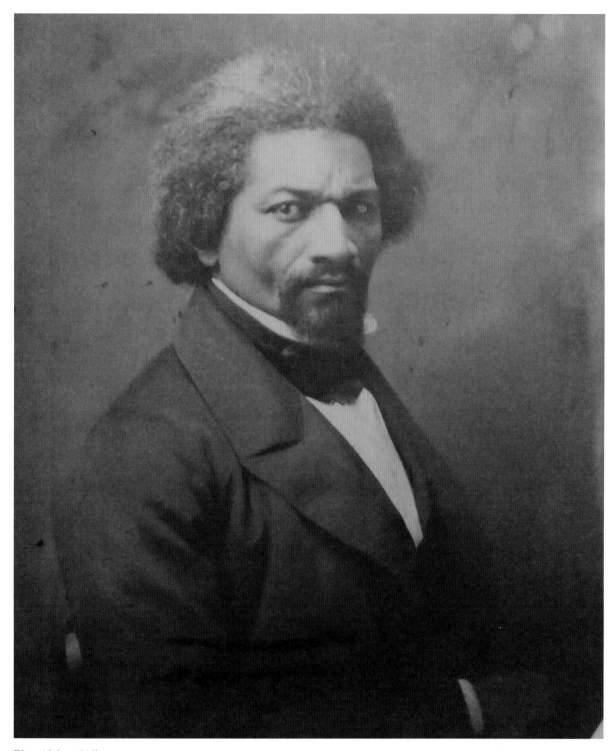

Plate 13 (cat. #13)
Unknown photographer
c. 1858
Copy print from a lost daguerreotype or ambrotype (8 × 10 in.)
New-York Historical Society

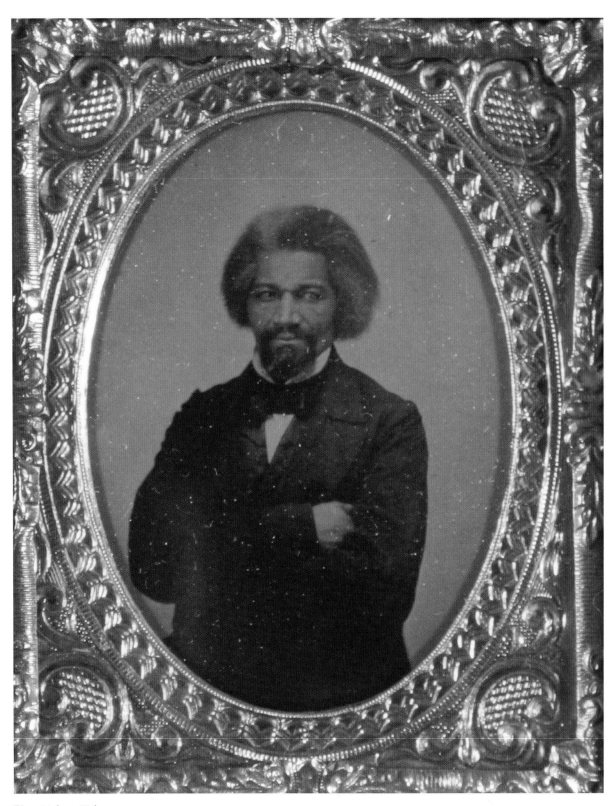

Plate 14 (cat. #14)
Unknown photographer
c. 1859
Ninth-plate ambrotype (2 × 2½ in.)
University of New Mexico Art Museum

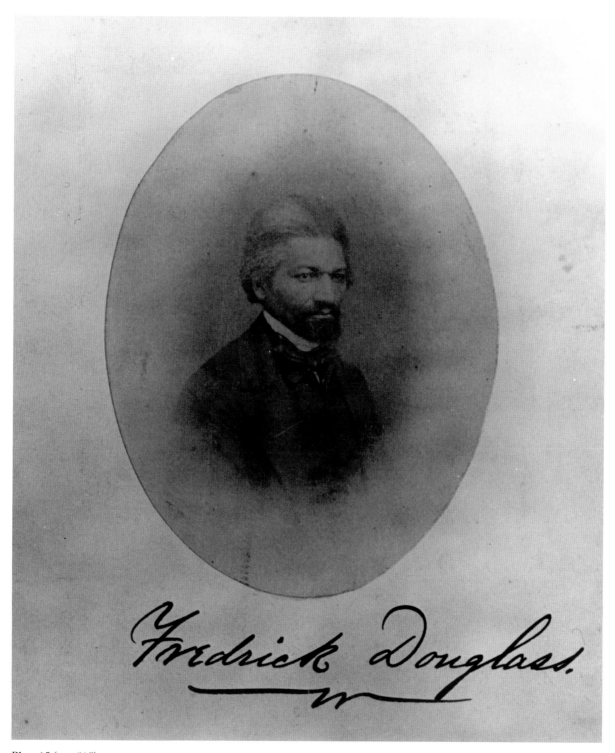

Plate 15 (cat. #15)
Unknown photographer
c. 1860
Salted paper print (4 × 3⅛ in.)
National Portrait Gallery, Smithsonian Institution

Benjamin Reimer, an abolitionist, was active as a photographer in Philadelphia between 1849 and the late 1870s. By 1866 he had moved his studio to 624 Arch Street.

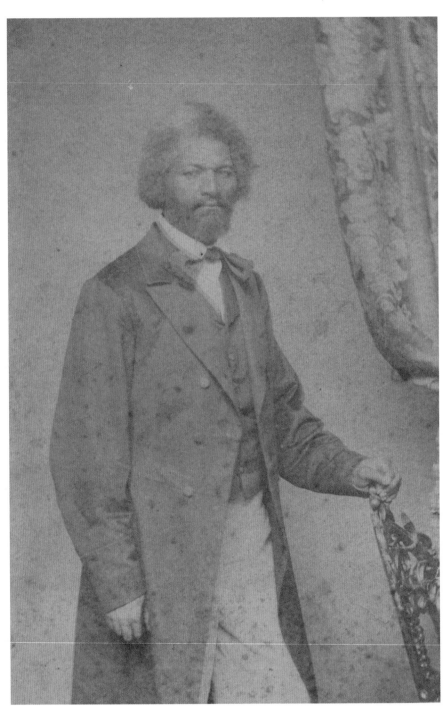

Plate 16 (cat. #16)
Benjamin F. Reimer (1826–1899)
c. 1861
615 & 617 North 2nd Street, Philadelphia, PA
Carte-de-visite (2½ × 4 in.)
National Park Service, Frederick Douglass National Historic Site

Douglass likely sat for this photograph when he visited Philadelphia on January 14, 1862, to speak at National Hall, just one block from John White Hurn's studio. Three photographs survive from this sitting in 1862. Hurn photographed Douglass again in 1866 and 1873, for a total of nine extant photographs, the most by any Douglass photographer. Hurn was active as a photographer in Philadelphia in the 1860s and 1870s. In 1859 he was also a telegraph operator and aided Douglass's escape to Canada after news broke of John Brown's capture at Harpers Ferry. Douglass had arrived in Philadelphia on October 17, 1859, to give his "Self-Made Men" speech. For three hours, Hurn suppressed the delivery of a message from the sheriff of Franklin County to the sheriff of Philadelphia ordering the arrest of Douglass as a conspirator in Brown's raid. During those three hours, Hurn worked with a local Underground Railroad operator to warn Douglass, who left Philadelphia immediately by train, reached Rochester, then left for Canada and England.

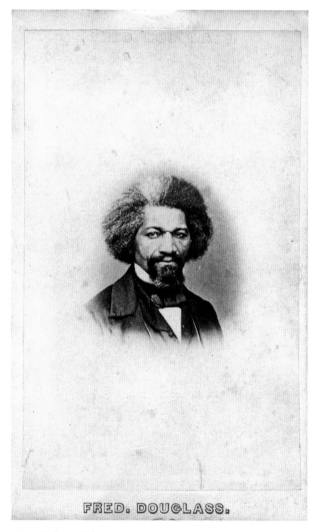

FRED. DOUGLASS.

Plate 17 (cat. #18)
John White Hurn (1822–1887)
January 14, 1862
1319 Chestnut Street, Philadelphia, PA
Carte-de-visite (2½ × 4 in.)
Collection of Greg French. (Also held by Schomburg Center for Research in Black Culture; Swarthmore College; National Park Service, Frederick Douglass National Historic Site.)

Douglass arrived in Hillsdale via the Michigan Southern Railroad on January 21, 1863, to give a speech called "Truth and Error," hosted by the Ladies' Literary Union in the college chapel. One of the photographers, Edwin Ives, left the partnership of Ives and Andrews in Hillsdale for Niles, Michigan, in October 1864.

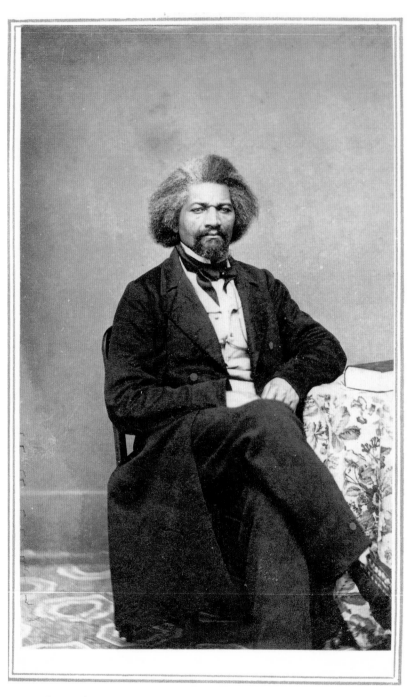

Plate 18 (cat. #21)
Edwin Burke Ives (1832–1906) and Reuben L. Andrews
January 21, 1863
Howell Street, Hillsdale, MI
Carte-de-visite (2½ × 4 in.)
Hillsdale College

The vignetting process has made Douglass's hair appear whiter than it was in 1863. He likely sat for this photograph during one of several trips through western Massachusetts to recruit black soldiers for the 54th Massachusetts Regiment between February and April 1864. After beginning as a daguerreotypist in Philadelphia, Thomas Painter Collins worked as a photographer in Westfield throughout the 1860s. He was active in the abolitionist movement.

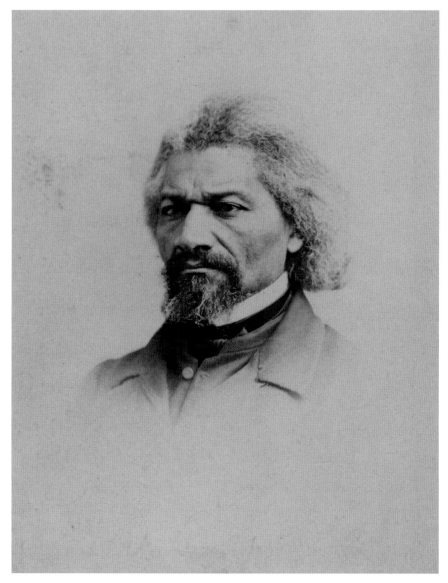

Plate 19 (cat. #22)
Thomas Painter Collins (1823–1873)
February–April 1863
Westfield, MA
Carte-de-visite (2½ × 4 in.)
Special Collections, Lavery Library, St. John Fisher College

Douglass probably sat for this photograph during a visit to speak at the Brooklyn Academy of Music, located near Augustus Morand's studio, on May 15, 1863. Morand was a well-known New York photographer who served as president of the New York State Daguerreian Society in 1851.

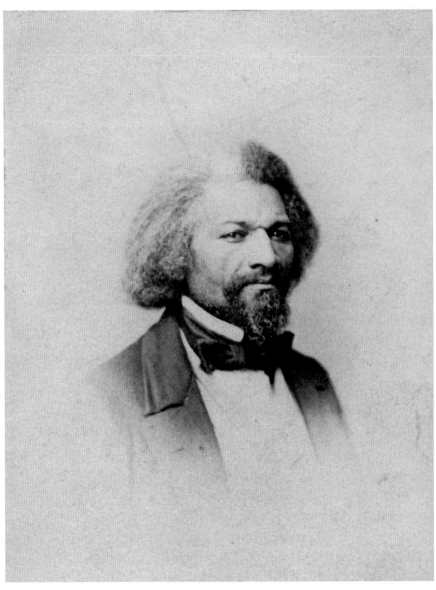

Plate 20 (cat. #23)
Augustus Morand (1818–1896)
May 15, 1863
297 Fulton Street, New York, NY
Carte-de-visite (2½ × 4 in.)
Lynn Museum and Historical Society, Hutchinson Family
Singers Album

Douglass likely sat for this photograph when visiting Portland, Maine, in January and February 1864.

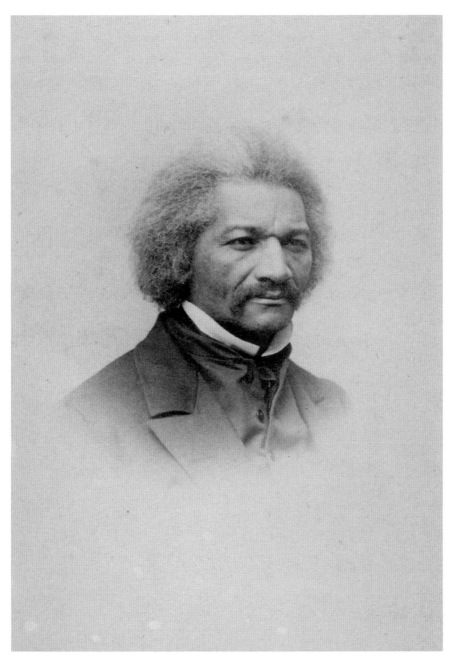

Plate 21 (cat. #25)
Benjamin F. Smith (1830–1927)
January–February 1864
153 Middle Street, Portland, ME
Carte-de-visite (2½ × 4 in.)
Division of Rare and Manuscript Collections, Cornell University

Douglass probably sat for this photograph while visiting Chicago to deliver two lectures on February 25 and 28, 1864, both at Bryan Hall, located directly opposite Samuel Fassett's studio. Born in Canada, Fassett was based in Chicago from 1855 to 1875. He moved to Washington, D.C., in 1875 and photographed Douglass there in 1878. He worked as the official photographer to the Treasury Department from 1889 onward. His wife, Cornelia Adele Fassett, included Douglass in her painting *The Florida Case Before the Electoral Commission* of 1879.

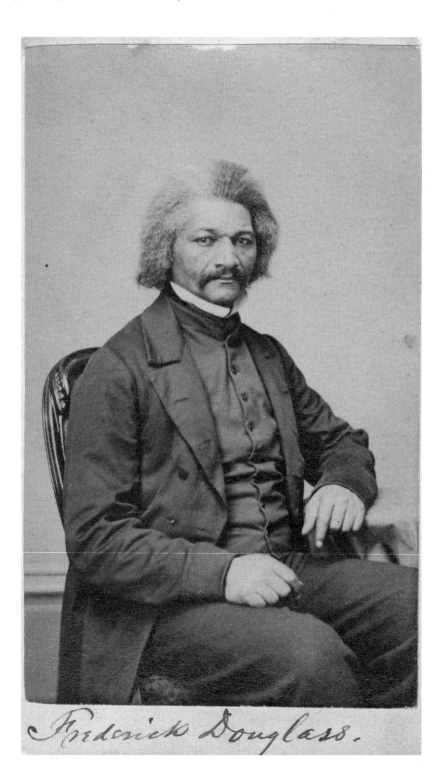

Plate 22 (cat. #28)
Samuel Montague Fassett (1825–1910)
Late February 1864
122 & 124 Clark Street, Chicago IL
Carte-de-visite (2½ × 4 in.)
Collection of Greg French. (Also held by Chicago History Museum; Ohio Historical Society; Benson Ford Research Center; Gilder Lehrman Institute; New-York Historical Society; Beinecke Rare Book and Manuscript Library; Kansas State Historical Society; Anacostia Community Museum; University of Rochester; Princeton University; Avery Research Center at the College of Charleston; New Bedford Whaling Museum; New York Public Library; Emory University; Clements Library, University of Michigan; and National Park Service, Frederick Douglass National Historic Site.)

Douglass is surrounded by influential abolitionists. Clockwise from top left are Charles Sumner, Wendell Phillips, and Generals David Hunter and Benjamin Butler. The print was probably created by Copperhead Northerners, for it casts these abolitionists as rogues worthy of death. Phillips wears a skull-and-bones tie pin. The Latin inscription reads: "To these men surrounding the black, death and death." The other quote, from Alexander Pope's *Essay on Man* (1733), likens them to the historical villains Caesar Borgia and Catiline. On the back is a handwritten message, dated 1870, from the New York merchant Cornelius Bliss to the Boston lobbyist Samuel Ward, attacking Radical Republicans and the Fifteenth Amendment.

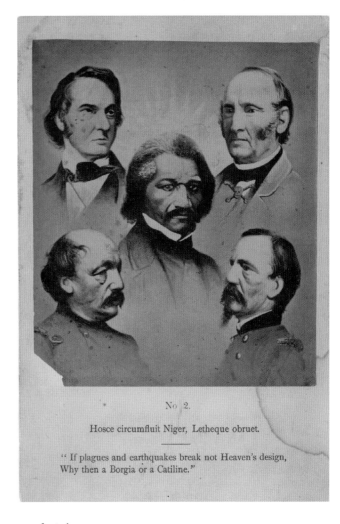

Plate 22a
Unknown artist, c. 1865–70
Postcard print
Massachusetts Historical Society

Douglass appears alongside Hiram Revels and Martin Delany and eight other named leaders who spearheaded the Fifteenth Amendment and "the rise and progress of the African Race": Abraham Lincoln, Hugh Lennox Bond, John Brown, Schuyler Colfax, Ulysses Grant, Thaddeus Stevens, Henry Winter Davis, and Charles Sumner. Douglass was present at Baltimore's celebrations of the Fifteenth Amendment's ratification on May 19, 1870, along with Bond.

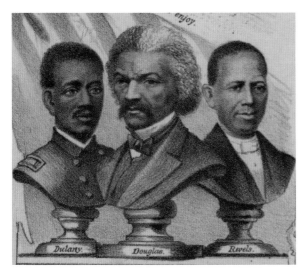

Plate 22b
Metcalf & Clark, Baltimore,
The Result of the Fifteenth Amendment, 1870
Detail from chromolithograph (19 × 25 in.)
Library of Congress

Douglass spoke at Meonian Hall in Augusta, Maine, on April 1, 1864, and likely visited nearby Farmington during the same trip. Israel Merrill was active as a photographer in Farmington from the 1860s to 1875, including in a brief partnership with Alfred Crosby of nearby Lewiston.

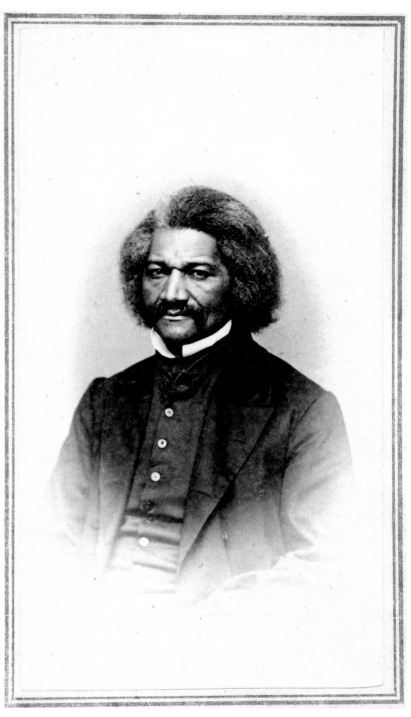

Plate 23 (cat. #32)
Alfred B. Crosby (1836–1879) and Israel Warren Merrill (1830–1894)
Early April 1864
Main Street, Farmington, ME
Carte-de-visite (2½ × 4 in.)
Boston Athenæum

Douglass likely sat for the Curtis & Crosby studio in Lewiston, Maine, during his early April 1864 trip to Maine, when he also visited nearby Augusta and Farmington. Cyrus Curtis and Alfred Crosby operated their studio until Crosby's death in 1879. Curtis continued at the same studio with his new partner, Henry C. Ross, through the 1890s.

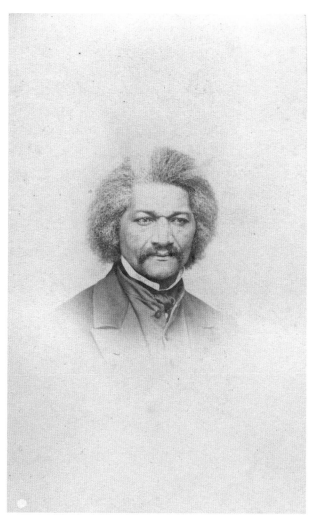

Plate 24 (cat. #33)
Alfred B. Crosby and Cyrus W. Curtis (1833–1903)
Early April 1864
138 Lisbon Street, Lewiston, ME
Carte-de-visite (2½ × 4 in.)
Collection of Greg French

Douglass delivered a speech in Hartford's Allyn Hall on April 16, 1864, titled "The National Crisis." He probably sat for this photograph the previous day because by the morning of April 16, the *Hartford Daily Courant* listed a Douglass carte-de-visite by Stephen Waite for sale and on display in the window of a local shop. Waite was a friend of John Greenleaf Whittier and Theodore Parker. He operated a studio in Hartford from 1862 to 1879, then moved to Emporia, Kansas, in 1880 and continued to work there as a photographer until four years before his death.

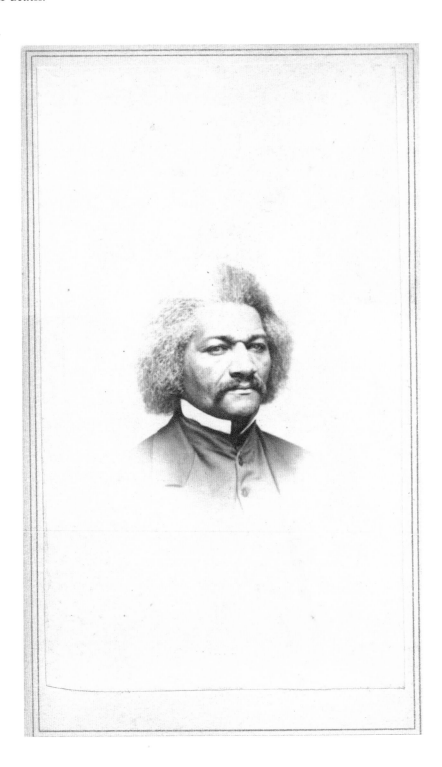

Plate 25 (cat. #37)
Stephen H. Waite (1832–1906)
April 15, 1864
271 Main Street, Hartford, CT
Carte-de-visite (2½ × 4 in.)
Connecticut Historical Society

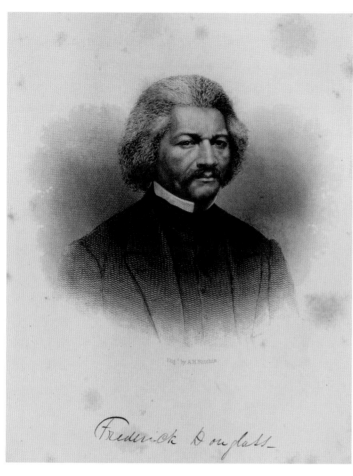

Plate 25a
Alexander Hay Ritchie (1822–1895)
Engraving, c. 1868
Published in Harriet Beecher Stowe, *Men of Our Times; or, Leading Patriots of the Day. Being Narratives of the Lives and Deeds of Statesmen, Generals, and Orators* (Hartford, CT: Hartford Publ. Co., 1868), following p. 380
Author's collection

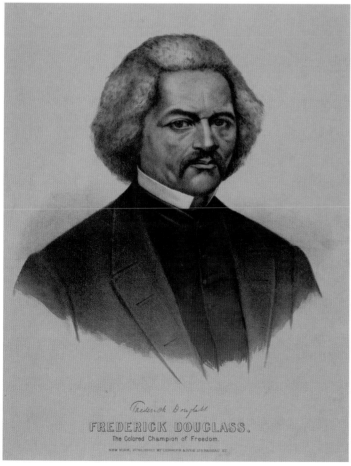

Plate 25b
Currier and Ives, New York
The Colored Champion of Freedom, c. 1873
Lithograph (17 × 13½ in.)
Author's Collection

Henry Rundel was a cousin of George Eastman, who founded the East-man Kodak Company in 1888. He helped his elder brother Morton Rundel run the Art Emporium, established in Rochester in 1865 to sell paintings, engravings, and photographs. Charles Woodward moved to Rochester in 1862. After a short-lived partnership with Rundel, he went on in 1870 to establish the Rochester Picture Frame Depot, which sold stereo views.

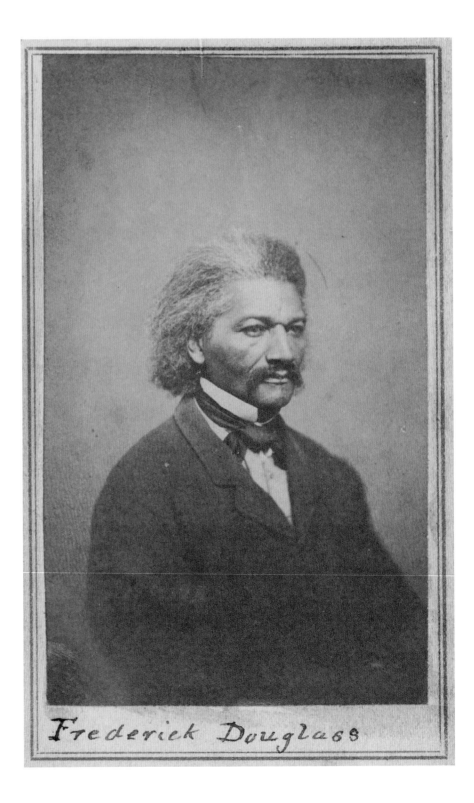

Plate 26 (cat. #39)
Henry P. Rundel (1844–1886) and Charles
Warren Woodward (1836–1894)
c. 1865
126 State Street, Rochester, NY
Carte-de-visite (2½ × 4 in.)
Beinecke Rare Book and Manuscript Library.
(Also held as a vignetted version by Rochester
Public Library; Moorland-Spingarn Research
Center, Howard University.)

Douglass likely sat for this photograph when visiting Philadelphia on September 4–6, 1866. Isaac Tyson was a Quaker. First active as a photographer in Philadelphia from 1856 to 1860, he joined his brother, Charles J. Tyson, to run a photography business in Gettysburg between 1860 and 1865, but returned to Philadelphia to open a new studio in 1866. He was based on 8th Street until the late 1870s.

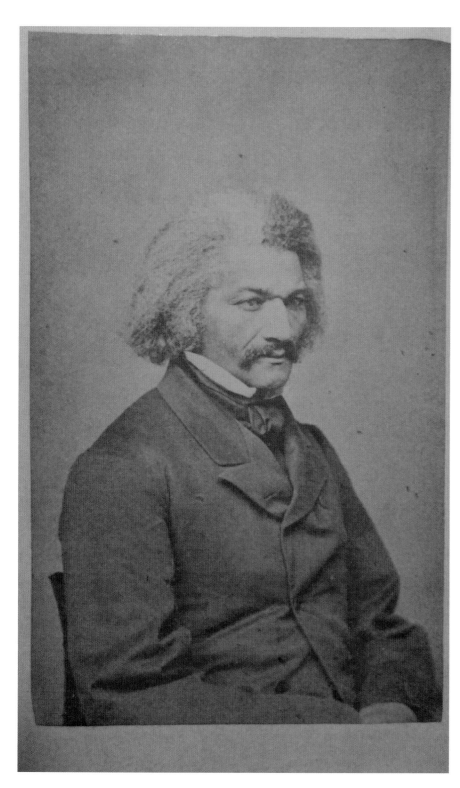

Plate 27 (cat. #49)
Isaac G. Tyson (1833–1913)
Early September 1866
240 North 8th Street, Philadelphia, PA
Carte-de-visite (2½ × 4 in.)
Historical Society of Pennsylvania, Society Portrait Collection. (Also held as a vignetted version by Moorland-Spingarn Research Center, Howard University.)

As reported by the *Cincinnati Daily Gazette* on January 15, 1867, James P. Ball took this photograph while Douglass was visiting the city to give a speech at Mozart Hall on January 12. Ball was an African American photographer, one of four known black photographers of Douglass. Born free in Virginia, he learned the craft from another black photographer, John B. Bailey. Douglass republished a front-page illustration of Ball's "Great Daguerreian Gallery of the West" in *Frederick Douglass' Paper* on May 5, 1854.

Plate 28 (cat. #50)
James Presley Ball (1825–1904)
January 12, 1867
30 West 4th Street, Cincinnati, OH
Carte-de-visite (2½ × 4 in.)
Cincinnati History Library and Archives

Douglass likely sat for this photograph in late February or early March 1867, before or after visiting the nearby city of Mount Pleasant to deliver an address on February 28. Samuel Root was born in Ohio and was active in Philadelphia in 1846–49, New York City in 1849–57, and Dubuque in 1857–87. He learned daguerreotyping practices from his brother, Marcus Aurelius Root, who wrote *The Camera and the Pencil, or the Heliographic Art* (1864).

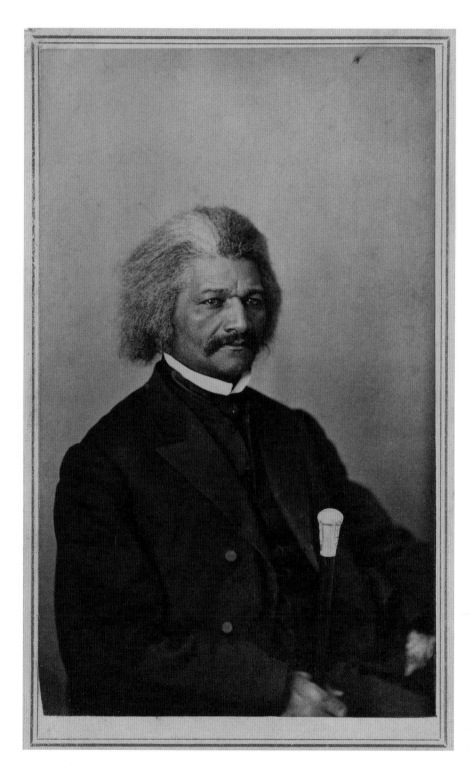

Plate 29 (cat. #52)
Samuel Root (1819–1889)
February–March 1867
166 Main Street, Dubuque, IA
Carte-de-visite (2½ × 4 in.)
Gilder Lehrman Institute of American History

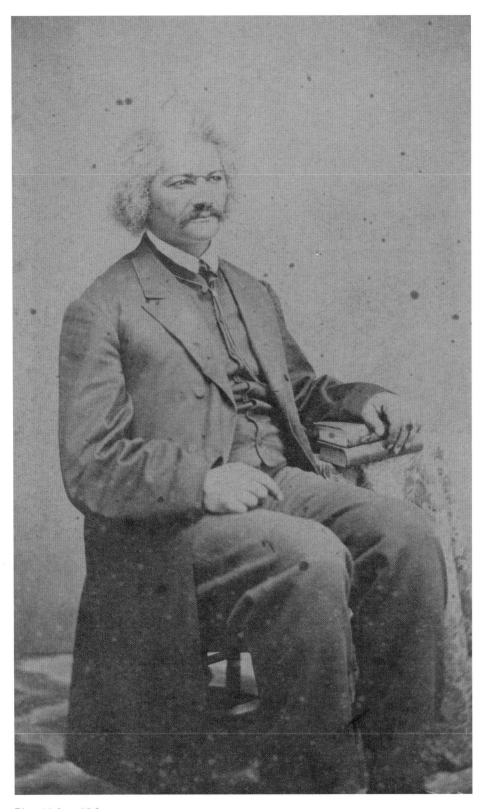

Plate 30 (cat. #54)
Unknown photographer
c. 1867
Carte-de-visite (2½ × 4 in.)
National Park Service, Frederick Douglass National Historic Site

Douglass likely sat for this photograph during a speaking tour of the Midwest, stopping in Rochester, Minnesota, between a lecture farther south in Peoria, Illinois, on February 22 and one farther north in St. Paul, on March 11. James Hiram Easton was mixed race and active as a photographer in Rochester from 1862 until the late 1880s, with his wife Lucy Jane Bolt Easton as his photographic partner. He was the nephew of Hosea Easton, a prominent black Bostonian.

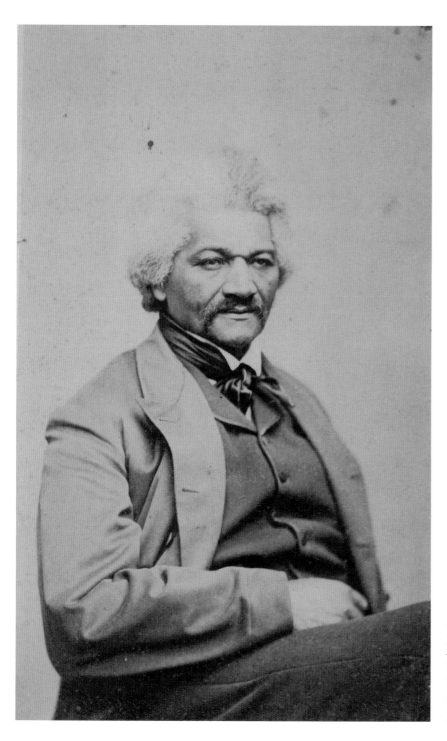

Plate 31 (cat. #59)
James Hiram Easton (1828–1900)
February–March 1869
Broadway, Rochester, MN
Carte-de-visite (2½ × 4 in.)
Kansas State Historical Society

Douglass probably sat for this photograph when attending celebrations of the Fifteenth Amendment ratification in Philadelphia on April 26, 1870. The nature of the occasion, to celebrate the last of three Reconstruction amendments that tried to guarantee freedom and equality for African Americans in the wake of Emancipation, perhaps explains why he chose to hold Lincoln's cane, just visible in his hands. Mary Todd Lincoln sent Douglass the cane after her husband's assassination in 1865. Thanking her, Douglass called the cane a symbol of Lincoln's "humane interest [in the] welfare of my whole race." George Schreiber was born in Germany and emigrated to the United States in 1834.

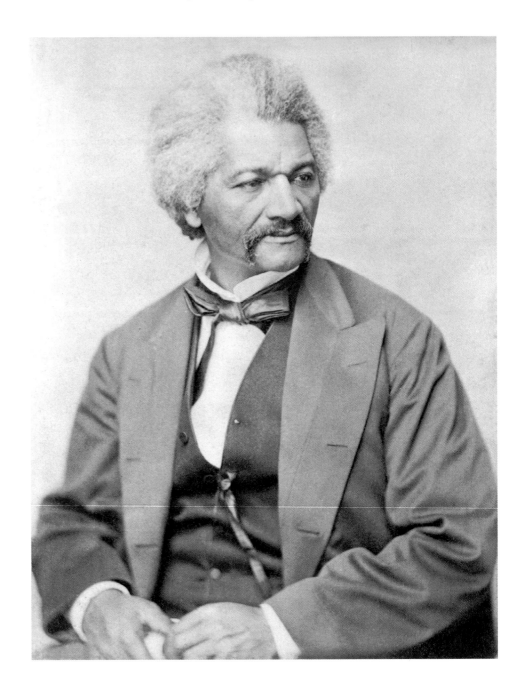

Plate 32 (cat. #61)
George Francis Schreiber (1804–1892)
April 26, 1870
818 Arch Street, Philadelphia, PA
Carte-de-visite (2½ × 4 in.)
Library of Congress. (Also held by
National Park Service, Frederick
Douglass National Historic Site;
National Portrait Gallery; Moorland-
Spingarn Research Center, Howard
University; Smith College; and the
Chris Webber Collection of African
American Artifacts and Documents.)

Douglass sits with other members of the Commission of Inquiry to Santo Domingo, Andrew White, Benjamin Wade, and fellow abolitionist Samuel Gridley Howe, as well as the ship's captain, William G. Temple. Congress had authorized the advisory commission to study the proposition to annex the Republic of Santo Domingo to the United States. The commission terminated after submitting its final report on April 5, 1871. Oliver Buell was born in Henry County, Illinois, but settled in Montreal, and made his living through traveling lantern and lecture shows.

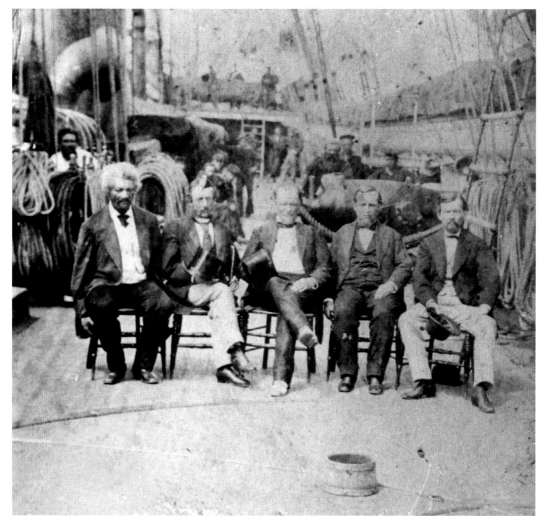

Plate 33 (cat. #63)
Oliver B. Buell (1844–1910)
January 17, 1871
Deck of the USS *Tennessee*, Key West, FL
Stereoview (3½ × 7 in.)
Monroe County Public Library, State Archives of Florida

Douglass was unhappy with the quality of the engravings in *Life and Times* and threatened to sue his publisher.

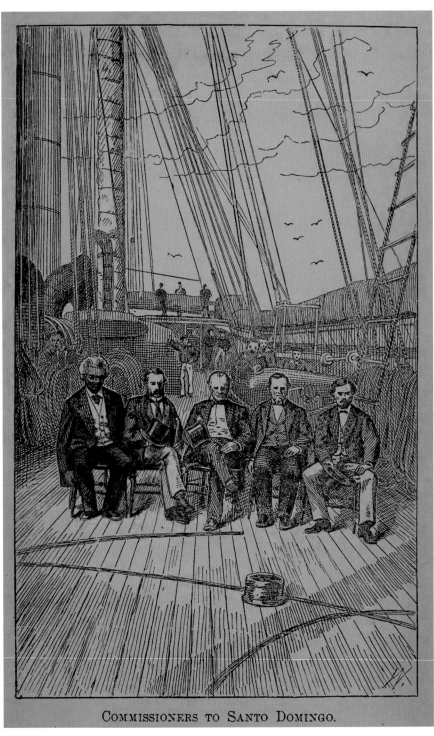

Plate 33a
Unknown engraver, *Commissioners to Santo Domingo*, c. 1881
Published in *The Life and Times of Frederick Douglass* (1881), p. 420

Members of the Commission of Inquiry to Santo Domingo stand for a photograph after their return from Santo Domingo to Charleston. The photographer J. S. Thompson was usually based in Kingston, Jamaica, and was active there from the late 1860s at 26 Harbour Street, and by the early 1870s at 7 Church Street. The commission spent several days in Kingston from March 11 onward before beginning the journey home, so Thompson perhaps traveled with them to the United States.

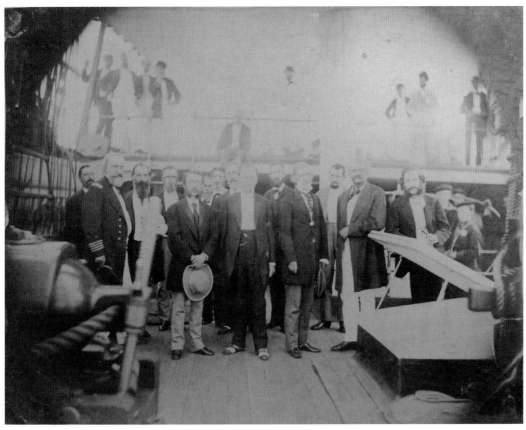

Plate 34 (cat. #64)
J. S. Thompson
Deck of the USS *Tennessee*, Charleston, SC
March 26, 1871
Albumen print (10½ × 12½ in.)
Anacostia Community Museum Archives, Smithsonian
Institution. (Also held by Emory University, Manuscript,
Archives, and Rare Book Library.)

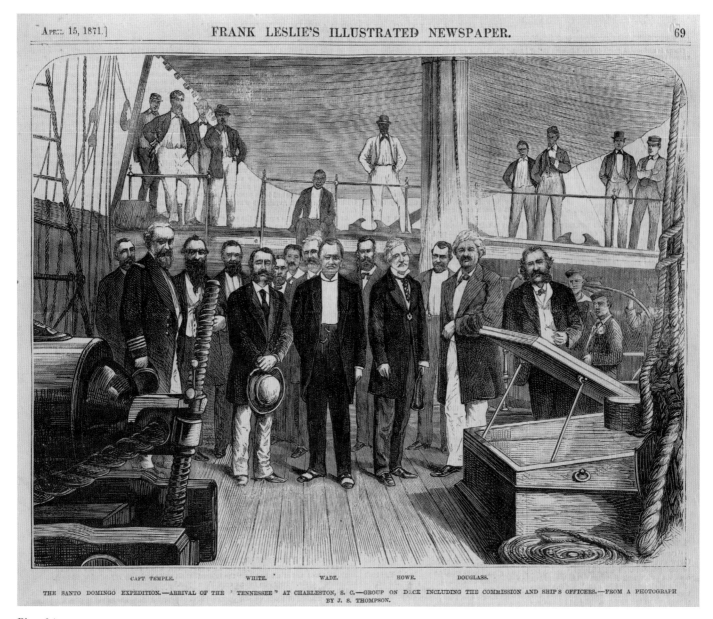

CAPT TEMPLE. WHITE. WADE. HOWE. DOUGLASS.

THE SANTO DOMINGO EXPEDITION.—ARRIVAL OF THE "TENNESSEE" AT CHARLESTON, S. C.—GROUP ON DECK INCLUDING THE COMMISSION AND SHIP'S OFFICERS.—FROM A PHOTOGRAPH BY J. S. THOMPSON.

Plate 34a
"The Santo Domingo Expedition—Arrival of the *Tennessee* at
Charleston, SC, Group on Deck including the Commission and
Ship's Officers. From a Photograph by J. S. Thompson," *Frank
Leslie's Illustrated Newspaper*, April 15, 1871, p. 69

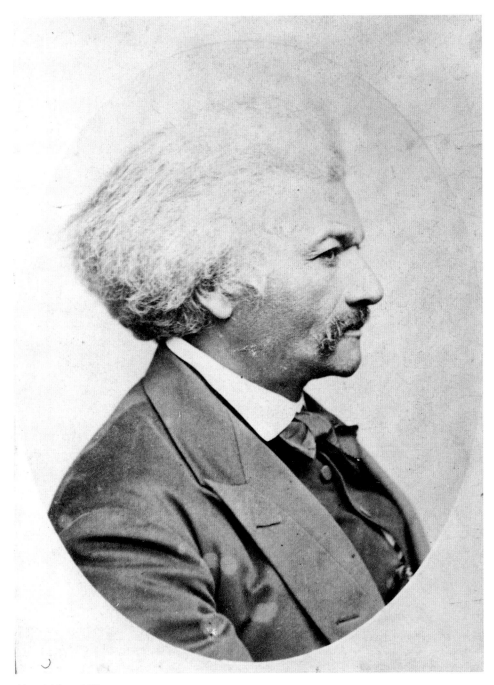

Plate 35 (cat. #65)
Unknown photographer
c. 1871
Carte-de-visite (2½ × 4 in.)
Library of Congress. (Also held by the National Park Service,
Frederick Douglass National Historic Site.)

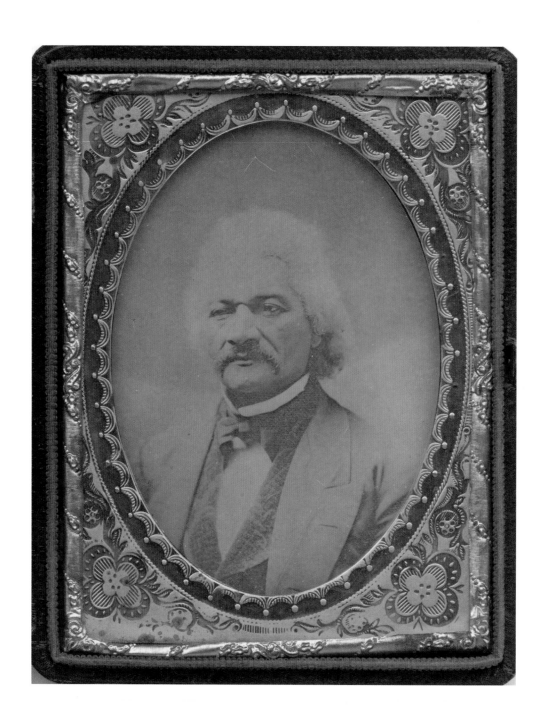

Plate 36 (cat. #68)
Unknown photographer
c. 1872
Quarter-plate ambrotype (3¼ × 4¼ in.)
Smithsonian National Museum of African American History and Culture

Douglass likely sat for this photograph when he visited Philadelphia on March 10, 1873, to lecture at the Academy of Music, located just four blocks from Hurn's studio.

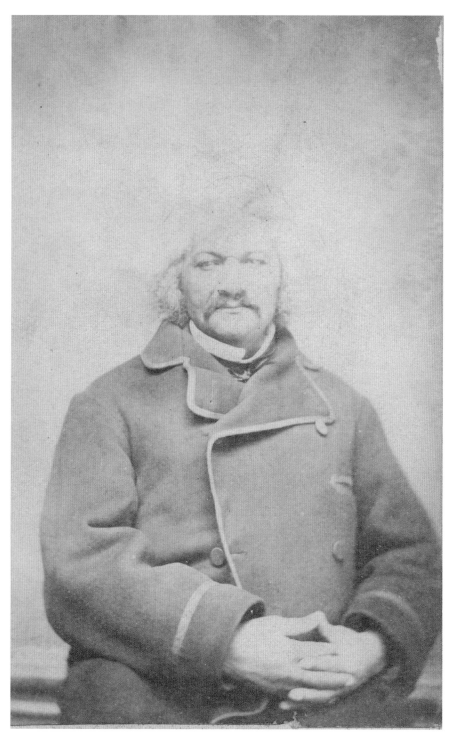

Plate 37 (cat. #75)
John White Hurn
March 10, 1873
1319 Chestnut Street, Philadelphia, PA
Carte-de-visite (2½ × 4 in.)
Author's collection

Douglass sat for this photograph when visiting Nashville in September 1873, to speak at the third annual fair of the Tennessee Colored Agricultural Association on September 18, and to address former slaves on the site of a plantation (now Hadley Park) at the invitation of the plantation owner on September 19. It is one of seven confirmed photographs of Douglass in the South. Carl Giers was born in Bonn, Germany, and had arrived in Nashville in 1852.

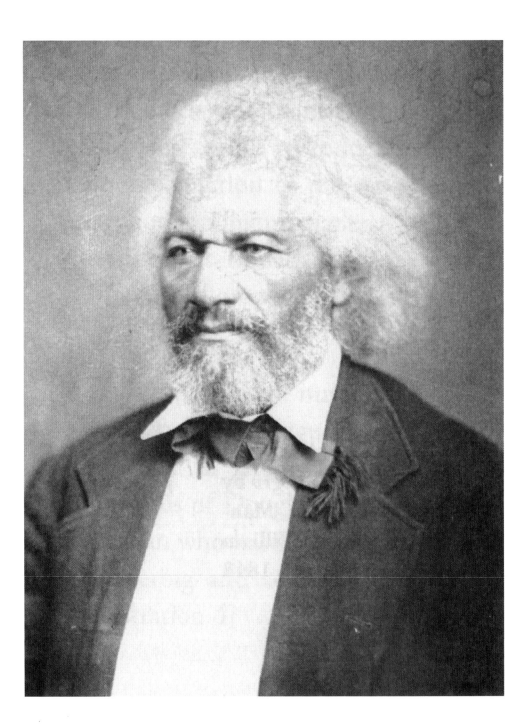

Plate 38 (cat. #76)
Carl Casper Giers (1828–1877)
September 1873
43–45 Union Street, Nashville, TN
Carte-de-visite (2½ × 4 in.)
Moorland-Spingarn Research
Center, Howard University

George William Curtis, the political editor of *Harper's Weekly*, wrote the feature article accompanying this engraving. He called Douglass "one of the most interesting figures in the country," and added that "no American career has had more remarkable and suggestive vicissitudes than his."

Plate 38a
Unknown artist
Harper's Monthly, February 1875, p. 310

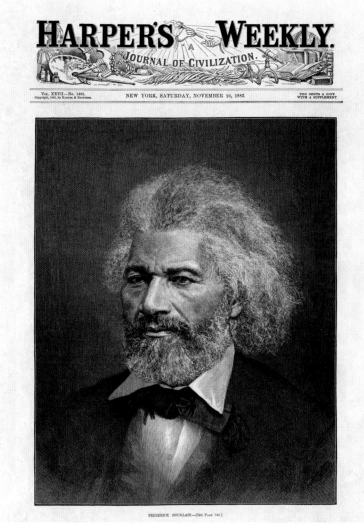

Plate 38b
Unknown artist
Harper's Weekly (cover), November 24, 1883

Plate 38c
Jacob C. Strather
Drawing, 1884
Museum Resource Center, National Park Service, Landover, MD

Strather was an African American artist based in Washington, D.C. He was around twenty years old when he completed this drawing.

Douglass likely sat for this photograph on a visit to Rochester on January 26, 1874, to speak at Corinthian Hall, located on the same block as John Howe Kent's studio. His friend Ottilie Assing sent her sister the photograph in September 1874. Kent had a photography studio in Rochester from 1870 through the 1890s; he became vice president of the Eastman Kodak Company and president of the Photographers Association of America. The studio was based in various buildings on State Street (no. 58 until 1879, no. 30 until 1883, then no. 24).

Plate 39 (cat. #79)
John Howe Kent (1827–1910)
January 26, 1874
58 State Street, Rochester, NY
Cabinet card (4¼ × 6½ in.)
Rochester Public Library. (Also held by Ohio
Historical Society; St. John Fisher College.)

Kent took this photograph during the same sitting as the previous image. Douglass has removed his hat, leaving an indentation in his hair.

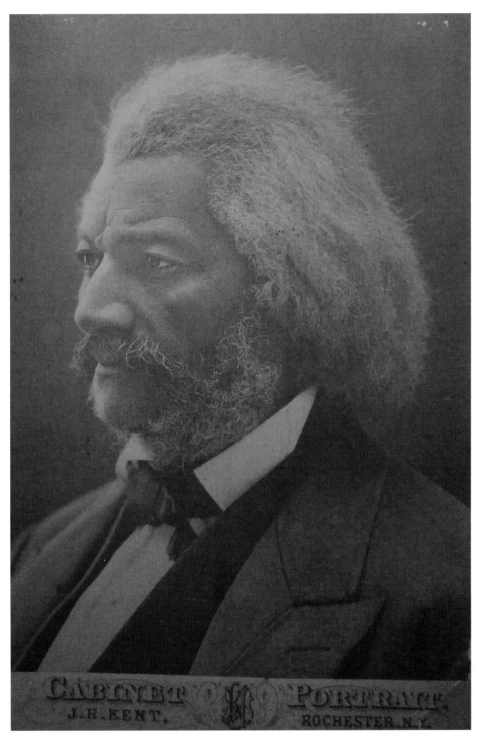

Plate 40 (cat. #83)
John Howe Kent
January 26, 1874
58 State Street, Rochester, NY
Cabinet card (4¼ × 6½ in.)
Beinecke Rare Book and Manuscript Library. (Also held by Rochester Public
Library; Moorland-Spingarn Research Center, Howard University.)

FREDERICK DOUGLASS.

Plate 40a
Unknown artist
William C. Roberts, *The Leading Orators of Twenty-Five Campaigns* (New York: L. K. Strouse, 1884), p. 59

FREDERICK DOUGLASS.

Plate 40b
Unknown artist
Washington Press, August 31, 1889

Douglass probably sat for Lydia Cadwell while visiting Chicago on January 5, 1875, to lecture about John Brown at Farwell Hall, located on Madison Street between Clark and LaSalle Streets, just three blocks from Cadwell's studio. Cadwell is the only known woman photographer of Douglass. She worked in Chicago in the 1870s and 1880s, opened her Gentile Photographic Studio in 1872, and added her Lydian Art Gallery at the same address in 1874, closing both in 1884. She was also an inventor and secured seventeen patents, including for food preservation devices.

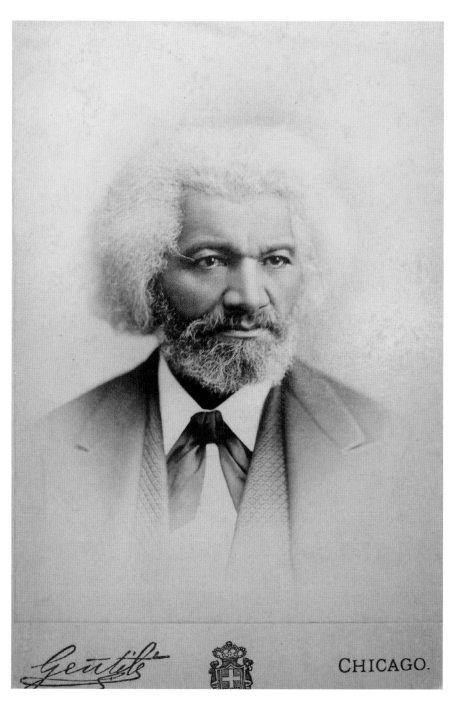

Plate 41 (cat. #84)
Lydia J. Cadwell (1837–1896)
January 5, 1875
103 State Street, Chicago, IL
Cabinet card (4¼ × 6½ in.)
Chicago History Museum

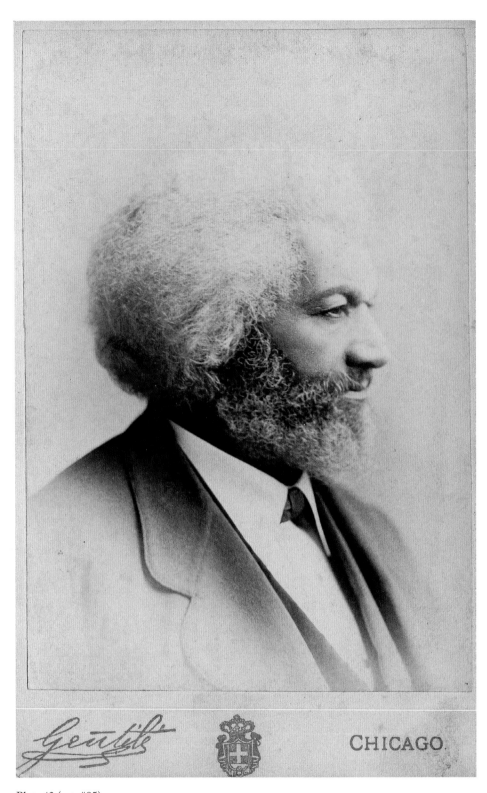

Plate 42 (cat. #85)
Lydia J. Cadwell
January 5, 1875
103 State Street, Chicago, IL
Cabinet card (4¼ × 6½ in.)
Beinecke Rare Book and Manuscript Library. (Also held by Anacostia
Community Museum; St. John Fisher College.)

Douglass's portrait and the accompanying feature article appears alongside that of the Reverend Josiah Henson, famous as "the original of 'Uncle Tom.'"

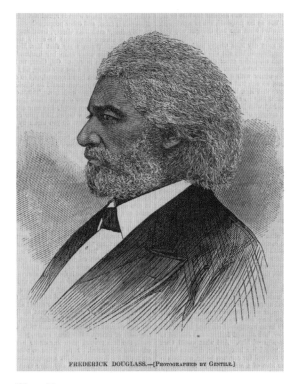

Plate 42a
Unknown artist
Harper's Weekly, April 21, 1877, p. 305
Author's collection

Eva Webster (later Eva Webster Russell) was a well-known Chicago artist and thirty-one years old when she made this charcoal print of Douglass. She later worked in oil and watercolor. A member of the National Academy of Design, her work was featured at the 1893 Columbian Exposition.

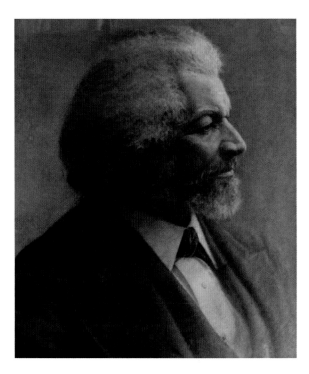

Plate 42b
Eva Webster
1887
Charcoal print (27 × 23 in.)
National Park Service, Frederick Douglass
National Historic Site

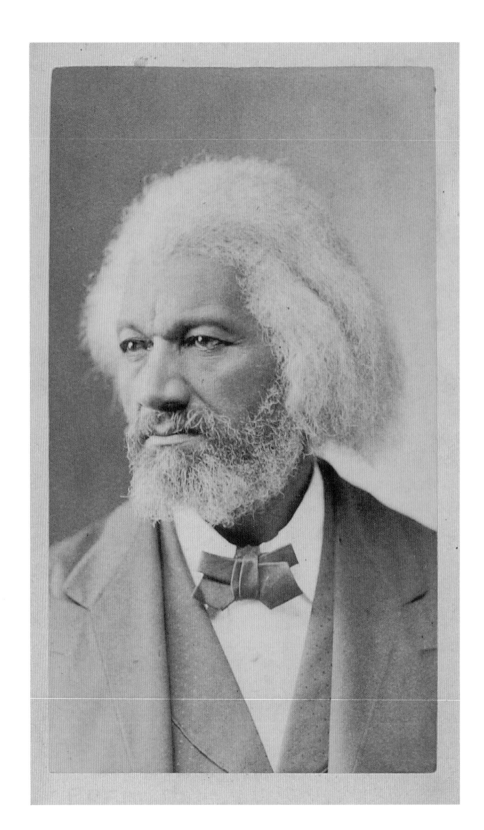

Plate 43 (cat. #92)
Mathew B. Brady (1822–1896)
c. 1877
625 Pennsylvania Avenue, Washington, DC
Carte-de-visite (2½ × 4 in.)
Beinecke Rare Book and Manuscript Library.
(Also held as a cabinet card or carte-de-
visite by Moorland-Spingarn Research
Center, Howard University; Chicago
History Museum; Library of Congress;
National Museum of American History; and
Huntington Library.)

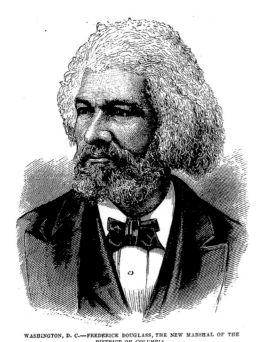

WASHINGTON, D. C.—FREDERICK DOUGLASS, THE NEW MARSHAL OF THE DISTRICT OF COLUMBIA.

Plate 43a
Unknown artist, "Washington, D.C., Frederick Douglass, The New Marshal of the District of Columbia," *Frank Leslie's Illustrated Newspaper*, April 7, 1877, p. 85

Douglass is flanked by U.S. senators Blanche Bruce and Hiram Revels.

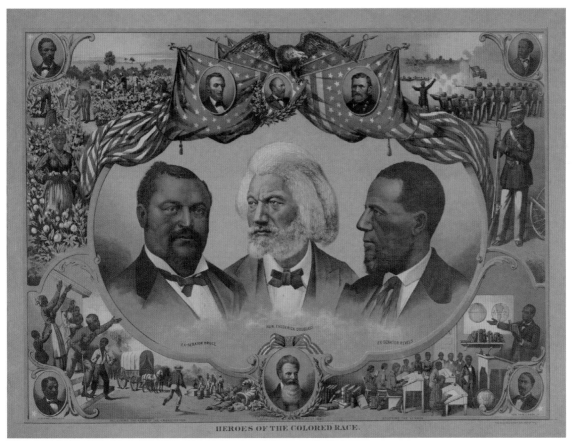

Plate 43b
Joseph Hoover
Heroes of the Colored Race, 1881
Chromolithograph
Library of Congress

Plate 44 (cat. #93)

Mathew B. Brady

c. 1877

625 Pennsylvania Avenue, Washington, DC

Stereoview (5 × 7 in.)

Library of Congress. (Also held as a cabinet card by the New-York Historical Society.)

George Kendall Warren was active as a photographer in Massachusetts from 1851 to 1881, based in Lowell until he moved to Boston in 1870. He opened his studio on Washington Street in 1872. He specialized in collegiate class photographs for universities along the east coast and portraits of celebrities and entertainers.

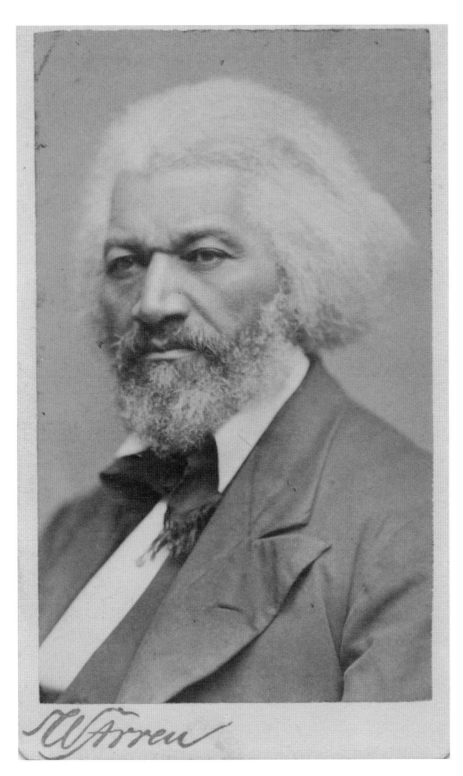

Plate 45 (cat. #96)
George Kendall Warren (1824–1884)
c. 1879
289 Washington Street, Boston, MA
Carte-de-visite (2½ × 4 in.)
Author's collection (Also held as a cabinet card or carte-de-visite in full or cropped form by the National Park Service, Frederick Douglass National Historic Site; Beinecke Rare Book and Manuscript Library; National Portrait Gallery; National Archives and Records Administration; Schomburg Center for Research in Black Culture; Gilder Lehrman Institute; New York Public Library; New-York Historical Society; Nelson-Atkins Museum of Art; Library Company of Philadelphia; Wisconsin Historical Society; Harvard University; University of Michigan; Princeton University; and Collection of Greg French.)

Plate 45a
Augustus Robin
Engraving, c. 1881
Frontispiece to *The Life and Times of Frederick Douglass* (1881)

Plate 45b
Unknown artist
Engraving, c. 1886
Published in Allen Thorndike Rice,
Reminiscences of Abraham Lincoln by Distinguished Men of His Time (1886), p. 185

Though some copies of this photograph have C. F. Conly's imprint, Conly was Warren's successor and simply kept reprinting the photograph once he took over the studio in 1884.

Plate 46 (cat. #97)
George Kendall Warren
c. 1879
289 Washington Street, Boston, MA
Cabinet card (4¼ × 6½ in.)
Metropolitan Museum of Art (Also held as a cabinet card or carte-de-visite in full or cropped form by National Portrait Gallery; Chicago History Museum; Massachusetts Historical Society; Amistad Center for Art & Culture; Allen County Public Library; Beinecke Rare Book and Manuscript Library; and New Bedford Whaling Museum.)

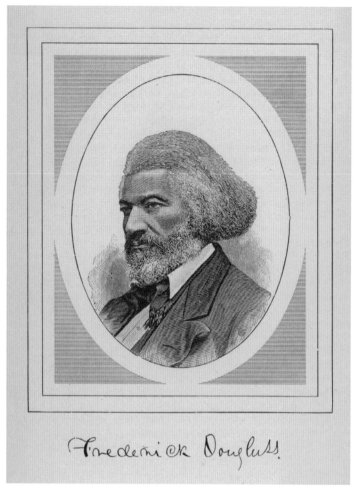

Frederick Douglass

Plate 46a
Unknown artist
Engraving, c. 1887
Published in Henry Ward Beecher, *Patriotic Addresses in America and England* (1887), p. 407

HON. FREDERICK DOUGLASS

Plate 46b
Unknown artist
Indianapolis Freeman,
December 15, 1888

Luke Dillon was active as a photographer in Washington, D.C., during the 1870s and 1880s. While working for Pullman's Gallery, he was also the official photographer at Mount Vernon from 1880 to 1890, photographing Douglass there on a visit with friends in the late 1880s.

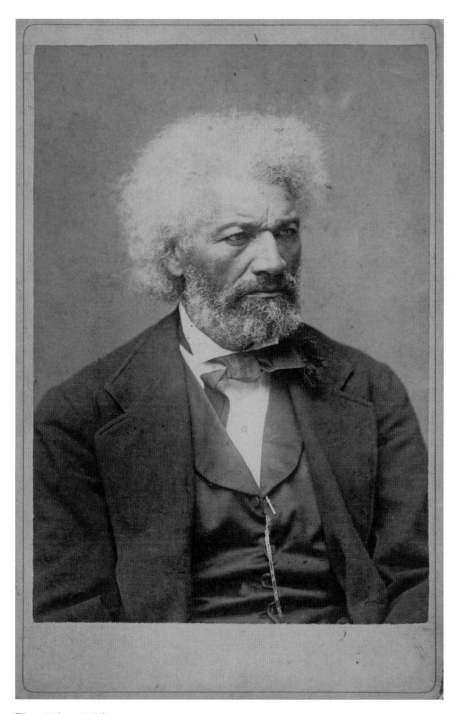

Plate 47 (cat. #100)
Luke C. Dillon (1844–1886)
c. 1880
Pullman's Gallery, 935 Pennsylvania Avenue, Washington, DC
Cabinet card (4¼ × 6½ in.)
Special Collections, Lavery Library, St. John Fisher College.
(Also held by Amistad Research Center, Tulane University.)

Charles Bell took over the family photographic business of Bell & Brothers in 1874 and ran it until his death. He is primarily known for photographing Native American subjects. Douglass used this photograph in his letterhead when sending out letters in support of particular congressional candidates in 1894.

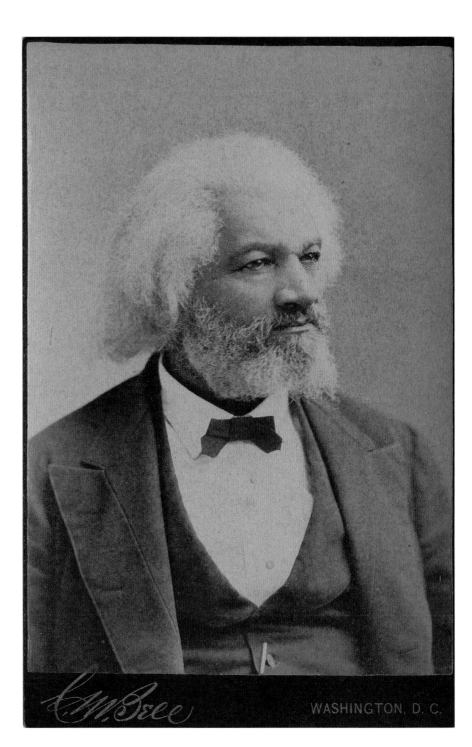

Plate 48 (cat. #105)
Charles Milton Bell (1848–1893)
c. 1881
463–465 Pennsylvania Avenue,
Washington, DC
Cabinet card (4¼ × 6½ in.)
Beinecke Rare Book and Manuscript
Library. (Also held by Schomburg Center
for Research in Black Culture; Library of
Congress; Gilder Lehrman Institute; New-
York Historical Society; Chicago History
Museum; and Robert W. Woodruff Library,
Atlanta University Center.)

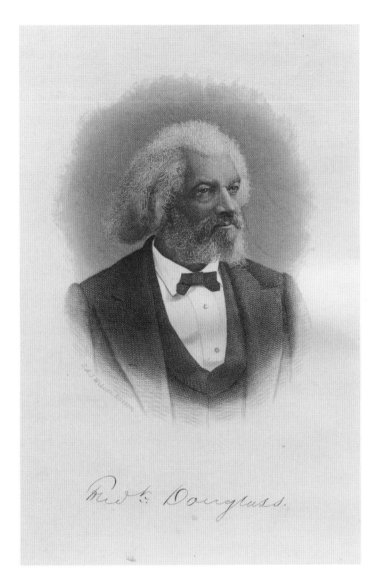

Plate 48a
J. A. J. Wilcox
Engraving, c. 1882, Boston, MA
Frontispiece to *The Life and Times of Frederick Douglass*
(Hartford: James Betts & Co., 1882)
Author's collection

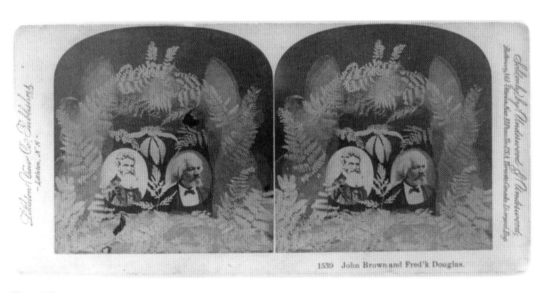

Plate 48b
Littleton View Co., *John Brown and Fred'k Douglas*, 1891
Stereoview
Library of Congress

Douglass likely sat for this photograph while visiting Rochester, New York, on November 3, 1882, to lecture at Washington Hall, just two blocks from Kent's new studio on State Street. A note accompanying an engraving of this image in Charles Chesnutt's autobiography of Douglass (1899) claims it is the photograph "most highly thought of by his family."

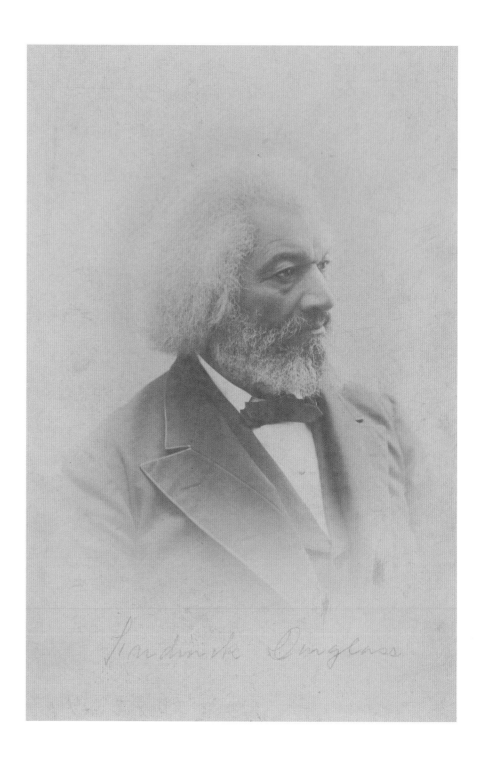

Plate 49 (cat. #107)
John Howe Kent
November 3, 1882
24 State Street, Rochester, NY
Cabinet card (4¼ × 6½ in.)
Beinecke Rare Book and Manuscript Library.
(Also held by University of Rochester;
Lynn Museum; Ohio Historical Society;
Auburn Avenue Research Library on African
American Culture and History; and Bryn
Mawr College.)

Plate 49a
Unknown artist for J. W. Cromwell & Co.
Eminent Colored Men, 1884
Lithograph (17 × 22 in.)
Schomburg Center for Research in Black Culture

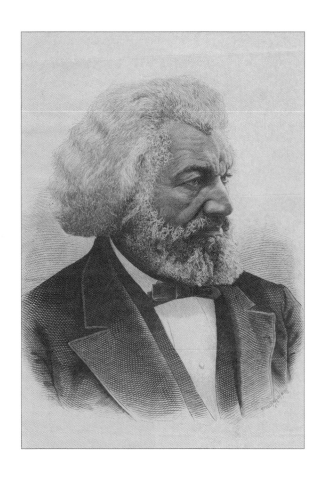

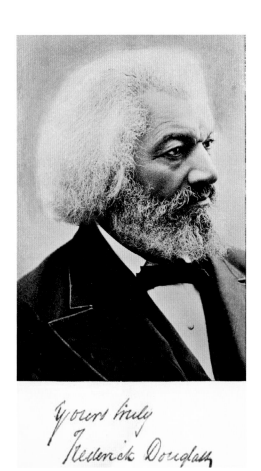

Plate 49b
Unknown artist
Frontispiece engraving to *The Life and Times of Frederick Douglass* (1892)
Author's collection

Plate 49c
Thomas & Evans
Cover to "Lessons of the Hour," 1894
Frederick Douglass Papers, Library of Congress

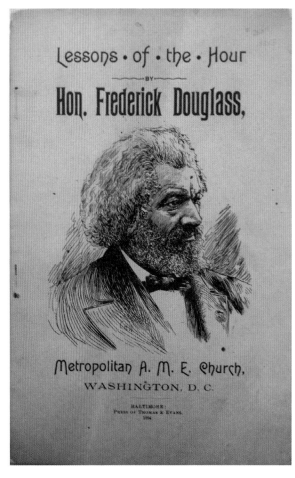

Douglass sits with his second wife Helen Pitts Douglass (right) and her sister Eva (center). He married Helen on January 24, 1884. His first wife, Anna Murray, died in 1882.

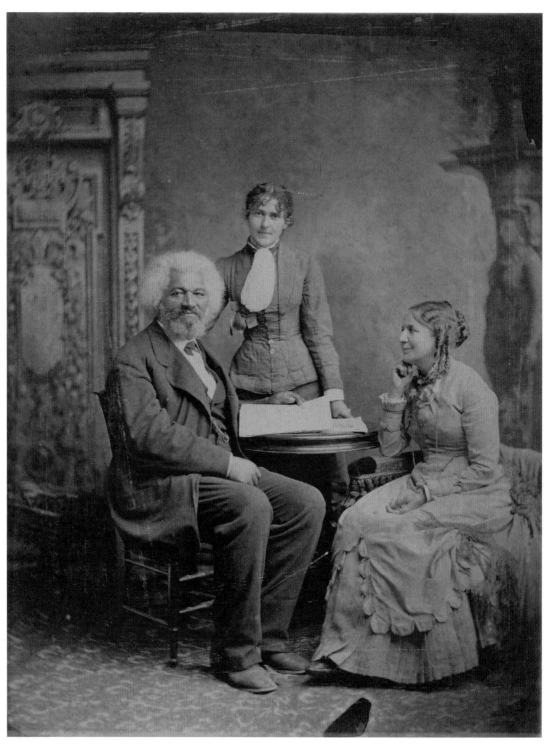

Plate 50 (cat. #109)
Unknown photographer
c. 1884
Albumen print (8 × 10 in.)
National Park Service, Frederick Douglass National Historic Site

Douglass sits in his home office during his tenure as Minister Resident and Consul General to the Republic of Haiti. He left the United States on October 3, 1889, came back on leave from July 25 to December 6, 1890, and returned from his term on July 3, 1891. W. Watson was an English photographer based in Port-au-Prince from at least the 1870s to the 1890s.

Plate 51 (cat. #117)
W. Watson
c. 1890
Villa Tivoli, 111 Avenue Jean Paul II, Port-au-Prince, Haiti
Albumen print (8 × 10 in.)
National Park Service, Frederick Douglass National Historic Site

Douglass delivered the address at the Tuskegee Normal and Industrial Institute's annual commencement exercises in 1892. He gave a lecture titled "Self-Made Men" before five thousand people in a temporary structure, the Pavilion, erected for commencement day. Most likely Booker T. Washington is seated to Douglass's right.

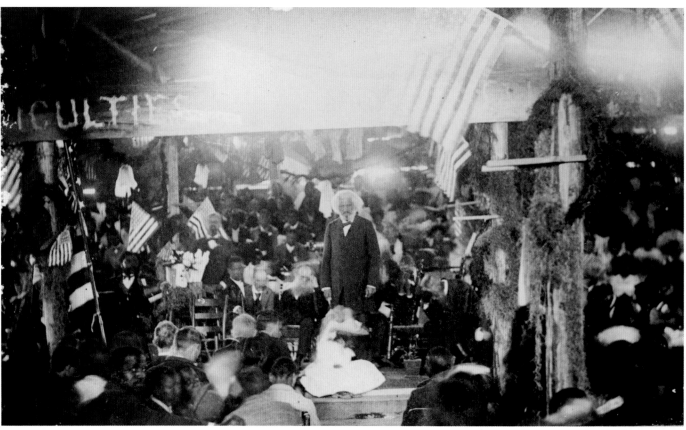

Plate 52 (cat. #125)
Unknown photographer
May 26, 1892
The Pavilion, Tuskegee, AL
Albumen print (7½ × 9½ in.)
Library of Congress. (Also held by Tuskegee University.)

Douglass stands with the other directors and board members of the black-owned Alpha Life Insurance Company, which filed articles of incorporation in early 1892. The company was based in the neighborhood of Howard University. Douglass served as vice president and was a shareholder. Seated in front of Douglass and slightly to his left is Milton Murray Holland, who was the son of a slave, a Union Army veteran, and the company's president.

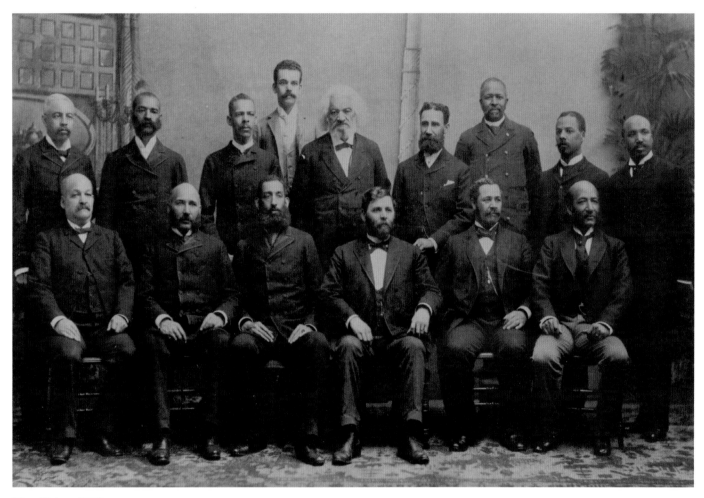

Plate 53 (cat. #129)
Unknown photographer
c. 1892
Washington, DC
Albumen print (9½ × 11½ in.)
Collection of Anna Roelofs

Douglass probably sat for this photograph during a visit to New York City in February 1893, which included an address at the Union League Club of Brooklyn on February 13. One of the four known black photographers of Douglass, Cornelius Battey was born in Augusta, Georgia. His first job was in 1888 at a photography studio in Cleveland, then for six years he was superintendent of the Bradley Photographic Studio on Fifth Avenue in New York City. He later opened the Battey and Warren Studio in New York and by 1916 was the director of the Photography Division at the Tuskegee Institute.

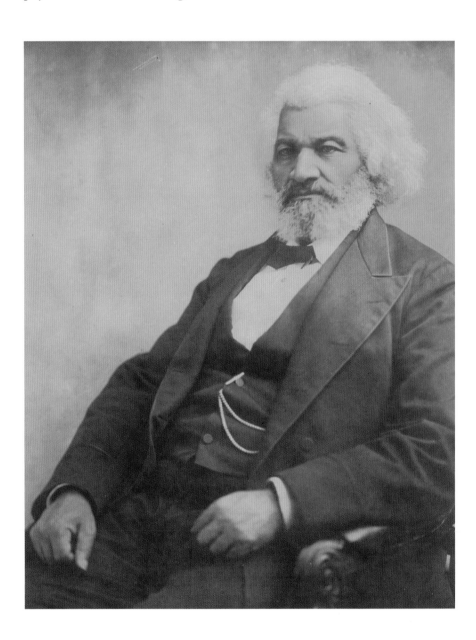

Plate 54 (cat. #130)
Cornelius Marion Battey (1873–1927)
February 1893
402 Fifth Avenue, New York City, NY
Gelatin silver print (9 × 7 in.)
Smithsonian National Museum of African American History and Culture. (Also held as a cropped version by Columbia University; Rochester Public Library; and Schomburg Center for Research in Black Culture.)

Douglass works at his desk with Frank, his mastiff, lying beside him.

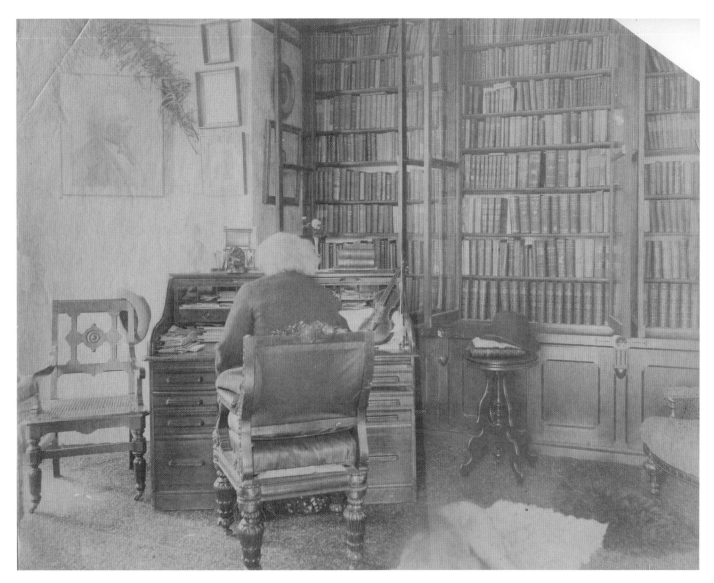

Plate 55 (cat. #143)
Unknown photographer
c. 1893
Library at Cedar Hill, 1411 W Street SE, Washington, DC
Albumen print (9 × 7 in.)
National Park Service, Frederick Douglass National Historic Site

Douglass sat for this photograph when he visited Boston on May 10, 1894, to give an evening address at the People's Church, located at the corner of Columbus Avenue and Berkeley Street, just three blocks from the Notman studio on Boylston Street. He stayed at Parker House Hotel and also visited the nearby Massachusetts State House in the morning, then attended an afternoon reception in his honor at 3 Park Street, hosted by the Massachusetts Woman Suffrage Association. His grandson Joseph accompanied him on the trip and gave violin solos at the evening lecture before and after Douglass's remarks. The Notman Photographic Company wrote to Douglass on May 29 to enclose Joseph's order of this "head and shoulder picture" and other photographs from the same sitting, including a dozen complimentary copies. Denis Bourdon was the chief photographer and manager at Notman's Boston branch from 1880 through the early twentieth century, becoming president of the whole company in 1918.

Plate 56 (cat. #147)
Denis Bourdon
May 10, 1894
Notman Photographic Company
480 Boylston Street, Boston, MA
Cabinet card (4 × 5½ in.)
Beinecke Rare Book and Manuscript Library.
(Also held by Massachusetts Historical Society;
University of Virginia; and Library of Congress.)

Eight different photographs survive from the Notman sitting of May 10, including four of Douglass alone in this lion's head chair and three of Douglass in the same chair with Joseph standing or sitting next to him. One of the photographs with Joseph has a handwritten inscription by Douglass to the woman's suffrage activist and sociologist Mary Burt Messer, dated September 29, 1894.

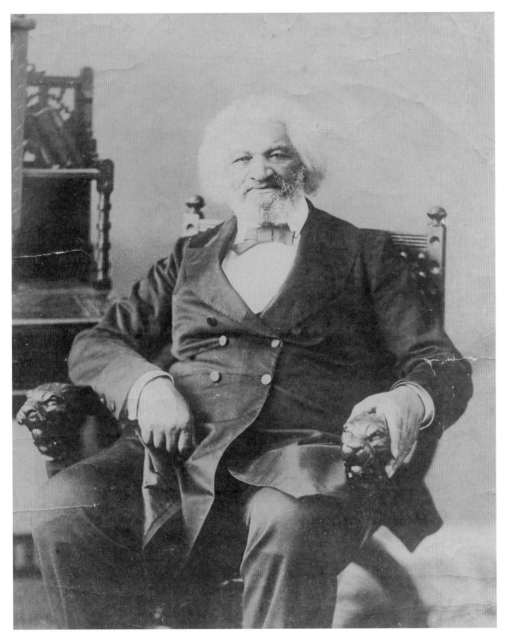

Plate 57 (cat. #148)
Denis Bourdon
May 10, 1894
Notman Photographic Company
480 Boylston Street, Boston, MA
Cabinet card (4¼ × 6½ in.)
National Park Service, Frederick Douglass National Historic Site.
(Also held by Beinecke Rare Book and Manuscript Library.)

Douglass appears as the culminating image in a visual chronicle of black life in North America that begins with the arrival of African slaves in 1619.

Plate 57a
B. F. Hammond
Afro-American Monument, 1897
Lithograph
Library of Congress

Plate 57a detail

Douglass and his grandson Joseph sat for this photograph during a visit to New Bedford in October 1894, when Douglass spoke at the YMCA and Joseph performed on the violin. Two photographs survive from the sitting. On November 5, 1894, photographer James Reed wrote to explain that he would charge five dollars for a dozen cabinet cards but would give Douglass himself a 20 percent discount. He noted that he also would sell the photographs to "outsiders" and give the profits to Douglass's "Southern school." Reed is one of four known black photographers of Douglass. Born to free parents in North Carolina, he moved to New Bedford in 1878 and worked as an assistant photographer in G. F. Parlow's gallery.

He formed a partnership with Phineas Headley in 1888 and the two bought out Parlow's gallery. Headley was a white man who had trained as a minister. Both continued in business until 1895, when Reed bought out Headley's interest and operated alone. Headley went on to become a cotton broker in New Bedford.

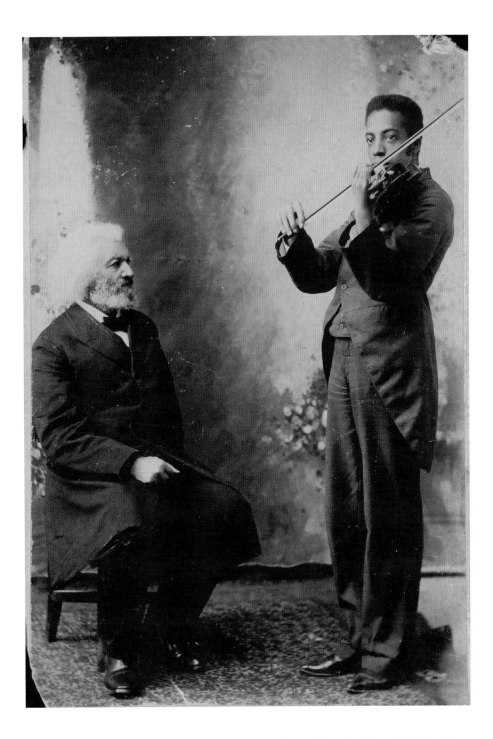

Plate 58 (cat. #157)
Phineas Camp Headley, Jr. (1858–1921)
and James E. Reed (1864–1939)
October 31, 1894
5 Purchase Street, New Bedford, MA
Cabinet card (4¼ × 6½ in.)
Beinecke Rare Book and Manuscript
Library. (Also held by Library of
Congress.)

This is one of the only known photographs that depicts Douglass smiling.

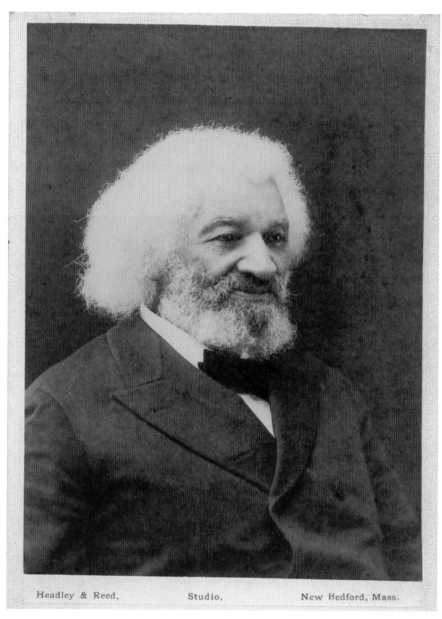

Headley & Reed, Studio, New Bedford, Mass.

Plate 59 (cat. #158)
Phineas C. Headley, Jr., and James E. Reed
October 31, 1894
5 Purchase Street, New Bedford, MA
Cabinet card (4¼ × 6½ in.)
New Bedford Whaling Museum

After Douglass's death, hundreds of obituaries included engravings based on photographs, especially plates 39, 42, 43, 45, 48, & 49. This is the only identified obituary illustration based on plate 59.

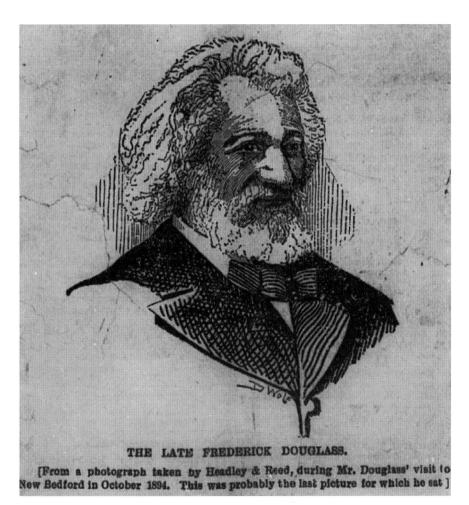

THE LATE FREDERICK DOUGLASS.

[From a photograph taken by Headley & Reed, during Mr. Douglass' visit to New Bedford in October 1894. This was probably the last picture for which he sat]

Plate 59a
D. Wolf
Engraving, 1895
Frederick Douglass Papers, Library of Congress

Douglass died on February 20, 1895, and was buried on February 26. Most likely this deathbed photograph was taken on February 21, the day that the Washingtonian sculptor Ulric Dunbar came to Cedar Hill and created a mask of Douglass's face and a plaster cast of his right hand.

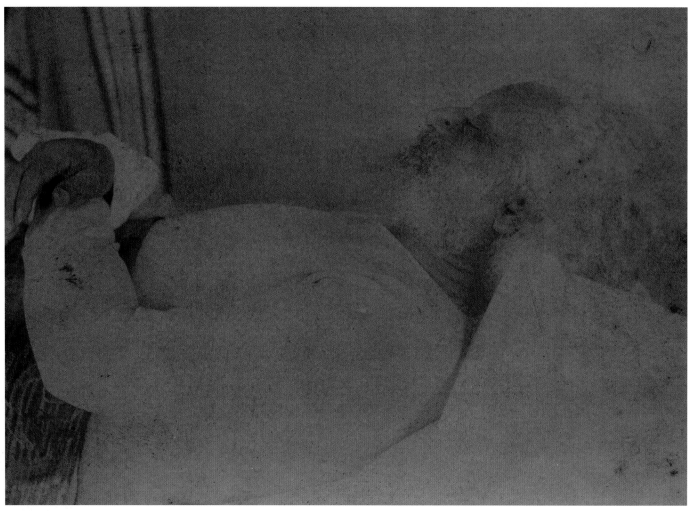

Plate 60 (cat. #160)
Unknown photographer
February 21, 1895
Cedar Hill, 1411 W Street SE, Washington, DC
Cabinet card (4¼ × 6½ in.)
National Park Service, Frederick Douglass National Historic Site

PART II

Contemporaneous Artwork

This section features images of Douglass from his lifetime that are *not* based on photographs. Most are engravings, but we also include lithographs, paintings, drawings, and sculpture. These artworks derived from sketches rather than photos.

Sketch artists were the precursors of photojournalists. They covered the news with their sketches, which were disseminated to the masses as engravings. But unlike photographers, they sacrificed accuracy and detail for timeliness. Their livelihoods depended upon it. Even the most talented sketch artist could not approach the detail and accuracy of a photograph.

The images in this section thus function as a kind of counterbalance to Part I. There is a comparative paucity of detail, texture, and tonal range. Distortion has replaced accuracy, caricature and crudeness stand in for verisimilitude. Such distortions are one reason why Douglass was so in love with photography. Indeed, he objected to many of the images that appear here, from the 1848 engraving in an abolitionist book by Wilson Armistead to the engravings in his 1881 autobiography.

This section also reveals the importance of photography in shaping the artistry of mass-produced prints. There is a world of difference between the engravings cut from photographs in Part I and those based on sketches here.

In essence, we see a war waged over Douglass's visual persona. On the one side were photographs and the images based upon them; on the other side, caricature and distortion. By the end of the Civil War, Douglass had won this visual war. Americans everywhere recognized him by his photographic likeness. Art had trumped artifice at the same time that freedom triumphed over slavery. Douglass recognized that visual wars could affect political and military conflicts, noting that "the moral and social influence of pictures" was more important in shaping national culture than the "making of its laws."

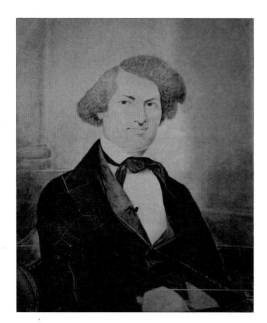

Plate 2.1: Unknown artist, c. 1844
Oil on canvas (copy) (26½ × 21½ in.)
Moorland-Spingarn Research Center, Howard
University

Face of a Fugitive: The 1840s

The frontispiece engraving of Douglass's 1845 *Narrative* was possibly based on the c. 1844 painting, owing to the similarities of dress, pose, and expression. But more probably it was based on a lost daguerreotype. The Massachusetts Anti-Slavery Society (MASS) published Douglass's *Narrative,* and two years later it published *Narrative of William W. Brown, a Fugitive Slave.* The frontispiece engraving for Brown's *Narrative* is strikingly similar to that of Douglass's: both men wear almost identical ties and are posed slightly in profile, and in both engravings there is a paucity of detail below the shoulders. For Brown's frontispiece, MASS hired the daguerreotypist Lorenzo Chase, whose studio was at 257 Washington Street in Boston, and then hired Joseph Andrews, another local artist, to create the frontispiece engraving from Chase's daguerreotype.[1] MASS may also have hired Chase to create Douglass's daguerreotype, now also lost (plates 2.1 & 2.2).

The c. 1844 painting may be the painting, thought to be lost, by the antislavery artist Elisha Livermore Hammond (1799–1882), which Douglass bequeathed in his will to his daughter Rosetta as a "certain portrait of myself, painted more than forty years ago by Mr. Hammond of Florence, Massachusetts."[2]

The National Portrait Gallery painting (c. 1845), once thought to be Hammond's painting, is in fact by an unidentified artist (plate 2.3).

The kind of caricature in *Abolition Fanaticism in New York* was common in the anti-abolitionist press. Published in Maryland, it reprints a speech from Douglass to warn Southerners what happens to "a runaway . . . when he reaches the abolition regions of the country" (plate 2.4).[3]

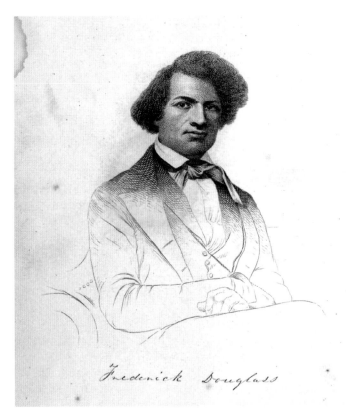

Plate 2.2: Unknown artist, c. 1845
Frontispiece for *Narrative of the Life of Frederick Douglass* (1845)
Author's collection

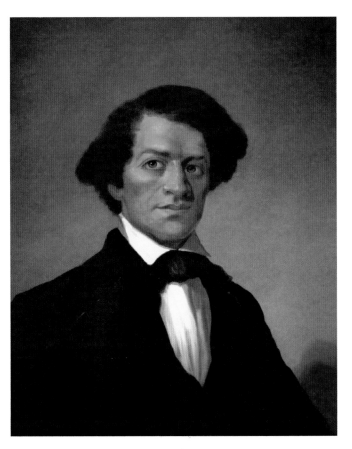

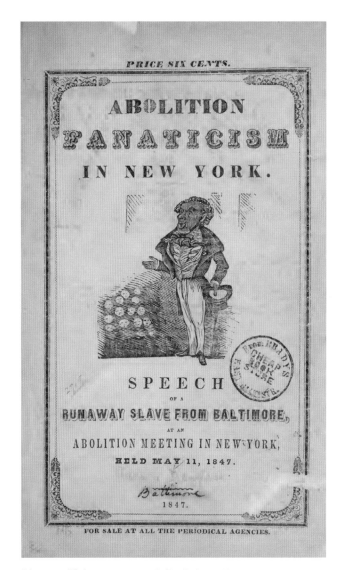

Plate 2.4: Unknown artist, 1847, *Abolition Fanaticism in New York: Speech of a Runaway Slave from Baltimore, at an Abolition Meeting in New York, Held May 11, 1847*

Plate 2.3: Unknown artist, c. 1845
Oil on canvas (27⅝ × 22⅝ in.)
National Portrait Gallery

Through International Eyes: 1840s Britain

The engraving in *A Tribute for the Negro* by Wilson Armistead, a British Quaker and abolitionist, was cut from the frontispiece of the first British edition of Douglass's *Narrative*. Douglass disliked both images, and accused the engraver in Armistead's book of rendering him as a happy slave, "with a much more kindly and amiable expression than is generally thought to characterize the face of a fugitive." Charles Dickens disliked the image too, and when sending a copy of the *Narrative* to a friend observed: "There was such a hideous and abominable portrait of him in the book, that I have torn it out, fearing it might set you, by anticipation, against the narrative" (plates 2.5 & 2.6).[4]

The frontispiece to the British edition of Douglass's *Narrative* may have been based on a lost daguerreotype or painting; Douglass told his publisher in January 1846 that it was "not as good as the original portrait. I don't like it."[5]

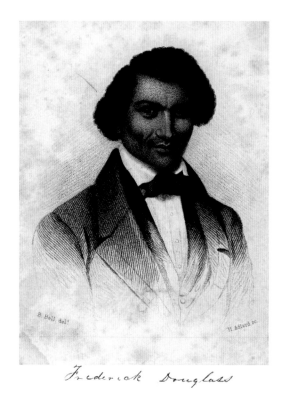

Plate 2.5: B. Bell (drawing) and Henry Adlard (engraving), 1845
Frontispiece for the Dublin edition of *Narrative of the Life of Frederick Douglass* (1845)

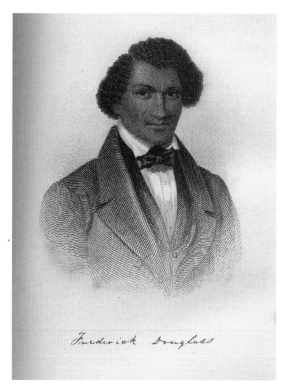

Plate 2.6: Unknown artist, 1848
Engraving in Wilson Armistead, *A Tribute for the Negro* (1848)

The *Illustrated London News* featured Douglass as one of the World Temperance Convention's "most distinguished speakers." The most popular paper in England, it shared with its readers a vigorous opposition to slavery and racism. The artist likely drew Douglass from life at the convention, which took place in London in August 1846 (plates 2.7 & 2.8).[6]

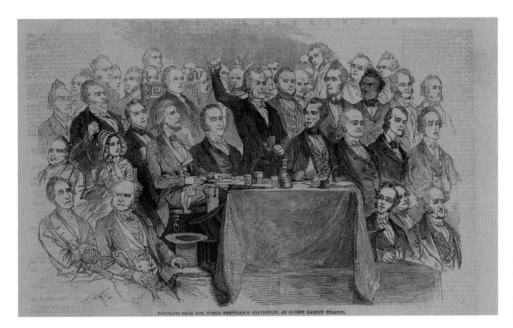

Plate 2.7: Unknown artist, "Frederick Douglas, of Maryland," *Illustrated London News*, August 15, 1846

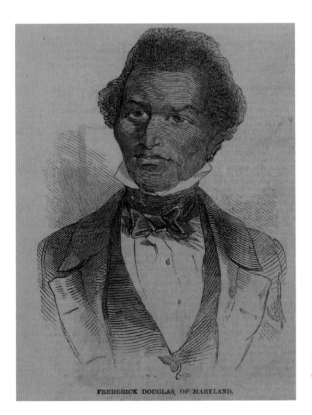

Plate 2.8: Unknown artist, "Portraits from the World Temperance Convention, at Covent Garden Theatre," *Illustrated London News*, August 15, 1846

Abolition Activist: The 1850s–1860s

George Cruikshank was one of England's best known illustrators, renowned in particular for his illustrations in the British edition of *Uncle Tom's Cabin*. He likely drew Douglass from life during his speaking tour in England, Ireland, and Scotland in 1845–47, and published the drawing as an engraving in *The Uncle Tom's Cabin Almanack; or, Abolitionist Memento for 1853* (1852). The drawing was captioned: "Frederick Douglass, the escaped slave, on an English platform, denouncing slaveholders and their religious abettors." The *Almanack* was designed to build upon the extraordinary success of Harriet Beecher Stowe's novel in England, by rallying British support for the abolition of slavery in the United States and throughout the world. As the editors state in their introduction, "if slavery were exterminated in America, it would immediately cease." They marketed their antislavery message in an almanack because "our aim is to give a daily lesson, and to bear a daily witness" (plate 2.9).[7]

Frank Leslie's Illustrated Newspaper caricatured Douglass's flight to Canada in October 1859 following John Brown's raid on Harpers Ferry with a drawing captioned: "'I have always been more distinguished for running than fighting.—Fred. Douglass' Letter to the Rochester Papers." Douglass was a close friend of Brown, but refused to participate in the raid (plate 2.10).[8]

Six weeks later, *Frank Leslie's Budget of Fun* again caricatured Douglass. Virginia governor Henry Wise and antislavery editor Horace Greeley fight over him during the Harpers Ferry affair. In the caption, Douglass says: "Golly! What fools dese white men are! All did muss about me!" This issue republished the *Leslie's* cartoon of Douglass fleeing to Canada (plate 2.11).[9]

On the anniversary of John Brown's execution, abolitionists met in Boston to commemorate his raid. A mob broke up the meeting and tried to silence Douglass. Winslow Homer portrayed Douglass being accosted during his speech. Homer, who began his career as a sketch artist for *Harper's Weekly*, was almost certainly present at Tremont Temple and made the drawing as an eyewitness artist. His initials, "WH," are at the bottom right on the side of the stage (plate 2.12).

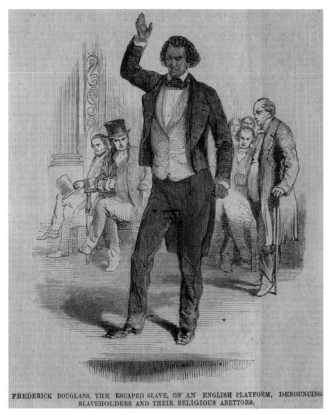

FREDERICK DOUGLASS, THE ESCAPED SLAVE, ON AN ENGLISH PLATFORM, DENOUNCING
SLAVEHOLDERS AND THEIR RELIGIOUS ABETTORS.

Plate 2.9: After George Cruikshank (1792–1878), 1852,
engraving, in *The Uncle Tom's Cabin Almanack; or, Abolitionist
Memento for 1853*, p. 7.

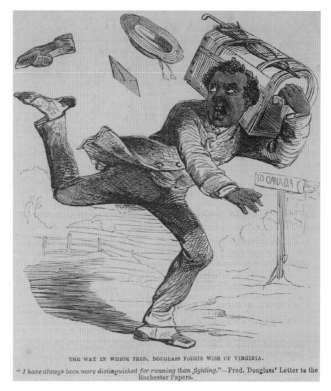

THE WAY IN WHICH FRED. DOUGLASS FIGHTS WISE OF VIRGINIA.

" I have always been more distinguished for running than fighting."—Fred. Douglass' Letter to the
Rochester Papers.

Plate 2.10: Unknown artist, "The Way in Which Fred.
Douglass Fights Wise of Virginia," *Frank Leslie's Illustrated
Newspaper*, November 12, 1859

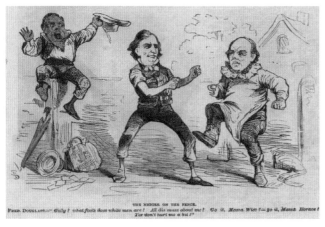

Plate 2.11: Unknown artist, "The Nigger on the Fence,"
Frank Leslie's Budget of Fun, January 1, 1860

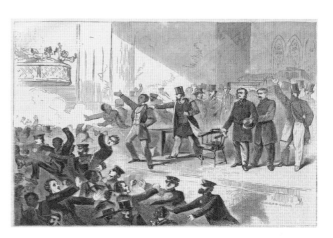

Plate 2.12: After Winslow Homer (1836–1910), "Expulsion
of Negroes and abolitionists from Tremont Temple, Boston,
Massachusetts, on December 3, 1860," *Harper's Weekly*,
December 15, 1860

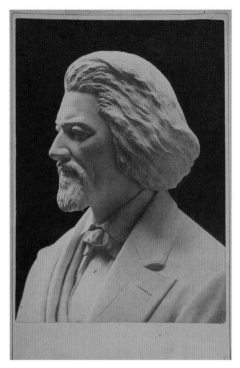

Plate 2.13: Johnson M. Mundy (1832–1897), 1870s. Plaster bust. Cabinet card by John Howe Kent. Harvard University Fine Arts Library

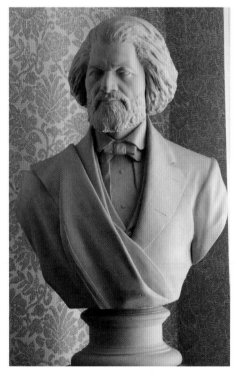

Plate 2.14: C. Hess, 1870s. Plaster bust. National Park Service, Frederick Douglass National Historic Site. After Johnson M. Mundy, 1870s, marble bust. University of Rochester

A Political Insider: The 1870s

Johnson Marchant Mundy was a well-known midcentury sculptor. Born in New Jersey, he moved to Rochester in 1863, where he established an art school. After Douglass left Rochester for Washington, D.C., in 1872, Rochester residents commissioned Mundy to create a bust. He visited Douglass in Washington and modeled a cast of his features, then produced two versions, one with a goatee and another with a full beard. A marble version of the full-bearded bust was unveiled in 1879 and placed on view at the University of Rochester. Another artist, C. Hess, made a plaster likeness which Douglass kept for himself (plates 2.13 & 2.14).

Frank Leslie's Illustrated Newspaper portrays Douglass and a score of other African Americans mourning the death of Charles Sumner, the Massachusetts senator who had dedicated his life to racial equality. *Leslie's* devoted the entire issue to Sumner's death and funeral, which "more deeply touched the heart" of America than any event since Lincoln's assassination (plate 2.15).[10]

Three years later, Douglass became the marshal of the District of Columbia. It was the first time a black man had received a federal appointment requiring Senate approval. Joseph Becker, the manager of *Leslie's* art department, sketched Douglass in his office. Becker had originally made a name for himself by publishing eighty-eight wartime drawings in *Leslie's* while accompanying the Union Army between 1863 and 1865 (plate 2.16).

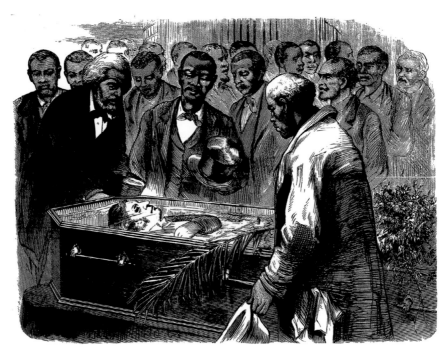

Plate 2.15: After Joseph Becker (1841–1910), "The Late Senator Sumner; Ceremonies in the Capitol; Colored People of Washington, Heading by Frederick Douglass, Viewing the Remains, "*Frank Leslie's Illustrated Newspaper*, March 28, 1874

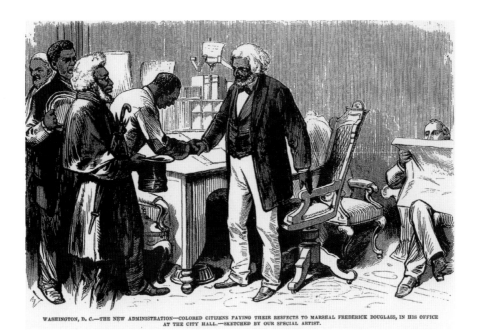

WASHINGTON, D. C.—THE NEW ADMINISTRATION—COLORED CITIZENS PAYING THEIR RESPECTS TO MARSHAL FREDERICK DOUGLASS, IN HIS OFFICE AT THE CITY HALL.—SKETCHED BY OUR SPECIAL ARTIST.

Plate 2.16: After Joseph Becker, "Washington, D.C.—The New Administration.—Colored Citizens Paying Their Respects to Marshall Frederick Douglass, in his office at the City Hall," *Frank Leslie's Illustrated Newspaper*, April 7, 1877

Illustrating the Life: The 1880s

When Douglass completed his third autobiography, *Life and Times of Frederick Douglass* (1881), the Park Publishing Company illustrated it with engravings based primarily on sketches (rather than photographs) without Douglass's approval. Douglass wrote to his editor before publication, calling the images "coarse and shocking woodcuts such as may be found in the newspapers of the day" and caricatures "of my own face." He added that the illustrations had "marred and spoiled my work entirely," and threatened to sue. He had no objection to the frontispiece, however, which Augustus Robin engraved from a photograph by George Kendall Warren. The book came out, complete with seventeen illustrations, in spite of his protests (plates 2.17–2.20).[11]

Below left:
Plate 2.17: Unknown artist, 1881. "At the Wharf in Newport," illustration from *Life and Times of Frederick Douglass* (1881)

Below right:
Plate 2.18: Unknown artist, 1881. "Fighting the Mob in Indiana," illustration from *Life and Times of Frederick Douglass* (1881)

AT THE WHARF IN NEWPORT.

FIGHTING THE MOB IN INDIANA.

MARSHAL AT THE INAUGURATION OF PRES. GARFIELD.

Plate 2.19: Unknown artist, 1881. "Marshal at the Inauguration of Pres. Garfield," illustration from *Life and Times of Frederick Douglass* (1881)

REVISITS HIS OLD HOME.

Plate 2.20: Unknown artist, 1881. "Revisits His Old Home," illustration from *Life and Times of Frederick Douglass* (1881)

Political Cartoons: The 1880s

As Douglass became a Republican figurehead, he was increasingly featured in political cartoons. The four shown here render Douglass's early 1880s style quite accurately, with the long hair and full beard. In one by Frederick Burr Opper, a prominent cartoonist, he stumps for James Garfield during the 1880 presidential campaign. In another, by Canadian artist Frederick J. Willson, likely intended for publication in the *Daily Graphic* or the *Canadian Illustrated News*, he is surrounded by political protestors (plates 2.21 & 2.22).

One of the most prolific portrayers of Douglass was Henry Jackson Lewis, an African American political cartoonist. Born into slavery in Yalobusha County, Mississippi, he was completely self-taught and the only ex-slave to make visual representations of Douglass. The black photographers and other black artists who depicted Douglass during the nineteenth century were either born free during slavery or after Emancipation. Lewis published his first cartoons in 1872 and began working for an Indianapolis black weekly newspaper, *The Freeman*, in the late 1880s. This was the first illustrated black newspaper in the United States, billed as "the *Harper's Weekly* of the Colored Race."[12]

Lewis's drawings here are two of thirteen featuring Douglass that he did for the *Indianapolis Freeman* before his death from pneumonia in 1891. One cartoon from May 1889 critiques Secretary of State James G. Blaine's awarding of appointments to "big leaders." Douglass converses with Blaine while dogs with human heads represent black newspapers that cannot "be reconciled" like Douglass. The following month, Douglass accepted the appointment as U.S. Minister to Haiti and so the second cartoon depicts a larger-than-life Douglass heading for the Caribbean (plates 2.23 & 2.24).

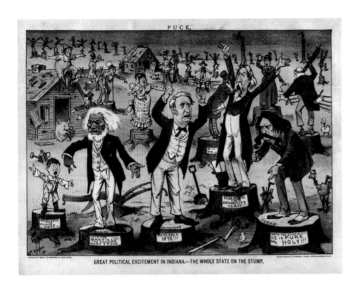

Plate 2.21: Frederick Burr Opper (1857–1937), "Great Political Excitement in Indiana: The Whole State on the Stump," *Puck*, September 29, 1880

Plate 2.22: Frederick J. Willson, "Protest," 1883
Pen and ink
(19¼ × 16¾ in.)
American Antiquarian Society

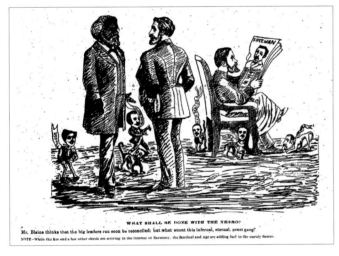

Plate 2.23: Henry Jackson Lewis (1837–1891), "What Shall Be Done With the Negro?" *Indianapolis Freeman*, May 25, 1889

Plate 2.24: Henry Jackson Lewis, "Hon. Frederick Douglass Off for Hayti," *Indianapolis Freeman*, October 5, 1889

An Elder Statesman: The 1880s

Sarah Jane Eddy, a well-known painter, knew Douglass from abolition and women's rights circles. He sat for an oil portrait and a pen-and-ink drawing by Eddy during two visits to Rhode Island in 1883. The baton symbolized his tenure as marshal of the District of Columbia from 1877 to 1881. W. E. B. Du Bois displayed the painting in the offices of *The Crisis* magazine in the early twentieth century (plates 2.25 & 2.26).

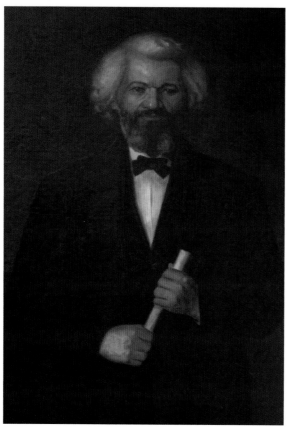

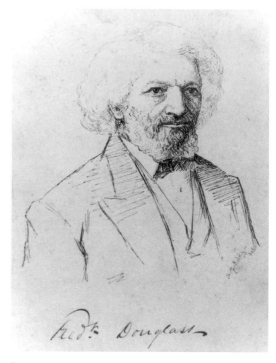

Plate 2.26: Sarah Jane Eddy, c. 1883.
Pen and ink, published in Francis F. Browne, *The Every-Day Life of Abraham Lincoln* (1886), p. 583

Plate 2.25: Sarah Jane Eddy (1851–1945), 1883.
Oil on canvas. (64 × 49 in.)
National Park Service, Frederick Douglass National Historic Site

Artists began to rely more and more upon memories of Douglass's photographic image. The result was a marked increase in the accuracy of their sketches, as in the *Chicago Tribune* scenes from the Republican Convention of 1888 (plate 2.27).

But as Douglass's persona proliferated, it was used in advertisements, without permission or compensation. One chromolithograph advertisement highlighted Douglass's fame and used the recent controversy over his marriage to Helen Pitts to try to sell a homeopathic remedy (plate 2.28).

Plate 2.27: Unknown artist, "Republican Convention," *Chicago Tribune*, June 20 and 23, 1888

Plate 2.28: Mayer Markel & Ottman, New York, c. 1884
Sulphur Bitters chromolithograph advertisement
(10 × 8 in.)
National Park Service, Frederick Douglass National Historic Site

D ouglass's 160 photographic portraits have left a vast visual legacy, which includes hundreds of paintings, drawings, sculptures, and public murals based on specific photographs. The majority of these twentieth- and twenty-first-century reimaginings are indebted to Douglass's own strategies of self-memorialization: the artists who made Douglass part of their communities via murals or statues clearly had access to some of the nineteenth-century photographs in private collections, black newspapers, or library archives. The photographs have the same legacy in visual culture as Douglass's writings have in literary culture, becoming the foundation for numerous later artworks.

By far the most fertile site for Douglass's image is murals. They outstrip in quantity and variety all other categories of art in his visual afterlife. In street art, Douglass is one of the most frequent presences of all American figures. He appears in both his youthful and aged forms in 110 murals, all in the United States except for two in Belfast, Northern Ireland. The murals are on the walls of fifty neighborhoods; seventeen schools or universities; seven libraries or historical societies; seven community centers; five public housing projects; five government buildings; five churches; three stores; three playgrounds and parks; two prisons; two underpasses; one fire station; one newspaper building; one publishing house; and one subway station.

Some of these murals are Douglass-focused, where he is the central or singular figure. In others, artists have set him alongside historical figures, including Martin Luther King, Jr. (29 murals); Malcolm X (27); Harriet Tubman (24); Sojourner Truth (17); W. E. B Du Bois (17); Marcus Garvey (14); Rosa Parks (12); Abraham Lincoln (11); Muhammad Ali (10); John Brown (9); Thurgood Marshall (9); Nelson Mandela (8); Mary McLeod Bethune (8); Jesse Jackson (7); Booker T. Washington (7); Barack Obama (6); Elijah Muhammad (6); Huey Newton (4); Angela Davis (3); William Lloyd Garrison (3); Mahatma Gandhi (2); Desmond Tutu (2); and Stokely Carmichael, H. Rap Brown, Fred Hampton, Ida B. Wells, and Nat Turner (1 each).

Plate 7

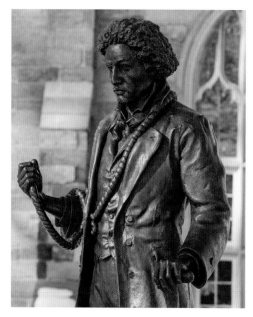

Plate 3.1: Richard Blake, *Frederick Douglass*, 2013, West Chester University, PA

Legacies of Samuel Miller (Plate 7)

The three recent reworkings of Miller's daguerreotype—one statue and two murals—point to artists' growing interest in the younger Douglass. Of the 110 murals that depict Douglass, 62 were made in the twentieth century (1933–99) and 48 in the twenty-first century (2000–14). One third of the total murals picture a younger Douglass; of these, over half were created in the twenty-first century. They include the two published here: Shawn Dunwoody's 2014 mural under the Interstate 490 bridge in Rochester, which also features Rochesterians Susan B. Anthony, Nathaniel Rogers, and Austin Steward (plate 3.3); and Lunar New Year's *I Am / Yo Soy* (2013) on Joseph Avenue in Rochester, which includes a portrait of Trayvon Martin next to the young Douglass. On the far right is the older Douglass, based on cat. #109 (plate 3.2).

Similarly, of the world's fourteen full-length, life-sized (or larger) statues of Douglass that exist (rather than busts or miniatures), five are nineteenth or twentieth century and nine are twenty-first century. Nine depict the Douglass of the 1870s or later, and of the five that depict the younger Douglass, all but one are twenty-first century.

It wasn't until 1993 that the first full-length statue of the young Douglass appeared, as part of a life-sized group statue by Lloyd Lillie, *The First Wave*, for the Seneca Falls visitor center. The other four younger Douglass statues were Pepsy Kettavong's *Let's Have Tea* in Rochester (2001); Gabriel Koren's statue for Douglass Circle in New York City (2010); Andrew Edwards's Dublin statue (2011); and Richard Blake's statue for West Chester University, which depicts Douglass the fugitive and fighter (plate 3.1).

Plate 3.2: Lunar New Year, *I Am / Yo Soy*, 2013, Rochester, NY

Plate 3.3: Shawn Dunwoody, *Historic Rochester*, 2014

Legacies of *Life* (Plate 8)

Following the same pattern as the statues, Douglass paintings and drawings see him growing younger over time. The militant abolitionist Douglass made his first sustained appearances in paintings and prints in the 1960s. Emmy Lou Packard depicts him in a 1960 woodcut for the *Daily Worker* (plate 3.4) He is featured on the cover of *Life* magazine in 1968 (plate 3.5). Then, while the elder statesman Douglass continued to thrive, the younger Douglass largely vanished again until the twenty-first century. He was resurrected alongside Harriet Tubman in a mural in Virginia (plate 3.6), and by Elizabeth Catlett in a 2004 woodcut, *Young Douglass* (plate 3.7).

He also appeared in three other murals: *The Arc of History Is Long*, at the King Open School in Cambridge, MA, 2002 (plate 3.8); Harper Leich's mural on Market Street in Asheville, NC, 2012 (plate 3.9); and *Wings of Faith* on East 97th Street in Los Angeles, 2005 (plate 3.10).

All these images were based on the same 1853 daguerreotype, no doubt owing to its wide circulation from the *Life* cover of 1968.

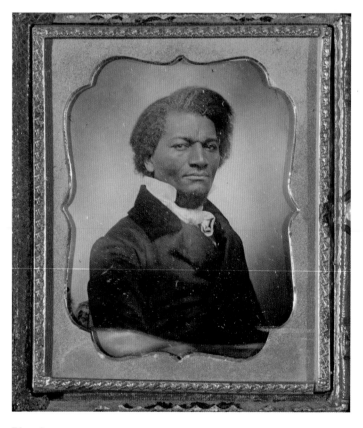

Plate 8

Plate 3.4: Emmy Lou Packard, *Frederick Douglass*, c. 1960

Plate 3.5: *Life* magazine, November 22, 1968

Plate 3.8: Unknown artist, *The Arc of History Is Long*, 2002, Cambridge, MA

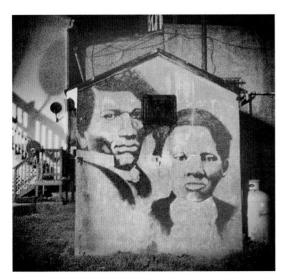

Plate 3.6: Unknown artist, *Frederick Douglass and Harriet Tubman*, c. 2012. Berryville, VA

Plate 3.9: Harper Leich, untitled mural, 2012, Asheville, NC

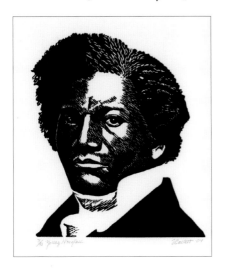

Plate 3.7: Elizabeth Catlett, *Young Douglass*, 2004

Plate 3.10: Unknown artist, *Wings of Faith*, 2005, Los Angeles, CA

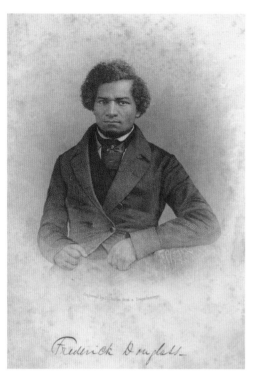

Plate 9

Legacies of *My Bondage* (Plate 9)

One reason that artists focused on Douglass the elder statesman in the twentieth century was the relative unavailability of the younger Douglass. The photographs from the 1840s and 1850s are daguerreotypes and ambrotypes, one-of-a-kind images that were disseminated only as engravings. The photographs from the 1870s–90s are cartes-de-visite and cabinet cards. They were easily reproducible—indeed, many copies of the same image circulated.

This means that when contemporary artists want to depict Douglass, they can draw from multiple extant copies of the later images. George Kendall Warren's carte-de-visite (plate 45) is owned by fourteen different archives, John Howe Kent's cabinet card (plate 49) by seven, and Mathew Brady's carte-de-visite (plate 43) by six, all from the late 1870s or early 1880s. By contrast, in order to see a daguerreotype before twenty-first-century digital archives (excepting the rare twentieth-century halftone reproduction of it, such as the *Life* cover of a daguerreotype in 1968), artists had to track down the unique image in a single museum. In addition, many daguerreotypes were lost for decades, and have been rediscovered and sold at auction only in the last twenty years.

This explains why there are very few twentieth-century representations of Douglass based on his daguerreotypes and ambrotypes.

One readily available image has been John C. Buttre's frontispiece to Douglass's second autobiography from 1855, *My Bondage and My Freedom* (itself engraved from a lost daguerreotype). It gave twentieth-century artists rare access to the young Douglass.

We present four artworks inspired by Buttre's frontispiece: Mel Boldin's cartoon in *Baltimore Afro-American*, February 10, 1945 (plate 3.11); Ben Irving's quilt design for the Negro History Club of Marin City and Sausalito, 1953 (plate 3.12); the cover of *Golden Legacy's Frederick Douglass: Part One*, 1969 (plate 3.13); and Lloyd Lillie's bust (plate 3.14), which he created for Boston's Faneuil Hall in 1995 and modeled on his *First Wave* statue (featuring Douglass and other early women's rights activists) for the Women's Rights National Historical Park in Seneca Falls (1993).

"Neither Institutions Nor Friends Can Make A Race to Stand Unless It has Strength In Its Own Legs"

Plate 3.11: Mel Boldin, cartoon in *Baltimore Afro-American*, February 10, 1945

Plate 3.12: Ben Irving, quilt design, 1953

Plate 3.13: *Golden Legacy Illustrated History Magazine, Frederick Douglass: Part One*, 1969

Plate 3.14: Lloyd Lillie, *Frederick Douglass*, Faneuil Hall, Boston, MA, 1995

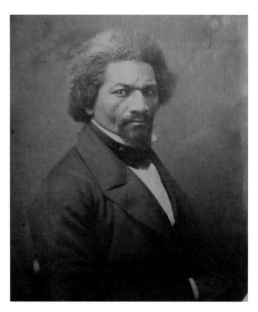

Plate 13

Legacies of a Lost Daguerreotype (Plate 13)

Several artists were inspired by the copy print of the lost 1857 daguerreotype (plate 13), where a goateed Douglass clenches his fist and his jaw. In 2010, Gabriel Koren used this image to create her eight-foot bronze statue, *Frederick Douglass*, on 110th Street at Central Park West, which faces uptown toward Manhattan's black community at the south edge of Harlem (plate 3.19).

The photograph was also used in three mural depictions over the past few years: Parris Stancell's *Freedom School*, on Girard Avenue in Philadelphia, 2002 (plate 3.15); John Lewis and Delia King's *Leidy School Mural* in Philadelphia, 2004 (plate 3.16); and Aniekan Udofia's *Bread for the City* on Good Hope Road in Washington, D.C., 2011 (plate 3.17).

Like Koren's statue, these three murals are in predominately black neighborhoods. This reflects a pattern in which artists turn to the younger Douglass more frequently in historically black neighborhoods than in white ones.

The presence of Malcolm X in one Philadelphia mural is also significant. Murals in black neighborhoods often portray the younger, militant Douglass alongside other revolutionary figures. These community murals tend to include messages of rebellion, struggle, and black unity; and Douglass is often paired with Malcolm X, Marcus Garvey, Huey Newton, and other Black Power figures.

In choosing the younger Douglass, these artists lay claim to the radical abolitionist who advocated armed rebellion and defensive violence against slave catchers, and who worked closely with John Brown and then Lincoln during the war, rallying African Americans to vanquish slavery. Preston Jackson's *African American Civil War Monument* in Decatur, Illinois, 2009 (plate 3.18) recalls Douglass's collaborations with Lincoln in using African Americans as a potent source of power for destroying slavery and winning the war.

Plate 3.15: Parris Stancell, *Freedom School*, 2002, Philadelphia, PA

Plate 3.16: John Lewis and Delia King, untitled mural, 2004, Philadelphia, PA

Plate 3.17: Aniekan Udofia, *Bread for the City*, 2011, Washington, DC

Plate 3.18: Preston Jackson, *African American Civil War Monument*, 2009, Decatur, IL

Plate 3.19: Gabriel Koren, *Frederick Douglass*, 2010, New York City

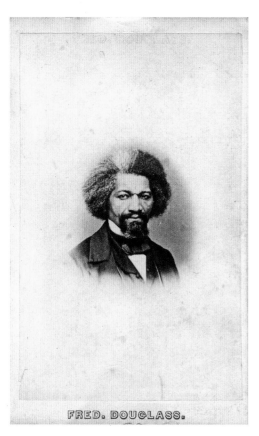

FRED. DOUGLASS.

Plate 17

Legacies of John White Hurn (Plate 17)

At some mural sites, artists have replaced the older Douglass for the younger. In Boston, Arnold Hurley and Gary Rickson's mural for the African American neighborhood of Lower Roxbury (1976) was based on Denis Bourdon's Douglass of 1894 (see "Legacies of Denis Bourdon I" on page 119). Destroyed in 1987, it was replaced in 2003 with a new mural on Hammond Street, *Frederick Douglass*, designed by Deborah Browder and Heidi Schork, and based on John White Hurn's youthful, fierce Douglass of 1862 (plate 3.22). The new mural then appeared as the backdrop for an album cover by the Hip Hop artist Reks in 2008.

Hurn's photograph inspired three other murals: St. George's *Frederick Douglass*, in Los Angeles, California, 2013 (plate 3.23); Ax Rochester, *Without Struggle There Can Be No Progress*, on the Douglass–Anthony Memorial Bridge in Rochester, 2013 (plate 3.24); and G. Byron Peck's *Frederick Douglass* on 12th Street NW in Washington, D.C., 1995 (destroyed in 2002) (plate 3.21). Peck added two locket images of Douglass at the top left, one based on the young Douglass of plate 4, and the other based on a cabinet card from May 1894 (cat. #153). The two Douglasses hang as two halves of a necklace, containing between them a half century of portraiture. At the bottom left of his mural, Peck painted the elderly Douglass seated at his writing desk (plate 55).

Hurn's image also formed the basis for Ben Shahn's lithograph of 1965 (plate 3.20), one of a series of four lithographs that Shahn made, each one based on a different Douglass photograph.

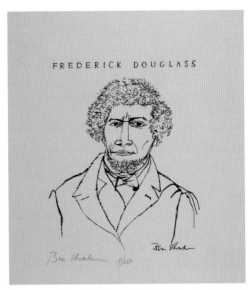

Plate 3.20: Ben Shahn, *Frederick Douglass I*, 1965

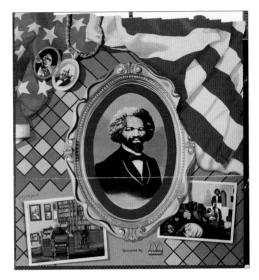

Plate 3.21: G. Byron Peck, *Frederick Douglass*, 1965, Washington, DC

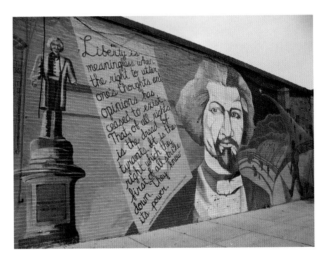

Plate 3.22: Deborah Browder and Heidi Schork, *Frederick Douglass*, 2003, Roxbury, MA

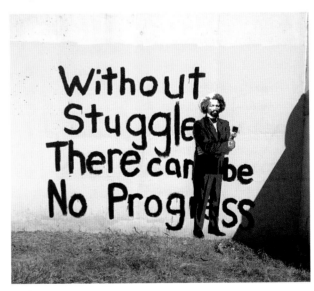

Plate 3.24: Ax Rochester, *Without Struggle There Can Be No Progress*, 2013, Rochester, NY

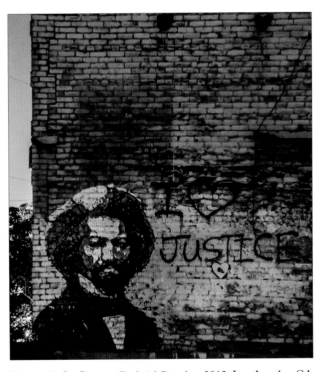

Plate 3.23: St. George, *Frederick Douglass*, 2013, Los Angeles, CA

Legacies of Samuel Fassett (Plate 22)

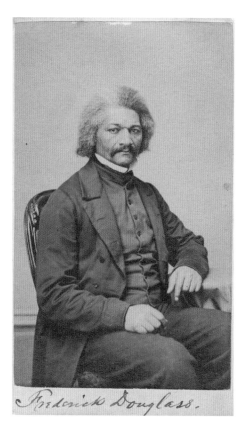

Plate 22

Clark Hampton, an African American artist, was the first in the twentieth century to rework Samuel Fassett's carte-de-visite of Douglass from a February 1864 photo shoot. Hampton painted Douglass in 1900 (plate 3.25). Then the *Call and Post*, a black newspaper in Cleveland, used Fassett's photo for an illustration of Douglass and Lincoln in 1963 (plate 3.26). The paper was the first of the legacy images to achieve temporal accuracy in pairing Douglass with Lincoln. Most artists depict a much older Douglass with a full beard alongside the President.

Fassett's photograph then vanished from visual culture for thirty years, finally appearing again in 1995 on a USPS stamp (plate 3.27). The first Douglass stamp, printed in 1967, had used Charles Bell's cabinet card of 1881 (plate 48). The Post Office chose Fassett's photo to represent a younger version of Douglass. The stamp takes Douglass's downward-pointing finger from the photograph and turns it upward, creating a pose that Douglass never affected in any sitting.

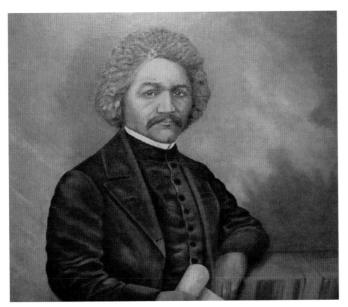

Plate 3.25: Clark Hampton, *Frederick Douglass*, c. 1900

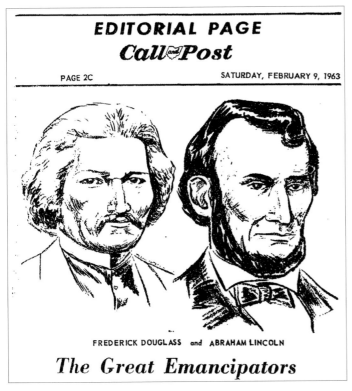

Plate 3.26: Unknown artist, "Frederick Douglass and Abraham Lincoln: The Great Emancipators," *Call and Post*, February 9, 1963

Plate 3.27: United States Postal Service, *Frederick Douglass*, 1995

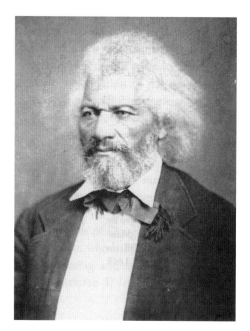

Plate 38

Legacies of Carl Giers (Plate 38)

As well as slavery, Emancipation, and civil rights, the Douglass murals focus on the black press (five murals), education (four), interracial collaboration (three), labor rights (two), law and justice (two), free speech (one), gang violence (one), and peace (one).

On community walls, Douglass learns to read, breaks his chains, speaks out against racism and for women's rights, Irish rights, and even animals' rights in one mural. His famous quote, "If there is no struggle, there is no progress," is the most common phrase to accompany his image, appearing on six murals and in several drawings. Giers's photograph is the basis for at least three murals: Don Rodgers, *Our Brothers and Sisters*, on Halsted Street in Chicago, 1984 (plate 3.30); a mural by an unidentified artist on Roosevelt Road in Chicago, 1990 (plate 3.33); and Munir Mohammed's *The Shoulders of Heroes We Lean On*, for the Black Heritage Society of Providence, 2012 (plate 3.32).

Giers's photograph had a wide variety of uses in Douglass's visual legacy, including for a labor union flyer in 1945, by the International Fur and Leather Workers Union (plate 3.28); a 1963 *Ebony* magazine cover commemorating the centennial of the Emancipation Proclamation (plate 3.29); and alongside John Brown on an advertisement for a "Negro Life" exhibition (plate 3.31) with an all-black cast of 500 that opened in Brooklyn on May 25, 1895, and ran in Boston, Philadelphia, and other northeast cities until November 1895. The exhibition's creator was Nate Salsbury, who had worked on Buffalo Bill's Wild West Show.

Plate 3.28: International Fur and Leather Workers Union, flyer, "The lesson of the ages is that a wrong done to one man is a wrong done to all men," 1945

Plate 3.29: *Ebony* Special Issue, September 1963

Plate 3.30: Don Rodgers, *Our Brothers and Sisters*, 1984, Chicago, IL

Plate 3.31: Calhoun Printing Co, "Gigantic Exhibition of Negro Life and Character," broadside advertisement, 1895

Plate 3.32: Munir Mohammed, *The Shoulders of Heroes We Lean On*, 2012, Providence, RI

Plate 3.33: Unknown artist, untitled mural, 1990, Chicago, IL

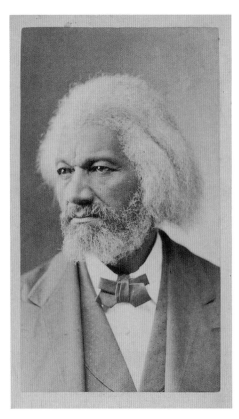

Plate 43

Legacies of Mathew Brady (Plate 43)

In spite of the exceptions—five statues, a handful of paintings, some recent murals—and the small but consistent shift toward a youthful Douglass in all art forms after 2000, the elder statesman persona (1870s and later) dominates Douglass's visual afterlife.

The older Douglass appears in 73 of the 110 total murals; the younger Douglass appears in just 36 (one mural depicts him only in silhouette, where his age is unidentifiable).

However, some murals attempt to bridge the divide between the different eras. Dan Devenny's *Labor History Mural* on Sixth Street in New Bedford, 2001 (plate 3.36), has the late 1870s Brady photograph for its central figure, but includes another Douglass portrait on the mural's left side based on a daguerreotype (plate 4), and a third portrait on the mural's right side based on the frontispiece for *My Bondage and My Freedom* (plate 9). Statesman Douglass is larger-than-life at the mural's center, but flanked by two smaller, younger versions of himself.

To our knowledge, the only Douglass murals outside of the United States were painted in Belfast: Devenny's *Solidarity Mural* on Falls Road, 2006 (destroyed in 2011) (plate 3.37); and *Anti-Racism Mural* by the Open Hands Community Group with Marion Weir, near Falls Road, 2011 (plate 3.38). Douglass loved Ireland and was in turn beloved there—in life and legacy. Douglass and his legacy inspired Irish claims for citizenship, equality, and independence. Like Devenny's New Bedford mural, the 2011 Belfast mural puts Brady's Douglass at the center and adds a smaller Douglass, based on plate 8, on the left.

We include two other murals that were inspired by Brady's photo: Ashanti Johnson, Nathan Hoskins, and Verna Parks, *Wall of Respect*, Auburn Avenue, Atlanta, 1975 (destroyed in 2007) (plate 3.35); and Helen Haynes, *Afro-American History*, Grenville High School, Cleveland, Ohio, 1976 (plate 3.34).

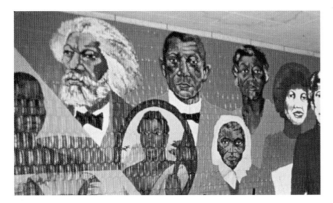

Plate 3.34: Helen Haynes, *Afro-American History*, 1976, Cleveland, OH

Plate 3.35: Ashanti Johnson, Nathan Hoskins, and Verna Parks, *Wall of Respect*, 1975, Atlanta, GA

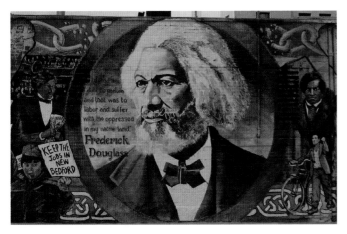

Plate 3.36: Dan Devenny, *Labor History Mural*, 2001, New Bedford, MA

Plate 3.37: Dan Devenny, *Solidarity Mural*, 2006, Belfast, Northern Ireland

Plate 3.38: Open Hands Community Group, *Anti-Racism Mural*, 2011, Belfast, Northern Irleand

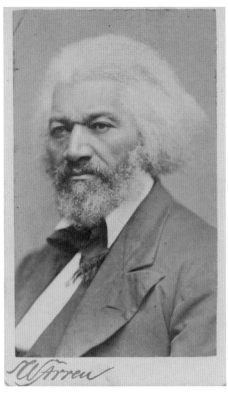

Plate 45

Legacies of George Warren (Plate 45)

One of the most commonly used photographs is George Kendall Warren's, which has Douglass at his most statesmanlike: a three-quarter pose, tightly cropped to a bust portrait, with a stern visionary gaze out to the horizon beyond the viewer. One reason for the frequent use is that Douglass included this photograph as an engraved frontispiece in the first edition of his third autobiography, *The Life and Times* (1881). When artists began sculpting or drawing Douglass in the twentieth century, one of the most available photographs from which they could work was this frontispiece, available in old copies of *The Life and Times.*

Muralists combined Warren's photograph, and many others, with national and local interests. Warren's Douglass appears with Lincoln on an Emancipation broadside (plate 3.39) and an Emancipation Day pin by the Cincinnati company Pettibone to commemorate the jubilee of the Proclamation (plate 3.40). He appears with Harold Washington, the first African American mayor, and other significant black Chicagoans in Paul Minnihan's *I Dare to Dream* mural on West 13th Street in Chicago from 1995 (plate 3.41). He promotes education in a mural of 2013 on Metropolitan Avenue in the Bronx by an unidentified artist (plate 3.43). In Louisiana, he is aligned with the Baton Rouge Mayor's Office Community Project in Rahmann Statik's mural of 2013 (plate 3.46) and is a face of activism for Project Be in Brandan Odums's New Orleans mural of 2013 for the Florida Projects (plate 3.45). In Los Angeles, he is at the base of the black family tree in Moses X's *Black Seeds* mural of 1991 on Jefferson Boulevard (plate 3.42), and part of RTN Crew's *African American Progress* mural of 2002 on Crenshaw Boulevard (plate 3.44).

Plate 3.39: E. G. Renesch, *Emancipation Proclamation*, broadside, 1919

Plate 3.40: Emancipation Day pin, 1916

Plate 3.41: Paul Minnihan, *I Dare to Dream*, 1995, Chicago, IL

Plate 3.42: Moses X, *Black Seeds*, 1991, Los Angeles, CA

Plate 3.43: Unknown artist, untitled mural, 2002, New York City

Plate 3.44: RTN Crew, *African American Progress*, 2002, Los Angeles, CA

Plate 3.45: Brandan Odums, *Project Be Mural*, 2013, New Orleans, LA

Plate 3.46: Rahmann Statik, *Mayor's Office Community Project Mural*, 2013, Baton Rouge, LA

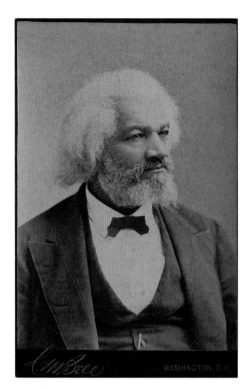

Plate 48

Legacies of Charles Bell (Plate 48)

Like George Warren's Douglass, Charles Bell's cabinet card (plate 48) became an engraved frontispiece for a printing of *The Life and Times* (1882), and therefore was an available starting point for artists.

Yet the answer to the question of why the elder statesman is more visible in Douglass's visual legacy than the young abolitionist does not lie solely in the relative availability of these later photographs.

Douglass as elder statesman is more useful for "family tree" artwork, where he serves as the father of the race—the patriarch and origin point—as in Moses X's *Black Seeds* (plate 3.42). In a mural shown here, Pontella Mason's *Ancestral Roots*, E. Lombard Street, Baltimore, 1999 (plate 3.49), Douglass is again at the base of the tree, along with Sojourner Truth, Harriet Tubman, and W. E. B. Du Bois. They represent the ancestral roots of the mural's title, and the faces of King, Malcolm X, Rosa Parks, and Tupac, among others, emerge from the tree's branches. Douglass's mythic, wise man persona bestows a heroic gravitas onto black history.

But activist artists used the elder statesman Douglass too. Ben Shahn, a prominent white protest artist from the 1920s through the 1960s, reimagined Charles Bell's Douglass (plate 3.47), as did a community group that put Bell's Douglass on a prototype of a twenty-dollar bank note in 1999, intended for use in a black Chicago neighborhood (plate 3.48).

Plate 3.47: Ben Shahn, *Frederick Douglass III*, 1965

Plate 3.48: Twenty-dollar bank note, 1989, Chicago, IL

Plate 3.49: Pontella Mason, *Ancestral Roots*, 1999, Baltimore, MD

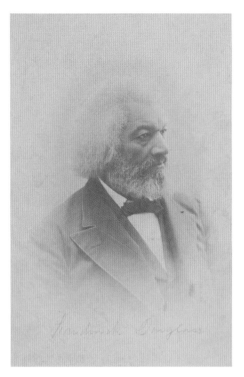

Plate 49

Plate 3.50: "Friendship Week—Feb. 6th–
12th," *Philadelphia Tribune*, February 5, 1927

Legacies of John Howe Kent (Plate 49)

Along with George Warren's photograph, John Howe Kent's 1882 cabinet card (plate 49) was the image that twentieth- and twenty-first-century artists used most often, in part because it became the engraved frontispiece for the final edition of *Life and Times* (1892) and so was readily available. Like Warren and Bell, Kent depicts Douglass as the wise and skeptical statesman, in a tightly cropped bust portrait, coupled with visionary gaze and furrowed brow.

Forgoing temporal accuracy, Kent's Douglass was frequently paired with Lincoln. Instead of the forty-five-year-old Douglass of the early 1860s, the *Philadelphia Tribune* used Kent's seventy-year-old Douglass with Lincoln for its illustration of February 5, 1927 (plate 3.50). This was true of murals, too, including Joshua Sarantitis's *Lincoln Legacy* (2006) for Philadelphia, almost 10,000 square feet in full and made of mosaic tiles (plate 3.53). In fact, of all the murals that picture Douglass and Lincoln, only one paints Douglass as he was in the 1860s, with just a touch of gray (by MTC Studios for the Frederick Douglass Recreation Center in Washington, D.C., 2012).

Though Lincoln was older than Douglass when they met, artists suggest that only a man with more years than Lincoln might confront and sway him. Whether knowingly or not, these artworks propose that age might trump race—that aged wisdom might make up for social inferiority.

Kent's Douglass appears in a 1935 monument in Staten Island Memorial Park, New York (plate 3.51). Other notable renderings include Daniel Koerner's drawing from 1952 (plate 3.52); Thomas Stockett's "History's Giant Whose Words Still Ring True," published in the *Baltimore Afro-American* on February 16, 1957 (plate 3.54); the USPS 1967 postage stamp (plate 3.55); Romare Bearden's 1978 drawing (plate 3.56); and the Association for the Study of Negro Life and History's civil rights era pin (plate 3.57).

Plate 3.51: *Frederick Douglass Monument*, 1935, New York City

Plate 3.52: Daniel Koerner, *Frederick Douglass*, 1952

Plate 3.53: Joshua Sarantitis, *Lincoln Legacy*, 2006, Philadelphia, PA

Plate 3.54: Thomas Stockett, *Baltimore Afro-American* illustration, February 16, 1957

Plate 3.55: United States Postal Service, *Frederick Douglass*, 1967

Plate 3.56: Romare Bearden, *Frederick Douglass*, 1978

Plate 3.57: Association for the Study of Negro Life and History, "Proud American" pin, 1961

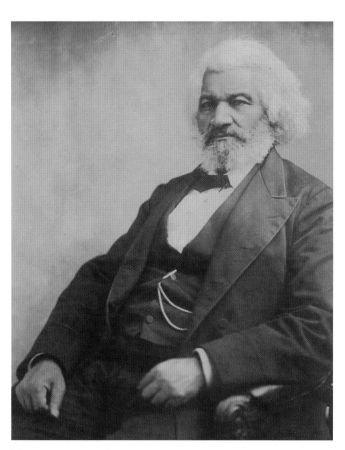

Plate 54

Legacies of Cornelius Battey (Plate 54)

Cornelius Battey's photograph of Douglass from 1893 was a frequent starting point for artists in the first half of the twentieth century, aided by Battey's distribution of this and other photographs of black leaders as picture postcards, collectible prints, and collage posters until his death in 1927.

The inclusion of particular figures with Battey's Douglass reflects an artwork's originating moment. Pre–civil rights paintings, murals, and ephemera from the 1910s to the 1940s set Douglass alongside other nineteenth-century figures, from Lincoln, John Brown, and William Lloyd Garrison to Nat Turner, Harriet Tubman, Sojourner Truth, and Booker T. Washington, and used him to champion current causes. A Tuskegee broadside, c. 1915, promotes Washington's school (plate 3.58). Charles Alston's drawing of 1943 connects Douglass with the Second World War (plate 3.60). Elizabeth Ross Hayne's book, *Unsung Heroes* (1921), set Douglass alongside other black leaders, from Phillis Wheatley to Alexander Pushkin and John Mercer Langston, and printed C. Thorpe's illustration (plate 3.61). And a National Negro Congress pin of 1936 places Douglass in the service of the Communist Party U.S.A. (plate 3.59).

From the 1960s onward, however, artists set Douglass alongside Martin Luther King, Jr., and Malcolm X. By the 1980s, Jesse Jackson, Desmond Tutu, and Nelson Mandela appear. Barack Obama is present after 2008.

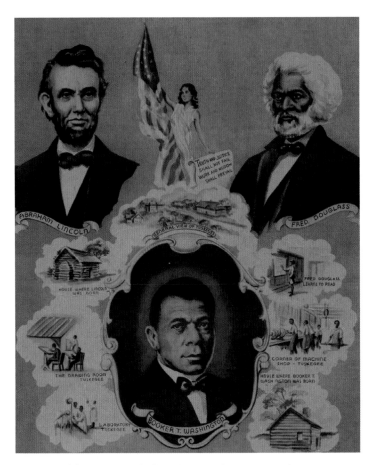

Plate 3.58: Tuskegee broadside and postcard print, c. 1915

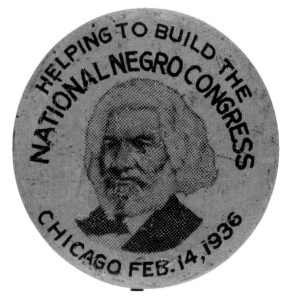

Plate 3.59: National Negro Congress pin, 1936

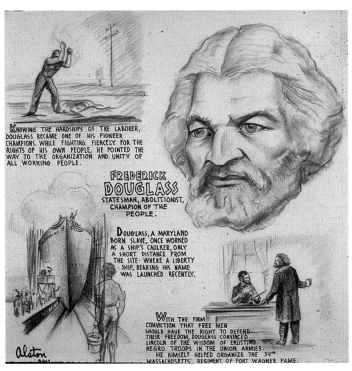

Plate 3.60: Charles Alston, "Frederick Douglass, Statesman, Abolitionist, Champion of the People," 1943

Plate 3.61: C. Thorpe, untitled illustration, c. 1921

Plate 56

Legacies of Denis Bourdon I (Plate 56)

The sage statesman also lends himself to the tradition of reimagining black history as biblical history. Artists used Denis Bourdon's cabinet card from 1894 to reimagine him as a prophet or apostle who fits within black tableaus that restage biblical scenes.

In Otto Scheible's *Beacon Lights* lithograph, 1910, Bourdon's Douglass appears as a patriarch with the young Paul Laurence Dunbar, while a black angel hovers above (plate 3.63). He evokes Isaiah, the radical prophet of justice, in Ben Shahn's 1965 lithograph (plate 3.62). He sits as one of Christ's apostles in several black *Last Supper* paintings and murals (including Maurice Myron's *Last Supper* for the Union Temple Baptist Church in Washington, D.C., 1990).

In Cletus Alexander's mural, *Frederick Douglass Inspiring the Youth of the Negro Race*, at MacFarlane Middle School in Dayton, Ohio, 1933, a Moses-like Douglass with flowing white hair and beard, wearing Moses' traditional red and white robe, points the way to the Promised Land (plate 3.64). The "youth" from the mural's title sit at his feet and gaze in the direction of his gesture, toward the dawning horizon.

Sometimes this religious strand crosses with the secular heroic strand, so that Douglass is both a biblical figure and an inspirational ancestor. For example, in Arnold Hurley's 1976 mural on Tremont Street in Boston (destroyed in 1987), the grand-authority Douglass wears psychedelic clothes, as if to suggest that despite his age, he continues to resonate with youth (plate 3.65).

FREDERICK DOUGLASS

Plate 3.62: Ben Shahn, *Frederick Douglass IV*, 1965

Plate 3.63: Otto Scheible, *Beacon Lights*, 1910

Plate 3.65: Arnold Hurley, *Frederick Douglass*, 1967, Boston, MA

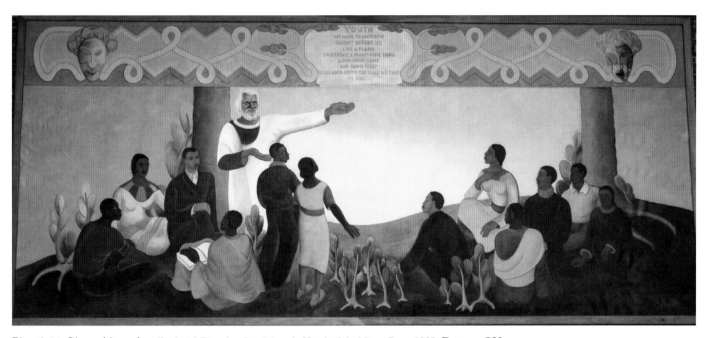

Plate 3.64: Cletus Alexander, *Frederick Douglass Inspiring the Youth of the Negro Race*, 1933, Dayton, OH

Legacies of Denis Bourdon II (Plate 57)

Muralists tend to use the bearded wise man of Douglass's final two decades when painting for white neighborhoods or when placing him alongside moderate reform figures. It is as though the Douglass of the late 1870s and after—the D.C. insider who was appointed to roles like U.S. Marshal for the District of Columbia (1877), Recorder of Deeds (1881), and consul-general to the Republic of Haiti (1889)—is the safer, more inclusive Douglass; the one with cross-racial appeal who belongs in city-sponsored murals and on downtown walls.

For example, in David Fichter's *Freedom Quilt Mural*, painted for the American Friends Service Committee building on Piedmont Avenue in downtown Atlanta, the elder Douglass sits alongside King and Mahatma Gandhi (the mural's largest figures), as well as Rosa Parks and other icons of non-violent civil disobedience (plate 3.69). In an anonymous mural of 2008 on Ralph Avenue in Brooklyn, he is literally a centrist—at the center of a triptych between Harriet Tubman and an icon of non-violent civil disobedience, Nelson Mandela (plate 3.71).

Jameel Parker's mural *Gang Peace* of 1992, on Blue Hill Avenue in a black neighborhood of Boston, is more unusual, in that it puts elder statesman Douglass alongside Malcolm X and Elijah Muhammad (plate 3.68).

In the other adaptations of Bourdon's photograph, Cal Massey's 1971 portrait drawing makes Douglass appear benevolent (plate 3.67). Douglass makes a gesture of inclusion in Vinnie Bagwell's statue at Hofstra University of 2008, which deviates from the photograph to add this open hand (as well as a sheet of paper in Douglass's other hand) (plate 3.70).

But other artists opt for both versions of Douglass, roughly pre- and post–Civil War. In 1969 and 1970, a two-part *Golden Legacy* comic book used the frontispiece to *My Bondage and My Freedom* (plate 9) for *Frederick Douglass: Part One*; and Bourdon's cabinet card for *Part Two* (plate 3.66).

Plate 57

Plate 3.66; *Golden Legacy Illustrated History Magazine*, *Frederick Douglass, Part Two*, 1970

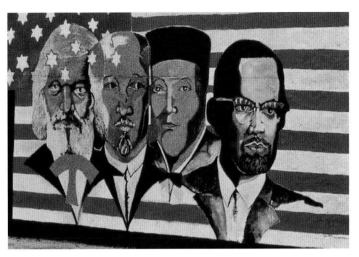

Plate 3.67: Cal Massey, *Frederick Douglass*, 1971

Plate 3.68: Jameel Parker, *Gang Peace*, 1992, Boston, MA

Plate 3.69: David Fichter, *Freedom Quilt Mural*, 1988, Atlanta, GA

Plate 3.70: Vinnie Bagwell, *Frederick Douglass Circle*, 2008, Hofstra University

Plate 3.71: Unknown artist, untitled mural, 2008, New York City

Douglass's Writings on Photography

During the Civil War years, Douglass penned four lectures on photography and "picture-making." We include three: first, "Lecture on Pictures" (1861); then "Age of Pictures" (1862) and "Pictures and Progress" (1864–65), which have never before been published and are among his greatest speeches. In all four speeches Douglass connects photography and picture making to abolitionism. "Life Pictures" (1861), which is not included in this volume, and "Lecture on Pictures" were his first attempts to develop these connections. He was only partly successful; they seem unfinished.

But he continued grappling with "the philosophy of art," by which he meant the "source, range and influence" of art, particularly its influence on individual uplift and social reform. The results were extraordinary. "Age of Pictures" describes a modern world in which individuals are at the mercy of much larger forces. But photography and picture making, Douglass argues, offer an antidote to fatalism. "Pictures and Progress" is his most sustained examination of the link between art and reform, particularly the role of photography in ending slavery and racism.

It was the Civil War that inspired Douglass to write and speak on photography. There were three reasons for this. Like many Americans, he believed that photographs and pictures greatly contributed to secession and a war over slavery. Mathew Brady's photograph of Lincoln, taken a few hours before Lincoln's Cooper Institute address in February 1860, introduced Lincoln's image to the public with full-page engravings in *Harper's Weekly* and *Frank Leslie's Illustrated* (see figures 7 & 8). Brady's portrait became ubiquitous during the presidential campaign, the source of virtually all the images of Lincoln, from campaign buttons, sheet music, and cartes-de-visite to brooches, pins, and studs made of tintypes (see figures 9 & 10). According to Brady, Lincoln himself had declared: "Brady and the Cooper Institute made me president," precipitating secession and war. In "Lecture on Pictures" and "Age of Pictures," Douglass alludes to the power of Brady's photograph: "the portrait makes our president."[1]

Then, in December 1860, a few weeks before South Carolina seceded, President James Buchanan delivered his annual message to Congress and blamed the likelihood of secession on abolitionists, who sent images throughout the South, exciting "the passions of slaves" and

inspiring them to rebel. Douglass refers to Buchanan's address and acknowledges that abolitionists widely disseminated images in their efforts to end slavery.[2]

Second, the Civil War was America's first "living-room war," owing to the millions of photographs and engravings from *Harper's Weekly* and *Frank Leslie's* that permeated all aspects of American life in the North. Like Douglass, *Harper's* recognized the conflict as an abolitionist war from the outset.[3]

Third, the war coincided with the growing popularity of the lyceum lecture circuit, which paid more than other venues and expected lecturers to deliver formal, intellectual addresses that had been written out. This format for lyceums encouraged Douglass to explore the relationship between reform, photography, and "picture-making," a term he used as a symbol and metaphor for representation and truth that revealed the inner soul and the unseen spiritual world. "Art is a special revelation of the higher powers of the human soul," he said in "Pictures and Progress," inspiring people to realize the divine ideals of freedom and equality.

In these three speeches Douglass repeats phrases, images, and even quotes. It was a habit that he employed in most of his speeches. This was partly because he delivered so many; but his repetition also stemmed from his desire to develop ideas and concepts from earlier speeches.

In transcribing the speeches we have standardized punctuation involving parentheses, quotation marks, colons, commas, and dashes. The originals, handwritten, are in the Frederick Douglass Papers at the Library of Congress.

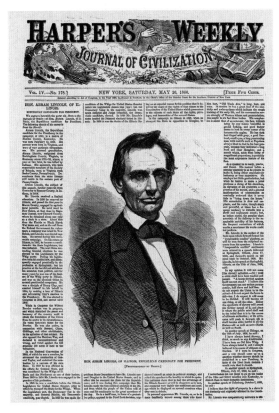

Figure 7: "Hon. Abram Lincoln of Illinois, Republican Candidate for President [Photographed by Brady]" (cover), *Harper's Weekly*, May 26, 1860

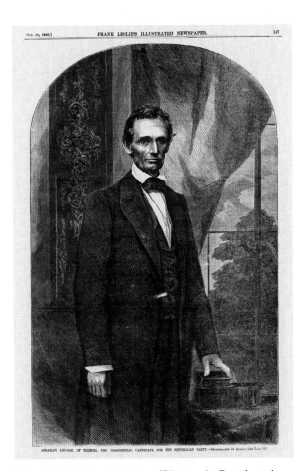

Figure 8: "Abraham Lincoln, of Illinois, the Presidential Candidate for the Republican Party—Photographed by Brady," *Frank Leslie's Illustrated Newspaper*, October 20, 1860

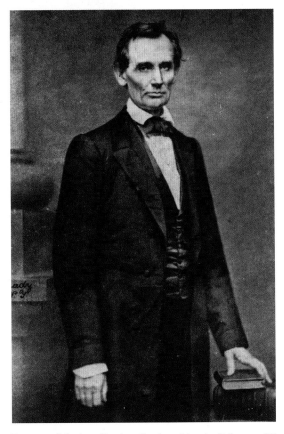

Figure 9: Mathew Brady, *Abraham Lincoln*, February 27, 1860. Carte-de-visite. Library of Congress

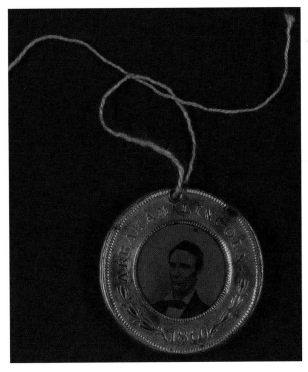

Figure 10: Unkown artist, presidential campaign button [Abraham Lincoln], 1860. Library of Congress

"Lecture on Pictures"

Douglass delivered "Lecture on Pictures" in Boston's Tremont Temple on December 3, 1861, one year after being attacked on the same stage during the anniversary meeting of John Brown's execution (see plate 2.12). His speech was part of the Fraternity Course lectures, created to commemorate the life and teachings of Theodore Parker, the Unitarian minister and militant abolitionist who had died in May 1860. Although Douglass titled his speech "Lecture on Pictures," it was advertised in the press as "Pictures and Progress."

The Temple was "filled to overflowing," and most papers described the lecture as a great success. One reviewer called it "elegant" and Douglass's logic "irresistible." Another favorably compared it to the Fraternity lectures already given by Ralph Waldo Emerson and Henry Ward Beecher, and called Douglass "a genius": "no one has crystalized" the theory and practice of picture making "more clearly than Mr. Douglass; and this seemed to be the feeling of the highly educated and thinking audience."

One negative review came from William Robinson, a conservative Republican who wrote under the pen name of "Warrenton" for The Springfield Republican*: Robinson said the speech "came near being a total failure," and then mocked Douglass's stature as a preeminent writer and orator: "a nigger ain't much better than a white man after all!"*[4]

In this first sustained lecture on photography, Douglass connects picture making to faith in progress, especially the progress of the war.

<p style="text-align:center">～</p>

The title of my lecture has the excellent merit of indefiniteness. It confines me nowhere and leaves me free to present anything from which may be derived instruction or amusement. With this latitude of range, allow me to say that I am profoundly grateful for the honor of being called to lecture in this most popular course. I take it as a compliment to my enslaved race that while summoning men before you from the highest seats of learning, philosophy, and statesmanship, you have also summoned one from the slave plantation. On this, the committee of management have, in one act, labeled their course both philanthropic and cosmopolitan.[5]

I confess that lecture reading is not my fort, and that consenting to stand here at all comes more from confidence in your indulgence, than from any confidence in my own ability.[6]

Our age gets very little credit either for poetry or for song. It is generally condemned to wear the cold metallic stamp of a passion-

less utilitarianism. It certainly is remarkable for many achievements, small and great, which accord with this popular description—and yet, for nothing is it more remarkable than for the multitude, variety, perfection and cheapness of its pictures. The praises of Arkwright, Watt, Franklin, Fulton and Morse are upon all lips.[7] But the great father of our modern pictures is seldom mentioned, though as worthy as the foremost. If by means of the all-pervading electric fluid Morse has coupled his name with the glory of bringing the ends of the earth together, and of converting the world into a whispering gallery, Daguerre, by the simple but all-abounding sunlight, has converted the planet into a picture gallery.[8] As munificent in the exalted arena of art, as in the radiation of light and heart, the God of day not only decks the earth with rich fruits and beautiful flowers, but studs the world with pictures. Daguerreotypes, ambrotypes, photographs and electrotypes, good and bad, now adorn or disfigure all our dwellings.[9] It has long been a standing complaint with social reformers and political economists that mankind have everywhere been cheated of the natural fruit of their own inventive genius: &c.

I shall not stop here to argue whether this broad and bitter complaint is well or ill-founded. It is enough for the present that it does not stand against the wonderful discovery and invention by Daguerre. Men of all conditions may see themselves as others see them. What was once the exclusive luxury of the rich and great is now within reach of all. The humblest servant girl, whose income is but a few shillings per week, may now possess a more perfect likeness of herself than noble ladies and even royalty, with all its precious treasures, could purchase fifty years ago.[10] Yet Daguerre might have been forgotten, but for incorporating his name with his wonderful discovery. That so little is said of the author of this pictorial abundance is explained only on the principle that men are prone to value things more for their rarity than for their excellence. We drink freely of the water at the marble fountain, without thinking for the moment of the toil and skill employed in constructing the fountain itself.[11]

That Daguerre has supplied a great want is seen less in eulogies bestowed upon his name, than in the rapidity and universality with which his invention has been adopted. The smallest town now has its daguerreian gallery, and even at the crossroads where stands but a solitary blacksmith's shop and what was once a country tavern but now [is] in the last stages of dilapidation, you will find the inevitable daguerreian gallery, shaped like a baggage car, with a hothouse window at the top, adorned with red curtains, resting on Gutta Perchian springs and wooden wheels painted yellow. The farmer boy gets an iron shoe for

his horse and metallic picture for himself at the same time, and at the same price.

The old commercial maxim that demand regulates supply is reversed here.[12] Supply regulates demand. The facilities for travel has sent the world abroad, and the ease and cheapness with which we get our pictures has brought us all within range of the daguerreian apparatus.

I think it may be fairly doubted if this pictorial plenty has done much for modest distrust of our good looks. No one hesitates thus to commit himself to the judgment of posterity. A man who nowadays publishes a book, or peddles a patent medicine and does not publish his face to the world with it may almost claim and get credit for singular modesty. Handsome or homely, manly or mean, if an author's face can possibly be other than fine looking, the picture must be in the book, or the book be considered incomplete.

It may also be proper here to notice that pictures are decidedly conservative. It would be difficult to determine as between a man's picture and a man's religious creed, which of the twain is most conservative in its influence upon him. The one is the measure of outer man and the other of the inner, and both are positive law on the points to which they apply. Once fairly in the book and the man may be considered a fixed fact, public property. In nine cases out of ten, he so regards himself. The picture may be like him or not like him, or like anybody else than him. But this trifling circumstance, however much he may regret it, cannot be allowed to make any manner of difference in his conduct.

On no account whatever, either indifference to an improved taste or a change of fashion, can he be allowed any liberties with the style of his coat, the shape of his collar, or the cut of his hair. His position is defined, and his whole *persona* must now conform to, and never contradict, the immortal likeness or unlikeness in the Book.

Byron says a man always looks *dead* when his Biography is written.[13] The same is even more true when his picture is taken. There is even something statue-like about such men. See them when or where you will, and unless they are totally off guard, they are either serenely sitting or rigidly standing in what they fancy their best attitude for a picture.

The stern serenity of our photographic processes, in tracing the features and forms of men, might deter some of us from the operation, but for that most kind natural Providence, by which most men easily see in themselves points of beauty and excellence, which wholly elude the observation of all others.

There is scarcely any weakness which is more common, or of which men are more ashamed, than that of conceitedness and vanity of personal appearance. And yet, it may be doubted if any man ever sat for a

picture or stood for a bust, without being conscious of more or less of that girlish weakness.

The stringent and celebrated order given to his artist by Oliver Cromwell, may seem to make him an exception to this criticism. "Paint me as I am" sounds well, and accords well with the popular idea of the manly character of the stern old Puritan. It is taken to mean: I want no favor, no flattery, no fraud—"paint me as I am," nothing extenuate, nor aught set down in malice. But certain facts common to humanity might suggest another meaning and another motive, quite as human and quite as likely, if not quite so creditable! Men do not often lose their self-love in their all-abounding love of truth. To himself and to his friends and admirers, Cromwell's person, not less than his genius, was admirable. "Paint me as I am" may therefore mean, "I am handsome enough, don't try to improve upon the original." It is somewhere said of him that he esteemed the huge wart on his face as less a deformity than a beauty.[14]

As to the moral and social influence of pictures, it would hardly be extravagant to say of it, what Moore has said of ballads, give me the making of a nation's ballads and I care not who has the making of its laws.[15] The picture and the ballad are alike, if not equally social forces—the one reaching and swaying the heart by the eye, and the other by the ear.

As an instrument of wit, of biting satire, the picture is admitted to be unrivalled. It strikes human nature on the weakest of all its many weak sides, and upon the instant, makes the hit palpable to all beholders. The dullest vision can see and comprehend at a glance the full effect of a point which may have taken the wit and skill of the artist many hours and days.

Nowhere is this power better understood, or where it is practiced with better results, than in England. *Punch* is a power more potent than Parliament.[16] He commands both Lords and Commons, and does not spare even Windsor Castle. Always on the side of liberal ideas and progress, he is no more welcome in Austria than the *Liberator* in South Carolina.[17]

It is commonly said over there, that a man not great enough to be caricatured in *Punch*, is not great enough to carry a measure in Parliament. The inventive fertility of its conductors is the greatest marvel. It never repeats and is never exhausted. It not only has the art of laughing contagiously, but, what is more important, it knows how to laugh in the right place and in the right time. John Bull reports all its wise sayings at the breakfast table—and only laughs when *Punch* gives the word—though that shall be at his own expense.[18]

In our country, though we have no *Punch* of this wry sort, though we have plenty of the other, the picture plays an important part in

our politics and often explodes political shams more effectively than any other agency. All have remarked that men can better bear to be denounced as knaves than to be laughed at as fools.

In the making of our presidents, the political gathering begins the operation, and the picture gallery ends it.[19] The winner, in order to out-vote, must out-laugh his adversary.

Success is the admitted standard of American greatness, and it is marvelous to observe how readily it also becomes the standard of manly beauty. There is marked improvement in the features of the successful man, and a corresponding deterioration in those of the unsuccessful. Our military heroes look better even in pictures after winning an important battle than after losing one. The pictures do not change, but we look at them through the favorable or unfavorable prevailing public opinion. Honest old Thomas Whitson, a man possessing far more wit than beauty, was not far wrong when he said that even he should be handsome upon a favorable change in public opinion.[20]

It is perhaps on the same principle of prospective beauty that ministers sometimes console the race to which I belong, assuring them that though black and ugly on the Earth, they will all be white and beautiful in heaven.

Next to bad manuscripts, pictures can be made the greatest bores. Authors, editors, and printers suffer by the former, while almost everybody has suffered by the latter. They are pushed at you in every house you enter, and what is worse, you are required to give an opinion of them.

Now, it is easy enough for one who thoroughly understands the art, to criticize pictures generally, but who can comment satisfactorily upon the various performances of our youngest daughter when that amiable young lady is right at your elbow? To say anything is positively dangerous—and to say nothing is more so. It is no kindness to a guest to place him in such circumstances. Pictures, like songs, should be left to make their own way in the world. All they can reasonably ask of us is that we place them on the wall, in the best light, and for the rest allow them to speak for themselves. Music is excellent, but too much of it will disturb the nerves like the filing of a saw.

Of all things the mental atmosphere surrounding us is most easily moved in this or that direction. The first causes of its oscillations are often too occult for the most subtle. The influence of pictures upon this all-surrounding and all-powerful thought element may some day furnish a theme for those better able than I to do it justice. It is evident that the great cheapness and universality of pictures must exert a powerful, though silent, influence upon the ideas and sentiment of present and future generations. The family is the fountainhead of all mental and

moral influence. And the presence there, of the miniature forms and faces of our loved ones, whether separated from us by time and space, or by the silent continents of eternity, must act powerfully upon the minds of all. They bring to mind all that is amiable and good in the departed, and strengthen the same qualities [in the living].[21]

But it is not of such pictures that I am here to speak exclusively. I am at liberty to touch [on] the element out of which our pictures spring. There are certain groups and combinations of facts and features, some pleasant, some sad, which possess in large measure the quality of pictures and affect us accordingly. They are thought pictures—the outstanding headlands of the meandering shores of life, and are points to steer by on the broad sea of thought and experience. They body forth in living forms and colors the ever varying lights and shadows of the soul.

It is worthy of remark to begin with that of all the animal world man alone has a passion for pictures. Neither dogs nor elephants ranging nearest to man in point of intelligence show any sensation of pleasure in the presence of the highest work of art. The dog fails to recognize his own features in a glass. The power to make and to appreciate pictures belongs to man exclusively.

Some of our so-called learned naturalists, archeologists, and ethnologists have professed some difficulty in settling upon a fixed, certain, and definite line separating the lowest man from the highest animal.[22] To all such I commend the fact that man is everywhere a picture-making animal. The rudest of men have some idea of tracing definite lines and of imitating the forms and colors of objects about them. The verist savage has found means of doing this upon his own cuticle. Savages have been found with the form of a European coat tattooed on their skins. The rule I believe is without an exception and may be safely commended to the Notts and Gliddens, who are just now puzzled with the question as to whether the African slave should be treated as a man or an ox.[23]

Rightly viewed, the whole soul of man is a sort of picture gallery, a grand panorama, in which all the great facts of the universe, in tracing things of time and things of eternity, are painted. The love of pictures stands first among our passional inclinations, and is among the last to forsake us in our pilgrimage here. In youth it gilds all our Earthly future with bright and glorious visions; and in age, it paves the streets of our paradise with gold, and sets all its opening gates with pearls.[24]

But childhood especially delights in symbols. Our natural and primary instructors, both as nations and individuals, are symbols and songs. For this child state, let the broad world be filled with the music of song—and pictures. The world has no sight more pleasant and hopeful,

either for the child, or for the race, than one of these little ones in rapt contemplation of a pure work of art. The process is one of self-revelation, a comparison of the pure forms of beauty and excellence without, with those which are within.[25]

Men talk much of a new birth. The fact is fundamental. But the mistake is in treating it as an incident which can only happen to a man once in a lifetime; whereas the whole journey of life is a succession of them. A new life springs up in the soul with the discovery of every new agency by which the soul is raised to a higher level of wisdom: goodness and joy.

The poor savage, accustomed only to the stunning war whoop of his tribe and to the wild and startling sounds in nature of winds, water-falls, and thunder, meets with a change of heart the first time he hears the divine harmonies of scientific music: and the child experiences one with every new object by means of which it is brought into a nearer and fuller acquaintance with its own subjective nature. With every step he attains a larger, fuller and freer range of vision. All the pictures in the book are known before a single lesson is learned. They speak to him in his own tongue.

On the hillside, in the valley, under the grateful shades of sol-itary oaks and elms, the boy of ten, all forgetful of time or place, calls to books or to boyish sports, looks up with silence and awe to the blue overhanging firmament, and views with dreamy wonder its ever-drifting drapery; tracing in the clouds and in their ever-changing forms and colors the outlines of towns and cities, great ships and hos-tile armies of men, of horses, solemn temples, and the Great Spirit of all: Break in if you please upon the prayers of monks or nuns, but I pray you, do not disturb the divine meditations of that little child. He is unfolding to himself the divinest of all human faculties, for such is the picture-making faculty of man.

It is a chief element of all that is religious and poetic about us. To the eye and spirit it is what music is to the ear and heart. We may enjoy all the delights of the concord of sweet sounds long before we under-stand the subtle principles and processes of their harmonious combi-nation. Their mission, like that of music, is to refine the taste, ennoble the spirit, and to lead on, through all the depressing vicissitudes of life, the longing soul by glorious prophecies of ever unfolding beauty and excellence.

I have said that man is a picture-making and a picture-appreciating animal and have pointed out that fact as an important line of distinc-tion between man and all other animals. The point will bear additional emphasis.

It lies directly in the path of what I conceive to be a key to the great mystery of life and progress. The process by which man is able to invent his own subjective consciousness into the objective form, considered in all its range, is in truth the highest attribute of man's nature. All that is really peculiar to humanity, in contradistinction from all other animals, proceeds from this one faculty or power. It is that which has sometimes caused us, in our moments of enthusiasm, to lose sight of man as a creature, finite and limited, and to invest him with the dignity of a creator.[26]

It is said that the best gifts are most abused, this among the rest. Conscience itself is misdirected: shocked at delightful sounds, beautiful colors and graceful movements—but sleeps at ease amid the ten thousand agonies of war and slavery.

This picture-making faculty is flung out into the world like all others—subject to a wild scramble between contending interests and forces. It is a mighty power, and the side to which it goes has achieved a wondrous conquest. For the habit we adopt, the master we obey in making our subjective nature objective, giving it form, colour, space, action and utterance, is the all important thing to ourselves and our surroundings. It will either lift us to the highest heavens or sink us to the bottomless depths, for good and evil know [no] limits. A man once fairly started in the wrong direction runs with ever increasing speed like a frightened child in the wilderness, from the distant echoes of his own footfalls.

All wishes, all aspirations, all hopes, all fears, all doubts, all determinations grow stronger and stronger precisely in proportion as they get themselves expressed in words, forms, colours, and action.

The work of the revivalist is more than half done when he has got a man to stand up in the congregation as an indication of his need of grace. The strength of an iron halter was needed for this first act, but now like Rarey's horses, he may be led by a straw.[27]

Of all our religious denominations, the Roman Catholic understands this picture passion best. It wisely addresses the religious consciousness in its own language—the child language of the soul. Pictures, images, and other symbolical representations speak to the imagination. The mighty fortress of the human heart silently withstands the assaults by the rifled cannons of reason, but readily falls before the magic power of mystery. Remove from the church of Rome her cunning illusions— her sacred altars, her pictures, her images, her tapers, her mitres, her solemn pomp, and her gorgeous ceremonies, the mere shards of things, and her magical and entrancing power over men would disappear. Take the cross from before the name of the archbishop—and he is James or John like the rest of us.

Protestantism relies more upon words and actions than upon paints or chisels to express its sentiments and ideas—and yet the most successful of her teachers and preachers are but painters: and succeed because they are such.

Dry logic and elaborate arguments, though perfect in all their appointments, and though knitted together as a coat of mail, lay down the law to empty benches.

But he who speaks to the feelings, who enters the soul's deepest meditations, holding the mirror up to nature, revealing the profoundest mysteries of the human heart to the eye and ear by action and by utterance, will never want for an audience.

Only a few men wish to think, while all wish to feel, for feeling is divine and infinite.

Feeling and mystery are not, however, the only conditions of successful painting, speaking, or writing. No man can have permanent hold upon his fellows by means of falsehood. He must conform to the Cromwellian rule. Better remain dumb than utter a falsehood—better repeat the old truth forever than to spin out a pure fiction. With the clear perception of things as they are, must stand the faithful tendering of things as they seem. The dead fact is nothing without the living impression. Niagara is not fitly described when it is said to be a river of this or that volume falling over a ledge of rocks two hundred feet, nor is thunder when simply called a jarring noise. This is truth, but truth disrobed of its sublimity and glory. A kind of frozen truth, destitute of motion itself—it is incapable of producing emotion in others.

But on the other hand, to give us the glory as some do without the glorified object is a still greater transgression and makes those who do it as those who beat the air.

We are all deeply affected by Hogarth's pictures.[28] The secret is to [be] found only in the fact that he painted life both as it is, and as it seems. The power of his pictures is the power of truth.

His characters, like those of Shakespeare, are clothed with flesh and blood, and are warm with the common sympathies of the race. They speak to us in a known tongue, and of men and women here on the earth, where men and women live, and not among the stars, where men and women do not live. They are not angels nor demons—but much of both in their tendencies and possibilities. They are our brothers and sisters: thinking, living, acting very much as we easily fancy we might have done in their places.

Man everywhere worships man, and in the last analysis worships himself. He finds in himself the qualities he calls divine and reverently bows before them. This is the best he can do. It is the measure of his

being. The God of the merciful and just man is merciful and just despite the church creed: and the God of the selfish and cruel man is a king in wood, stone, iron, or in imagination after his own image, no matter what he has sworn to believe in the church creed.

Our angel has a human face and the wings of a bird. Both are of the Earth—Earthy—but this too, is the best we can do in angel picturing, for man can never rise above humanity—even in his religion.

The church that we build unto the Lord, we build unto ourselves—and the style which pleases us best pleases best our God. At one end we have the shed-like building of the Quaker, and at the other the splendid architecture of the Roman Catholic.

The sword we present to our military hero and the banner we present to our regiment we present to ourselves, and the joy of the receiver is the joy of the giver.

Man warms, glows, and expands only where [he] sees himself asserted broadly and truly. This is the crucible in which we try all laws, religions, morals, and governments.

But man is not a block of marble—measured and squared by rule and compass—so that his inches can be set down on a slate.

All that would permanently minister to him must, like himself, contain the element of progress.

Desire rises with gratification. What pleased in the morning fails to please in the evening. The manna must be fresh or it is good for nothing.[29]

The whining school boy with satchel and shining morning face is entranced by sights and sounds in nature which lose all their enchanting power over him when he touches that ambitious point of life, where Shakespeare paints him bearded like a pard—jealous in honor, sudden and quick in quarrel, seeking the bubble reputation even in cannon's mouth. [30]

Failing to meet this requirement, [the] teacher, the sect, the party, the nation, the government must fail.

The United States government is yet within a century of its birth. It is not old, as we span the lives of nations. It is still in the inner circle of boyhood. It is a big boy, however, and has grown immensely and rapidly. It has risen in three-quarters of a century from three millions to thirty.[31] It is great in population, great in wealth, great in knowledge, great in commerce, great in nearly all the fundamental elements of national greatness.

But yesterday the Republic of America sat as a queen among the nations of the earth, knowing no sorrow—smiling in safety while crowns and coronets were rent, and thrones and dynasties were toppling in Europe.[32]

Today, every pillar in our great national temple is shaken. We have fallen asunder in the centre. War and blood have burst forth with savage ferocity among brothers. A million of men are in arms—and the end is not yet.

To what cause may we trace this dreadful calamity? Not the secondary cause, but the grand original cause.

Some say to sectionalism. But there is nothing in the geographical divisions of the country which should cause trouble.

Lands intersected by a narrow frith abhor each other
And mountains interposed make enemies of nations
Which else like kindred drops had mingled into one.[33]

But even this cause does not hold here, for all our rivers and mountains point to unity and oneness. There is no reason why the cornfields of the North should quarrel with the cotton fields of the South.

Some say it is the slaveholders who have brought this great evil upon us. I do not assent even to this.

Others say that the real cause of all our troubles may be traced to the busy tongues and pens of the abolitionists.

The cause is deeper down than sections, slaveholders, or abolitionists. These are but the hands of the clock. The moving machinery is behind the face. The machinery moves not because of the hands, but the hands because of the machinery. To make the hands go right you must make the machinery go right. The trouble is fundamental. Two cannot walk together except they be agreed. No man can serve two masters. A house divided against itself cannot stand.[34] It is something to ride two horses going the same way, but impossible when going opposite ways. *The folly is just here:*

We have attempted to maintain a union in defiance of the moral chemistry of the universe. To join together what God has put asunder—.[35] We have thought to keep one end of the chain on the limbs of the bondman without having the other on our own necks.

Anchoring the ship of state to the dull dead mass of slavery, we have set sail for a prosperous voyage—and we have got our sails and rigging blown away, and our cable broken as the result of our experiment.

Here is the trouble, plain before all Israel & the sun & c.[36] Slavery *and* rebellion go hand in hand.

But since the evil has not been prevented, how shall it be remedied?

My opinion may not be worth much, but such as it is, *it* is freely given.

Thus far, it must be confessed that we have struck wide of the mark,

and very feebly withal. The temper of our stead is better than the temper of our minds.

While I do not charge, as some have, that the government is conducting the war on peace principles, it is plain that they are not conducting it on war principles.

We are fighting the Rebels with only one hand when we ought to be fighting them with both. We are recruiting our troops at the North when we ought to be recruiting them at the South. We are striking with our white hand, while our black one is chained behind us. We are catching slaves instead of arming them.[37] We are repelling our natural friends to win the friendship of our unnatural enemies. We are endeavoring to heal over the rotten cancer instead of cutting out its death-dealing roots and fibres. We seem a little more concerned for the safety of slavery than for the safety of the Republic.

I say here and now that if this nation shall be destroyed—the government shall be broken to pieces, the union of these states dissolved—it will neither be for want of men nor money nor bravery, but because the Government at Washington has shouldered all the burdens of slavery in the prosecution of the war—and given to its enemies all its benefits.

Witness: The treatment of Frémont's Proclamation.

Witness: The removal of General Butler.

Witness: The removal of Commodore Stringham.

Witness: The recent proclamation of General Sherman.[38]

Remarks on the president's letter to Frémont.[39]

I have been often asked since the war began why I am not at the South battling for freedom. My answer is with the Government. It wants men, but it does not yet rank me or my race with men. Let the fact go down to posterity in vindication of my race, if not in condemnation of the Government, that reasons of state, such as did not control the policy of General Jackson at New Orleans, nor the fathers of the Republic, have thus far compelled the Republican Party now in power to deny the black man the honor of bearing arms against slaveholding rebels for the preservation of the Government.[40]

One situation only has been offered me, and that is the office of a body servant to a colonel: I would not despise that if I could by that means be of any service to the cause of impartial freedom. In that temple there is no seat too low for me.

But one thing I have a right to ask when I am required to march to the battlefield, and that is that I shall have a country or the hope of a country under me, a government that recognizes my manhood around me, and a flag of freedom waving over me!

We have recently held a solemn fast and have offered up innumer-

able prayers for the deliverance of the nation from the manifold perils and calamities that surround it.[41] I say nothing against these prayers, but I know well enough that both the work of making and the work of answering them must be performed by the same hands.

If the loyal North succeed in suppressing this foul and scandalous slaveholding rebellion, the fact will be due to the amount of wisdom and force they bring against the rebels in arms. Thus far we have shown no lack of force. A call for men is answered by a half a million. A call for money is answered by hundreds of millions, and a call for prayers brings a whole nation to its altars; but still the rebellion rages. Jeff Davis is defiant. United States ships run the gauntlet of rebel guns within a few miles of Washington, and the rebels are quietly talking of going into winter quarters.

What is the remedy? I answer, have done, forever, with the wild and guilty fantasy that man can hold property in man.

Have done with the idea that [the] old union is either desirable or possible.

Accept the incontestable truth of the irrepressible conflict, which is now emphasized by all the horrors of rebellion.

Banish from your minds the last lingering shadow of a hope that your government can ever rest secure on a mixed basis of freedom and slavery. Lay the ax at the root of the tree, and hurl the accursed slave system into the pit from whence it came.[42]

The pretense that the Constitution stands in the way of [our] abolition plan for putting [down] the rebels is but a miserable pretense. Slavery has never been large enough to get itself named in the Constitution; but if every line and syllable of the Constitution contained an explicit prohibition of the abolition of slavery, the right of the nation to abolish slavery would still exist in full force, since the right to preserve itself from dissolution is before all laws—and is the foundation and authority of all laws and government.

But will our government at last arrive at this conclusion? That depends much upon the virtue of the North, and much more upon the villainy of the South: and I confess to a little more hope from the latter than from the former.

We are fighting not only a wicked and determined foe, but a desperate and maddened one. We are fighting our former political masters, who are enraged at the thought of our resistance, men who have ruled us for sixty years. If hard pressed, as they will be, they will break through all the restraints of civilized warfare, and compel the government to strike the blow for freed[om].

Events are greater than either party to the conflict, and rule both.

The first flash of rebel powder against the starving garrison at Sumter instantly changed the whole policy of the nation. Until then, the North in all its parties and parlours was found dreaming of compromise: a peaceable adjustment, state *"sovereignty,"* rights of *"secession," "no coercion,"* repeal personal liberty laws, call national convention, "change the Constitution"—flitted in the fevered brain, and fell from the quivering lip of the Northern people, and from our statesmen—cowering before the apprehended calamities of disunion, and the threats of civil war. These dreams have vanished before the onward progress and all-bending power of events.

Tonight, with saints and angels, with the glorious army of martyrs, of whom the world was not worthy, the brave spirit of John Brown serenely looks from his eternal rest, beholding his guilty murderers in torments of their own kindling—and the faith for which he nobly died, rapidly becoming the saving faith of the nation. Two years ago young John Brown was hunted in Ohio like a felon. Today he is a captain under the broad seal of the U.S. Government.[43]

Humanity sweeps onward. Where today the martyr stands—
On tomorrow crouches Judas with the silver in his hands.
Far in front the cross stands ready, and the crackling faggots burn
While the hooting mob of yesterday with silent awe return
To glean up the scattered ashes in history's golden urn.[44]

Only one brief year ago and this great city, the Athens of America, was convulsed by the rage of a howling mob, madly trampling upon the great law of liberty and progress, incited thereto by a fanatical devotion to the law of slavery.[45] It blocked your streets. It shut up your halls. It defied your Government, and madly clamored for the blood of one whose name adds lustre to the very name of Boston.[46]

Where is that mob tonight?

Some of them are doubtless in the regiment from Mass., which recently marched to Virginia singing hymns to the memory of John Brown.[47]

Where are the men who incited that mob? Urging upon the government to finish the very work which John Brown nobly began.

Two short years ago, as the old man, stretched on his pallet of straw, covered with blood, marred by sabre gashes in the hands of his enemies, not expecting to recover from his wounds—among those who came to torment him in this dark hour of distress, and to berate him for the awful sins of treason and rebellion, was one Senator Mason of Virginia. Where tonight is this haughty and supercilious senator? In your

own Fort Warren! What is his crime? Treason and rebellion.[48] I need not ring the changes on this point.

Nothing stands today where it stood yesterday. The choice which life presents is ever more between growth and decay, perfection and deterioration. There is no standing still, nor can be. Advance or recede, occupy or give place, are the stern and inoperative alternatives, [the] self-existing and self-enforcing law of life, from the cradle to the grave.[49]

He who despairs of progress despises the hope of the world, and shuts himself out from the chief significance of assistance—and is dead while he lives.

Great nature herself, whether viewed in connection or apart from man, is in its manifold operations a picture of progress and a constant rebuke to [the] moral stagnation of conservatism.

Conceive of life without progress and sun, moon and stars instantly halt in their courses. The restless ocean no longer heaves on high his proud dashing billows. The lightning hides itself in somber sky. The tempest dies on the mountain—and silent night, dark, shapeless, sightless, voiceless, settles down upon the mind, in a ghastly—as frightful as gloom—as the darkness of Byron's painting.[50]

But on the other hand, how glorious is nature in action. We get but an outside view, and while still amazed and curious, on goes the great mystery of mysteries—creating, unfolding, expanding, renewing, changing perpetually, putting on new forms, new colours, using new sounds, filling the world with new perfumes, and spreading out to the eye and heart unending scenes of freshness and beauty.

It gives us a thousand flowers for a single fruit and a thousand eggs for a single fish or bird, and yet earth, sea, and air overflow with all-pervading and never resting life.

In addition to the progressive lessons taught in the physical world, man has one written down in his own constitution, superior to all others.

Other animals only change the conditions of their existence in obedience to great natural causes over which they have no control. But the sublime mission of man is the discovery of truth—and all conquering resistance to all adverse circumstances, whether moral or physical.

By the cultivation of his intellect, by the development of his natural resources, by understanding the science of his own relations to the world, man has the marvelous power of enlarging the boundaries of his own existence.

Material progress may for a time be separated from moral progress. But the two cannot be permanently divorced.

It is natural, when the demand for bread and clothing and shelter has been complied with, man should begin to think and reason. When

this is done, let all the subtle enemies of the welfare of man, in the protean shapes of oppression, superstition, priestcraft, and slavery—plainly read their doom.

Steam and lightning and all manner of labor-saving machinery have come up to the help of moral truth as well as physical welfare.

The increased facilities of locomotion, the growing inter-communication of distant nations, the rapid transmission of intelligence over the globe—the worldwide ramifications of commerce—bringing together the knowledge, the skill, and the mental power of the world, cannot but dispel prejudice, dissolve the granite barriers of arbitrary power, bring the world into peace and unity, and at last crown the world with just[ice], liberty, and brotherly kindness.

In every lightning coire may be recognized a reformer.[51] In every bar of railroad iron a missionary. In every locomotive a herald of progress—the startling scream of the engine—and the small ticking sound of the telegraph are alike prophecies of hope to the philanthropist, and warnings to the systems of slavery, superstition, and oppression to get themselves away to the murky shades of barbarism.

"Age of Pictures"

Douglass probably wrote and delivered "Age of Pictures" in early 1862, although we have not found any reviews of the speech. He had probably lectured on "Life Pictures" (not included in this volume), which shares similarities, on November 15, 1861. Apparently it received only tepid praise: though "well written" and "a good lecturer," "Mr. Douglass's forte is extemporaneous speaking from the inspiration of the moment. Here he is peerless." "Age of Pictures" is more succinct and eloquent, suggesting that Douglass revised "Life Pictures" after delivering it.[52]

In early 1862 Douglass was distressed over the progress of the war, which perhaps reflects his pathos in this remarkable speech. He seems to recognize the costs of modern warfare, for he betrays a rare note of fatalism. Individuals are at the mercy of an all-powerful universe, and destiny is shaped in large part by chance. But the picture-making process, unique to humanity, offers an antidote to fatalism: "stern and all-conquering resistance to adverse circumstances . . . is the sublime and glorious mission of man, fortifying one's faith in 'the Eternal Law of progress.'"

❮~❯

This may be termed an age of pictures. The sun in his course having turned artist has flooded the world with pictures.[53] Daguerreotypes, ambrotypes, engravings, and drawings, good, bad, and indifferent, adorn or disfigure, and as frequently the latter as the former, all our dwellings.

No man thinks of publishing a book without sending his face to the world with it.[54] He may be handsome or homely, manly or otherwise, it makes no difference; the face, the inevitable face, must be there to meet the smiles or frowns of his readers. Once in the book, whether the picture is like him or not, he must forever after strive to look like the picture.

The photographic faithfulness of our pictures, in delineating the human face and form, answers well the stern requirement of Cromwell himself. "Paint me as I am," said the staunch old Puritan.[55] The order reveals perhaps quite as visibly his self-love as his love of truth. The huge wart on his face was probably, in the eyes of the great founder of the English Commonwealth, a beauty rather than a deformity. But in any case we are bound to respect the requirement.

No lack of personal comeliness deters any one now from sitting for his likeness, for there are none so unprepossessing as not to have an

admirer. It is sometimes a difficult task for a stranger to comment upon the family pictures everywhere presented to his admiring eyes. The portrait makes our president.[56] The political gathering begins the work and the picture gallery ends it.

A rather awkward looking friend of mine, having far more wit than beauty, and far more philosophy than most men, used to console himself with the idea that he too, would be beautiful upon a favorable change in public sentiment. Nearly all religious teachers admit that negroes will be white when they get to heaven. The president of the United States has improved much since his Inauguration.[57]

A very pleasing feature of our pictorial relations is the very easy terms upon which all may enjoy them. The servant girl can now see a likeness of herself such as noble ladies, and even royalty itself, could not purchase an hundred years ago. Formerly the luxury of a likeness was the exclusive privilege of the rich and great; but now, like education and a thousand other blessings brought to us by the advancing march of light and civilization, such pictures are brought within the easy reach of the humblest members of society.

It is not, however, of such pictures and embellishments that I am here to speak. The artist and art student can best treat of these. My course lies in another direction.

There are certain groups and combinations of facts and features everywhere met with in the journey of life, some pleasant and some sad, which possess in large measure the quality of pictures. They illustrate and body forth phases of real life common to all, and translate into living forms and colours the outgrowths of the inner life of the Soul.[58]

Some such pictures as these, if I do not miss my aim, as many other lecturers have done before me, may pass in review this evening.

Happily, however, no great skill or special talent is required to describe them. They stand boldly out from the broad canvas of human experience, and fringe the horizon of our existence like the many shapes and many coloured clouds against a summer sky. They flit by us like the dreams of childhood.

There are, then, pictures of mind as well as of matter. They have an interest for man which accords with their relative values. To describe fitly a mental translation, an operation of the mind, is more than to paint the form of a horse—and yet there are more good mind painters than good painters of horses.

The explanation is in the relative attractiveness of the two subjects. Of all the animal world, man alone has a passion for pictures. Even the dog, the most intelligent [of the brute creation], and man's constant and ever-faithful companion, fails to recognize his own features in a glass.

This picture-making and picture-appreciating power may be properly set down, if any other is wanted, as another dividing line between the human race and the brute creation. It is a power of great dignity and is closely allied to, if not identical with, the poetic and religious element of man's nature.

Pictorial representations are to the eye and to the imagination what music, the concord of sweet sounds, is to the ear and heart. They ennoble our taste and elevate our affections, and inspire the mind with prophecies of beauty and excellence, which may be hid from us by the rubbish of common life.

Earliest among our passional inclinations, it is happily among the last to forsake us. It gilds our earthly future in youth with bright and glorious prospects, and in age and infirmity paves our paradise with gold, [and] sets its opening gates with pearl.[59]

But childhood especially delights in symbols. Nothing is really more pleasant, pure and beautiful than the fact of an intelligent child sweetly and earnestly contemplating a work of art. All the engravings in the book are mastered before a single lesson is learned. Such is added to the sum of human happiness by the fact that, as with music, so with pictures: we may fully enjoy the beauty of forms and colours, though we may never master their principles, or the art of harmoniously combining them.

On the hillside, in the valley, perchance under the grateful shadow of an aged tree, the boy of ten, all forgetful of his young companions and his boyish sports, alone, and in solitude, looks up to the blue overhanging firmament, and views with rapture the ever-changing forms and colours of its drifting drapery—tracing in the clouds the resemblances of towns, cities, the forms of great beasts, and of men. The same dreamy, poetic, and religious disposition derives even an higher gratification when these objects are seen mirrored in the quiet waters of a lake or stream.

It is an attribute of man's nature thus to convert the subjective consciousness into the objective form. The exercise of this divine faculty, or element of our nature, may be made a source of great happiness or of great pain. The best gifts are liable to the greatest abuse. It may fill our future with visions of joy—or distress. Angels and demons alike proceed from assuming their forms of characteristic beauty or ugliness, their sweet and tranquil faces, or the opposite ones of malignity and horror.

The habit of making our subjective nature objective thus becomes evermore a matter of vast importance for good or for evil. Taking a gloomy religious direction, it connects life and fills the world with distressing images and tormenting fears. All subjective ideas become more

distinct, palpable and strong by the habit of rendering them objective. By its exercise it is easy to become bigoted and fanatical, or liberal and enlightened.

Of all our religious denominations, the Roman Catholics seem to understand this element of human nature best. Much of the iron mastery held over that vast confederacy of Ecclesiastical power may be fairly ascribed to its management of this peculiar element of human nature. It addresses the imagination and the religious consciousness with images, pictures, and symbolical representations, and by means of these, captivate and entrance the affections, even at the expense of the understanding. Strip Catholicism of its images, its tapers, its mitres, its crosses, its flowing robes and gorgeous ceremonies, which appeal directly to the senses, and its power over men would cease.

With Protestantism there is little dependence upon this method of dealing with souls. It deals more in words than paints or chisels. Nevertheless, its teachers and preachers are painters and succeed because they paint. He who gives a beautiful and perfect form to our unexpressed idea easily makes us his pliant disciples. Those are ever the most popular preachers whose sermons are but a succession of pictures. The cold and flinty logician, who knits his arguments like a coat of mail, lays down the law to empty benches. But he who enters the soul's deepest meditations and reveals the profoundest secrets of the human heart to the eye and ear, by action and by utterance, will never want for an audience.

But here as elsewhere, desire increases with gratification. Each new period and each new condition seeks its needed and appropriate representation. What pleases in the morning may not please in the evening. The whining school boy, with his satchel and shining morning face, is entranced by sights and sounds in nature, which loose all their dreamy and enchanting power over him when he touches that more advanced and ambitious point of life, where Shakespeare paints him bearded like a pard, jealous in honour, sudden and quick in quarrel, seeking the bubble reputation even in the cannon's mouth.

But under all conditions, one essential principle must be observed and complied with. And that is truth, the perception of things as they really are. Hogarth's pictures were nothing but for their truth.

Historical paintings, though far less highly finished, have a stronger attraction for us than those which are merely allegorical. Shakespeare's men and women, living centuries ago, are interesting to us because we find them real men and women. We see in them full and accurate representations of ourselves. They lived, thought, felt, spoke and acted nearly as we should have done in their stead. Receding from our to their times, we live among them partaking of their joys and sorrows, their

fortunes and misfortunes, their power and their impotency, their victories and their defeats. What is true of Shakespeare's characters is true of the Bible, and all records of the lives and experiences of men. We find ourselves and are glad or sorry, happy or miserable, weak or strong, as we gaze upon the portrait and contemplate these elements reflected. He who is true to nature will ever find nature true to him. Charlotte Bronte with her Jane Eyre, Harriet Beecher Stowe with her Uncle Tom, found all the portals of the human heart opened [to] them.[60] The blended voice of truth and skill will ever find it thus.

But times and seasons are important. We are much at the mercy of our moods. By certain strong subjective conditions, the objective borrows largely. The active fancy of a child, for a time, can make a horse of a broomstick and a house of an oyster shell. But "Ole Bulls" playing makes us put away our fiddles, and the singing of Jenny Lind puts an end to our song.[61] The little Homestead, large and grand in childhood, looks small and ill-shaped when we return from the great city.

Already you will have seen that the field opened is a broad one. Like most fields near populous towns, it is well trodden. Poets, scholars, historians and philosophers have all taken their morning excursion through it. And it [will] not be remarkable if I, a stranger and sojourner, should sometimes be found treading in the sharp and well defined footprints of other men.

Of all men in the world, Lyceum lecturers have most reason to complain that the ancients have stolen their best thoughts.[62]

If the lecture going public will only have such lecturers as can say things never said before, or say things better than they were ever said before, they must be content with brief lectures and a short course.

It may not be inconsistent with the title and scope of my lecture to notice a fact which may have impressed you as well as myself. Those are the most fashionable and popular lecturers, who can utter very common sense things in a very odd and striking way. Such lecturers are painters, but their genius often ranges no higher than the ability to exhibit the strange, grotesque, outlandish abnormalities of human life.

Another sort of popular lecturers are those who, having written out and committed to memory a fine compilation of words, rush on in their discourse with about as much noise as speed, carrying their hearers with them like the Lightning Express, so swiftly over the ground that the passengers either lose sight of, or totally forget, every feature of the landscape—and can only say at the end of the journey, it was very beautiful.[63]

A new title and the same lecture may be delivered once a year in the same place for a generation, with about the same popular impression; for

scarcely one in ten will catch and retain the exact forms of speech which constitute the essential excellence of the discourse.

But here again comes the old saw of glass houses.[64] And besides, we must not forget that to relish the dinner, we must avoid the kitchen.

The uses to which some men put life may well amaze as well [as] amuse the student and the observer. One man spends his times in quarrelling with all the natural sources of his own happiness and goes down to the grave a grumbler, persuading himself to the last that he is the best abused man in the world: May you never be blest with such a companion.

It is not uncommon to meet with characters that remind us of a dog looking for the head of his bed. They never seem to find their place in the world, and go about wondering what they are fitted to do, or be.

You also meet with men who are always in a hurry and yet never seem to accomplish anything. They are strangers to repose, and treat life only as a hired horse, engaged for [a] long journey, to be accomplished in a short time, riding it under whip and spur, determined to get the worth of their money or kill the animal. They fill themselves with all sorts of exciting beverages, and make of themselves seething cauldrons, soon exhausted by their own vapouring. Always in haste and always too late.[65]

Others again treat life like a boy, who stands up to his knees in snow and water, only to prove to his fellows that his new boots are waterproof.

The highest compliment paid to the pugilist is the greediness with which he receives the blows and the bruises inflicted by another human brute. As if the human face were only made to be pounded under a trip hammer.

Some men will brave the ocean twice, and travel six thousand miles to play a game of chess or cricket.

Another class will walk a thousand miles in a thousand hours, and [are] sure of a crowd, though the admission fee is demanded at the door. People believe in Barnum though he tells them that humbug is his profession.[66]

One man seems made for his whiskers, and another for his coat and hat. Life to them is to exhibit the handy work of the tailor and the barber.

If you take out the horse and the profanity of barroom conversation, the result will be silence.

Pictures of life are about as varied as they are numerous. Each, like the apple, is colored according to the place of its growth and the proportions of light and shade that have fallen upon it. Every man must of necessity have his own view of life, which is large or limited, high or low, according to his position.

It is perhaps fortunate that truth is too large to be described by one man. It belongs, like the Earth, to all the Earth's inhabitants. The possessions of one are often too distant, and too obscure, to be seen and appreciated by another. The caterpillar knows the leaf on which it feeds, but a higher intelligence must explain the tree.

A man is worked upon by what he works on. His occupation writes its history in his manners and shapes his character. The ship's motion is detected in the rolling gait of the sailor. His fearless, gallant and cheerful spirit accords well with the dash and daring required by his useful but perilous vocation. He lives in the salt sea air and the dashing spray. With him, life is an iron-ribbed ship, richly freighted, canvas all spread, defying the storm! When at home he pines for the sea; and when at sea, dreams of the joys of home. His music is the gale and his pictures the glowing stars.

To the farmer with the solid earth under his feet, life is a very different thing. He stands erect, strong and steady. A good crop, fair prices, fat cattle, choice fruit, a farm for each of his sons, and a suitable marriage for his daughters are the subjects of most interest to him. Politics and religion have a place in his mind, but the nature of his vocation is a constant barrier against fanaticism. In contact with the sober realities of nature, he resembles them in the order and regularity of their movements. With him, the union may be dissolved, but he never doubts the return of seed-time and harvest.

Life to the architect stands out against the clear blue sky as a gorgeous palace, a solemn temple, with pillars, spires, domes, towers and turrets. His is an eye for proportions. The rule, the compass, and square are the final arbiters and tests of all arguments and theories.

Phrenologists settle all questions of law, politics, mind, morals, marriage and religion by a comparison of the form and size of the head, while the devout spiritualist solves, to his own satisfaction, past, present, and future by raps on a pine table—through the living, by the dead. The medium must be present, or the spirit is paralyzed and dumb. The medium is important.

It would be hard to make a professional jester admit that anything in life is serious, solemn, and earnest. Life to him is a broad grin—an endless laugh on the surface—and yet below, in the soul, where he refuses to look, there is deep sorrow and darkness. Light and sparkling without, heavy and sad within.

To the great dramatic poet, "life's a stage and men are but players," each playing his part—and some playing many—but to him, it was all play.[67] The realities of life were ever viewed by him through the refractive and illusive haze of poetry.

Broad is the world and vast are its activities. To the teacher, life is a school. From the cradle to the grave, the oldest and wisest not less than the youngest and the simplest, are but learners; and they that learn most seem to have most to learn. For them, the night is too long and the day too short, and life passes as a dream that was told. The great Humboldt at ninety was still a learner, for he was still a teacher and the teacher must never cease to learn.[68]

The mightiest intellect of his time, the great discoverer of the principles of the universe, likened himself to a child gathering pebbles on the borders of the limitless ocean of truth.[69]

Theodore Parker, after mastering more learning, and venturing further into the fathomless depths of truth than most men of his time, exclaimed, as if in despair of comprehending all, "Why, all the space between my mind and God's mind is crowded with truths that wait to be discovered and organized into law."[70]

In contemplating life as a school for the highest development of manly character, and for the largest measure of human happiness, one is forcibly and painfully impressed by the many striking and glaring inequalities, contrasts, and contradictions which everywhere marks the scene. At first view, it would seem that the most extreme doctrines of Election and reprobation ever taught were literally fulfilled in the everyday facts of human experience.[71] "Jacob have I loved and Esau have I hated."[72] All classes, conditions and circumstances are spread out before us. Here are the lofty and there the lowly, with all their good and bad surroundings.

Looking only at the surface, we find it hard to vindicate the great idea of equal benevolence. But the result, the sum of good attained, the happiness enjoyed, go far towards proving the existence of a great law of compensation, as contended for by some of our transcendental philosophers.[73] Whether there be any such law or not, it certainly is amply demonstrated that human nature rises high above all factitious social conditions—and that individual men can rise above or fall below their circumstances as they will. While all opportunities seem lost upon some men, others seem to rise without any.

Look over the vast and varied field of human endeavor. Some are found in magnificent halls of learning, brilliantly lighted and splendidly furnished, supplied with countless volumes in languages living and dead. It oppresses the brain to go through them and note the elaborate arrangement. On the right and on the left, wherever the eye is turned, you see curious rooms, arches, niches, alcoves, and closets, filled with every appliance for assisting the student. No pains, no expense are spared. Everything is on a magnificent scale, and admi-

rably adapted to kindle the flame of ambition and rouse the mind and soul to the most ardent aspirations and the most determined exertions. All that science has discovered and art has created, all that ingenuity could devise or wealth purchase, has been brought here from the ends of the earth and put at the disposal of the student. Over every department, you find the highest order of talent, the largest culture, the fullest experience, and the most sleepless solicitude. Fortune's favorites are here, with full round faces, hands unsoiled and sinews unstrained, opulent in all that the world has to give. The very atmosphere about some of our great institutions of learning seem full of noble ideas, associations, and inspirations.

But this is one picture. Life has many others. Look away from the brilliant and classic hall, and you need not look far either, for the evil is never far from the good in this world. The unfortunate and the fortunate jostle each other on all sides. Multitudes of human beings are found in miserable huts, the gloomy abodes of poverty. Their inmates seem born to an inheritance of wretched vessels of dishonor, marked out for destruction. The reverse of all you see yonder, you see here. No splendid libraries, no costly apparatus, meet the eye. You look in vain for books or for broadcloth. Presidents, professors, friends and donors are alike absent. No one single sense is pleased with the prospect. All lights, all sounds, offend and repel; you shrink from it as from a place fitted to breed contagion, moral and physical, the very grave of all intellectual life—a place fitted to change the very lineage and superscription of the Deity into a ferocious beast, where every noble aspiration of the soul has been stunned into silence by the hoarse cry of mere physical wants.

But even here, it is something to know that the darkness is not total. Amidst all the gloom, there is life and therefore there is hope. Humanity is a great worker and sometimes works wonders. Armed with almost Godlike forces, it [is] master of all situations and seems a full match for all adversities. Notwithstanding the vast disparity between the hut and the hall, these two extremes and opposites do sometimes meet in the strange allotments of life, and shake hands with each other on a common platform of knowledge, wisdom, usefulness, and fame.

But life presents us with many puzzles, as well as contrasts in equalities and contradictions, and perhaps none has more perplexed the thoughtful man than the fact that men can resemble each other so closely and yet differ from each other so widely.

While none of Earth's teeming millions are exactly alike, and the marks of difference are sufficient for all the purposes of individuality, there is nevertheless a wonderful sameness in the outward appearances of men. In the face, however, of a general exterior resemblance in the

physical man, we have the wildest variety in mental and moral qualities. The question will come, who hath made us to differ? Here we are, possessed of the same faculties and powers, vitalized by the same life blood, sustained by the same elements, healed by the same medicines, die by the same diseases, and yet how endless, how endless are the dissimilarities and contradictions in the characters we form and the influence we exert on the world's affairs. While some are Miltons, Shakespeares, and Bacons,[74] illuminating and thrilling a wondering world by the resplendent glories of their genius, working miracles in the region of ideas, others seem about as dull as dead,—dead weights on the world of thought, and rise no higher in life than a merely physical existence.

Wherever else there may be unity and equality among men, here at least there is discord and division, wisdom and folly, knowledge and ignorance, opulence and indigence through the same broadway of human life in all countries, under all governments, and defy all human power to produce uniformity.

The natural laws for the development and preservation of human faculties seem to be equal, and are equal. They are uniform, harmonious and perfect. But the subjects of them abound in oddities and opposites. We meet with fruit where we saw no flowers, and plenty of flowers where we find no fruit. The brilliant promise of growth often fades away in manhood, while real excellence frequently looms out from unexpected quarters and comes unheralded.

The picture which life presents at this point I have sometimes likened to a thousand arrows shot from the same standpoint, aimed at the same object, united in aim but divided in flight. Some go one way and some another. Some to the right, others to the left; some too high, others too low; some too far, others not far enough; and only a few seem to hit the mark, and apparently less by design and skill than by accident. Such is life. Equal in the quiver, unequal in the air. Matched when dormant, unmatched, mismatched, and countermatched in action. If we go in search of them after the great trial of life is over, we shall find them just where they ceased to move, lying in all directions and positions. Some are broken, some are whole, some are both.

The boundless realms of the past are covered with these fallen arrows. We walk among them in history, biography, and among all the artistic and architectural monuments of departed ages and generations of men.

Human curiosity, in matters of this sort, has no limit. It increases with gratification. We never entirely solve the mystery which the subject presents, but nothing is more natural, and few things are more attractive, than walking among those fallen arrows and estimating the prob-

able amount of force and skill employed in bearing each to his specific position.

Excepting the golden rule, no maxim has found greater acceptance than that attributed to Socrates, that "the proper study of mankind is man."[75] Men never tire of this aphorism. It expresses not only a sublime and glorious truth, but a characteristic inclination of the human mind. Its utterance comes fresh to the ear and heart every time and vibrates the soul like lightning the wire. It is felt as well as thought, and felt before it is thought.

Man to man has ever been and must ever be an object of irrepressible fascination.[76] I do not stop to explain why. That is a task for philosophers. For the time, I am only the painter, to give form and expression to facts, and appeal to the mental experience of all for the fidelity of my pictures. Of all earthly objects, man is his own charmer. Mountains, landscapes and mighty rivers; oceans, islands and continents; gloomy deserts, boundless plains and desolate rocks; the iron-ribbed earth, and the hollow sky—all have their charms, and are viewed with dreamy wonder. But a single living human soul, standing here among us, one of ourselves, occupying the narrow margin of life and looking away with wondering eyes, with prophetic vision, striving to scan the outlines of the vast and silent continents of Eternity, possesses far more powerful and ever enduring attractions than all other objects real or imaginary.

We look upon these, but we think of man. Indeed, it is man's relation to the objects about him that clothes them with about all the interest they possess. The solitary form of the peerless Doctor Kane, wedged in between the crushing walls of eternal ice and snow, casts all the gloomy wonders of the Arctic into the shade.[77] He is greater to us than polar night and northwest passage. There is in the simple quality of his manhood a charm greater than any connected with dead matter, or with the forms and habits of living beasts. We read what he describes as passing before him; but he, himself, is the chief chord that explains the secret of our interest in all connected with his voyage. What he thought, felt, and endured on his perilous voyage of discovery are the matters that chiefly concern us. Ice we know, and cold we know, darkness and loneliness we know, but there is something in the other direction not yet known, and that is man himself. In him, there are vast depths, resting in unbroken silence, never yet fathomed. We all feel that there is something more, that the curtain has not yet been lifted. There is a prophet within us, forever whispering that behind the seen lies the immeasurable unseen.

We go about the world with this ever restless, eager and active curiosity burning within us. We scan every new face, listen to every new voice, weigh and measure every new man who steps forward on

the stage of observation, that we may at last gain a rational solution [to] the mysterious powers and possibilities of the species. This voyage of discovery lies over the broad ocean of our common humanity. We are not content with the study of our race, or variety of men. All nations, kindred tongues, and peoples help make up the great lesson which each successive generation in its turn endeavours to master. Nor is the task a hopeless and fruitless one.

It is quite true that we do not find that for which we search, but we do find that which makes the search worth the making. It is something to find out for ourselves, as we may do, that man to man is the king of Earthly wonders, the tallest and grandest figure that dots the horizon, the source and the one great centre of unceasing and never flagging interest, the index of all things in the heavens above and in the Earth beneath, that all things are possible to him, because he partakes of the nature and qualities of all things: that in him is the whole universe reflected; and that the Everlasting Father, shining through all His wondrous works, nowhere reveals His infinite perfections and makes known His Eternal wisdom and power as when, clothed in humanity, He becomes God manifested in the flesh.

In seeking this treasure, man is noble and generous. He seeks it not as for silver, or for gold, with a view to self-approbation. He seeks his Ideal man for the benefit of the whole race. And should he find him, he will behave as did the woman at the well. He will turn in all directions saying, "Come see a man that told me all things—is not this the true prophet?"[78]

Consciously or unconsciously, we are all man-worshippers. We find in him the qualities we attribute to the Divine being. A good man will ever have a good God. A bad man's God is made up of the wicked passions and conceptions of an evil heart. If the man is proud, selfish and revengeful, delighting in caste, war, and slavery, his conceptions of the Deity will be much the same. Ministers can be found to bless a palmetto or a rattlesnake flag—and the God of the South smiles upon slavery, treason, and rebellion—and is invoked to bless, protect and preserve it from harm.[79] It is a great mistake to suppose that our Gods are always invisible. Man centres in himself the objects of his worship.

I once saw a swarm of little boys following the great O'Connell from square to square in the city of Dublin, all forgetful of their poverty and wretchedness, despising wind and rain and mud and cold, treading with bare feet upon the melting snow, swept on by a joyous enthusiasm, which drew me along with them. They made the Welkin ring with ecstatic praises of the great Irish Liberator.[80]

Why did they thus follow and shout? The answer is, they could not well do otherwise. They were lifted by the common tide of human

nature. They obeyed a sacred impulse, which left them no time to reason about what they were doing. There walked before them the manhood of all their dreams, and every Irishman of them felt larger and stronger for walking in the stately shadow of this one great Irishman. It is nothing against this man-worshipping and man-investigating feeling that it sometimes crowns, where it should decapitate. It always means well, though it sometimes works ill. It stumbles only when it walks in darkness. Place it in the broad sunlight of truth, justice, and liberty, and it scorns all baseness and meanness, and turns with spontaneous energy to the noble and the good.

There is always something of ourselves in what we do. The house that we build to God we build to ourselves as well. Each denomination leans to a given style, and the gradation is from the splendid and imposing architecture of the Roman Catholics to the plain shedlike building of the Quakers.

While to a noble soul it is ever cheering to meet with any high degree of moral and intellectual excellence, attained under unfavorable circumstances, there is even in this feeling something that looks like personal interest.

Victories gained by individual men in the field of mind or matter bring credit and glory to the whole race. They raise the dignity and swell the honor of the species. What man has done, that man can do, is the creed of humanity condensed. But the thing must be done before it can be repeated. We are taught by examples. One sets out to equal his master and surpasses him—holding himself the mastery, until he is in turn surpassed by some other aspiring disciple. Each individual achievement is an added treasure to the world's wealth—and opens the way to still greater opulence. The great deeds of our Brothers reveal the high nature of our own powers, and the seeming limitlessness of our own possibilities.

Here comes the great Law of human progress, the Law of all social health. In no department of life—social, moral, religious, or political—can things remain as at the beginning. The physician must vary his treatment, the preacher his doctrine, and the politician his platform. There is no standing still in life. Advance or recede, occupy or give place, are the stern and immutable alternatives self-proclaimed and self-enforced with power and authority in all the manifold conditions, circumstances, and relations of human experience.

I have small consolation for him who prides himself on his conservatism, and thinks the happiness and well-being of mankind depends upon continuing evermore in the beaten path trodden by those who have gone before us.

Nothing stands today where it stood yesterday. The choice which life presents is evermore between growth and decay, perfection and deterioration. The forms of increase and declension are of every variety and degree; but the Law of *Change* is fixed and immutable. Only change itself is unchangeable. Society can no more stand still than the ocean. It is ever-rolling forward or backward. The first causes of either movement elude even the most subtle. Why men are eager and earnest in one direction today, and are equally so in another and opposite direction tomorrow, is too occult for detection. Shakespeare refers all such questions to a Divinity that shapes our ends, rough hew them how we will.[81] Our range of vision surveys only the actualities of life, and these are more than enough for human powers. We stand confounded in the presence of a blade of grass, or the leaf of a tree—much more so in respect to the world's greatest and most significant facts.

Life may be called the Divine essence of the universe—order, strength, and beauty are its developments. Men can only see its marvelous phenomena, and hear its many voiced utterances. These are enough to fill the mind with reverence and wondering amazement.

Life itself is a picture. But to be seen it must be withdrawn from view. Only begin to imagine its absence, and sun, moon, and stars halt in their courses: the restless ocean no longer heaves on high his proud dashing billows; the lightning no longer flashes against the summer sky; and the solemn crash of the tempest is no longer heard on the mountain. The earthquake has gone to sleep, and the volcano has ceased to send forth fire and smoke. All nature is hushed silent, petrified—dark, shapeless, voiceless, sightless—*dead*.

All that man can see, know, and experience here on the Earth are but the utterances of this subtle element, or essence of the Universe. It breathes from all Eternity and never rests from all its mighty labors. With it there is neither night nor day. It animates the mightiest constellations and sends them sweeping in majesty round the sky at the same time that it fills earth, sea, and air with countless, endless, living creatures, some too small to be seen by the human eye, and others too huge for belief. Its source and its destiny, its beginning and its end, meet and mingle in Eternity and none can explain its whence or whereto. We only see its works and wonders, while on it goes, creating, unfolding, renewing, changing, perpetually taking on new forms, issuing new sounds and filling the world with new perfumes—and new life. It scatters its fruits with a lavish hand, and revels in its all-creating, boundless, eternal and inexhaustible power. It gives us a thousand seeds for a single plant—and a thousand eggs for a single fish, and yet the whole world is full and overflowing and never-resting life. The telescope and

the microscope both come to our assistance. We look up and are filled with wonder. We look down, and the very Earth beneath us seems one living mass of ever-moving matter. Like the Hebrew king, we may well exclaim that we are fearfully and wonderfully made.[82]

Without treading upon the domains of theology; yet looking at this life only as an individual fact, standing alone, full and complete in itself, having no relation or bearing upon any other state or place, an independent and isolated existence, it is still a glorious fact: It is crowded with arguments the most convincing, and with motives the most powerful, in favor of the construction and cultivation of a true and manly character. Such are the transcendent rewards of virtue, wisdom, and power, even in this life. On the other hand [is] the certain misery and destitution brought on by vice. Man is ever under the pressure of mighty motives for leading a noble life.

It is no mean enquiry when the question is asked how shall we live, even with respect to the present brief space of human existence, since he who is best fitted to live is best fitted to die.

While in the world, a man's work is with and for the world. Human contact, not isolation, useful activity, not dull, monastic torpidity, is the mission to which the glorious fact of life calls the whole human family. It is something to be a man among trees. It is more to be a man among men. We live most who experience most. Welcome, welcome joy, welcome sorrow, welcome pleasure, welcome pain. You are all the ingredients of life—and with you all, life is an inestimable blessing.

It is good to think that in Heaven all troubles will be over, that war and carnage will be no more, that all injustice, cruelty and wrong shall be no more; but incomparably better is it for a man to gird on the whole armour of truth and righteousness, and wage war with these evils, and banish them from the Earth—and thus have the will of God done on earth as done in Heaven. Of what is to be and what has been done, why queerest thou, the past and the time to be are one and both are now![83]

We cannot urge too strongly the contemplation of the manifold uses to which men put the glorious opportunities of life.

To young men especially, such subjects cannot be too much commended. The broad ocean of life is before them; and the wisdom and the folly, the good and bad which have gone before, may show them more clearly the true course. The diligent sower must hope to reap. Labor and reward work best in the same harness. The old man says, "I have lived long and have observed much, but the time is short. I shall continue in the old paths:—The thing you point out may be well enough, but I am in no mood for experiments." He as naturally clings to the old as the

young man seeks the new. Many lectures have been delivered to young men; few to old.

In thought for the young, we have sometimes forgotten to do honor to age. For my own part, I feel an attraction to old people. He who plants an orchard that he may eat the fruit thereof does well, but he who plants that others may eat does better.

The world has many spectacles, but it has none more impressive, serene and beautiful than the silver-haired old man, full of years and full of knowledge, wise and good, calmly rounding up the full measure of human life. There he stands, keenly alive to the welfare of all who live, tender and kind to animals, full of love to children—taking an interest in all their childish sports and amusements—and cheerfully looking forward to the peaceful end of a life well spent. No earthly object has higher claims upon human veneration, regard and affection. The fireside is more attractive for his presence. The family is more secure for his vigilance, the church is hardly a place of worship without him, and the state is in constant peril without his unimpassioned wisdom and experience for its counselor and guide. It is no mock-worship that reverently bows to aged worth, whether that worth is found in man or woman.

But to be old is not always to be either wise or good. It is a sad thought that there are those to whom it matters little what views of life are presented. They have given up the ship before the voyage of life is ended. They float, but only at the mercy of the winds and waves of life. They heed no suggestions of wisdom, and obey no calls to duty. The class is numerous. We see them every day and find them everywhere; men who have grown old and hardened, either in the violent abuse, or in the indolent neglect of life's best privileges. With such, life is altogether a disheartening failure.

This is the saddest picture of all. Broken columns, ruined walls, great pictures, the marvelous works of ancient masters—all defaced and lost. Statues, almost divine, fallen, marred, mutilated by vandal hands, touch the heart and draw the tears of the aesthetic student; but what are all these soul-moving calamities, these destructions and mutilations of the symmetry and beauty of lifeless forms, and the illusions of art, when flung into the balance against the living wrecks of men, the noblest works of God? Lingering on the narrow verge of misspent time, looking mournfully back on wasted opportunities, youthful beauty and manly strength wantonly flung away. Clinging still to life while every life-charm has been blurred, broken, dispelled and blotted out, their last and only service, like that of stranded barks, is to disclose the points of danger and peril to others. The chance to redeem the time for themselves

has come and gone forever; the past is covered with regret, the present is without the life, power, and the glowing inspirations of hope—and the future is mantled with sorrow and gloom.

But to the young, with all this bright world before them where to choose, the case is widely and cheeringly different. Dangers great and numerous do beset and menace the young pilgrim, but how vast are his appliances and resources, especially in our day. Bad as may be our age, where is the misanthrope who can point us to any other period in the history of the world, when youth was bulwarked about with higher moral and intellectual walls than now?

In this land especially, we seem to live for the rising generation. For them, institutions of learning dot every hill—and authors, preachers, and teachers address themselves mainly to their wants. Every incitement is applied to stimulate to noble endeavour.

By wisdom, by firmness, by manly and heroic self-denial, all may escape the sharp and flinty rocks, the false lights and treacherous shores, which have sent others to the bottom, wrecked and ruined.

Man, by the cultivation of his faculties, and by the development of natural and external resources, possesses the marvelous power of enlarging the margin and extending the boundaries of his own existence. What he may yet accomplish in this respect, the boundless future must unfold. His course is onward and upward and none can point us to the altitude at which he will stop. Other animals only change their conditions in obedience to great natural revolutions in the external world, in which they have no agency whatever. But stern and all-conquering resistance to adverse circumstances, creating new conditions and relations for himself at every step, is the sublime and glorious mission of man. By the aid of artificial means, or rather by a deeper knowledge of the mysterious powers of nature, he adapts himself to all the vicissitudes of cold and heat in all parts of the globe.

How vastly different and how grandly significant is life today, compared with that of an hundred years ago. We see more, feel more, and accomplish more in a single month than was then accomplished in a whole year. In this respect we are older than the generations that have gone before us. Steam and lightning have revolutionized all human relations and quickened into higher life all human activities. Mind is everywhere asserting its potent, wise, and beneficent mastery over matter. The world is in motion. Industry, enterprise, discovery and invention have in our day wrought wonders surpassing the wildest dreams of bygone generations. Oceans that divided have become, under the ministry of these great forces, but bridges to connect man-

kind in the bonds of common brotherhood—and the great globe has become a whispering gallery.

The young man of twenty has learned more of the institutions and manners of the world than his grandfather at seventy. These great and ever accumulating victories over the iron barriers of nature are full of glorious promises to the lovers of mankind. The brazen ribs of slavery and despotism, priestcraft, and bigotry, though they may hold out against the appeals of reason, justice and humanity, must break down under the pressure of physical progress. All material improvements look toward the freedom and unity of man. Increased powers and facilities of locomotion and intercommunication dispel prejudice and remove the stony walls of arbitrary distinctions. Every bar of Rail Road iron is a death-dealing weapon against tyranny, and every whistle from the steam locomotive is a warning to slavery to get itself away to the shades of barbarism. Human language itself is no match for these agents. They change both the modes of thought and utterance, and will eventually make the speech of those on the other side of the mountain or ocean correspond with that on this. Revisiting old England after a period of fifteen years, and traveling over much the same ground traversed before, I was forcibly struck by this tendency to unity of language everywhere exhibited.[84] People living in one shire had peculiar accents, pronunciations and dialects; but education and intercommunication have now well nigh blotted out these distinctions, and a common language is the result. The same effect will eventually be produced on a larger and grander scale—and who shall say that the time will never come, when mankind will have a common language?

Manners, customs, habits, and institutions are all under the influence of the same mighty powers, and they increase and decline in obedience to their self-executing Laws. Nothing shall stand unmoved—unshaken and in safety which does not minister to the well-being of man as man, and fails to adjust itself to reason and truth. All governments not based upon justice; all religions not founded in truth; all institutions ministering to the selfishness of the few at the expense of the many shall dissolve and vanish before the silent but all conquering tread of physical improvements.

He who would make the best of the great and glorious fact of life—and would clothe it with a sublime and Godlike significance, must conform himself to the Eternal Law of progress, written in the Constitution of man. He must learn that life without exertion is life without happiness and life to no purpose. To make of life the high privilege and precious gift which its nature involves, there must be no mere selfish

plodding looking to personal gain. Life is more than meat. Man lives not by bread alone.[85] To save it is often to lose it. And to lose it is often to gain it.[86] There must be ever present in the mind some high, comprehensive, soul-enlarging and soul-illuminating idea, earnestly held and warmly cherished, looking to the elevation and advancement of the whole race. He must learn, in the language of Baily, that:

> Life is more than breath, and the quick round of blood.
> It is a great spirit and a busy heart.
> The coward and the small in soul scarce do live.
> One generous feeling, one great deed, one thought of good,
> Ere night, would make life longer seem
> Than if each year might number a thousand days.
>
> We live in deeds, not years; in thoughts not breaths,
> In feeling, not figures on a dial,
> We should count time by heart-throbs,
> He most lives who thinks the most,
> Feels the noblest, acts the best.[87]

"Pictures and Progress"

Based on references within the speech, Douglass wrote "Pictures and Progress" between Lincoln's reelection in November 1864 and his Second Inaugural in March 1865. (We have not found any reviews.) "Pictures and Progress" describes in greater detail than any other speech he gave the vital link between art and reform, and the importance of photography in achieving freedom and uprooting racism.

In view of the stupendous contest of which this country is now the theatre, this fierce and sanguinary debate between freedom and slavery, between republican institutions and a remorseless oligarchy, upon the decision of which depends for weal or for woe the destiny of this great nation, it may seem almost an impertinence to ask your attention to a lecture on pictures; and yet in this very fact of the all-engrossing character of the war may be found the needed apology for this seeming transgression.

The American people are not remarkable for moderation. They despise halfness. They will go with him who goes farthest and stay with him who stays longest. What the country thinks of half men and half measures is seen by the last election. We repudiate all such men and all such measures. The people said to the Chickahominy hero, "We do abhor and spurn you, and all whose sympathies are like yours"; and to Abraham Lincoln, they say, "Go forward, don't stop where you are, but onward."[88]

This wholeness of American character may be seen in our attention to the war. Intent upon suppressing the rebellion, we have refused to be diverted from that one great object for any cause whatever.

Does Napoleon plant a prince of a detestable family in Mexico?[89] We have but one answer, and that is down with the Rebellion! Does England take advantage of our misfortunes?[90] Our answer is down with the rebellion. Does Brazil assume an unbecoming haughtiness?[91] Our answer is, down with the slaveholding rebellion. Does the tempter at home plead for compromise?[92] Our answer is sternly, down with the accursed rebellion.

The fact is that the whole thought of the nation during the last four years has been closely and strongly riveted to this one object. Every fact and every phase of this mighty struggle has been made the subject of exhausting discussion. The pulpit, the press, and the platform—political

and literary—the street and the fireside, have thought of little else and spoken of little else during all these four long years of battle and blood.

It were easy to commend this almost universal and unceasing thought for the safety of the nation. It is in this deep and heartfelt *solicitude* that the safety of the country is assured.

It may be laid down as an axiom that no man was ever yet lost who seriously thought himself worth saving—and what is true of an individual man the same is true, equally true, of a great nation.[93]

It is said that Nero fiddled when Rome was on fire, and some amongst us have manifested a levity quite as disgraceful and shocking; but the heart of the nation is sound.[94] Those who thought the country not worth saving have found the country entertaining a similar opinion respecting themselves. They are not worth saving, yet we mean to save them by saving the country they would ruin.

It may be assumed, moreover, that this war is now rapidly drawing to its close. The combustible material which caused the explosion is nearly exhausted. It is now seen, even at the South, that cotton is not king, because it has not raised the blockade and given the Confederacy foreign recognition. It is seen too, that slavery, hitherto paramount and priceless, may be less valuable than an army—that the Negro can be more useful as a soldier than as a slave. In all this we see that the rebellion is perishing, not only for the want of men and for the materials and munitions of war, but from a more radical exhaustion—one which touches the vital sources out of which the rebellion sprang.

The people can afford, therefore, to listen for a moment to some other topic. There is no danger of being injuriously diverted from the one grand fact of the hour.

The bow must be unbent occasionally in order to retain its elastic spring and effective power, and the same is true of the mind: A brief excursion in the woods, a change of scene, however trifling, a transient communion with the silent and recuperative forces of nature—the secret sources of pure thought and feeling—constitute an elementary worship, impart tone and vigor to the mind and heart, and enable men to grapple more effectively with the sterner duties and dangers of practical life.

Thoughts that rise from the horrors of the battlefield, like the gloomy exhalations from the dampness and death of the grave, are depressing to the spirit and impair the health. One hour's relief from this intense, oppressive, and heart-aching attention to the issues involved in the war may be of service to all.

The title of my lecture is a very convenient one. It leaves me perfectly free to travel where I list in the realms of thought and experience and to avail myself of any facts and features—any groups or combinations of sentiments, thoughts and ideas from which may be derived either instruction, gratification, or amusement.

The narrowest and shallowest stream from the mountainside may conduct as to the open sea; we have but to go forward to go round the world. No one truth stands alone. Any one truth leads to the boundless realms of all truth: So under the somewhat indefinite title of pictures and by means of pictures, we may be led to the contemplation of great truths—interesting to man in every stage of the journey of life.

Besides, it matters very little what may be the text in these days—man is sure to be the sermon. He is the incarnate wonder of all the ages: and the contemplation of Him is boundless in range and endless in fascination. He is before all books a study—for he is the maker of all books—the essence of all books—the [text] of all books.[95] On earth there is nothing higher than the Human Soul.

Again the books that we write and the speeches that we make—what are they but the extensions, amplifications and shadows of ourselves, the peculiar elements of our individual manhood? Though we read and listen during forty years—it is the same old book and the same old speech, native to the writer's or speaker's heart, and co-extensive with his life—a little shaded by time and events, perhaps, but it is the same old book and speech over again—the pear tree is always a pear tree—and never apple.

Now the speech I was sent into the world to make was an abolition speech. Gough says, whatever may be the subject announced for him the lecture itself is sure to be upon temperance.[96] Sojourner Truth says that she does not speak to tell people what they don't know—but to tell them what she herself knows.[97]

I am somewhat in the condition of Gough—and perhaps also in that of Sojourner Truth. When I come upon the platform the Negro is very apt to come with me. I cannot forget him: and you would not if I did.

Men have an inconvenient habit of reminding each other of the very things they would have them forget.

Wishing to convince me of his entire freedom from the low and vulgar prejudice of color which prevails in this country, a friend of mine once took my arm in New York, saying as he did so—"Frederick, I am not ashamed to walk with you down Broadway." It never once occurred to him that I might for any reason be ashamed to walk with him down Broadway. He managed to remind me that mine was a despised and hated color—and his the orthodox and constitutional one—at the same

time he seemed endeavoring to make me forget both. Pardon me if I shall be betrayed into a similar blunder tonight—and shall be found discoursing of Negroes when I should be speaking of pictures.

The saying that happiness depends upon little, not less than upon large things, has often encouraged me to speak when otherwise I might have remained silent. And such is the case now. As I cannot bring before you the fruits of deep and thorough culture—which the more favored lecturers are able to do—I am encouraged to present such small things—large to me, small to you, as I have in store such facts, such fancies, such flowers, per chance such reveries—such dreams, images, ideas, and pictures—such earnest outlook into the ever-tempting invisible, unfathomable, and unknown—as have touched my spirit in passing along the mysterious journey of life—may occasionally show themselves in what I have here to say of pictures.

In doing this, hold me to no logical arrangement. I shall probably leave my picture base of supplies about as far in the rear as Sherman left his when he turned his back upon Atlanta for the Atlantic.[98] The most I can promise is that you shall in case of need subsist upon the country through which we pass.

Movement is sometimes the chief end of movement. A trip down the Hudson pays better than a sight of New York. A view from the mountain is more than the mountain. It is not the apex upon which we stand, but the vast and glorious expanse that awes and thrills us.

Our age gets very little credit for poetry or music or indeed for art in any of its branches. It is commonly and often scornfully denominated the age of money, merchandise, and politics, a metallic, utilitarian, dollar-worshipping age; insensible to the song of birds and perfume of flowers: An age which can see nothing in the grand old woods, but timber for ships and cities—nothing in the waterfall but mill power, nothing in the landscape but cotton, corn and cattle; dead alike to the poetic charms both of nature and of art.

That there is much in the tendency of the times to justify this sweeping condemnation, it is needless to deny, and yet, for nothing is this age more remarkable than for the multitude, variety, perfection, and cheapness of its pictures. Indeed the passion for art was never more active and never more productive. The art of today differs from that of other ages, however, only as the education of today differs from that of other ages; only as the printing press of modern times, turning off ten thousand sheets an hour, differs from the tedious and laborious processes by which the earlier thoughts of men were saved from oblivion.

The great discoverer of modern times, to whom coming generations will award special homage, will be Daguerre. Morse has brought

the ends of the earth together and Daguerre has made it a picture gallery.[99] We have pictures, true pictures, of every object which can interest us. The aspiration of Burns is now realized. Men of all conditions and classes can now see themselves as others see them, and as they will be seen by those [who] shall come after them.[100] What was once the special and exclusive luxury of the rich and great is now the privilege of all. The humblest servant girl may now possess a picture of herself such as the wealth of kings could not purchase fifty years ago.

The progress of science has not been more logical than that of art. Both have grown with the increasing wants of men. Franklin brought down the lightning, Morse made it a bearer of dispatches, and in answer to the increasing human demands of progressive human nature, Daguerre has taught the god of day to deck the world with pictures far beyond the art of ancient masters.

As knowledge has left the cloister, pouring itself through the iron gates of the printing press, so art has left the studio for new instruments of expression and multiplication.[101]

Steam has shortened the distance across the ocean, but a voyage is unnecessary to look at Europe. We can see Paris without the steamship, and St. Peters without visiting Rome.[102] You have but to cross the parlor to see both, and with them all the wonders of European architecture, which by the way is about all that the traveler sees abroad that he could not see at home.

That Daguerre has supplied a deep-seated want of human nature is seen less in the eulogies bestowed upon his name than in the universal appropriation of his discovery. The smallest town now has its picture gallery, and even where the roads cross, where stands but a solitary blacksmith shop and a deserted country tavern, there also stands the inevitable gallery—painted yellow, perched upon gutta percha springs, ready to move in any direction, wherever men have the face to have their pictures taken. The farmer boy can get a picture for himself and a shoe for his horse at the same time, and for the same price. The facilities for traveling have sent the world abroad, and the ease with which we get our pictures has brought us all within range of the daguerreian apparatus.

Among the good things growing out of this pictorial abundance, modest distrust of our personal appearance is not greatly distinguished. No one hesitates on account of this sentiment to commit himself to posterity: for a man's picture, however homely, will, like himself, find somebody to admire it. No man contemplates his face in a glass without seeing something to admire. But for this natural self-complacency, the stern severity of the photographic art would repel rather than attract.

A man is ashamed of seeming to be vain of his personal appearance, and yet who ever stood before a glass preparing to sit or stand for a picture without a consciousness of some such vanity?

A man who peddles a patent medicine, writes a book, or does anything out of the common way, may, if he does not give his picture to the public, lay claim to singular modesty. But it so happens that nobody thinks of such an omission.

It is not, however, of such pictures as already intimated that I am here to speak. A wider and grander field of thought lies open before us.

The nature of my discourse is already indicated. What I have said in respect to the character of lectures generally will apply to my own: namely, whatever may be the text, man is sure to be the sermon.

Man, however, is a many-sided being, and the subject I have chosen treats of his best and most interesting side; it is his dreamy, clairvoyant, poetic, intellectual, and shadowy side; the side of religion, music, mystery and passion, wherein illusions take the form of solid reality and shadows get themselves recognized as substance: the side which is better pleased with feeling than reason, with fancies than with facts, with things as they seem, than things as they are, with contemplation rather than action, with thought rather than work.

I have no learned theory of art to present, no rules of wise criticism to explain or enforce, no great pictures to admire, no distinguished artists, ancient or modern, to commend. I bring to the work before me only the eye and thought of a lay man.

It is objected that the crowd, of which I am one, knows nothing of art. The objection is well taken. It however should have only the same weight and application to pictures, where applied, as to poetry and music, for to the eye and spirit, pictures are just what poetry and music are to the ear and heart. One may enjoy all the pleasant sensations arising from the concord of sweet sounds without understanding the subtle principles of music, and the skillful arrangement by which those delightful sensations are produced.

But my discourse has more to do with the philosophy of art than with art itself, with its source, range and influence than with its facts and perfections—with the soul, rather than the body, with the silence of music, rather than sound, and with the ideal forms of excellence floating before the eye of the spirit, rather than with those displayed upon dull canvass.

Man is the only picture-making animal in the world. He alone of all the inhabitants of earth has the capacity and passion for pictures.

Reason is exalted and called Godlike, and sometimes accorded the highest place among human faculties; but grand and wonderful as is this

attribute of our species, still more grand and wonderful are the resources and achievements of that power out of which comes our pictures and other creations of art.

Reason is said to be not the exclusive possession of men. Dogs and elephants are said to possess it. Ingenious arguments have been framed in support of this claim for the brutes. But no such claim, I believe, has been set up for imagination: This sublime, prophetic, and all-creative power of the human soul—proving its kinship with the eternal sources of life and creation—is the peculiar possession and glory of man.[103]

For man, and for man alone, all nature is richly studded with the material of art. Not only the outside world, but the inside soul may be described as a picture gallery, a magnificent panorama in which things of time and things of eternity are silently portrayed. Within as without there are beautiful thought valleys, varied and far-reaching landscapes, abounding in all the interesting and striking forms and features of external nature. Mountains, plains, rivers, lakes, oceans, woods, water-falls, outstanding headlands and precipitous rocks have their delightful shadows painted in the soul.

This full identity of man with nature, this affinity for, and this rela-tion to all forms, colors, sounds and movements of external nature that finds music in the slightest whisper of the zephyr-stirred leaf, and in the roaring torrent deep and wild; this all embracing and all sympathizing quality, which everywhere matches the real with the artificial—which endears substances because of its shadow—is our chief distinction from all other beings on earth and the source of our greatest achievements.

A certain class of ethnologists and archeologists, more numerous in our country a few years ago than now and more numerous now than they ought to be and will be when slavery shall have no further need of them, profess some difficulty in finding a fixed, unvarying, and definite line separating what they are pleased to call the lowest variety of our species, always meaning the Negro, from the highest animal.[104]

To all such scientific cavilers, I commend the fact that man is everywhere a picture-making animal, and the only picture-making ani-mal in the world.[105] The rudest and remotest tribes of men manifest this great human power—and thus vindicate the brotherhood of man. All have some idea of tracing definite lines and imitating the forms and col-ors of things as they appear about them.

Hand in hand, this picture-making power accompanies religion, supplying man with his God, peopling the silent continents of eternity with saints, angels, and fallen spirits, the blest and the blasted, making manifest the invisible, and giving form and body to all that the soul can hope and fear in life and in death.

Humboldt tells of savage tribes of men, remote from commerce and civilization, who nevertheless had coats and other garments, after European patterns, painted on their skin.[106] They no doubt thought themselves very comfortably and very elegantly dressed. The painted coat was a real coat to the savage, and will be 'til latitude and temperature, or some other source of knowledge, shall make him wiser. Until then, let him enjoy his delightful illusion, even as more enlightened men enjoy theirs.

The savage is not the only man nor is savage society the only society dressed out in a painted coat and other habiliments. Examples are all around us. Church and state, religion and patriotism, refinement and learning, manners and morals, all have their counterfeit presentments in paint. You often meet coarse and vulgar persons dressed in the painted appearance of ladies and gentlemen—a slight touch removes the paint and discloses their true character and the class to which they belong. But this is digression.

The unalloyed creations of imagination, conscious of no contradiction, no deception, are solid and flinty realities to the soul. Granite and iron are not more real supports to things material than are those to the subtle architecture of the mind.

"Among eminent persons," says *Emerson*, "those who are most dear to men are not of the class which the economist calls producers: they have nothing in their hands; they have not cultivated corn, nor made bread; they have not led out a colony nor invented a loom. A higher class, in the estimation of this city-building, market-going race of mankind, are the poets, who, from the intellectual kingdom, feed the thought and imagination with ideas and pictures."[107]

This statement of the Concord philosopher is but the repetition or amplification of that of Scripture: "Men do not live by bread alone."[108] It affirms that to be happy is more than to be rich—and that happiness results less from external conditions than from internal exercises. Leaning upon this inner staff of the soul, John Brown went to the gallows as serenely as other men go to church on Sunday morning. He [endured by] seeing the angel with his crown of glory—saying come up higher.[109] With the same support too, the martyr John Huss could shout amid the blazing faggots.[110]

In youth this unreal, apparent, unlimited and shadowy side of our nature, full of faith and poetry—so insubstantial and yet so strong—gilds all our earthly future with bright and glorious visions, and in age and in sickness and in death paves the streets of our paradise with gold and sets all its opening gates with pearls.[111]

It is from this side of his nature that man derives his chief and most lasting happiness. There is no measure for the depth and purity of

the happiness that childhood feels in [the] presence of pictures, symbol and song! Among all the soul-awakening powers to which our nature is susceptible, there are none greater than these. A little child in rapt contemplation of a work of art is itself a delightful picture—full of promise both to the child and to the world.

What is the secret of this childhood pleasure in pictures? What power is it that rivets attention to the speechless paint? The great poet explains for us. In certain conditions of the mind, men may

find tongues in trees, books in the running brooks,
Sermons in stones, and good in everything.[112]

This truth childhood realizes in all its fullness and beauty. Could the joy imparted by the contemplation of pictures be analyzed, it would be found to consist mainly in [the] self tenfold much, a gratification of the innate desire for self-knowledge with which every human soul is more or less largely endowed. Art is a special revelation of the higher powers of the human soul. There is in the contemplation of it an unconscious comparison constantly going on in the mind, of the pure forms of beauty and excellence, which are without to those which are within, and native to the human heart.[113]

It is a process of soul-awakening self-revelation, a species of new birth, for a new life springs up in the soul with every newly discovered agency, by which the soul is brought into a more intimate knowledge of its own Divine powers and perfections, and is lifted to a higher level of wisdom, goodness, and joy.

The savage, accustomed only to the wild and discordant war whoop of his tribe, whose only music comes to him from winds, waterfalls, and the weird sounds of the pathless forest, discovers a new place in his heart, a purer and deeper depth in his soul, the first time his ear is saluted by the divine harmonies of scientific music.

To know man civilized we must study him as a savage.

We are all savages in childhood. And men, we are told, are only children of a larger growth. The life of society is analogous to the life of individual men. It passes through the same gradations of progress. California was not Massachusetts at the first and is not now. She was savage even in the manifestation of her justice. Not that which is spiritual is first, but that which is natural. After that, that which is spiritual.

The sound of a common hand organ in the new streets of San Francisco caused tears to roll down the cheeks of the sun-burnt miners. As are songs to the savage, so are pictures to the boy. They are his earliest and most effective teachers. All the pictures in the book are known

before a single lesson is learned. The great teacher of Galilee only uttered a truth deep down in nature, when he opened the Kingdom of heaven only to those who came as little children.

To the flinty-hearted materialists, insensible to aught but dull facts, to the miser, whose every thought is gold, to the [weak], whose every impulse is sensual, pictures like flowers have no voice and impart no joy. Theirs is the ministry of youth and self-forgetfulness. They come oftenest and stay longest when the morning sun is just disclosing the mountain peaks leaning against the distant sky.

In the valley, on the hillside, in distant groves, where cloud-flung shadows sweep the green fields in noiseless majesty, far away from the hum and din of town and city, the boy of ten, yet unconscious of spot or blemish, forgetful of time and place, indifferent alike to books and sport, looks up with silence and awe to the blue overhanging sky, and views with dreamy wonder its ever-drifting drapery, tracing in the clouds themselves and in their ever-changing forms and colors colossal figures, mighty men of war, great cities dotted about with vast temples of justice and religion, adorned with domes and steeples, towers and turrets, and sees mighty ships sailing in grandeur around the hollow firmament: break in if you must upon the prayers of monks or nuns, or upon any of the pomp and show of fashionable worship—but here is a devotion which it were sacrilege to disturb.

At this altar man unfolds to himself the divinest of human faculties—for such is the picture-conceiving and the picture-producing faculty or power of the human soul. This devotion is the prelude to the vision and transfiguration, qualifying men and women for the sacred ministry of life. He who has not borne some such fruits—[has not] had some such experiences in child[hood], gives us only barrenness in age.

I have said that man is a picture-making and a picture-appreciating animal, and have cited that fact as the most important line of distinction between him and all others. The point will bear additional emphasis.

The process by which man is able to posit his own subjective nature outside of himself, giving it form, color, space, and all the attributes of distinct personality, so that it becomes the subject of distinct observation and contemplation, is at [the] bottom of all effort and the germinating principles of all reform and all progress. But for this, the history of the beast of the field would be the history of man. It is the picture of life contrasted with the fact of life, the ideal contrasted with the real, which makes criticism possible. Where there is no criticism there is no progress, for the want of progress is not felt where such want is not made visible by criticism. It is by looking upon this picture and upon that which enables us to point out the defects of the one and the perfections of the other.

Poets, prophets, and reformers are all picture-makers—and this ability is the secret of their power and of their achievements. They see what ought to be by the reflection of what is, and endeavor to remove the contradiction.[114]

We can criticize the characters and actions of men about us because we can see them outside of ourselves, and compare them one with another. But self-criticism, out of which comes the highest attainments of human excellence, arises out of the power we possess of making ourselves objective to ourselves—[we] can see our interior selves as distinct personalities, as though looking in a glass.

Men drunk have been heard addressing themselves—as if speaking to a second person—exposing their faults and exhorting themselves to a higher and better life.

It is said that the best gifts are most abused and this among the rest. Be it so. Conscience itself is often misdirected—shocked at delightful sounds, beautiful colors, and graceful movements, yet smiles at persecution, sleeps amid the agonies of war and slavery, hangs a witch, burns an heretic, and drenches a continent in blood!

This picture-making faculty is flung out into the world like all others, capable of being harnessed to the car of truth or error: It is a vast power to whatever cause it is coupled. For the habit we adopt, the master we obey, in making our subjective nature objective, giving it form, color, space, action and utterance, is the one important thing to ourselves and our surroundings. It will either lift us to the highest heaven or sink us to the lowest depths, for good and evil know no limits.

Once fully started in the direction of evil, man runs with ever-increasing speed, a child in the darkness, frightened onward by the distant echoes of his own footfalls.

The work of the revivalist is more than half done when he has once got a man to stand up in the congregation as evidence of his need of religion. The strength of an iron halter was needed for this first act, but now like Rarey's horse he may be led by a straw.[115]

All wishes, all aspirations, all hopes, all fears, all doubts, all determinations grow stronger by action and utterance, by being rendered objective.

Of all our religious denominations, the Roman Catholic understands this picture passion of man's nature best. It addresses the religious consciousness in its own language: the child language of the soul.

Pictures, images, and other symbolical representations speak the language of religion. The mighty fortress of the human heart silently withstands the rifled cannon of reason, but its walls tremble when brought under the magic power of mystery.

Remove from the church of Rome her cunning illusions, her sacred altars, her glowing pictures, her speaking images, her tapers, miters, incense, her solemn pomp and gorgeous ceremonies, the mere outward shows and signs of things fancied or real, and her magical and entrancing power over men would disappear. Take the cross from before the name of the archbishop, and he will stand before the world as James or John like the rest of us.

Protestantism pays less deference to this natural language of religion. It relies more upon words and actions than upon paints and chisels to give form and body to its sentiments and ideas. Nevertheless, her most successful teachers and preachers are painters, and succeed because they are such. Dry logic and elaborate arguments, though knitted as a coat of mail, linked and interlinked, perfect in all their appointments, lay down the law as empty benches.

But he who speaks to the feelings, who enters the soul's deepest meditations, holding the mirror up to nature, revealing the profoundest mysteries of the heart by the magic power of action and utterance to the eye and ear, will be sure of an audience.

The few think, the many feel. The few comprehend a principle, the many require illustration. The few lead, the many follow. The dignified few are shocked by Mr. Lincoln's homely comparisons and quaint stories, but the many like them and elect him president.

There is our national flag: a grand national picture: the glorious red white and blue: nothing of itself but everything for what it represents. We search the woods and bring out the tallest spar: raise our banner, give it ample folds to the breeze, its glorious stars to the sky, and hail with a shout that general who orders to be shot the first man who pulls down that flag. When the hands of Joshua were held up Israel prevailed, when the horns were blown the walls of Jericho fell, and when the flag of the union is borne aloft the country is safe from its foes. The ancient and modern emblems serve the same purpose: nothing in themselves, but everything in what they signify. They speak to the feeling by every mystic fascination.

But feeling and mystery are not the only elements of successful painting, whether of the voice, pen, or brush. Truth is the soul of art, as of all things else. No man can have [a] permanent hold upon his fellows by means of falsehood. "Paint me as I am," said Cromwell, and such is the voice of nature everywhere, when nature is allowed to be natural. Better remain dumb than letter a falsehood—better repeat the old truth forever, than to spin out a pure fiction.

Nevertheless, with the clear perception of things as they are, must stand the faithful rendering of things as they seem. The dead fact is

nothing without the living expression. Niagara is not fitly described when said to be a river of this or that volume falling two hundred feet over a ledge of rocks; nor is thunder when simply called a loud noise or a jarring sound. This is truth but truth disrobed of its sublimity and glory: a kind of frozen truth, destitute of motion itself and incapable of exciting emotion in others.

But on the other hand, to give us the glory without some glimpse of the glorified object is a still greater transgression, and makes those who do it as him who beateth the air. The looker and the listener are alike repelled by any straining after effect.

We have learned nothing higher in the art of speech since Shakespeare wrote, "Suit the action to the word, and overstep not the modesty of nature."[116]

Whether we read Shakespeare or look at Hogarth's pictures, we commune alike with nature and have human beings for society. They are of the earth and speak to us in a known tongue. They are neither angels nor demons, but in their possibilities both. We see in them not only men and women, but ourselves.

The great philosophical truth now to be learned and applied is that man is limited by manhood. He cannot get higher than human nature, even in his conceptions. Laws, religion, morals, manners, and art are but the expressions of manhood, and begin and end in man. As he is enlightened or ignorant, as he is rude or refined, as he is exalted or degraded, so are his laws, religion, morals, manners—and everything else pertaining to him.

PART V
Catalogue Raisonné

Abbreviations used in Catalogue Raisonné captions

AARL: Auburn Avenue Research Library on African American Culture and History, Atlanta
AAS: American Antiquarian Society
AC: Amistad Center for Art & Culture, Wadsworth Atheneum Museum of Art
ACM: Anacostia Community Museum Archives, Smithsonian Institution
ACPL: Allen County Public Library
AIC: Art Institute of Chicago
ARC: Amistad Research Center, Tulane University
AUC: Robert W. Woodruff Library, Atlanta University Center
Avery: Avery Research Center, College of Charleston
BDM: Banneker-Douglass Museum
Beinecke: Beinecke Rare Book and Manuscript Library, Yale University
BFRC: Benson Ford Research Center
CCHS: Chester County Historical Society
CHLA: Cincinnati History Library and Archives
CHM: Chicago History Museum
CHS: Connecticut Historical Society
Clements: William L. Clements Library, University of Michigan
Columbia: Rare Book and Manuscript Library, Columbia University
Cornell: Rare and Manuscript Collections, Cornell University
Duke: David M. Rubenstein Rare Book and Manuscript Library, Duke University
Emory: Manuscript, Archives, and Rare Book Library, Emory University
FDM: Frederick Douglass Museum and Caring Hall of Fame
FDP: Frederick Douglass Papers, Department of Rare Books, Special Collections and Preservation,
 University of Rochester
GEH: George Eastman House International Museum of Photography and Film
Getty: J. Paul Getty Museum
GLI: Gilder Lehrman Institute of American History
Harvard: Special Collections, Fine Arts Library, Harvard College Library
Houghton: Houghton Library, Harvard University
HSP: Historical Society of Pennsylvania
KSHS: Kansas State Historical Society
Lavery: Special Collections, Lavery Library, St. John Fisher College
LC: Library of Congress
LCP: Library Company of Philadelphia
Lynn: Lynn Museum and Historical Society
MCHS: Madison County Historical Society
MCPL: Monroe County Public Library, State Archives of Florida

MHS: Massachusetts Historical Society

MiDAH: Mississippi Department of Archives and History

MMA: Metropolitan Museum of Art

MSA: Maine State Archives

MSRC: Moorland-Spingarn Research Center, Howard University

NAMA: Nelson-Atkins Museum of Art

NARA: National Archives and Records Administration

NBWM: New Bedford Whaling Museum

NSHS: Nebraska State Historical Society

NMAAHC: National Museum of African American History and Culture, Smithsonian Institution

NMAH: National Museum of American History, Smithsonian Institution

NPG: National Portrait Gallery, Smithsonian Institution

NPS: National Park Service, Frederick Douglass National Historic Site

NPS-MW: National Park Service, Maggie L. Walker National Historic Site

NYHS: New-York Historical Society

NYPL: New York Public Library

OHA: Onondaga Historical Association

OHS: Ohio Historical Society

Princeton: Rare Books and Special Collections, Princeton University

RPL: Rochester Public Library

SAG: Swann Auction Galleries

Schlesinger: Schlesinger Library on the History of Women in America, Radcliffe Institute

Schomburg: Schomburg Center for Research in Black Culture, New York Public Library

Smith: Sophia Smith Collection, Smith College

UNMAM: University of New Mexico Art Museum

UVA: Albert and Shirley Small Special Collections Library, University of Virginia

VHS: Virginia Historical Society

WHS: Wisconsin Historical Society

WPL: Whittier Public Library

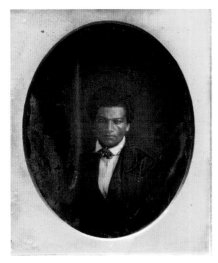

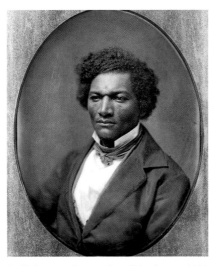

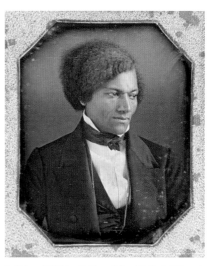

1. Unknown photographer, c. 1841. Sixth-plate daguerreotype. 2¾ × 3¼ in. Greg French.

2. Unknown photographer, July–August 1843. Syracuse, New York. Whole-plate daguerreotype, 6½ × 8½ in. OHA.

3. Edward White Gallery, May 1848. 247 Broadway, New York City. Sixth-plate daguerreotype, 2¾ × 3¼ in. CCHS.

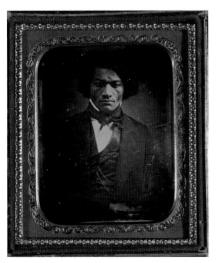

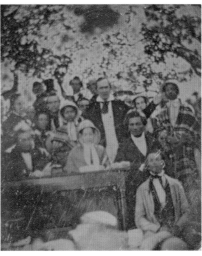

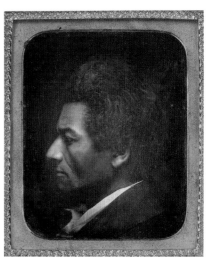

4. Unknown photographer, c. 1850. Sixth-plate daguerreotype, copy of lost c. 1847 daguerreotype, 2¾ × 3¼ in. NPG.

5. Ezra Greenleaf Weld (1801–1874), August 22, 1850. Cazenovia, New York. Sixth-plate daguerreotype, 3⅛ × 2¾ in. Getty; MCHS; NPG.

6. Unknown photographer, c. 1850. Quarter-plate daguerreotype, 3¼ × 4¼ in. MSRC.

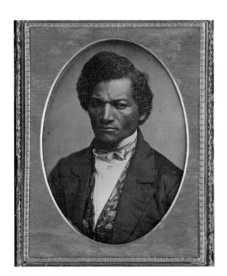

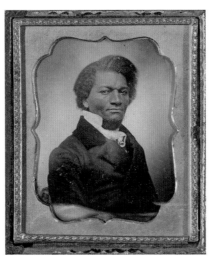

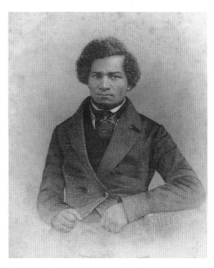

7. Samuel J. Miller (1822–1888), August 1852. Akron, Ohio. Half-plate daguerreotype, 4¼ × 5½ in. AIC.

8. Unknown photographer, c. 1853. Sixth-plate daguerreotype, 3⅛ × 2¾ in. MMA.

9. John Chester Buttre (1821–1893), c. 1855. Engraving from a lost daguerreotype, published as the frontispiece to Douglass's *My Bondage and My Freedom* (1855), 5 × 3 in.

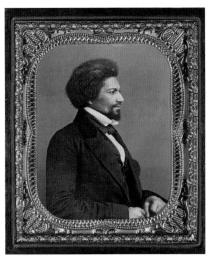

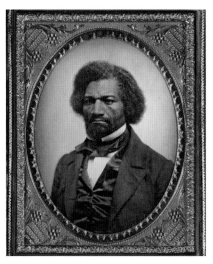

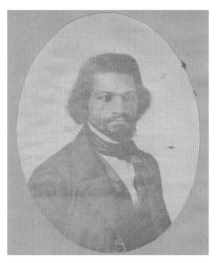

10. Unknown photographer, c. 1855. Sixth-plate daguerreotype, 2¾ × 3¼ in. NAMA.

11. Unknown photographer, c. 1856. Quarter-plate ambrotype. 4¼ × 3¼ in. NPG.

12. Unknown photographer, c. 1857. Copy print from a lost daguerreotype or ambrotype, 2 × 3 in. Clements.

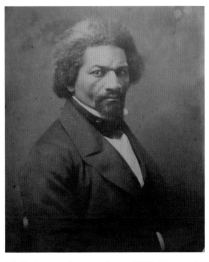

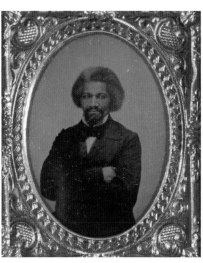

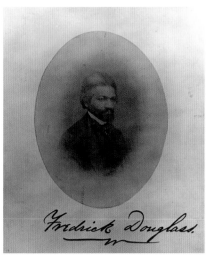

13. Unknown photographer, c. 1858. Copy print from a lost daguerreotype or ambrotype, 8 × 10 in. NYHS.

14. Unknown photographer, c. 1859. Ninth-plate ambrotype, 2 × 2½ in. UNMAM.

15. Unknown photographer, c. 1860. Salted paper print, 4 × 3⅛ in. NPG.

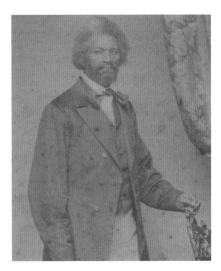

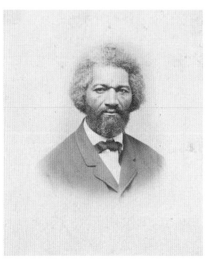

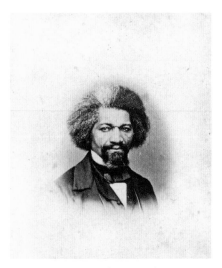

16. Benjamin F. Reimer (1826–1899), c. 1861. 615 & 617 North 2nd Street, Philadelphia, Pennsylvania. Carte-de-visite, 2½ × 4 in. NPS.

17. Robert M. Cargo, c. 1861. 69 5th Street, Pittsburgh, Pennsylvania. Carte-de-visite, 2½ × 4 in. Sold by SAG, 2239.42.

18. John White Hurn (1822–1887), January 14, 1862. 1319 Chestnut Street, Philadelphia, Pennsylvania. Carte-de-visite, 2½ × 4 in. Greg French; Schomburg; Swarthmore; NPS.

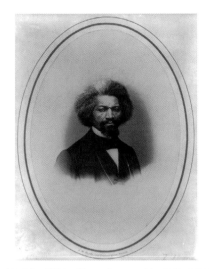

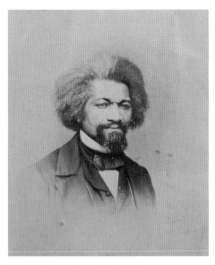

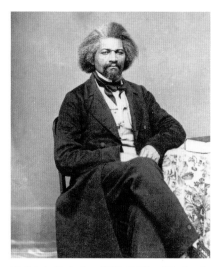

19. John White Hurn, January 14, 1862. 1319 Chestnut Street, Philadelphia, Pennsylvania. Carte-de-visite, 2½ × 4 in. LC.

20. John White Hurn, January 14, 1862. 1319 Chestnut Street, Philadelphia, Pennsylvania. Carte-de-visite, 2½ × 4 in. MHS; Granger Collection; Schomburg.

21. Edwin Burke Ives (1832–1906) and Reuben L. Andrews, January 21, 1863. Howell Street, Hillsdale, Michigan. Carte-de-visite, 2½ × 4 in. Hillsdale College.

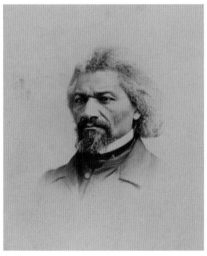

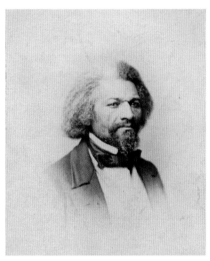

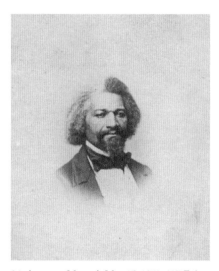

22. Thomas Painter Collins (1823–1873), February–April 1863. Westfield, Massachusetts. Carte-de-visite, 2½ × 4 in. Lavery.

23. Augustus Morand (1818–1896), May 15, 1863. 297 Fulton Street, Brooklyn, New York. Carte-de-visite, 2½ × 4 in. Lynn.

24. Augustus Morand, May 15, 1863. 297 Fulton Street, Brooklyn, New York. Carte-de-visite, 2½ × 4 in. NPS; VHS.

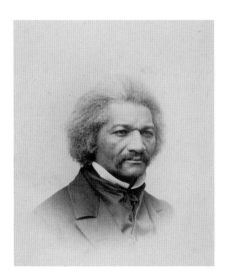

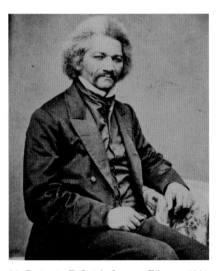

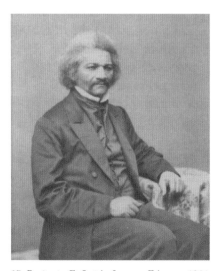

25. Benjamin F. Smith (1830–1927), January–February 1864. 153 Middle Street, Portland, Maine. Carte-de-visite, 2½ × 4 in. Cornell.

26. Benjamin F. Smith, January–February 1864. 153 Middle Street, Portland, Maine. Carte-de-visite, 2½ × 4 in. NPS; FDP.

27. Benjamin F. Smith, January–February 1864. 153 Middle Street, Portland, Maine. Carte-de-visite, 2½ × 4 in. NPS.

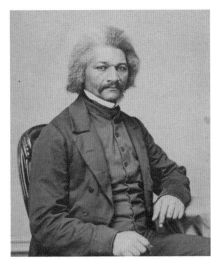

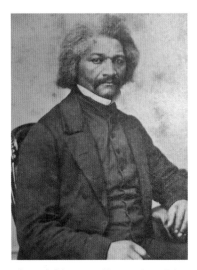

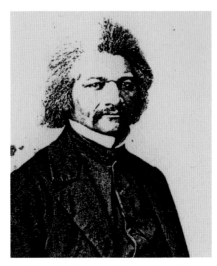

28. Samuel Montague Fassett (1825–1910), late Feb. 1864. 122 and 124 Clark St., Chicago, Ill. Carte-de-visite, 2½ × 4 in. NPS; CHM; OHS; BFRC; GLI; NYHS; Beinecke; KSHS; ACM; FDP; Princeton; Avery; NBWM; NYPL; Emory; Greg French, Clements.

29. Samuel Montague Fassett, late February 1864. 122 and 124 Clark Street, Chicago, Illinois. Carte-de-visite, 2½ × 4 in. AC.

30. Samuel Montague Fassett, late February 1864. 122 and 124 Clark Street, Chicago, Illinois. Carte-de-visite, 2½ × 4 in. MSRC.

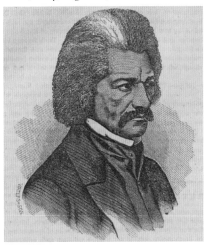

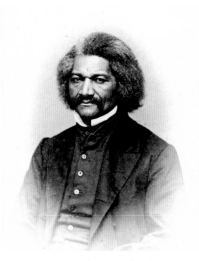

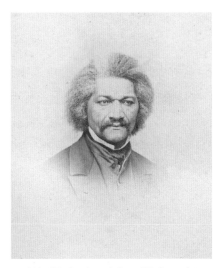

31. Samuel Montague Fassett, late February 1864. 122 and 124 Clark Street, Chicago, Illinois. Waters & Son, engraving from a lost photograph, 2 × 3 in. *American Phrenological Journal*, (May 1866): 148.

32. Alfred B. Crosby (1836–1879) and Israel Warren Merrill (1830–1894), early April 1864. Main Street, Farmington, Maine. Carte-de-visite, 2½ × 4 in. Boston Athenæum.

33. Alfred B. Crosby and Cyrus W. Curtis (1833–1903), early April 1864. 138 Lisbon Street, Lewiston, Maine. Carte-de-visite, 2½ × 4 in. Greg French.

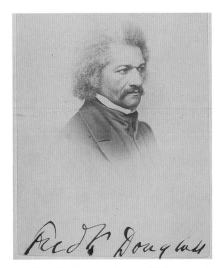

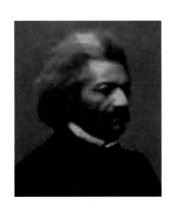

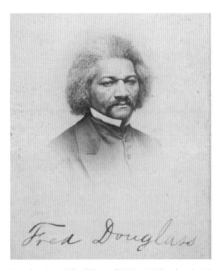

34. Alfred B. Crosby and Cyrus W. Curtis, early April 1864. 138 Lisbon Street, Lewiston, Maine. Carte-de-visite, 2½ × 4 in. Sold by R. R. Auction, 401.140.

35. Alfred B. Crosby and Cyrus W. Curtis, early April 1864. 138 Lisbon Street, Lewiston, Maine. Carte-de-visite, 2½ × 4 in. NPS.

36. Stephen H. Waite (1832–1906), April 15, 1864. 271 Main Street, Hartford, Connecticut. Carte-de-visite, 2½ × 4 in. CHS.

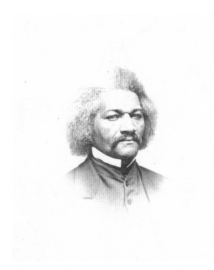

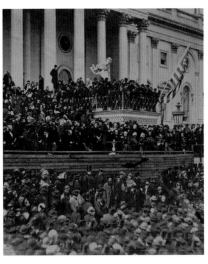

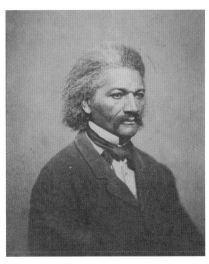

37. Stephen H. Waite, April 15, 1864. 271 Main Street, Hartford, Connecticut. Carte-de-visite, 2½ × 4 in. CHS.

38. Alexander Gardner (1821–1882), March 4, 1865. U.S. Capitol, Washington, D.C. Matte collodion print, 6⅞ × 9½ in. LC.

39. Henry P. Rundel (1844–1886) and Charles Warren Woodward (1836–1894), c. 1865. 126 State Street, Rochester, New York. Carte-de-visite, 2½ × 4 in. Beinecke; RPL; MSRC.

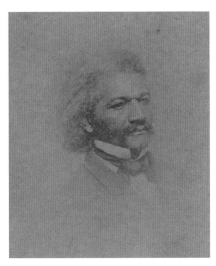

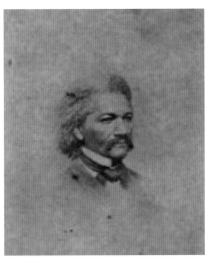

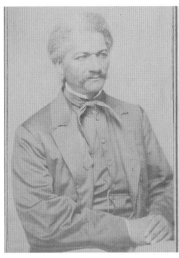

40. Henry P. Rundel and Charles Warren Woodward, c. 1865. 126 State Street, Rochester, New York. Carte-de-visite, 2½ × 4 in. NPS.

41. Henry P. Rundel and Charles Warren Woodward, c. 1865. 126 State Street, Rochester, New York. Carte-de-visite, 2½ × 4 in. Sold at auction on eBay, 2007.

42. Unknown photographer, c. 1865. Carte-de-visite, 2½ × 4 in. Sold by PBA Galleries, 400.70.

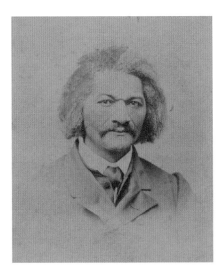

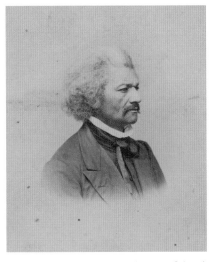

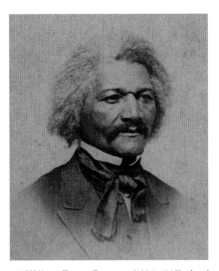

43. John White Hurn. February 8, 1866. 1319 Chestnut Street, Philadelphia, Pennsylvania. Carte-de-visite. 2½ × 4 in. NPS.

44. H. N. Roberts, late March 1866. Gilman's Block, Madison, Wisconsin. Carte-de-visite, 2½ × 4 in. KSHS.

45. William Emory Bowman (1834–1915), April 1866. Court Street, Ottawa, Illinois. Carte-de-visite, 2½ × 4 in. AAS.

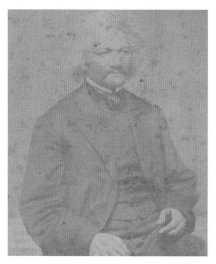

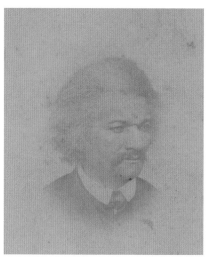

46. L. E. Gibbs (1810–1875), April 1866. The National Gallery, Main and LaSalle Streets, Ottawa, Illinois. Carte-de-visite, 2½ × 4 in. NPS.

47. Newton Briggs (1830–1911), April 1866. 4 Main Street, Galesburg, Illinois. Carte-de-visite, 2½ × 4 in. NPS.

48. J. Marsden Fox (1825–1901) and Menzo Edgar Gates (1832–1890), c. 1866. Concert Hall, 40 and 42 State Street, Rochester, New York. Carte-de-visite, 2½ × 4 in. Harvard University Archives.

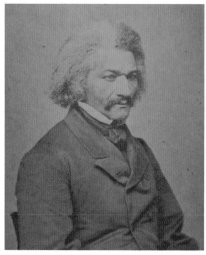

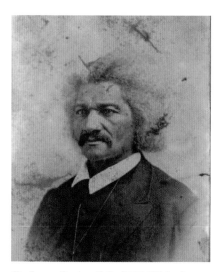

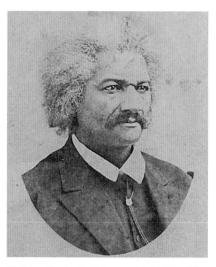

49. Isaac G. Tyson (1833–1913), early September 1866. 240 North 8th Street, Philadelphia, Pennsylvania. Carte-de-visite, 2½ × 4 in. HSP; MSRC.

50. James Presley Ball (1825–1904), January 12, 1867. 30 West 4th Street, Cincinnati, Ohio. Carte-de-visite, 2½ × 4 in. CHLA.

51. James Presley Ball, January 12, 1867. 30 West 4th Street, Cincinnati, Ohio. Carte-de-visite, 2½ × 4 in. Sold by Cowan's, 06.13.14, #423.

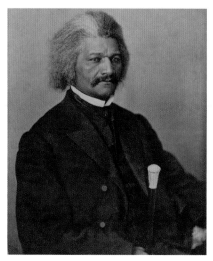

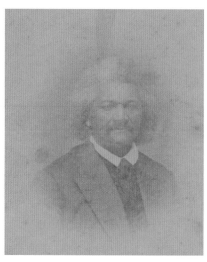

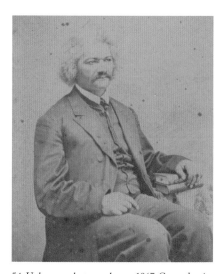

52. Samuel Root (1819–1889), February–March 1867. 166 Main Street, Dubuque, Iowa. Carte-de-visite, 2½ × 4 in. GLI.

53. Austin Kracaw (1833–1886), February–March 1867. Post Office Building, Washington, Iowa. Carte-de-visite, 2½ × 4 in. NPS.

54. Unknown photographer, c. 1867. Carte-de-visite, 2½ × 4 in. NPS.

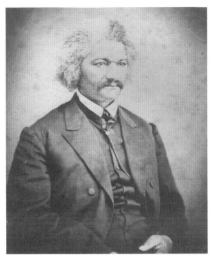

55. Unknown photographer, c 1867. Carte-de-visite, 2½ × 4 in. LC.

56. Dayton Morgan (1842–1914), 1868. Life-sized plaster bust from a lost photograph, 28¼ × 20 in. Sold by SAG, 2342.47.

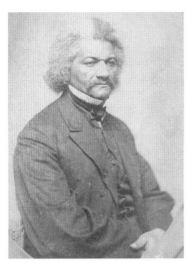

57. Unknown photographer, c. 1868. Carte-de-visite, 2½ × 4 in. NPS.

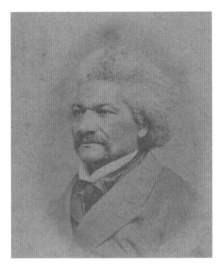

58. Benjamin E. Hawkins, March 1868. 417 Market Street, Steubenville, Ohio. Carte-de-visite, 2½ × 4 in. NPS.

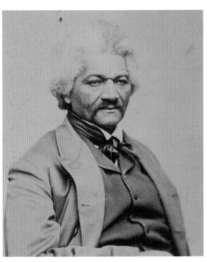

59. James Hiram Easton (1828–1900), February–March 1869. Broadway, Rochester, Minnesota. Carte-de-visite, 2½ × 4 in. KSHS.

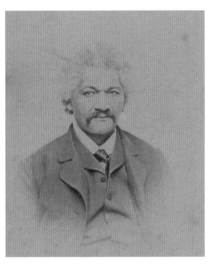

60. J. E. Small, February–March 1869. Berlin, Wisconsin. Carte-de-visite, 2½ × 4 in. NPS.

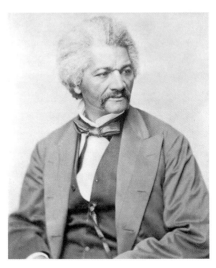

61. George Francis Schreiber (1804–1892), April 26, 1870. 818 Arch Street, Philadelphia, Pennsylvania. Carte-de-visite, 2½ × 4 in. LC; NPS; NPG; MSRC; Smith; Chris Webber.

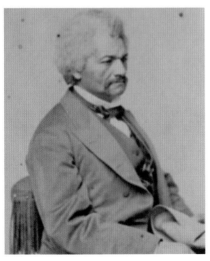

62. George Francis Schreiber, April 26, 1870. 818 Arch Street, Philadelphia, Pennsylvania. Carte-de-visite, 2½ × 4 in. MSRC.

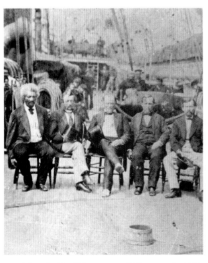

63. Oliver B. Buell (1844–1910), January 17, 1871. Deck of the USS *Tennessee*, Key West, Florida. Stereoview, 3½ × 7 in. MCPL.

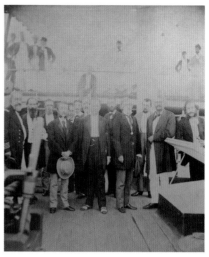

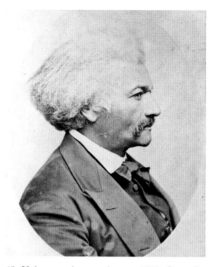

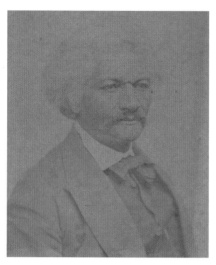

64. J. S. Thompson, March 26, 1871. Deck of the USS *Tennessee*, Charleston, South Carolina. Albumen print, 10½ × 12½ in. ACM; Emory.

65. Unknown photographer, c. 1871. Carte-de-visite, 2½ × 4 in. LC; NPS.

66. Unknown photographer, c. 1871. Carte-de-visite, 2½ × 4 in. NPS; MSRC.

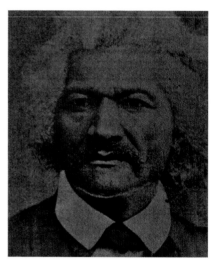

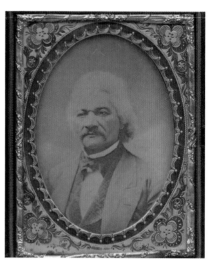

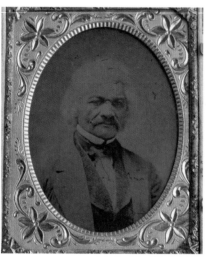

67. Unknown photographer, c. 1872. Albumen print, 9 × 11 in. NPS; Schomburg.

68. Unknown photographer, c. 1872. Quarter-plate ambrotype, 3¼ × 4¼ in. NMAAHC.

69. Unknown photographer, c. 1872. Quarter-plate ambrotype, 3¼ × 4¼ in. Sold by SAG, 2204.33.

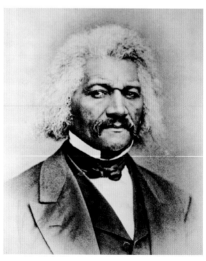

70. James M. LeClear (1837–1914), late January 1873. Jackson, Michigan. Carte-de-visite, 2½ × 4 in. Duke.

71. John White Hurn, March 10, 1873. 1319 Chestnut Street, Philadelphia, Pennsylvania. Carte-de-visite, 2½ × 4 in. LC; GEH.

72. John White Hurn, March 10, 1873. 1319 Chestnut Street, Philadelphia, Pennsylvania. Carte-de-visite, 2½ × 4 in. NPS.

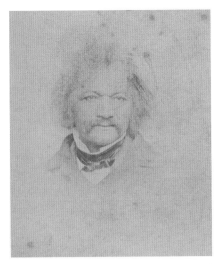

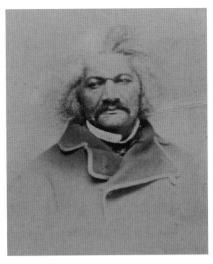

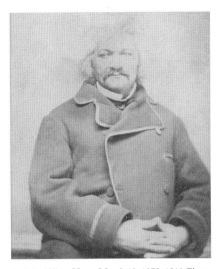

73. John White Hurn, March 10, 1873. 1319 Chestnut Street, Philadelphia, Pennsylvania. Carte-de-visite, 2½ × 4 in. NPS.

74. John White Hurn, March 10, 1873. 1319 Chestnut Street, Philadelphia, Pennsylvania. Carte-de-visite, 2½ × 4 in. MHS.

75. John White Hurn, March 10, 1873. 1319 Chestnut Street, Philadelphia, Pennsylvania. Carte-de-visite, 2½ × 4 in. Author's collection.

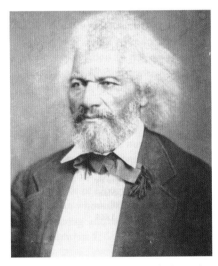

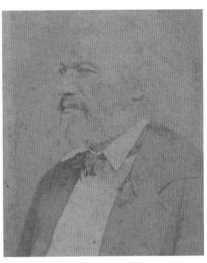

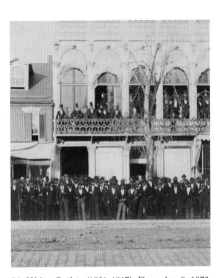

76. Carl Casper Giers (1828–1877), September 1873. 43–45 Union Street, Nashville, Tennessee. Carte-de-visite, 2½ × 4 in, MSRC.

77. Carl Casper Giers, September 1873. 43–45 Union Street, Nashville, Tennessee. Carte-de-visite, 2½ × 4 in. NPS.

78. Walter Ogilvie (1831–1917), December 9, 1873. National Equal Rights Convention meeting, Metzerott Hall, 925 Pennsylvania Avenue, Washington, D.C. Cabinet card, 4¼ × 6½ in. LC.

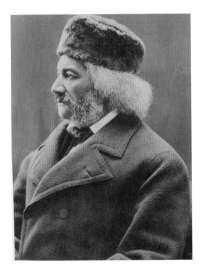

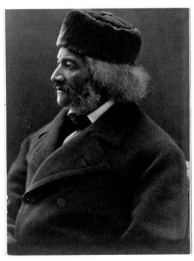

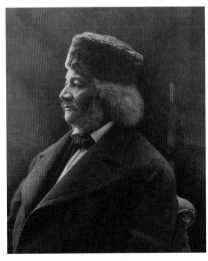

79. John Howe Kent (1827–1910), January 26, 1874. 58 State Street, Rochester, New York. Cabinet card, 4¼ × 6½ in. RPL; OHS; Lavery.

80. John Howe Kent, January 26, 1874. 58 State Street, Rochester, New York. Cabinet card, 4¼ × 6½ in. GEH.

81. John Howe Kent, January 26, 1874. 58 State Street, Rochester, New York. Cabinet card, 4¼ × 6½ in. NPS.

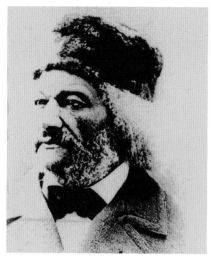

82. John Howe Kent, January 26, 1874. 58 State Street, Rochester, New York. Cabinet card, 2½ × 4 in. MSRC; NSHS.

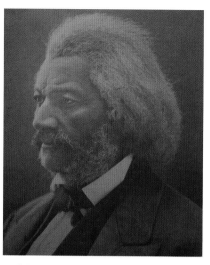

83. John Howe Kent, January 26, 1874. 58 State Street, Rochester, New York. Cabinet card, 4¼ × 6½ in. Beinecke; MSRC; RPL.

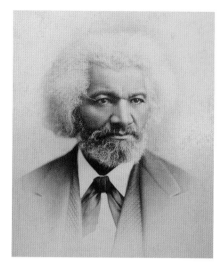

84. Lydia J. Cadwell (1837–1896), January 5, 1875. 103 State Street, Chicago, Illinois. Cabinet card, 4¼ × 6½ in. CHM.

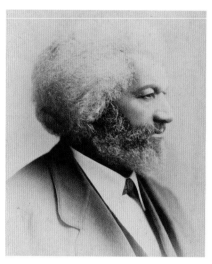

85. Lydia J. Cadwell, January 5, 1875. 103 State Street, Chicago, Illinois. Cabinet card, 4¼ × 6½ in. Beinecke; ACM; Lavery.

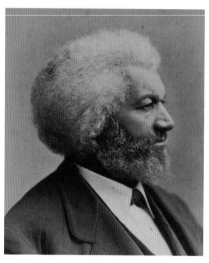

86. Lydia J. Cadwell, January 5, 1875. 103 State Street, Chicago, Illinois. Cabinet card, 4¼ × 6½ in. KSHS.

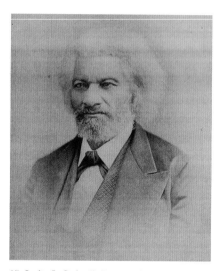

87. Lydia J. Cadwell, January 5, 1875. 103 State Street, Chicago, Illinois. Cabinet card, 4¼ × 6½ in. MSRC.

MISSING FROM ARCHIVE

AS OF 2013

88. Charles Delevan Mosher (1829–1897), c. 1875. 125 State Street, Chicago, Illinois. Cabinet card, 4¼ × 6½ in. CHM.

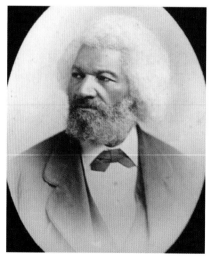

89. S. H. McLoughlin, from a negative held by the Redpath Lyceum Bureau, c. 1876. 36 Bromfield Street, Boston, Massachusetts. Lantern slide, 3¼ × 4¼ in. Sold at auction on eBay, 2014.

90. William W. Core (1853–1890), 1876. Douglass's house at 316A Street NE, Washington, D.C. Albumen print, 10½ × 12½ in. NPS.

91. William W. Core, 1876. Douglass's house at 316 A Street NE, Washington, D.C. Albumen print, 16 × 20 in. NPS; FDM.

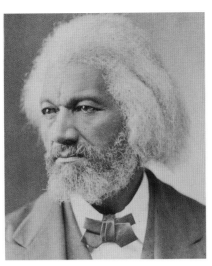

92. Mathew B. Brady (1822–1896), c. 1877. 625 Pennsylvania Avenue, Washington, D.C. Carte-de-visite, 2½ × 4 in. Beinecke; MSRC; CHM; LC; NMAH; Huntington Library.

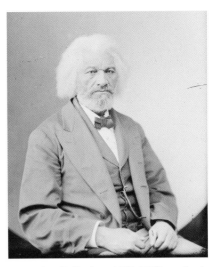

93. Mathew B. Brady, c. 1877. 625 Pennsylvania Avenue, Washington, D.C. Stereoview, 5 × 7 in. LC; NYHS.

94. Unknown photographer, August 8, 1877. Ocean House, Old Orchard Beach, Maine. Mounted albumen print, 6½ × 9¼. MSA.

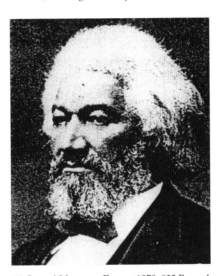

95. Samuel Montague Fassett, 1878. 925 Pennsylvania Avenue NW, Washington, D.C. Carte-de-visite, 2½ × 4 in. MSRC.

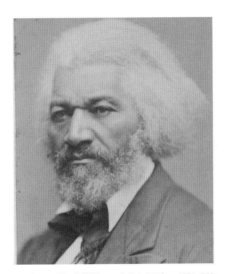

96. George Kendall Warren (1824–1884), c. 1879. 289 Washington St., Boston, Mass. Carte-de-visite, 2½ × 4 in. Author's collection; Beinecke; NPS; NPG; NARA; Schomburg; GLI; NYPL; NYHS; NAMA; LCP; WHS; Harvard; Clements; Princeton; Greg French.

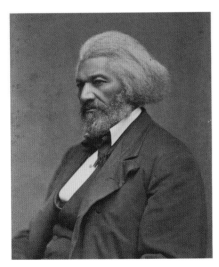

97. George Kendall Warren, c. 1879. 289 Washington Street, Boston, Massachusetts, Cabinet card, 4¼ × 6½ in. MMA; NPG; CHM; NBWM; MHS; AC; ACPL; Beinecke.

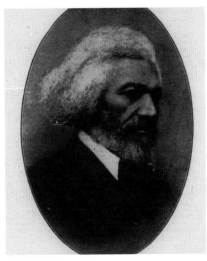

98. George Kendall Warren, c. 1879. 289 Washington Street, Boston, Massachusetts. Carte-de-visite, 2½ × 4 in. NPS-MW.

99. Unknown photographer, c. 1879. Engraving from a lost photograph. LC.

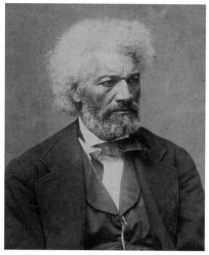

100. Luke C. Dillon (1844–1886), c. 1880. Pullman's Gallery, 935 Pennsylvania Avenue, Washington, D.C. Cabinet card, 4¼ × 6½ in. Lavery; ARC.

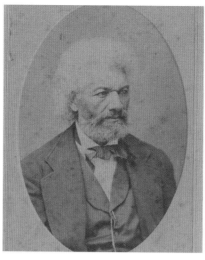

101. Luke C. Dillon, c. 1880. Pullman's Gallery, 935 Pennsylvania Avenue, Washington, D.C. Cabinet card, 4¼ × 6½ in. NPS; BDM.

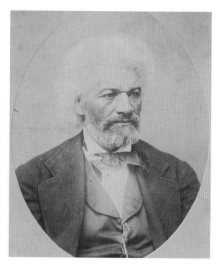

102. Luke C. Dillon, c. 1880. Pullman's Gallery, 935 Pennsylvania Avenue, Washington, D.C. Cabinet card, 4¼ × 6½ in. MiDAH.

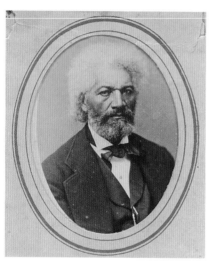

103. Luke C. Dillon, c. 1880. Pullman's Gallery, 935 Pennsylvania Avenue, Washington, D.C. Carte-de-visite, 2½ × 4 in. MiDAH.

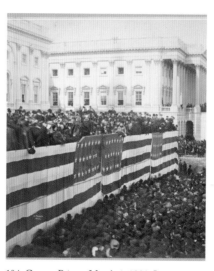

104. George Prince, March 4, 1881. Inauguration of President Garfield, U.S. Capitol, Washington, D.C. Albumen print, 7 × 9 in. LC.

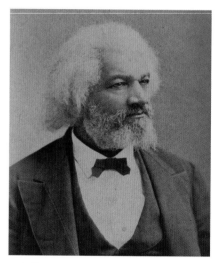

105. Charles Milton Bell (1848–1893), c. 1881. 463 and 465 Pennsylvania Avenue, Washington, D.C. Cabinet card, 4¼ × 6½ in. Beinecke; Schomburg; LC; GLI; NYHS; CHM; AUC.

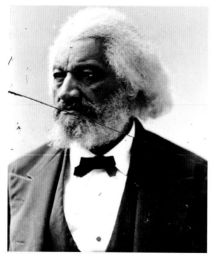

106. Charles Milton Bell, c. 1887. 463 and 465 Pennsylvania Avenue, Washington, D.C. Wet-plate collodion glass negative, 18 × 22 in. LC.

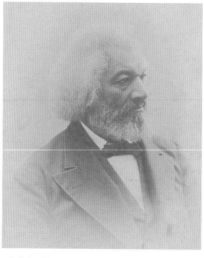

107. John Howe Kent, November 3, 1882. 24 State Street, Rochester, New York. Cabinet card, 4¼ × 6½ in. Beinecke; FDP; MSRC; Lynn; OHS; AARL; Bryn Mawr.

108. Unknown photographer, c. 1883. Engraving from a lost photograph. *Christian Herald*, October 11, 1883, p. 652.

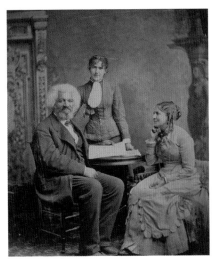

109. Unknown photographer, c. 1884. Albumen print, 8 × 10 in. NPS.

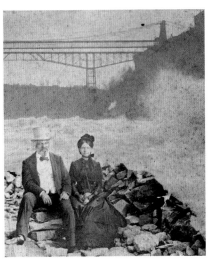

110. Unknown photographer, August 1884. Niagara Falls, New York. Albumen print, 8 × 10 in. NPS.

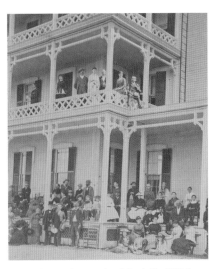

111. Unknown photographer, March 31, 1888. International Council of Women and National Woman Suffrage Association Convention, Washington, D.C. Albumen print, 7 × 9 in. Beinecke; NPS.

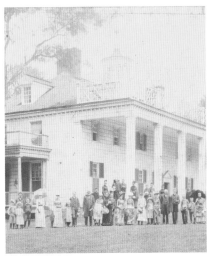

112. Luke C. Dillon, c. 1888. Mount Vernon, Virginia. Albumen print, 7 × 9 in. NPS.

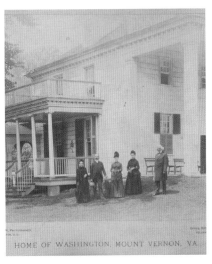

113. Luke C. Dillon, c. 1888. Mount Vernon, Virginia. Albumen print, 7 × 9 in. NPS.

114. Luke C. Dillon, c. 1888. Mount Vernon, Virginia. Albumen print, 7 × 9 in. NPS.

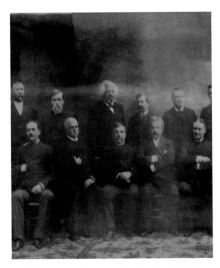

115. Unknown photographer, Early 1889. Members of Benjamin Harrison's Inaugural Executive Committee, Washington, D.C. Albumen print, 16 × 9 in. NPS.

116. Unknown photographer, c. 1889. Albumen print, 7 × 9 in. ACM.

117. W. Watson, c. 1890. Villa Tivoli, 111 Avenue Jean Paul II, Port-au-Prince, Haiti. Albumen print, 8 × 10 in. NPS.

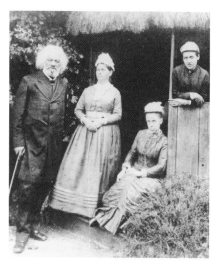

118. W. Watson, c. 1890. Port-au-Prince, Haiti. Albumen print, 4 × 3½ in. NPS; GLI; MSRC.

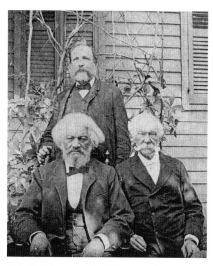

119. W. Watson, c. 1890. Port-au-Prince, Haiti. Albumen print, 5 × 4 in. MSRC.

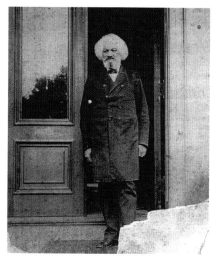

120. W. Watson, c. 1890. Port-au-Prince, Haiti. Albumen print, 8 × 5½ in. MSRC.

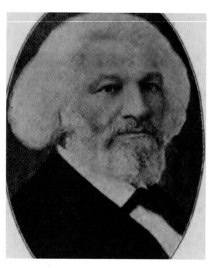

121. Unknown photographer, c. 1891. Drawing from a lost photograph, 2 × 4 in. NPS.

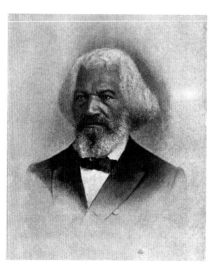

122. Unknown photographer, c. 1891. Engraved frontispiece from a lost photograph. Frederic May Holland, *The Colored Orator* (1891).

123. Unknown photographer, c. 1891. Cedar Hill, 1411 W Street SE, Washington, D.C. Albumen print, 5 × 7 in. NPS; MSRC.

124. Unknown photographer, c. 1891. Cedar Hill, 1411 W Street SE, Washington, D.C. Albumen print, 4 × 6 in. NPS; Walter O. Evans.

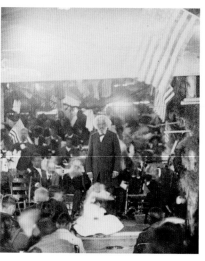

125. Unknown photographer, May 26, 1892. Albumen print, 7½ × 9½ in. The Pavilion, Tuskegee, Alabama. LC; Tuskegee University.

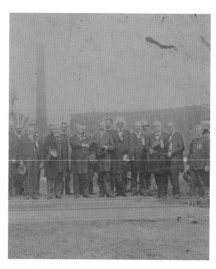

126. John Howe Kent, May 30, 1892. Unveiling of the Soldiers and Sailors Monument, Kodak Park, Rochester, New York. Albumen print, 9 × 7 in. RPL; FDP; GEH.

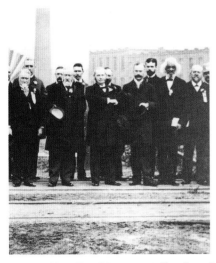

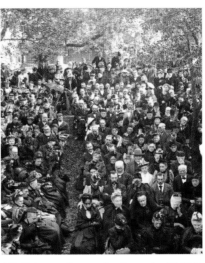

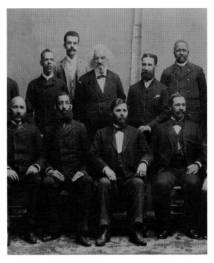

127. John Howe Kent, May 30, 1892. Unveiling of the Soldiers and Sailors Monument, Kodak Park, Rochester, New York. Albumen print, 9 × 4 in. NPS.

128. Unknown photographer, September 10, 1892. 86 Friend Street, Amesbury, Massachusetts. Albumen print, 7½ in × 4½ in. NPS; WPL; Houghton.

129. Unknown photographer, c. 1892. Washington, D.C. Albumen print. 9½ × 11½ in. Anna Roelofs.

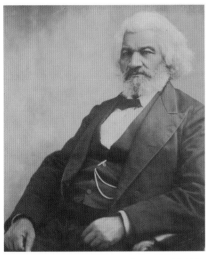

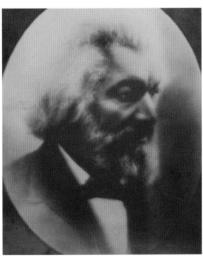

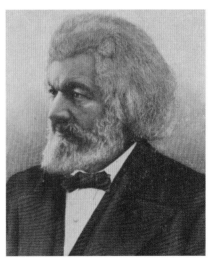

130. Cornelius Marion Battey (1873–1927), February 1893. 402 Fifth Avenue, New York, New York. Gelatin silver print, 9 × 7 in. NMAAHC; Columbia; RPL; Schomburg; MSRC.

131. Cornelius Marion Battey, February 1893. 402 Fifth Avenue, New York, New York. Albumen print, 8 × 10 in. Sherry Howard.

132. Cornelius Marion Battey, February 1893. 402 Fifth Avenue, New York, New York. Engraving from lost photograph, 3 × 2 in. in John W. Cromwell, *The Negro in American History* (1914), p. 114.

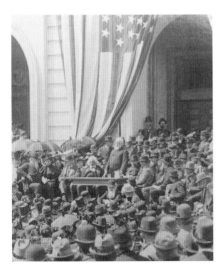

MISSING FROM ARCHIVE

AS OF 2013

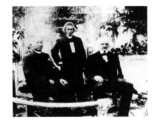

133. C. D. Arnold (1844–1927), May 1893. World's Columbian Exposition, Illinois Building, Chicago, Illinois. Albumen print, 10 × 14 in. CHM.

134. Alfred Brisbois (1854–1925), c. 1893. 125 State Street, Chicago, Illinois. Cabinet card, 4¼ × 6½ in. CHM.

135. Unknown photographer, June 15, 1893. Graduation at Wilberforce University, Ohio. Albumen print, 5 × 4 in. Wilberforce University.

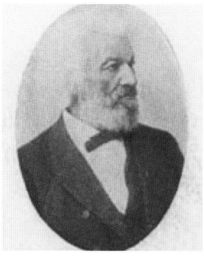

136. Unknown photographer, c. 1893. Print from a lost photograph in Horace Talbert, *The Sons of Allen* (1906), p. 279.

137. Unknown photographer, c. 1893. Washington, D.C. Albumen print, 8 × 10 in. NPS.

138. Unknown photographer, c. 1893. Cedar Hill, 1411 W Street SE, Washington, D.C. Albumen print, 9 × 7 in. NPS.

139. Unknown photographer, c. 1893. Cedar Hill, 1411 W Street SE, Washington, D.C. Albumen print, 9 × 7 in. NPS.

140. Unknown photographer, c. 1893. Cedar Hill, 1411 W Street SE, Washington, D.C. Albumen print, 10 × 6 in. NPS.

141. Unknown photographer, c. 1893. Cedar Hill, 1411 W Street SE, Washington, D.C. Albumen print, 3½ × 2½ in. MSRC.

142. Unknown photographer, c. 1893. Cedar Hill, 1411 W Street SE, Washington, D.C. Postcard print, 6 × 4 in. NPS; MSRC; Emory; LC.

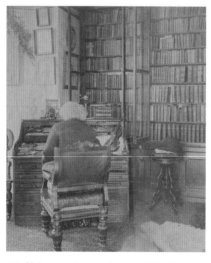

143. Unknown photographer, c. 1893. Library at Cedar Hill, 1411 W Street SE, Washington, D.C. Albumen print, 9 × 7 in. NPS.

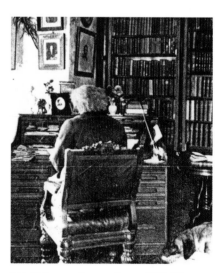

144. Unknown photographer, c. 1893. Library at Cedar Hill, 1411 W Street SE, Washington, D.C. Albumen print, 9 × 7 in. NPS; MSRC.

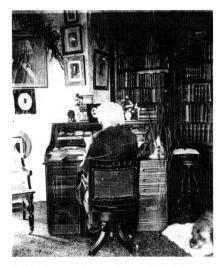

145. Unknown photographer, c. 1893. Library at Cedar Hill, 1411 W Street SE, Washington, D.C. Albumen print, 9 × 7 in. NPS; MSRC.

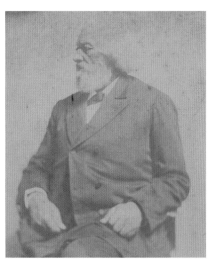

146. Unknown photographer, c. 1894. Cabinet card, 4¼ × 6½ in. NPS.

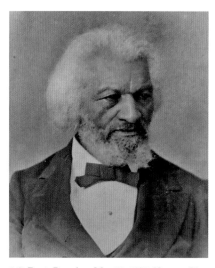

147. Denis Bourdon, May 10, 1894. Notman Photographic Company, 480 Boylston Street, Boston, Massachusetts. Albumen print, 4 × 5½ in. Beinecke; MHS; UVA; LC.

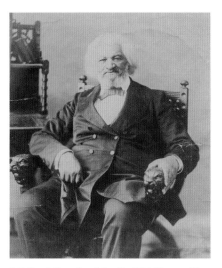

148. Denis Bourdon, May 10, 1894. Notman Photographic Company, 480 Boylston Street, Boston, Massachusetts. Cabinet card, 4¼ × 6½ in. NPS; Beinecke.

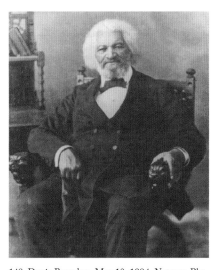

149. Denis Bourdon, May 10, 1894. Notman Photographic Company, 480 Boylston Street, Boston, Massachusetts. Cabinet card, 4¼ × 6½ in. LC; Schomburg.

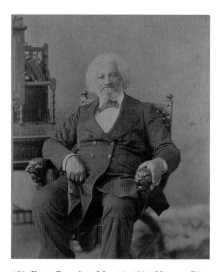

150. Denis Bourdon, May 10, 1894. Notman Photographic Company, 480 Boylston Street, Boston, Massachusetts. Cabinet card, 4¼ × 6½ in. Schlesinger; Smith.

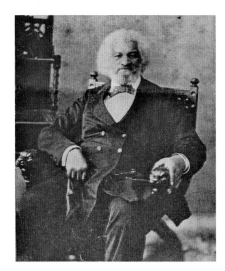

151. Denis Bourdon, May 10, 1894. Notman Photographic Company, 480 Boylston Street, Boston, Massachusetts. Cabinet card, 4¼ × 6½ in. ARC.

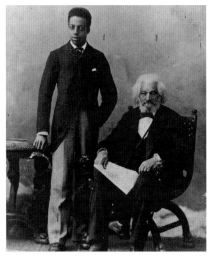

152. Denis Bourdon, May 10, 1894. Notman Photographic Company, 480 Boylston Street, Boston, Massachusetts. Cabinet card, 4¼ × 6½ in. Beinecke; LC; MSRC; Walter O. Evans.

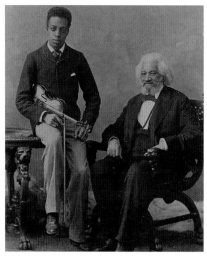

153. Denis Bourdon, May 10, 1894. Notman Photographic Company, 480 Boylston Street, Boston, Massachusetts. Cabinet card, 4¼ × 6½ in. Schlesinger.

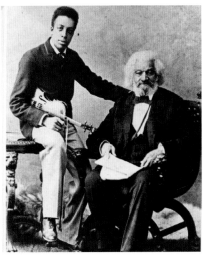

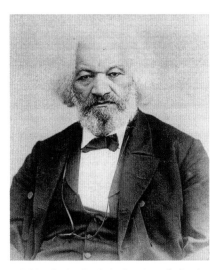

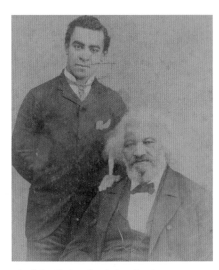

154. Denis Bourdon, May 10, 1894. Notman Photographic Company, 480 Boylston Street, Boston, Massachusetts. Cabinet card. 4¼ × 6½ in. LC; MSRC.

155. John Corbin Sunderlin (1835–1911), October 1894. 110–112 Main Street, Flemington, New Jersey. Cabinet card, 4¼ × 6½ in. MSRC.

156. John Corbin Sunderlin, October 1894. 110–112 Main Street, Flemington, New Jersey. Cabinet card, 4¼ × 6½ in. NPS.

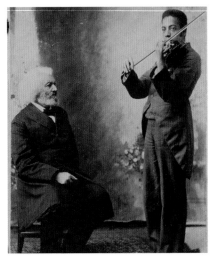

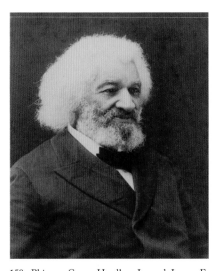

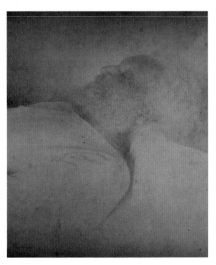

157. Phineas Camp Headley, Jr. (1858–1921), and James E. Reed (1864–1939). October 31, 1894. 5 Purchase Street, New Bedford, Massachusetts. Cabinet card, 4¼ × 6½ in. Beinecke; LC.

158. Phineas Camp Headley, Jr. and James E. Reed, October 31, 1894. 5 Purchase Street, New Bedford, Massachusetts. Cabinet card, 4¼ × 6½ in. NBWM.

159. Unknown photographer, February 21, 1895. Cedar Hill, 1411 W Street SE, Washington, D.C. Cabinet card, 4¼ × 6½ in. NPS.

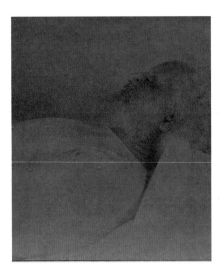

160. Unknown photographer, February 21, 1895. Cedar Hill, 1411 W Street SE, Washington, D.C. Cabinet card, 4¼ × 6½ in. NPS.

Epilogue:

Frederick Douglass's Camera Obscura: Representing the Anti-Slave "Clothed and In Their Own Form"

Henry Louis Gates, Jr.

And, when it lists him, waken can
Brute or savage into man.

—EMERSON, "FREEDOM," 1854

So now it seems to me that the arrival of such men as Toussaint if he
is pure blood, or Douglas [sic] if he is pure blood, outweighs all the
English & American humanity. The Antislavery of the whole world
is but dust in the balance, a poor squeamishness & nervousness[;] the
might & the right is here. Here is the Anti-Slave . . . now let them
emerge, clothed and in their own form.

—EMERSON, HOLOGRAPH, FIRST DRAFT OF EMERSON'S "EMANCIPATION OF
THE NEGROES IN THE WEST INDIES," 1844

If in all ideology men and their relations appear upside-down as in
a *camera obscura*, this phenomenon arises just as much from their
historical life-process as the inversion of objects on the retina does
from their physical life-process.

—KARL MARX, *THE GERMAN IDEOLOGY* (1845–47)

In October 1923, in his monthly column for *The Crisis* magazine,
W. E. B. Du Bois wondered, "Why do not more young colored men
and women take up photography as a career? The average white pho-

tographer does not know how to deal with colored skins and having neither sense of the delicate beauty or tone nor will to learn, he makes a horrible botch of portraying them."[1] Du Bois knew whereof he spoke, as both curator and subject. He pioneered the use of photography to introduce "The New Negro" to the world in his American Negro Exhibit of 363 photographs of African American life (masterfully selected for maximum political effect) at the Paris Exposition in 1900. As a trained historian, moreover, Du Bois well understood a simple rule for ensuring one's immortality: stage events of potential historical import, and have them photographed, preferably with one's self positioned at the center of the image, which Du Bois so frequently did.

Du Bois is recorded in an extraordinary number of photographs, often positioning himself in profile against the face-forward poses of his historical fellow travelers, the prophetic voice, the helmsman, poised to lead either with or against the grain. So the point he was making about the rather uneven quality of the tones of black skin and the texture of black hair captured on film, I would imagine, was something that he had noticed in photographs of himself and other black subjects, since black skin reflects (and that is the key word here) a wide range of phenotypes, and is a full f/stop different, on average, from white skin.

The problem of capturing texture and detail in a photographic scene composed of elements of different luminance (for Du Bois's purposes, lighter and darker skin and hair than those of standard white subjects) gave birth to the "Zone System," attributed to Ansel Adams and Fred Archer, and made popular, for my generation of photography students, in a book of that title by the great photographer Minor White, which was required reading when I studied photography as an undergraduate at Yale. The Zone System teaches a photographer to see the subjects in a scene as a range of ten "brightness values," ranging from 0 to 10, with 0 as the blackest-black, 10 as the whitest-white, and 5 as neutral gray. The skin of a white person, on average, would fall into Zone 5, but the skin of a black person, on average, would fall into Zone 4. And a black person's hair, depending on color and texture, could fall into Zone 3, or really somewhere in between. The difference between zones is equivalent to a full f/stop.[2]

If a photographer meters a scene consisting of the range of light and dark elements found in, say, a group of black and white people, or even a group of black people, considering the great diversity of colors and hair textures embraced by the terms "black" or "African American," with a meter that averages the light being reflected off of the various subjects in the scene, the darker elements in the photograph will be underexposed, appearing flat, textureless, and gray. This technological problem

is solved in the simplest and cleverest of ways: using a reflected light exposure meter (we used a Luna-Pro hand meter) to meter the darkest areas of the scene in which the photographer wants detail and texture to appear in the developed negative, and setting the camera's f/stop to that reading, rather than to the average of the overall scene. This is a solution that any outstanding photographer of black subjects, such as Carl Van Vechten or Gordon Parks, had to figure out in one way or another, even if he or she never heard of the Zone System. In general, metering for values in the darker elements of a photographic scene means a longer exposure time or a larger aperture opening, so that the darker "zones" can be exposed to more light as the photograph is being taken. The result is much greater detail in black skin and black hair textures, both on the head and in beards and eyebrows.

This is not a problem that would have plagued Du Bois's hero, Frederick Douglass, or that marred photographs of him, since daguerreotypes, ambrotypes, and other genres deriving from plate cameras depended on long exposures for all of the subjects they were used to photograph. And that long exposure time is why early portrait photographers often used headrests to lock their subjects into place, to keep them from moving, since any movement during that time would have blurred the resulting image.[3]

Large-format cameras render subjects in greater detail, in general, than 35mm photographs possibly can. The reason? Resolution: a 4x5-inch image is approximately *sixteen* times the total resolution of a 35mm image. And since Du Bois revered Douglass, even writing several drafts of a poem he never published on his feelings about his hero's passing upon hearing of Douglass's death in 1895, this is something that he probably noticed when studying Douglass's image in black-and-white. Indeed, the photographs of Frederick Douglass so carefully gathered together in this volume are remarkable for the sheer technical quality with which they have represented the tones and textures of their black subject's skin and hair, as well as a remarkable degree of detail in the subject's clothes. It is difficult to imagine that Douglass failed to notice how crucially the depth of field and exposure time related to the images of himself he most frequently circulated. Since he was photographed more than any other American of his time, and since, as John Stauffer explains, "he had his pick among photographers and the photo shoot was a kind of *pas de deux* between him and the photographer,"[4] it shouldn't surprise us that Douglass not only used photographic images of himself, like he used his oratory, in the battle to end slavery, first, and to ensure for the Negro full citizenship rights, second, but he also *theorized* about photography, about its nature and its uses.

Douglass was, by all accounts, a master orator on his feet, summoning rhetorical tropes and figures seemingly at will to maximum effect. For someone so urgently concerned with effecting immediate political change, he was extraordinarily patient in making his case, drawing upon a storehouse of rhetorical strategies to make that case most effectively and eloquently. One of his favorite tropes was chiasmus, repeating two or more words or clauses or grammatical constructions, balanced against each other in reverse order, a rhetorical *x*, somewhat akin to a linguistic seesaw: "You have seen how a man was made a slave; you shall see how a slave was made a man."[5] Repetition with a difference, as any good musician knows, can produce a most delightful effect in a keen listener.

And since chiasmus always entails a form of reversal, its potentially political uses are as great as its aesthetic uses, particularly if one is a fugitive slave implicitly making the case for his common humanity with his white reader through the text that reader is holding in her or his hands. Here, rhetoric is called upon to reverse the world's order, the order in which the associations between "slave" and "black" and "white" and "free" appear to have been willed, fixed, and natural. To reverse this supposedly "natural" order of things, to show that what seemed fixed was actually arbitrary (and evil), Douglass seized on the political potential inherent in this figure of reversals as the overarching rhetorical strategy of his carefully crafted first book—*Narrative of the Life of Frederick Douglass, an American Slave. Written by Himself*—which can be read as an extended chiasmus itself.[6]

Douglass sets out, through a series of binary oppositions that comprise his extended chiasmus, the salient characteristics of the world the master had made, as these occur to the slave child. Masters are your fathers; slaves are your mothers. Masters are white and ride in carriages when the sun is high, drawn by horses; slaves are black and arrive on foot in the middle of the night. Slaves tell time by the cycle of the seasons and the planting, growing, and harvesting of crops; masters mark time by the calendar, linear time. Masters know their exact birth date; slaves cannot. Masters figure the realm of Culture, which they also inhabit; slaves figure Nature, which they are thought to embody. Masters connote and carry civilization, culture; slaves denote and embody savagery, barbarity.

Then, all of a sudden, Douglass reverses these associations, turning them upside down just as surely as if he had grabbed the two branches on each side of the *x* of the chiasmus with both hands and flipped them, showing that we had gotten these associations wrong all along, that there was nothing natural or fixed about them after all; that they were

constructed, arbitrary, and, in fact, evil perversions of the natural order of things in which all men and women are meant to have equal rights. The world the planters have made shows that it is they who are the real beasts, the cannibals, because they consume their own flesh, consuming the children whom they have fathered, through rape and adultery, ensuring that those children remain slaves by violating one of the most sacred tenets of Western civilization, that the child should follow the condition of the father, not the mother.

What's more, he argues, the planters have converted subjects to objects, and turned human beings into property, sentient beings to things. This is a world in which human beings have been reified into property, the strangest and most barbaric reversal of all, a world in which an abstraction, an idea, has not only been treated as if it were real, natural, concrete, but also *institutionalized*. Douglass's job, the political work of his rhetoric, is to strip away the veil behind which this universe of illusion operates, defining its functional processes and machinery and unveiling its systems, apparatuses, and the functional processes by means of which it operates, thereby subverting its claims to be natural and fixed, along the way revealing the identity of the culprits who constructed this perverted apparatus and of the cannibals who eat their own children.

Slavery, Douglass is saying, is an abstraction that we have mistaken for the concrete, an idea that we have confused with the eternally real. On the strength of his mastery of figures and tropes, Douglass summoned his powerful rhetorical x to destroy this world order, as if his words possessed the might of the power of the *logos*, the power to make and unmake worlds. Slavery is, in the end, an arbitrary set of power relations not a fixed, *natural* entity, a manifestation of an idea in which the social is expressed through the traded, in which subjects ("You have seen how a man became a slave," Douglass says) are turned into objects, rendered passive and determined. Once exposed for what it is, the world the master has fabricated can be destroyed, "x"-ed, as it were, out: now "you shall see how a slave was made a man."[7]

The apparatus of the *camera obscura* is the optical counterpart of chiasmus, literally, the x at the back of the box, the mechanism that reproduces, rotates, and reverses a scene, transforming it into an image flipped 180 degrees. And here, Douglass anticipated Marx: "If in all ideology men and their relations appear upside-down as in a *camera obscura*, this phenomenon arises just as much from their historical life-process as the inversion of objects on the retina does from their physical life-process."[8] The camera obscura is the device that turns the natural visual world upside down. It is the device that made photography and the

camera possible. (Insertion of a mirror reverses the image so that what is being filmed appears "normal.")

And the large format of early cameras, the cameras that photographed Frederick Douglass—plate cameras, such as daguerreotype (which could also be used to make tintypes and ambrotypes) and wet-plate collodion cameras—demanded long shutter speeds to imprint the image onto photographic plates shielded from light in the enclosed black box. This process yielded photographs with great depth of field, ideal for revealing details of the darker zones of the subject's hair color and texture, the crease, fold, and quality of one's clothes, and, more importantly for Douglass and the black abolitionists, the range of skin colors that even then were all grouped under the rubric of "black." It was this depth of field in the dark zones of a subject or scene, rendered through these long exposures times, that was too often missing in images of black people shot by photographers who "under-metered" or underexposed snapshots of black subjects, turning the darker zones of the black body to neutral, and which led Du Bois to complain in his *Crisis* editorial in 1923 about the graying or erasing of black detail in photographs being created by "the white photographer."

I believe that Du Bois was troubled by the *sameness* that the new roll-film cameras were producing in depicting black subjects; plate cameras, for all of their limitations, were marvels at capturing *difference,* even *differences within difference,* as in the case of the individuality of former slaves. Think of these as "differences from within," black-to-black difference. And Du Bois understood, almost implicitly, why it was important in the larger quest for civil rights to chart the specificity—the uniqueness—of the members of the black community, all the while claiming its unity as a group for political purposes. This was his point when he curated those 363 images of American Negroes and American Negro Life at the American Negro Exhibit at the Paris Exposition in 1900. The range of "black" phenotypes he exhibited—virtually all of them middle or upper class, and a very large proportion of them "black" only in a country with a law of hypo-descent, the so-called "one drop rule" (which became codified with *Plessy v. Ferguson*)—was one of the most astonishing of the various political messages that his exhibition intended to project, revealing both a history of rape and forced race-mixing as well as extraordinarily class-as-color diversity in "a small nation of people," as Du Bois himself described the Negroes in his exhibition, a "nation" larger even than the populations of Canada, Poland, Saudi Arabia, or Australia.[9]

Douglass used photography in the same way, registering, through image of himself after image of himself, that "the Negro," "the slave,"

was as various as any human beings could be, not just in comparison to white people, but even more important, among and *within* themselves. Emerson once mused, in his journals, that "at night all men are black."[10] Douglass would have responded that not even all black men are black at night in exactly the same way; even blackness, as we have seen, occupies distinct "zones." Not only do all black people *not* look alike, Douglass repeatedly is attesting through these photographs, but even one black subject doesn't "look alike" over time; even he varies from self to self, remaining never static, a self always unfolding: dynamic, growing, changing, evolving. "The man is only half himself," Emerson wrote in "The Poet," "the other half is his expression."[11] Douglass manipulated the *expression* of what we have to call his "selves" over at least 160 photographic portraits and three full-length autobiographies.

Douglass made that point, most audaciously, I would say, in the bold manner in which he changed such fundamental details, in his three autobiographies, about the identities or characteristics of his own mother and father. "My father was white, or nearly white," he tells us in 1855, after telling us several times in the first chapter of his slave narrative published just a decade before that "my master was my father."[12] What was Douglass *seeing* when he looked at these selves of his, and what cultural and political *work* was he asking these images, over such a long period of time, to do, both in his own personal quest for fame and in his long-term quest for the larger cause of the freedom, equality, and citizenship of the Negro people?

Though it is astonishing that Frederick Douglass was the most photographed man in nineteenth-century America, as this book's authors tell us, it does not come as a surprise that he was the most photographed black man in the nineteenth century. Why wouldn't Frederick Douglass have been drawn to this seductive technology to further his antislavery political agenda, to show the *variation* in forms of black subjectivity, indeed to display individual black *specificity*, especially his own, in his larger process of becoming "the Representative American man—a type of his countryman," as his friend, the brilliant man of letters Dr. James McCune Smith, would describe him?[13] Even "the representative colored man in the United States" *presented* a range of selves over time. As any biographer of Douglass knows, there was not "a" Frederick Douglass; there were only "Douglasses." And that, for him, was his ultimate claim on being fully and equally and complexly *human*. (After all, we know this about ourselves, don't we?) Not only did the black object actually, all along, embody subjectivity, but this subjectivity evolved and mutated over time. The Frederick Douglass in the first photograph collected in this marvelous book is not the same Frederick Douglass registered in the

book's final photograph. And that, I think, is one of the most important political points about "the nature of the Negro" that Frederick Douglass was able to achieve over a half century, by his manipulation of his own image through the technological wonders of nineteenth-century plate photography.[14]

Douglass was acutely aware that *images* matter, especially when one's rhetorical strategy had been fashioned around the trope of chiasmus, the reversal of the black slave-object into the black sentient citizen-subject. Until mirrors were inserted in the camera's mechanism, even photographs saw the image they were filming as the camera obscura. (As Ellen Driscoll has demonstrated, Douglass's fellow slave Harriet Jacobs also understood all too keenly the workings of the camera obscura. The images projected through a single pinhole of light during Jacobs's seven-year self-imposed captivity in a dark garret in her grandmother's house would have been displayed upside down on the far wall opposite the pinhole.)[15]

Perhaps more than any other former slave who wrote about his or her transformation from enslavement to citizenship, Douglass seems to have understood that the war against slavery and the obliteration and reconstitution of one's black subjectivity assumed many shapes and forms more subtle than armed combat and the passage and enforcement of laws—so many of these operating in the realm of the symbolic and the cultural imaginary. And the battlefield on which he could serve as captain, without peer, was that of the representation through photography of a construct that Ralph Waldo Emerson had named "the Anti-Slave."[16]

Though I was pleased to learn from Len Gougeon and John Stauffer that Emerson and Douglass had met each other at least twice, I had absolutely no doubt that Douglass had carefully devoured Emerson's remarkable speech, "Emancipation of the Negroes in the British West Indies," delivered in Concord on August 1, 1844, in which he tells us what he means by "the Anti-Slave." (See the second epigraph to this essay.) I had become convinced of the direct relationship between that text and Douglass's first slave narrative, published just one year later, through close textual analysis alone. The formal signifying relationship, the call and response, between the two texts seemed palpably obvious to me. So imagine my delight when Len Gougeon told me that Douglass not only read Emerson's speech, he actually heard Emerson deliver it, sat on the stage at the event while doing so, and spoke himself on the same day at the same event, following lunch.[17]

As the first draft of Emerson's speech that day makes clear, Emerson clearly had Frederick Douglass in mind when he conceived of "the

anti-slave" and the crucial importance of black agency to the concept of a genuine emancipation of an enslaved self, since he included Douglass's name along with that of the hero of the Haitian Revolution, Toussaint Louverture. In his final version, however, Emerson deleted Douglass's name, perhaps because he knew Douglass would be sitting on the stage and might be embarrassed, but more likely because he knew that Douglass, as Douglass widely broadcast in his abolitionist speeches himself, was not of "pure blood." Douglass's hecklers would use this fact to question Douglass's use of himself as proof of black-white intellectual equality, which is probably the reason that Douglass transformed his father from a white man to possibly being a "nearly white" mulatto between his first and his second autobiographies. (Paradoxically, Emerson's anti-slave would erase racial difference—"Here is the anti-slave: here is man: and if you have man, black or white is an insignificance"—but a racially mixed man, specifically Douglass, he not of "pure blood," couldn't claim that role.)[18] For a black man to signify on the world's stage as "the anti-slave," Emerson seems to insist, he would have to be "pure" in order to demonstrate the inherent capacities of the African people. I turned to a critic of Emerson, David Bromwich, for a possible explanation of Emerson's motivation for this, and here is what he said: "My guess is that he wanted 'pure blood' for the sake of a pure scientific proof that genius (the genius of leadership and, in the case of Douglass, of language, too) can come from a black man, with absolute assurance that it wasn't white admixture that supplied the spark. Does this reveal Emerson's sincere belief, or was it tactical—i.e., something he thought he should say because his audience needed to hear it? It's impossible to be sure. On the basis of the rest of Emerson, I would guess: he didn't distrust the pseudo-biology *enough* to think he could afford to omit the pedantic qualification."[19] I would agree.

(Gougeon, by the way, traces several direct links between Emerson and Douglass, the latter younger by fifteen years, including the remarkable fact that Douglass actually "transcribed that portion of *The Liberator*'s description of Emerson's second emancipation address"—Emerson would deliver four of these between 1844 and 1849—and boldly wrote to Emerson asking for a complimentary copy of his *Representative Men*, which was published in 1850 though delivered as lectures in 1845 and 1846.)[20]

It is difficult for me to imagine a single text, except for perhaps the Bible, that so obviously influenced the shape of Frederick Douglass's thinking and the forms that his thinking would assume, especially in photographs of himself, other than this incredible speech that Emerson delivered in 1844, the year before Douglass finally sat down and wrote

his first slave narrative. Given the rhetorical structure of his *Narrative,* the effect on Douglass seems to have been electric: "The first of August marks the entrance of a new element into modern politics, namely, the civilization of the negro. A man is added to the human family. Not the least affecting part of this history of abolition is the annihilation of the old indecent nonsense about the nature of the negro." This "old indecent nonsense," of course, was the astonishingly ridiculous idea that the Negro was a beast, an animal, closer on the Great Chain of Being to an ape than to a European human. Lest his point be lost on his antislavery audience gathered in Concord that day on the tenth anniversary of the abolition of slavery in the British Empire, Emerson, for good measure, cites William Wilberforce saying, in 1791, that "we have obtained for these poor creatures the recognition of their HUMAN NATURE, which for a time was most shamefully denied them."[21]

But then he makes his grand point, the point that would so inform Frederick Douglass's sense of himself, his public image, and the relation between representations of his self and the political goals he wished to effect: nature, he writes, "will only save what is worth saving; and it saves not by compassion, but by power. It appoints no police to guard the lion but his teeth and claws; no fort or city for the bird but his wings; no rescue for flies and mites but their spawning numbers, which no ravages can overcome. It deals with men after the same manner."[22]

And how is that? "If they are rude and foolish, down they must go. When at last in a race a new principle appears, an idea—that conserves it; ideas only save races. If the black man is feeble and not important to the existing races, not on a parity with the best race, the black man must serve, and be exterminated. But if the black man carries in his bosom an indispensable element of a new and coming civilization; for the sake of that element, no wrong nor strength nor circumstance can hurt him: he will survive and play his part. . . ." In other words, black people have no choice but to achieve their subjectivity *by themselves*, by fashioning a self through writing, by writing themselves into the discourse of being, as Douglass would do just a year later in his *Narrative of the Life,* but also by "representing" that self, as Emerson expressed it in the climax of his speech, "in their own form":

> The intellect,—that is miraculous! Who has it, has the talisman: his skin and bones, though they were the color of night, are transparent, and the everlasting stars shine through, with attractive beams. . . . I say to you, to save yourself, black or white, man or woman, other help is none. I esteem the occasion of this jubilee to be the proud discovery that the black race can contend with the white: that in the great

anthem which we call history, a piece of many parts and vast compass, after playing a long time a very low and subdued accompaniment, they perceive the time arrived when they can strike in with effect and take a master's part in the music.

"Now," Emerson concludes with what must have struck Douglass as a call to arms, "let them emerge, clothed and in their own form."[23]

"He only who is able to stand alone," Emerson would write in 1854, "is qualified for society." As he put this in his poem "Freedom" that same year:

And, when it lists him, waken can
Brute or savage into man.[24]

Just a year later, Douglass would write, in his revised account of his road from slavery to freedom, that "A man without force is without the essential dignity of humanity. Human nature is so constituted, that it cannot *honor* a helpless man, although it can *pity* him; and even this it cannot do long, if the signs of power do not arise." But this begs the question: How does one broadcast those signs of power, the force of irresistible, inimitable subjectivity? How does one represent a group while at the same time charting the uniqueness of one's self, again, in one's "own form"?[25]

Douglass would, of course, speak, then write, himself into the republic of American letters, during the unfolding of what literary scholars today call the "American Renaissance," a curious term in retrospect, for the literature that emerged during one of the most politically active and contentious movements in American history, the antislavery movement, centered in and around Boston (where William Lloyd Garrison had founded *The Liberator* in 1831). Both the literary movement and the antislavery movement reached their zeniths in the 1850s. Though there are many personal and textual links between the two, Douglass and Emerson most certainly constitute one such direct bridge between them, even if linking these movements seems to have made scholars of literary history uncomfortable.

Douglass would take Emerson's call for the black representative man "to emerge in his own form," the challenge set for him by his friend, Dr. McCune Smith, that he be "the *representative American man*," one step further: by embracing the new technology of photography and repeatedly using that technology to fashion and refashion an image of a physical self, elegantly clothed in his own unique genetic embodiment of that sui generis American ethnic self linked, inextricably and inev-

itably connected, to both black and white: "the mulatto." Black, yes, but white as well. "Black-*ish*." Both and neither, as Charles Chesnutt put it.[26] Was that a disadvantage, this sui generis status of Douglass's? Hardly. As Emerson put it, "The possibility of interpretation lies in the identity of the observer with the observed."[27] And in Douglass's case, his hermeneutical circles were interlocking sets, separate but coinciding, one black, one white. And he stood at the center of the gray area of mixed-race overlap.

While it is true that "Men resemble their contemporaries even more than their progenitors," Emerson says, nonetheless, "He is great who is what he is from nature, and who never reminds us of others." Though Douglass was hardly alone by midcentury as a "mixed-race" American, as he was fond of pointing out in his indictments of the sexual abuse and rape black women slaves suffered at the hands of their masters, and although other black abolitionists, such as Douglass's rival, William Wells Brown, were also the offspring of white fathers, he more than any other of his contemporaries managed to fashion a self that seemed qualitatively unique, embodying Emerson's dictum that "He only who is able to stand alone, is qualified for society."[28] And Douglass used the photographs of himself precisely for this purpose, I think, to *demonstrate visually* that, as related to his peers, the slaves, for whose freedom he so passionately fought, and as related to the New England intelligentsia as he was striving to be, in the end, he was peerless. In response to McCune Smith's point, in his introduction to Douglass's second book, that "The style of a man *is* the man [emphasis added]," Douglass sought to embody his "style" uniquely in his spoken and written words, of course, but also in exceptionally attractive and compelling visual forms, forms that this collection reveals evolved incrementally over time.[29] Never was there a period in American history between 1841 and his death in 1895 that Frederick Douglass was not concerned about crafting his visual image.

"Men have a pictorial or representative quality," Emerson would also write in that same pivotal essay, "Uses of Great Men," the introduction to his *Representative Men,* "and serve us in the intellect. . . . Men are also representative; first, of things, and secondly, of ideas." Which things? Which ideas? "Each man is by secret liking connected with some district of nature, whose agent and interpreter he is. . . ."[30] For Douglass, without a doubt, that "district of nature" was the anti-slave. But he was also revealing what we might think of, after Emerson, as the secret nature of the Negro: "He is not only representative, but participant. Like can only be known by like. The reason he knows about them is that he is of them; he has just come out of nature, or from being a part

of that thing . . . and he can variously publish their virtues, because they compose him." Ultimately, even the historically silenced and unrepresentable, Emerson argues (in the case I am making, through this, the anti-slave), "Unpublished nature will have its whole secret told."[31]

So what "things" and "ideas" was Frederick Douglass trying to "represent," and, just as importantly by contrast, what was he trying, through his many photographs, *not to represent*? First and foremost, without a doubt, just leafing through the pages of this splendid book, one can almost hear Emerson's description of "the hero of the day": "The people cannot see him enough. They delight in a man. Here is a head and a trunk! What a front! what eyes; Atlantean shoulders, and the whole carriage heroic, with equal inward force to guide the great machine!" When Emerson asks: "What indemnification is one great man for populations of pygmies!" and then tells us that "We balance one man with his opposite, and the health of the state depends on the see-saw," we can begin to understand what he might think of as the larger "rhetorical strategy" of the text of Douglass's photographs of himself. But even more important, the representative man "is an exhibition, in some quarter, of new possibilities."[32]

What "new possibilities"? Douglass, through these images of himself, is attempting to both *display* and *displace:* he is seeking at once to show in two dimensions the contours of the anti-slave, "God's image in ebony," as the abolitionists liked to say, who in essence and in *possibility* fundamentally, by definition, shares the blood of the blood and flesh of the flesh of every other white human being.[33] Even as late as 1854, Douglass could point to claims that the Negro was really not a human being, as he did in his Case Western commencement address "The Claims of the Negro, Ethnologically Considered," citing a recent editorial in the *Richmond Examiner.* Douglass used these photographs to mark both the differences *and* the resemblances of black people to the larger human community. But he also was displaying, prima facie, the inextricable social *and* biological connection between the slave and his master, between bondsman and lord, between black and white. That was his first and most subtle intention.[34]

Even more directly, however, Douglass was intent on the use of this visual image to *erase* the astonishingly large storehouse of racist stereotypes that had been accumulated in the American archive of anti-black imagery, the bank of simian and other animal-like caricatures meant to undermine the Negro's claim of a common humanity, and therefore the rights to freedom and citizenship and economic opportunity (see figures E1–4). Douglass, as we shall see, does not distinguish, when he writes of "pictures," among photographs, paintings, chromolithographs, and so

on. While Douglass elsewhere, of course, condemns racist caricatures of black people—most notably in his essay "A Tribute for the Negro," published in his newspaper *The North Star* in 1849, he doesn't do so in this essay, or in his other three essays on photography.[35] Nor does he seem aware that *all* picture making most certainly is *not* the greatest evidence of humanity or genius. Some pictures, such as these, are simply vile and degrading, both to the people they represent and of the people who make them. As W. J. T. Mitchell said to me recently, "When it comes to racial stereotyping, photography is a very inefficient way of producing 'Sambo' images and other caricatures. With photography, the caricature resides in the eye of the (racist) beholder, not in the image created by drawing, painting or even sculpture, unless it is staged for the camera as caricature."[36]

However, it will not surprise us to learn that some would attempt to use the newly popular medium of photography to serve their racist vision. Among the most notable examples are the images of our Harvard predecessor, Louis Agassiz, who sought, unsuccessfully, to use photographs of dignified yet "unadulterated" South Carolina slaves to represent the large mass of the Negro people—images at the opposite pole of representation of Douglass's refined middle class parlor images— to serve as prima facie proof of his belief in polygenesis, proof that the African and the European could not possibly be members of the same species. As several commentators have pointed out, Agassiz's attempt failed: Agassiz showed the photographs only once to a group of other scientists and intellectuals, and then never again. Though compelled to strip naked for the photographer, the black "object's" inner subjectivity had deconstructed and derailed a most racist intention.[37] The slave, once again, has performed the chiastic function, unveiling the wickedness of the so-called "master." In the mirror of history, these photographs condemn Agassiz, not the human beings forced to function as photographic representatives either of "slaves," or of as sort of *tertium quid*, a third term between the European and the ape.

Engaging photographic imagery in this war over the representation of the black subject was a most daunting task. Douglass, of course, in the end, would realize this, as the decade of the 1890s, his final half decade, saw the unprecedented proliferation of "Sambo" imagery, in trade cards and advertisements, made cheap and affordable through the wonders of chromolithography. Ultimately, though, Douglass saw much more clearly than so many of his colleagues that no single text, no single photograph, no single word nor image, could stanch the Niagara flow of stereotypes that American society would call upon to do the symbolic work of a mode of economic neoslavery and legalized Jim Crow

segregation, long after slavery per se had been abolished. And if these images could not be crushed, they could be countered, and countered with force. More than anything else, this brilliant volume summons us all to visualize how these "signs of power," as Douglass called them in *My Bondage and My Freedom*, manifested themselves over a half century in the life of the anti-slave Frederick Douglass.[38]

It comes as a surprise even to many Douglass scholars that the "representative colored man in the United States" not only ensured that he was photographed frequently over the course of his professional life, from 1841 to somewhere between twelve to twenty-four hours after he died, but he also *theorized* about the nature and function of photography in four lectures, heretofore unpublished, "on photography and 'picture-making.'" He did so, of all times, amid the turbulence and turmoil of the Civil War. What is most remarkable about Douglass's theory of "pictures," actually a theory of the nature and function of visual art (he fails to distinguish among its types, as I mentioned above), is how inextricably intertwined it is both with his larger political philosophy and with this rhetorical strategy of self-fashioning through the rhetoric(s)—textual and visual—of autobiography.

Douglass tells us right away, in "Pictures and Progress," which John Stauffer says he wrote shortly before Lincoln's Second Inaugural, that fate had given him both a mission and a text with which to embark upon that mission: "Now the speech I was sent into the world to make was an abolition speech. . . . When I come upon the platform the Negro is very apt to come with me. I cannot forget him: and you would not if I did."[39] "You" would not, he is saying, because "the Negro" is written on his face at a time when the blackness of that face cannot possibly be erased or be rendered transparent or invisible. Hence, he is engaged— one might even say he is trapped—in a discursive arena in which even a lecture about something seemingly apolitical, something seemingly as far afield from the battles to liberate the black slave as photography and art, in the end must, by definition, be engaged within and through Douglass's state of being as a black man in a white society in which one's blackness signifies negation.

In other words, he says, if "the books that we write and the speeches that we make . . . are but the extensions, amplifications and shadows of ourselves, the peculiar elements of our individual manhood," then, for him, as inescapably representative of the larger black community, these things are also "the peculiar elements" of his *black subjectivity* (rendered here as "manhood") as well. "Whatever may be the text," he says wittily, "man is sure to be the sermon."[40]

So what is Douglass's "sermon" on the nature of the American Negro,

Figure E1: Unknown artist, *Jim Crow*, c. 1830. Etching and ink. Library of Congress

Figure E2: Edward Williams Clay, *Life in Philadelphia*, 1829. Etching, hand-colored. Library of Congress

Figure E3: Unknown artist, *Grand Football Match—Darktown Against Blackville. A Scrimmage.*
Currier & Ives, 1888. Chromolithograph. Library of Congress

Figure E4: Unknown artist, *The Two Platforms*, 1866.
Woodcut with letterpress on wove paper. Library of Congress

within the context of photography? After lauding the genius of Daguerre for making the earth "a picture gallery," then insisting that the one thing that incontrovertibly separates man from animal is the visual—"He alone of all the inhabitants of earth has the capacity and passion for pictures"—Douglass reveals the larger subtext for what would be mistaken as a diversion from his "text of abolition," as we might think of it.[41]

And here's what he says: "A certain class of ethnologists and archeologists, more numerous in our country a few years ago than now and more numerous now than they ought to be and will be when slavery shall have no further need of them, profess some difficulty in finding a fixed, unvarying, and definite line separating what they are pleased to call the lowest variety of our species, always meaning the Negro, from the highest animal." The proof that the Negro, too, is oh so human? But Douglass is also pointing to the fascination of visual texts, texts of the world and texts of the self: "To all such scientific cavilers, I commend the fact that man is everywhere a picture-making animal, and the only picture-making animal in the world." Lest anyone misunderstand the range of peoples Douglass is including under the rubric of "man," he goes on to say that "[Even] the rudest and remotest tribes of men manifest this great human power—and thus vindicate the brotherhood of man," whereas, pre-Daguerre, the presence and absence of "Reason," with a capital "R," manifesting itself through the written word and especially through poetry (as Emerson had pointed out in a passage that Douglass himself quotes in this essay), had stood as the demarcation line between animal and man, African and European. Douglass himself had made this very point just a decade earlier in his "Claims of the Negro, Ethnologically Considered." But recent scientific discoveries, Douglass says, reveal that both "dogs and elephants are said to possess it." Now, however, in a post-Daguerre universe, that line is also policed by the capacity for picture making—"picture-appreciating," as he puts it—and, we might add, picture taking.[42]

So what might all of this have to do with slavery, abolition, the Civil War?, his audience might have been forgiven for asking at this point. Douglass, in a rhetorical turn that is partly self-serving, tells us that we have been summoned for a revelation, a revelation about the role of reform and the reformer in the hierarchy of the most sublime of human endeavors. Douglass begins this rhetorical sleight of hand by repeating his point that picture making and picture-appreciating are at the apex of the arts, "the most important line of distinction between [man] and all others," on his way to making the case for the relation between the visual and the verbal, the fact that an image, a face, as it were, presupposes a voice.[43]

"To the flinty-hearted materialists," he argues, "pictures like flowers have no voice and impart no joy." Not only is this untrue, he insists, but this, the most sublime of all human faculties—the ability to objectify the self—unites the political reformer, in this case the anti-slave abolitionist, with both the poet *and* the prophet: "The process by which man is able to posit his own subjective nature outside of himself, giving it form, color, space, and all the attributes of distinct personality, so that it becomes the subject of distinct observation and contemplation, is at [the] bottom of all effort and the germinating principles of all reform and all progress. But for this, the history of the beast of the field would be the history of man. It is the picture of life contrasted with the fact of life, the ideal contrasted with the real, which makes criticism possible." And what is the function of criticism? "Where there is no criticism there is no progress, for the want of progress is not felt where such want is not made visible by criticism. It is by looking upon this picture and upon that which enables us to point out the defects of the one and the perfections of the other."[44]

And who within society is ideally suited to play this role; who are the philosopher-kings of criticism? Why, poets and prophets, of course, but also a third group: *reformers*! And why? Because "Poets, prophets, and reformers are all picture-makers—and this ability is the secret of their power and of their achievements. They see what ought to be by reflection of what is, and endeavor to remove the contradiction." Like poets and prophets, reformers strip away illusion, revealing the true nature of things, in the same way that Douglass used chiastic reversals of binary oppositions to unmask the deep structure of the perverted world that the planters had made, a world in which the master was really the slave, the civilized was really the cannibal, the so-called human being was really the savage, and the benighted slave was really the best hope for the future of American civilization, because she stood as the unassailable bulwark of Christian forbearance and forgiveness. The slave kept the faith; the fate of the culture was in her hands, not in the hands of her sadistic, licentious, hypocritical master. Criticism, for the slave and for the reformer, was a tool employed to unveil. And this is so because criticism is the deconstructive unmasking of illusion, "the picture of life contrasted with the fact of life," he says, and only "picture-makers" have this blessed capacity.[45]

"This ability," Douglass concludes with a flourish, that poets, prophets, and reformers share, "is the secret of their power and of their achievements. They see what ought to be by the reflection of what is, and endeavor to remove the contradiction." What Daguerre has done with modern technology, in other words, is precisely what the most sublime

among us can do through second-order reflection, through the critical consciousness: "We [reformers] can criticize the characters and actions of men about us because we can see them outside of ourselves," just as we can when viewing a photograph of ourselves, "and [can] compare them one with another. But self-criticism, out of which comes the highest attainments of human excellence, arises out of the power we possess of making ourselves objective to ourselves—[we] can see our interior selves as distinct personalities, as though looking in a glass." Just like a photograph, the critical thinker, in Douglass's case the reformer, makes "our subjective nature objective, giving it form."[46]

I find this one of the most remarkable statements in the entire canon of Douglass's speeches, essays, and books. Not only does this anticipate Du Bois's famous definition, just eight years after Douglass had passed, of the Negro's "double-consciousness," but it attests that for Douglass, at least, double-consciousness is the hallmark of genius, the sign of a depth of insight deeper than that of one's fellows, the characteristic that black people by their very situation may share the sublime perspective of the privileged few.[47] And Daguerre's genius is that he rendered in two dimensions, in tangible form, this wondrous process of visualizing ourselves *doing* an action and reflecting upon it as we do it, rendering the subjective "objective," giving it form.

Finally, Douglass explains that his other motivation for embracing this new technology with such alacrity, on behalf of the Negro, as representative Negro, as the anti-slave, is to counter the racist stereotypes, "the already read text" of the debased, subhuman Negro fabricated and so profusely distributed by the slave power, by supplanting those images—wherein illusions that "'take the form of solid reality' in which shadows get themselves recognized as substance"—with a proliferation of anti-caricatures.[48] No wonder Douglass emerges as the most frequently photographed American in the nineteenth century. He was a reformer on a mission: he seized upon those long-exposure glimpses of black and majestic human forms, miraculously generated by the chiastic magic of Daguerre's camera obscura, to fabricate—*to picture*—the very images through which, at long last, the Negro as anti-slave could emerge and then progress, "clothed in his own form."

Afterword

Kenneth B. Morris, Jr.

It is evident that the . . . universality of pictures must exert a
powerful, though silent, influence upon the ideas and sentiment of
present and future generations.

—FREDERICK DOUGLASS, "LECTURE ON PICTURES" (1861)

I was filled with pride when I first heard that Frederick Douglass was
the most photographed American of the nineteenth century. It is
mind-boggling to think that my great-great-great-grandfather, a former
slave, was photographed more often than towering figures such as Gen-
eral Custer, Walt Whitman, Ulysses S. Grant, and Abraham Lincoln.
Perhaps even more astounding, the only contemporaries to surpass his
remarkable legacy in pictures are members of the British royal family.

Prior to meeting Zoe Trodd and discussing her research for this
book, I was unaware of my ancestor's passion for photography and his
extensive writings and speeches on the subject. I was surprised to learn
he had written four lectures on photography during the Civil War years
and three of these brilliant speeches had never before been published.
"Lecture on Pictures," delivered December 3, 1861, is among the most
powerful and eloquent speeches I have ever read. Like most of the gen-
eral public I have focused my scholarship on his contributions to the abo-
lition of slavery in the United States and his leadership and legacy as the
father of the civil rights movement. I was not surprised, however, to learn
that Frederick Douglass had the foresight to skillfully use the emerging
medium of photography to shape his public image and define himself as
a free man and citizen in the public consciousness. He was a true Renais-
sance man, and I am extremely proud of his many achievements.

I can't say when I first realized I was related to the great man. When I was growing up, his pictures were everywhere and, most likely by unconscious assimilation, I just knew I descended from greatness. If the honor of being a descendant of one great American wasn't enough weight to carry, I also have the distinction of being the great-great-grandson of former slave and educator Booker T. Washington. This extraordinary lineage flows through the maternal side of my family by way of the union of my grandmother Nettie Hancock Washington (granddaughter of Booker T. Washington) and my grandfather Dr. Frederick Douglass III (great-grandson of Frederick Douglass) (figure A1). When my mother, Nettie Washington Douglass, was born, she united the bloodlines of these historic families. She was an only child, so I am the first male to do so.

The role of heir to a legacy is never chosen, and it is more often a burden than a blessing, no matter how bright or talented those heirs may be. For the descendants of men like Frederick Douglass and Booker T. Washington, who cast as great a shadow as any Americans ever have, the expectations can be all the more daunting. I am told that my grandfather Frederick III was truly a brilliant man. He was a surgeon assigned to Booker T. Washington's Tuskegee Institute by the Veteran's Administration during the early part of World War II. There he met my grandmother Nettie after a chance encounter on Tuskegee's campus in 1941. The great-grandson of Frederick Douglass and the granddaughter of Booker T. Washington fell madly in love and married three months later.

Their wedding day picture (figure A2) captures a beautiful couple in love. But behind my grandfather's movie star looks and smile was intense suffering. He was carrying the weight of expectation on his shoulders, bestowed upon him by virtue of his lineage. Many believed he was destined to become an iconic leader like his namesake . . . but there are so very few like Frederick Douglass. When my grandmother was three months pregnant with my mother, he succumbed to the burden of the family legacy and took his own life. It is impossible to know exactly why he did this, but when I was born, it was agreed that I would not feel the same pressure that my grandfather found too much to bear. My parents, grandmother, and great-grandmother made a concerted effort to instill in me the belief that I could be great walking in my own shoes. This well-intentioned affirmation was meant to build my confidence and put up a barrier of protection around me, but there was no way to shield me from such formidable legacies.

It seemed that everywhere I turned I saw symbols of my ancestors' awe-inspiring greatness. There were imposing bronze statues look-

Figure A1: Joseph H. Douglass and Fannie H. Douglass with their children Frederick Douglass III and Blanche Douglass. Frederick Douglass Family Initiatives (FDFI)

Figure A2: Wedding-day photograph at Tuskegee, November 11, 1941. Pictured (left to right): Frederick Douglass III, Nettie Hancock Washington, Booker T. Washington III. FDFI

Figure A3: Sidney W. Edwards, *Frederick Douglass Monument*, Highland Park, Rochester, NY, 1899. Author photograph

Figure A4: Highland Beach, Maryland, summer 1976. Pictured (left to right): Kenneth B. Morris, Jr., Fannie H. Douglass, Douglass Washington Morris. FDFI

Figure A5: Frederick Douglass III and his mother, Fannie H. Douglass, Highland Beach, Maryland. FDFI

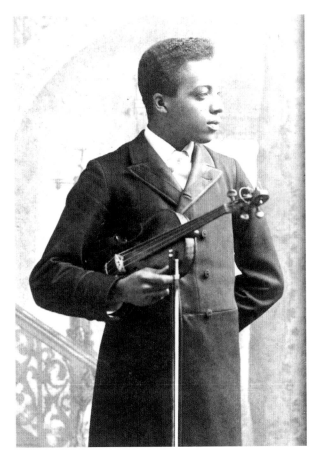

Figure A7: Joseph H. Douglass, grandson of Frederick Douglass. National Park Service, Frederick Douglass National Historic Site

Figure A6: Kenneth B. Morris, Jr., in the tower of the Douglass family summer-home, Highland Beach, looking back to the eastern shore of Maryland, April 2013. Kenneth B. Morris, Jr.

ing down from high above (figure A3) and patina-stained busts peering from behind overgrown shrubs. Douglass and Washington family photographs, vintage books, handwritten letters, commemorative stamps, and coins emblazoned with their images were always present in my home. There were schools, libraries, and bridges named for them. My teachers would lecture about their lives and importance. They were living in my history books and in our family's *Encyclopædia Britannica.* When I had to do a Black History Month assignment, I would hesitate to open research books because, inevitably, the Great Abolitionist and the Great Educator would be inside the pages staring back at me, examining my every move.

I spent my childhood summers at our family beach house at Highland Beach, Maryland (figure A4). The house was built for Frederick Douglass by his youngest son, Charles (my great-great grandfather), as a retirement home. It was there, on the shores of the Chesapeake Bay, where Frederick dreamed of spending the last years of his life, sitting in "the tower" at the top of his home, looking back to where he had been born into slavery on the Eastern Shore of Maryland. I loved spending my summers in that house at the beach (figure A5). When I was a little boy, I would sit in my great-great-great-grandfather's chair in "the tower" and look across the bay to the land of his birth, which looked generations away. My great-grandmother Fannie Howard Douglass, or Grandmere as we called her, would sit down, put me on her knee, and with dramatic flair tell me about the first time she met Frederick Douglass as a little girl in Atlanta, Georgia. Her father, David T. Howard, was born a slave and became one of the nation's first black millionaires, owning and operating a successful mortuary business. When Frederick visited Atlanta, my great-great-grandfather Howard would pick him up at the train station in the fanciest horse-drawn carriage in town. Their very tall visitor, with a shock of white hair, made quite an impression on young Fannie. From that day forward she began referring to him as "The Man with the Big White Hair" and did so until her death at the age of 103. She had no way of knowing at the time that she would grow up and marry his grandson Joseph. When Grandmere and I were alone in "the tower," she would point to the land on the other side of the Chesapeake and say, "That's where Frederick lived as a slave when he was your age." I was too young to appreciate the significance of her stories at the time, but now that I am older, I realize how blessed I am to carry those memories today (figure A6). Unfortunately, Frederick Douglass's dream of sitting in "the tower" was never realized. He passed away before the home was completed.

There were Douglass family pictures in every room of the house. I

was about five years old when I had my first memorable photographic encounter with "The Man with the Big White Hair." One day I noticed him observing me from a larger-than-life portrait hanging over the mantel. Like most young boys I had quite an imagination, and it only took a few seconds of staring at him before he came to life. He, with the fiery gaze, was watching my every move. I quickly turned away and snapped my head back to see if he was still looking. He was always looking . . . always staring. I tried to inconspicuously sneak by him and his eyes followed me. By the time I made it to the end of the hallway, I could feel his steely glare burning like fire on the back of my neck. Then, seemingly out of nowhere, a mighty baritone voice bellowed down and roared upon my tiny person, "You will do great things young man!" His booming command reverberated off of the walls with the acoustical resonance of a nineteenth-century abolitionist meeting hall and rooted itself deep into my consciousness, where it still lives today.

Frederick Douglass's pictures have moved and inspired me my whole life. For this reason, I am honored to have been asked to contribute to this project. These are remarkable photographs. Some of the images are familiar from my childhood and others I am being introduced to for the first time. All of the pictures stir up deep emotions, and I could write in detail about each one. But I will share my thoughts on a few where I had an instant emotional response.

The first photograph ever taken of Frederick Douglass in 1841 is one of my favorites (plate 1). It shows the twenty-three-year-old fugitive only three years removed from slavery. My analysis of this image differs from the authors of the book, who see uncertainty in his visual persona. I see a young man who had the courage to speak out against the inhumanity of slavery even though the notoriety he gained put his own freedom at risk. Emanating from deep within his eyes is the burgeoning confidence of a young man who had the inner strength to stand up to his overseer as a sixteen-year-old boy and escape the bonds of slavery at the age of twenty. For a first effort in front of the camera, he looks stylish, handsome, and curiously poised. And, most important, he is looking straight into the camera modeling a perfectly shaped afro that would make Angela Davis and my '70s-self proud.

The second and third pictures in the collection have intrigued me for quite some time (plates 2 & 3). I agree with the authors' analysis of these photographs; he does not look completely comfortable. His uneasiness is more pronounced in the third image taken in 1848 (plate 3). His head is down and he is sheepishly looking away from the camera. A letter written to a fellow fugitive in 1846 may explain the awkwardness he felt during this period in his life. Frederick writes, "I got real low

spirits a few days ago, quite down at the mouth. . . . I looked so ugly that I hated to see myself in the glass."[1] My ancestor has written many passages about his enslavement that have brought me to tears. I have spoken with other descendants of enslaved Africans who also agonize over the thought of their ancestors trapped within the hell of slavery. Most can only imagine the cruelty their forefathers endured, because there are no written accounts of their stories. But I have read Frederick's firsthand, detailed narratives of the brutality he survived and it is heart wrenching. The comment in this letter offers insight into the soul of a man whose humanity had been stripped away by the overseer's lash. And the reality of the trauma he was carrying, years after his enslavement, is evident in this photograph. It is very difficult to read his words and bear witness to his state of mind. It is nothing short of a miracle that this man with no family, no home, and no country summoned the strength to overcome immeasurable suffering and rise up to change the course of history.

The Hillsdale College photograph from January 1863 is my all-time favorite picture of Frederick Douglass (plate 18). It is one of the rare full-body studio shots of him in this collection. Taken during the Civil War, we see the commanding presence of a leader in the face of the storm, whirlwind, and earthquake.[2] FD, as we sometimes refer to him in the family, is dressed to perfection in a full-length frock coat. He is relaxed with legs crossed and hands resting in his lap. The Great Abolitionist has fully emerged as a powerful voice for four million men, women, and children toiling away in chains. Without breaking a sweat, he is wreaking havoc on the institution of slavery and leading his brethren to the promised land with determination and confidence. There has never been a cooler picture taken of my great ancestor. When I look at this photograph, all I can do is bow down and say, "You are the Man!"

Frederick Douglass had twenty-one grandchildren and the only grandchild he was ever photographed with was Joseph (plate 58). In fact, Joseph (my great-grandfather) is the only blood relative to appear in a picture with Frederick Douglass. This is perhaps due to the common bond they had in music and, more specifically, the violin. In addition to being an activist, journalist, statesman, and photography aficionado, Frederick was a self-taught and dedicated violinist. He introduced his grandson to the violin and gave Joseph his first lessons on the instrument. The two could often be heard playing Schubert together in the music room at Frederick's Cedar Hill home in southeast Washington, D.C. After receiving early training from his grandfather, Joseph continued his music education at the Boston Conservatory and eventually became an accomplished concert violinist (figure A7)—twice playing in

the White House for Presidents McKinley and Taft. He was the first black classical artist to make recordings for the Victor Talking Machine Company. I love seeing the two of them pictured together, because it proves, without question, that my great-grandfather was the favorite grandchild.[3]

The picture of Frederick Douglass at Booker T. Washington's Tuskegee Industrial and Normal Institute in 1892 is providential (plate 52). It is amazing that the only photograph of my ancestor giving a speech just happened to have been taken at the school that my great-great-grandfather Washington founded in 1881. This fact alone was reason enough for me to be drawn to this image, but, upon closer examination, I was stunned to discover that my ancestral universes had collided. I haven't seen it documented anywhere before, but I have identified Booker T. Washington in this picture. He is on the speaker's platform sitting in the third chair to the right of my great-great-great-grandfather Douglass. This is the only photograph I have ever seen of my ancestors together in front of a camera. Perhaps it is fate that their descendant, who unites their legacies in blood and in spirit, made this discovery. The photograph captures the moment that Divine Providence set in motion the order of events that would ultimately unite the Douglass and Washington families. It is no coincidence that the progenies of these great men bumped into each other on Tuskegee's campus, instantly fell in love, and married in the same space forty-nine years after this picture was taken.

After years of engaging Frederick Douglass's steely glare from the portrait above the mantel, it is beautiful to finally see a picture of him smiling (plate 59). It's not a big smile by any means, but, nevertheless, he is grinning and his eyes are sparkling. My mother, Nettie Washington Douglass, and I met Zoe Trodd at a conference at Yale University in 2012, where we had our first look at her research for this book. It was the first time either of us had seen this photograph. Over the years, we have shared similar stories of our childhood encounters with pictures of our ancestors, and Frederick's eyes followed her too. It was a special moment to be there with her when she looked at this image for the first time. Mom gets emotional when she thinks about the little boy who was forced to grow up without the love and nurturing of family because of the institution of slavery. She can relate to the pain and suffering of separation, having herself grown up without a father. With tears welling up in her eyes, she grinned and said, "I have been waiting my whole life to see him smile. He had been through so much in his life. Bless his heart." At that moment, I couldn't help but think of the father she never knew and wished he could have been with us to see Frederick smile too.

At the end, Frederick Douglass looks like an angel resting in peace. The deathbed photograph memorializes the end of an incredible life lived and a fifty-year legacy of being the most photographed American of the nineteenth century (plate 60). I am so proud of my beautiful ancestor for all he has given the world and all he has given our family. I am grateful for his lessons of love, humility, forgiveness, and compassion passed down through the generations. He belongs to eternity now, but his spirit and legacy live on in me. Humbling is the best way to describe what it feels like to have his blood flowing through my veins. When I look at this final image, I am reminded of the debt that I owe to him and to all those who came before me, upon whose shoulders I stand. Liberty's torch has been passed, and it is my obligation, by birthright, to continue his fight for freedom.

I mentioned that I was raised outside of my ancestors' shadow by design and I was always free to find my own path. That path finally led me back to the Douglass and Washington legacies. In late 2005, my friend and business associate Robert Benz showed me a *National Geographic Magazine* cover story called "21st-Century Slaves." The caption below the headline stunned me: "There are more slaves today than were seized from Africa in four centuries of the trans-Atlantic slave trade." When I read and absorbed this, I realized these great legacies were part of a calling for me—a calling to leverage history in order to help change the future for those held in modern-day slavery. The life I had been living all of those years ended abruptly, and I became an abolitionist like Frederick Douglass. Call it fate or fortune, destiny or DNA, I had been chosen by this path.

There are millions of people around the world who are bought and sold for sex and other forms of forced labor today. Young girls and boys enslaved in brothels; children forced to work because their hands are small enough to do close needlework or pull fish from nets; men and women forced to farm, mine, or work in factories or service industries in dangerous conditions. Many make the clothes and harvest the food that we consume at low prices every day. Slavery still exists in every country around the world and ensnares every race in the human family. Many of the victims live in conditions as horrific as the slavery my ancestors endured.[4]

Even after the legal demise of slavery brought by the Emancipation Proclamation and the Thirteenth Amendment in the United States, there is a paradigm that has remained unchanged. Frederick Douglass identified the key to ending this human scourge when he realized at the tender age of nine that "education makes a man unfit to be a slave." My great ancestor understood that knowledge was power, and it would one

day be his key to freedom. Unless we are able to educate people about slavery's past and present, about the methods that human traffickers use to entrap and exploit, it will continue unabated. This is the mission of the organization that my mother, Robert Benz, and I founded in 2007.

Through our organization, the Frederick Douglass Family Initiatives (FDFI), we memorialize the work of my ancestors, but, perhaps most important, we believe, as Frederick Douglass and Booker T. Washington did, that education or knowledge can make each one of us, no matter our position in the world, unfit to be enslaved. Frederick Douglass said, "It's easier to build strong children than to repair broken men." If we are to educate the public about the slavery that exists today, we need to start where education should start—with young people. Taking this philosophy as our foundation, FDFI develops human trafficking prevention curricula for secondary schools called "History, Human Rights, and the Power of One." They are designed to help keep children from becoming victims of various forms of slavery and to empower them to act against human trafficking in their communities. Educating students about the crime of human trafficking and modern-day slavery is an important first step if we are to end slavery once and for all. Douglass and Washington understood firsthand that the application of knowledge and the empowerment of an individual provides the best opportunity to remain free from bondage.[5]

It is breathtaking to see the fifty-year evolution of my ancestor through the analytical lens of *Picturing Frederick Douglass*. His writings and photographs were fundamental to his argument for liberation and equality. His words painted a portrait of profound depth and refinement, and they destroyed the enslaver's hoax that there are people born for a life of servitude. His photographs revealed the same truth by exposing, in detail, not a slave but a gentleman. Today, if Frederick Douglass were alive, modern slavery would be his fight. He would call upon young people to use art and technology to define the narrative of contemporary slavery in the public consciousness in the same way that he used words and photography to effect change so many years ago.

My great-great-great-grandfather's legacy in pictures reminds us all of our inherent dignity and of our duty to uphold the inalienable rights of all members of the human family. The fight for liberation and equality was his fight. I have decided to make it my fight too.

List of Illustrations

Plate 10 (cat. #10). Unknown photographer, c. 1855. Sixth-plate daguerreotype, 2¾ × 3¼ in. Nelson-Atkins Museum of Art, Kansas City, Missouri. Gift of Hallmark Cards, Inc. 2005.27.42

Plate 11 (cat. #11). Unknown photographer, c. 1856. Quarter-plate ambrotype, 4¼ × 3¼ in. National Portrait Gallery, Smithsonian Institution

Plate 12 (cat. #12). Unknown photographer, c. 1857. Copy print from a lost daguerreotype or ambrotype, 2 × 3 in. Clements Library, University of Michigan

Plate 13 (cat. #13). Unknown photographer, c. 1858. Copy print from a lost daguerreotype or ambrotype, 8 × 10 in. New-York Historical Society

Plate 14 (cat. #14). Unknown photographer, c. 1859. Ninth-plate ambrotype, 2 × 2½ in. University of New Mexico Art Museum

Plate 15 (cat. #15). Unknown photographer, c. 1860. Salted paper print, 4 × 3⅛ in. National Portrait Gallery, Smithsonian Institution

Plate 16 (cat. #16). Benjamin F. Reimer (1826–1899), c. 1861. 615 and 617 North 2nd Street, Philadelphia. Carte-de-visite, 2½ × 4 in. National Park Service, Frederick Douglass National Historic Site

Plate 17 (cat. #18). John White Hurn (1822–1887), January 14, 1862. 1319 Chestnut Street, Philadelphia. Carte-de-visite, 2½ × 4 in. Collection of Greg French

Plate 18 (cat. #21). Edwin Burke Ives (1832–1906) and Reuben L. Andrews, January 21, 1863. Howell Street, Hillsdale, MI. Carte-de-visite, 2½ × 4 in. Hillsdale College

Plate 19 (cat. #22). Thomas Painter Collins (1823–1873), February–April 1863. Westfield, MA. Carte-de-visite, 2½ × 4 in. Special Collections, Lavery Library, St. John Fisher College

Plate 20 (cat. #23). Augustus Morand (1818–1896), May 15, 1863. 297 Fulton Street, Brooklyn, NY. Carte-de-visite, 2½ × 4 in. Lynn Museum and Historical Society, Hutchinson Family Singers Album

Plate 21 (cat. #25). Benjamin F. Smith (1830–1927), January–February 1864. 153 Middle Street, Portland, ME. Carte-de-visite, 2½ × 4 in. Division of Rare and Manuscript Collections, Cornell University

Plate 22 (cat. #28). Samuel Montague Fassett (1825–1910), late February 1864. 122 and 124 Clark Street, Chicago. Carte-de-visite, 2½ × 4 in. Collection of Greg French

Plate 22a. Unknown artist, c. 1865–70. Postcard print. Massachusetts Historical Society

Plate 22b. Metcalf & Clark, Baltimore, *The Result of the Fifteenth Amendment*, 1870. Detail from chromolithograph, 19 × 25 in. Library of Congress

Plate 23 (cat. #32). Alfred B. Crosby (1836–1879) and Israel Warren Merrill (1830–1894), early April 1864. Main Street, Farmington, ME. Carte-de-visite, 2½ × 4 in. Boston Athenæum

Plate 24 (cat. #33). Alfred B. Crosby and Cyrus W. Curtis (1833–1903), early April 1864. 138 Lisbon Street, Lewiston, ME. Carte-de-visite, 2½ × 4 in. Collection of Greg French

Plate 25 (cat. #36). Stephen H. Waite (1832–1906), April 15, 1864. 271 Main Street, Hartford, CT. Carte-de-visite, 2½ × 4 in. Connecticut Historical Society

Plate 25a. Alexander Hay Ritchie (1822–1895), Engraving, c. 1868. Published in Harriet Beecher Stowe, *Men of Our Times; or, Leading Patriots of the Day. Being Narratives of the Lives and Deeds of Statesmen, Generals, and Orators* (Hartford, CT: Hartford Publ. Co., 1868), following p. 380. Author's collection

Plate 25b. Currier and Ives, New York. *The Colored Champion of Freedom*, c. 1873. Lithograph, 17 × 13½ in. Author's collection

Plate 26 (cat. #39). Henry P. Rundel (1844–1886) and Charles Warren Woodward (1836–1894), c. 1865. 126 State Street, Rochester, NY. Carte-de-visite, 2½ × 4 in. Beinecke Rare Book and Manuscript Library

Plate 27 (cat. #49). Isaac G. Tyson (1833–1913), early September 1866. 240 North 8th Street, Philadelphia. Carte-de-visite, 2½ × 4 in. Historical Society of Pennsylvania, Society Portrait Collection

Plate 28 (cat. #50). James Presley Ball (1825–1904), January 12, 1867. 30 West 4th Street, Cincinnati, OH. Carte-de-visite, 2½ × 4 in. Cincinnati History Library and Archives

Plate 29 (cat. #52). Samuel Root (1819–1889), February–March 1867. 166 Main Street, Dubuque, IA. Carte-de-visite, 2½ × 4 in. Gilder Lehrman Institute of American History, GLC07752.02

Plate 30 (cat. #54). Unknown photographer, c. 1867. Carte-de-visite, 2½ × 4 in. National Park Service, Frederick Douglass National Historic Site

Plate 31 (cat. #59). James Hiram Easton (1828–1900), February–March 1869. Broadway, Rochester, MN. Carte-de-visite, 2½ × 4 in. Kansas State Historical Society

Plate 32 (cat. #61). George Francis Schreiber (1804–1892), April 16, 1870. 818 Arch Street, Philadelphia. Carte-de-visite, 2½ × 4 in. Library of Congress

Plate 33 (cat. #63). Oliver B. Buell (1844–1910), January 17, 1871. Deck of the USS *Tennessee*, Key West, FL. Stereoview, 3½ × 7 in. Monroe County Public Library, State Archives of Florida

Plate 33a. Unknown engraver, Commissioners to Santo Domingo, c. 1881. Published in *Life and Times of Frederick Douglass* (1881), p. 420

Plate 34 (cat. #64). J. S. Thompson, March 26, 1871. Deck of the USS *Tennessee*, Charleston, SC. Albumen print, 10½ × 12½ in. Anacostia Community Museum Archives, Smithsonian Institution

Plate 34a. "The Santo Domingo Expedition—Arrival of the Tennessee at Charleston, SC, Group on Deck including the Commission and Ship's Officers. From a Photograph by J. S. Thompson," *Frank Leslie's Illustrated Newspaper*, April 15, 1871, p. 69

Plate 35 (cat. #65). Unknown photographer, c. 1871. Carte-de-visite, 2½ × 4 in. Library of Congress

Plate 36 (cat. #68). Unknown photographer, c. 1872. Quarter-plate ambrotype, 3¼ × 4¼ in. Collection of the Smithsonian National Museum of African American History and Culture, 2010.36.10

Plate 37 (cat. #75). John White Hurn, March 10, 1873. 1319 Chestnut Street, Philadelphia. Carte-de-visite, 2½ × 4 in. Author's collection

Plate 38 (cat. #76). Carl Casper Giers (1828–1877), September 1873. 43–45 Union Street, Nashville, TN. Carte-de-visite, 2½ × 4 in. Moorland-Spingarn Research Center, Howard University

Plate 38a. Unknown artist, *Harper's Monthly*, February 1875, p. 310

Plate 38b. Unknown artist, *Harper's Weekly* (cover), November 24, 1883

Plate 38c. Jacob C. Strather, Drawing, 1884. Museum Resource Center, National Park Service, Landover, MD

Plate 39 (cat. #79). John Howe Kent (1827–1910), January 26, 1874. 58 State Street, Rochester, NY. Cabinet card, 4¼ × 6½ in. Rochester Public Library

Plate 40 (cat. #83). John Howe Kent, January 26, 1874. 58 State Street, Rochester, NY. Cabinet card, 4¼ × 6½ in. Beinecke Rare Book and Manuscript Library

Plate 40a. Unknown artist. Published in William C. Roberts, *The Leading Orators of Twenty-Five Campaigns* (New York: L. K. Strouse, 1884), p. 59

Plate 40b. Unknown artist, *Washington Press*, August 31, 1889

Plate 41 (cat. #84). Lydia J. Cadwell (1837–1896), January 5, 1875. 103 State Street, Chicago. Cabinet card, 4¼ × 6½ in. Chicago History Museum

Plate 42 (cat. #85). Lydia J. Cadwell, January 5, 1875. 103 State Street, Chicago. Cabinet card, 4¼ × 6½ in. Beinecke Rare Book and Manuscript Library

Plate 42a. Unknown artist, *Harper's Weekly*, April 21, 1877. Author's collection

Plate 42b. Eva Webster, Charcoal print, 1887, 27 × 23 in. National Park Service, Frederick Douglass National Historic Site

Plate 43 (cat. #92). Mathew B. Brady (1822–1896), c. 1877. 625 Pennsylvania Avenue, Washington, DC. Carte-de-visite, 2½ × 4 in. Beinecke Rare Book and Manuscript Library

Plate 43a. Unknown artist, "Washington, D.C., Frederick Douglass, The New Marshal of the District of Columbia," *Frank Leslie's Illustrated Newspaper*, April 7, 1877, p. 85

Plate 43b. Joseph Hoover, *Heroes of the Colored Race*, 1881. Chromolithograph. Library of Congress

Plate 44 (cat. #93). Mathew B. Brady, c. 1877. 625 Pennsylvania Avenue, Washington, DC. Stereoview, 5 × 7 in. Library of Congress

Plate 45 (cat. #96). George Kendall Warren (1824–1884), c. 1879. 289 Washington Street, Boston. Carte-de-visite, 2½ × 4 in. Author's collection

Plate 45a. Augustus Robin, Engraving, c. 1881. Frontispiece to *The Life and Times of Frederick Douglass* (1881)

Plate 45b. Unknown artist, Engraving, c. 1886. Published in Allen Thorndike Rice, *Reminiscences of Abraham Lincoln by Distinguished Men of His Time* (1886), p. 185

Plate 46 (cat. #97). George Kendall Warren, c. 1879. 289 Washington Street, Boston. Cabinet card, 4¼ × 6½ in. Metropolitan Museum of Art

Plate 46a. Unknown artist, engraving, c. 1887. Published in Henry Ward Beecher, *Patriotic Addresses in America and England* (1887), p. 407

Plate 46b. Unknown artist, *Indianapolis Freeman*, December 15, 1888

Plate 47 (cat. #100). Luke C. Dillon (1844–1886), c. 1880. Pullman's Gallery, 935 Pennsylvania Avenue, Washington, DC. Cabinet card, 4¼ × 6½ in. Special Collections, Lavery Library, St. John Fisher College

Plate 48 (cat. #105). Charles Milton Bell (1848–1893), c. 1881. 463–465 Pennsylvania Avenue, Washington, DC. Cabinet card, 4¼ × 6½ in. Beinecke Rare Book and Manuscript Library

PART II: CONTEMPORANEOUS ARTWORK

PART III: THE PHOTOGRAPHIC LEGACY

Plate 3.11. Mel Boldin, "Neither Institutions nor Friends Can Make a Race to Stand Unless It has Strength in Its Own Legs," c. 1945. Cartoon, published in *Baltimore Afro-American*, February 10, 1945

Plate 3.12. Ben Irving, quilt design, 1953. Negro History Club of Marin City and Sausalito, CA. University of Louisville Archives and Records Center, Kentucky Quilt Project

Plate 3.13. *Frederick Douglass: Part One*, 1969. *Golden Legacy Illustrated History* magazine (Fitzgerald Publishing Co.). Author's collection

Plate 3.14. Lloyd Lillie, *Frederick Douglass*, Faneuil Hall, Boston, MA, 1995. Author photograph

Plate 3.15. Parris Stancell, *Freedom School*, 2002. Mural. Girard Avenue, Philadelphia, PA. Author photograph

Plate 3.16. John Lewis and Delia King, untitled mural, 2004. Leidy School, Philadelphia, PA. Author photograph

Plate 3.17. Aniekan Udofia, *Bread for the City*, 2011. Mural. Good Hope Road, Washington, DC. Author photograph

Plate 3.18. Preston Jackson, *African American Civil War Monument*, 2009. Decatur, IL. Author photograph

Plate 3.19. Gabriel Koren, *Frederick Douglass*, 2010. Statue. 110th Street at Central Park West, New York, NY. Author photograph

Plate 3.20. Ben Shahn, *Frederick Douglass, I*, 1965. Photolithograph (from a series of four lithographs). Stephen Lee Taller Ben Shahn Archive, Harvard Art Museums

Plate 3.21. G. Byron Peck, *Frederick Douglass*, 1995 (destroyed in 2002). Mural. 12th Street NW, Washington, DC. Author photograph

Plate 3.22. Deborah Browder and Heidi Schork, *Frederick Douglass*, 2003. Mural. Hammond Street, Roxbury, MA. Author photograph

Plate 3.23. St. George, *Frederick Douglass*, Los Angeles, CA, 2013. Author photograph

Plate 3.24. Ax Rochester, *Without Struggle There Can Be No Progress*, 2013. Mural. Douglass-Anthony Memorial Bridge, Rochester, NY. Author photograph

Plate 3.25. Clark Hampton, *Frederick Douglass*, c. 1900. Oil on canvas. National Park Service Museum Resource Center

Plate 3.26. Unknown artist, "Frederick Douglass and Abraham Lincoln: The Great Emancipators," *Call and Post* (Cleveland), February 9, 1963, editorial page

Plate 3.27. United States Postal Service, *Frederick Douglass*, 1995. 32¢ postage stamp. Author's collection

Plate 3.28. International Fur and Leather Workers Union, "The lesson of the ages is that a wrong done to one man is a wrong done to all men," 1945. Flyer. *Daily Worker* and *Daily World* Photographs Collection, Tamiment Library and Robert F. Wagner Labor Archive, NYU, 25.4801

Plate 3.29. *Ebony Special Issue: The Emancipation Proclamation* (cover), September 1963. Author's collection

Plate 3.30. Don Rodgers, *Our Brothers and Sisters*, 1984. Mural. Halsted Street, Chicago. Author photograph

Plate 3.31. Calhoun Printing Co, "Gigantic Exhibition of Negro Life and Character," 1895. Broadside advertisement. Beinecke Rare Book and Manuscript Library, Yale University

Plate 3.32. Munir Mohammed, *The Shoulders of Heroes We Lean On*, 2012. Mural. Black Heritage Society of Providence, RI. Author photograph

Plate 3.33. Unknown artist, untitled mural, 1990. Roosevelt Road, Chicago. Author photograph

Plate 3.34. Helen Haynes, *Afro-American History*, 1976. Mural. Grenville High School, Cleveland, OH. Author photograph

Plate 3.35. Ashanti Johnson, Nathan Hoskins, and Verna Parks, *Wall of Respect*, 1975 (destroyed in 2007). Mural. Auburn Avenue, Atlanta, GA. Author photograph

Plate 3.36. Dan Devenny, *Labor History Mural*, 2001. Sixth Street, New Bedford, MA. Author photograph

Plate 3.37. Dan Devenny, *Solidarity Mural*, 2006 (destroyed in 2011). Falls Road, Belfast, Northern Ireland. Author photograph

Plate 3.38. Open Hands Community Group, with Marion Weir, *Anti-Racism Mural,* 2011. Near Falls Road, Belfast, Northern Ireland. Author photograph

Plate 3.39. E.G. Renesch, *Emancipation Proclamation*, 1919. Broadside. Author's collection

Plate 3.40. *Emancipation Day, January 1.* 1916. Jubilee pin by Pettibone. Author's collection

Plate 3.41. Paul Minnihan, *I Dare to Dream*, 1995. Mural. West 13th Street, Chicago, IL. Author photograph

Plate 3.42. Moses X, *Black Seeds*, 1991. Mural. Jefferson Boulevard, Los Angeles, CA. Author photograph

PART IV: DOUGLASS'S WRITINGS ON PHOTOGRAPHY

Figure 8. "Abraham Lincoln, of Illinois, The Presidential Candidate for the Republican Party.—Photographed by Brady," *Frank Leslie's Illustrated Newspaper*, October 20, 1860

Figure 9. Mathew Brady, *Abraham Lincoln*, February 27, 1860. Carte-de-visite. Library of Congress

Figure 10. Unknown artist, Presidential campaign button [Abraham Lincoln], 1860. Library of Congress

PART V: CATALOGUE RAISONNÉ

The sixty plates in Part I, which also have a catalog number, are not duplicated here.

Cat. #17. Robert M. Cargo, c. 1861. 69 5th Street, Pittsburgh, PA. Carte-de-visite, 2½ × 4 in. Swann Auction Galleries

Cat. #19. John White Hurn, January 14, 1862. 1319 Chestnut Street, Philadelphia. Carte-de-visite, 2½ × 4 in. Library of Congress

Cat. #20. John White Hurn, January 14, 1862. 1319 Chestnut Street, Philadelphia. Carte-de-visite, 2½ × 4 in. Massachusetts Historical Society

Cat. #24. Augustus Morand, May 15, 1863. 297 Fulton Street, Brooklyn, NY. Carte-de-visite, 2½ × 4 in. National Park Service, Frederick Douglass National Historic Site

Cat. #26. Benjamin F. Smith, January–February 1864. 153 Middle Street, Portland, ME. Carte-de-visite, 2½ × 4 in. National Park Service, Frederick Douglass National Historic Site

Cat. #27. Benjamin F. Smith, January–February 1864. 153 Middle Street, Portland, ME. Carte-de-visite, 2½ × 4 in. National Park Service, Frederick Douglass National Historic Site

Cat. #29. Samuel Montague Fassett, late February 1864. 122 and 124 Clark Street, Chicago. Carte-de-visite, 2½ × 4 in. Amistad Center for Art & Culture, Wadsworth Atheneum Museum of Art

Cat. #30. Samuel Montague Fassett, late February 1864. 122 and 124 Clark Street, Chicago. Carte-de-visite, 2½ × 4 in. Moorland-Spingarn Research Center, Howard University

Cat. #31. Samuel Montague Fassett, late February 1864. 122 and 124 Clark Street, Chicago. Waters & Son. Engraving from a lost photograph, 2 × 3 in. *American Phrenological Journal* (May 1866): 148

Cat. #34. Alfred B. Crosby and Cyrus W. Curtis, early April 1864. 138 Lisbon Street, Lewiston, ME. Carte-de-visite, 2½ × 4 in. R. R. Auction

Cat. #35. Alfred B. Crosby and Cyrus W. Curtis, early April 1864. 138 Lisbon Street, Lewiston, ME. Carte-de-visite, 2½ × 4 in. National Park Service, Frederick Douglass National Historic Site

Cat. #37. Stephen H. Waite, April 15, 1864. 271 Main Street, Hartford, CT. Carte-de-visite, 2½ × 4 in. Connecticut Historical Society

Cat. #38. Alexander Gardner (1821–1882), March 4, 1865. U.S. Capitol, Washington, DC. Matte collodion print, 6⅞ × 9½ in. Library of Congress

Cat. #40. Henry P. Rundel and Charles Warren Woodward, c. 1865. 126 State Street, Rochester, NY. Carte-de-visite, 2½ × 4 in. National Park Service, Frederick Douglass National Historic Site

Cat. #41. Henry P. Rundel and Charles Warren Woodward, c. 1865. 126 State Street, Rochester, NY. Carte-de-visite, 2½ × 4 in. eBay

Cat. #42. Unknown photographer, c. 1865. Carte-de-visite, 2½ × 4 in. PBA Galleries

Cat. #43. John White Hurn, February 8, 1866. 1319 Chestnut Street, Philadelphia. Carte-de-visite, 2½ × 4 in. National Park Service, Frederick Douglass National Historic Site

Cat. #44. H. N. Roberts, late March 1866. Gilman's Block, Madison, WI. Carte-de-visite, 2½ × 4 in. Kansas State Historical Society

Cat. #45. William Emory Bowman (1834–1915), April 1866. Court Street, Ottawa, IL. Carte-de-visite, 2½ × 4 in. American Antiquarian Society

Cat. #46. L. E. Gibbs (1810–1875), April 1866. The National Gallery, Main and LaSalle Streets, Ottawa, IL. Carte-de-visite, 2½ × 4 in. National Park Service, Frederick Douglass National Historic Site

Cat. #47. Newton Briggs (1830–1911), April 1866. 4 Main Street, Galesburg, IL. Carte-de-visite, 2½ × 4 in. National Park Service, Frederick Douglass National Historic Site

Cat. #48. J. Marsden Fox (1825–1901) and Menzo Edgar Gates (1832–1890), c. 1866. Concert Hall, 40 and 42 State Street, Rochester, NY. Carte-de-visite, 2½ × 4 in. Harvard University Archives, HUM 2.85p

Cat. #51. James Presley Ball, January 12, 1867. 30 West 4th Street, Cincinnati, OH. Carte-de-visite, 2½ × 4 in. Cowan's Auctions

Cat. #53. Austin Kracaw (1833–1886), February–March 1867. Post Office Building, Washington, IA. Carte-de-visite, 2½ × 4 in. National Park Service, Frederick Douglass National Historic Site

Cat. #55. Unknown photographer, c. 1867. Carte-de-visite, 2½ × 4 in. Library of Congress

Cat. #56. Dayton Morgan (1842–1914), 1868. Life-sized plaster bust from a lost photograph, 28¼ × 20 in. Swann Auction Galleries

Cat. #57. Unknown photographer, c. 1868. Carte-de-visite, 2½ × 4 in. National Park Service, Frederick Douglass National Historic Site

Cat. #58. Benjamin E. Hawkins, March 1868. 417 Market Street, Steubenville, OH. Carte-de-visite, 2½ × 4 in. National Park Service, Frederick Douglass National Historic Site

Cat. #60. J. E. Small, February–March 1869. Berlin, WI. Carte-de-visite, 2½ × 4 in. National Park Service, Frederick Douglass National Historic Site

Cat. #62. George Francis Schreiber, April 16, 1870. 818 Arch Street, Philadelphia. Carte-de-visite, 2½ × 4 in. Moorland-Spingarn Research Center, Howard University

Cat. #66. Unknown photographer, c. 1871. Carte-de-visite, 2½ × 4 in. National Park Service, Frederick Douglass National Historic Site

Cat. #67. Unknown photographer, c. 1872. Albumen print, 9 × 11 in. National Park Service, Frederick Douglass National Historic Site

Cat. #69. Unknown photographer, c. 1872. Quarter-plate ambrotype, 3¼ × 4¼ in. Swann Auction Galleries

Cat. #70. James M. LeClear (1837–1914), late January 1873. Jackson, MI. Carte-de-visite, 2½ × 4 in. John Hope Franklin Papers, David M. Rubenstein Rare Book & Manuscript Library, Duke University

Cat. #71. John White Hurn, March 10, 1873. 1319 Chestnut Street, Philadelphia. Carte-de-visite, 2½ × 4 in. Library of Congress

Cat. #72. John White Hurn, March 10, 1873. 1319 Chestnut Street, Philadelphia. Carte-de-visite, 2½ × 4 in. National Park Service, Frederick Douglass National Historic Site

Cat. #73. John White Hurn, March 10, 1873. 1319 Chestnut Street, Philadelphia. Carte-de-visite, 2½ × 4 in. National Park Service, Frederick Douglass National Historic Site

Cat. #74. John White Hurn, March 10, 1873. 1319 Chestnut Street, Philadelphia. Carte-de-visite, 2½ × 4 in. Massachusetts Historical Society

Cat. #77. Carl Casper Giers, September 1873. 43–45 Union Street, Nashville, TN. Carte-de-visite, 2½ × 4 in. National Park Service, Frederick Douglass National Historic Site

Cat. #78. Walter Ogilvie (1831–1917), December 9, 1873. National Equal Rights Convention meeting, Metzerott Hall, 925 Pennsylvania Avenue, Washington, DC. Cabinet card, 4¼ × 6½ in. Library of Congress

Cat. #80. John Howe Kent, January 26, 1874. 58 State Street, Rochester, NY. Cabinet card, 4¼ × 6½ in. George Eastman House, International Museum of Photography and Film

Cat. #81. John Howe Kent, January 26, 1874. 58 State Street, Rochester, NY. Cabinet card, 4¼ × 6½ in. National Park Service, Frederick Douglass National Historic Site

Cat. #82. John Howe Kent, January 26, 1874. 58 State Street, Rochester, NY. Carte-de-visite, 2½ × 4 in. Moorland-Spingarn Research Center, Howard University

Cat. #86. Lydia J. Cadwell, January 5, 1875. 103 State Street, Chicago. Cabinet card, 4¼ × 6½ in. Kansas State Historical Society

Cat. #87. Lydia J. Cadwell, January 5, 1875. 103 State Street, Chicago. Cabinet card, 4¼ × 6½ in. Moorland-Spingarn Research Center, Howard University

Cat. #88. Charles Delevan Mosher (1829–1897), c. 1875. 125 State Street, Chicago. Cabinet card, 4¼ × 6½ in. Chicago History Museum (missing from archive as of 2013)

Cat. #89. S. H. McLoughlin from a negative held by the Redpath Lyceum Bureau, c. 1876. 36 Bromfield Street, Boston. Lantern slide, 3¼ × 4¼ in. eBay

Cat. #90. William W. Core (1853–1890), 1876. Douglass's house at 316 A Street NE, Washington, DC. Albumen print, 10½ × 12½ in. National Park Service, Frederick Douglass National Historic Site

Cat. #91. William W. Core, 1876. Douglass's house at 316 A Street NE, Washington, DC. Albumen print, 16 × 20 in. National Park Service, Frederick Douglass National Historic Site

Cat. #94. Unknown photographer, August 8, 1877. Ocean House, Old Orchard Beach, ME. Mounted albumen print, 6½ × 9¼. Maine State Archives

Cat. #95. Samuel Montague Fassett, 1878. 925 Pennsylvania Avenue NW, Washington, DC. Carte-de-visite, 2½ × 4 in. Moorland-Spingarn Research Center, Howard University

Cat. #98. George Kendall Warren, c. 1879. 289 Washington Street, Boston. Carte-de-visite, 2½ × 4 in. National Park Service, Maggie L. Walker National Historic Site

Cat. #99. Unknown photographer, c. 1879. Engraving from a lost photograph. Frederick Douglass Papers, Library of Congress

EPILOGUE

AFTERWORD

BIBLIOGRAPHY

OTHER NINETEENTH-CENTURY ENGRAVINGS, LITHOGRAPHS, PAINTINGS, AND DRAWINGS BASED ON PHOTOGRAPHS

From Cat. #36
G. F. Kahl for E. Sachse & Co. (Baltimore), "The Fifteenth Amendment and its Results," 1870
Metcalf & Clark (Baltimore), "The Result of the Fifteenth Amendment," 1870
Gaylord Watson for E. E. Murray & Co. (New York), "From the Plantation to the Senate," 1883

From Cat. #76
Unknown artist, *Harper's Weekly*, March 2, 1895
Unknown artist, *Denver Times*, March 8, 1895

From Cat. #83
Unknown artist, *Omaha World Herald*, August 7, 1891
Unknown artist, *Hoboken Evening News*, February 21, 1895
Unknown artist, *Minneapolis Times*, February 21, 1895
Unknown artist, *Kansas City Times*, February 21, 1895
Unknown artist, *The Island* (Floral Park, NY), February 23, 1895

From Cat. #85
Unknown artist, in Howard Carroll, *Twelve Americans, Their Lives and Times; with Portraits* (New York: Harper & Bros., 1883), p. 263
Unknown artist, in *Thos. W. Herringshaw, The Biographical Review of Prominent Men and Women of the Day* (Chicago: Home Publ. House, 1889), p. 342
Unknown artist, *The New York World*, October 1, 1889
Unknown artist, Negro Historical Society handbill, May 1892 (Wadsworth Atheneum)
Unknown artist, *The Observer* (Lancaster, PA), March 8, 1895

From Cat. #92
Unknown artist, *Washington Daily Critic*, February 20, 1880
Unknown artist, in Thomas E. Hill, *Hill's Album of Biography and Art* (Chicago: Hill Standard Book Co., 1882), p. 198

From Cat. #96
Unknown artist, frontispiece, *The Life and Times of Frederick Douglass* (London: Christian Age Office, 1882)
George F. Crane, "Distinguished Colored Men," hand-colored lithograph, 1883

Unknown artist, *The Graphic* (London), November 13, 1886, p. 509, and March 2, 1895, p. 258

Unknown artist, *Weekly Standard Echo* (Philadelphia), April 8, 1893

From Cat. #97

Unknown artist, *Rumor* (New York City), September 4, 1880

Unknown artist, in Alfred S. Johnson, ed., *Quarterly Register of Current History*, Vol. 1 (Detroit: Evening News Association, 1892), p. 440

Unknown artist, *The Outlook*, March 2, 1895

Unknown artist, *Anti-Caste*, April–May 1895, cover

From Cat. #105

Unknown artist, in William J. Simmons, *Men of Mark* (Cleveland: Geo. M. Rewell & Co., 1887), p. 64

Unknown artist, in William T. Alexander, *History of the Colored Race in America* (Kansas City: Palmetto Publ. Co., 1887), p. 389

Unknown artist, in *Appletons' Cyclopædia of American Biography*, Vol. 2 (New York: D. Appleton & Co., 1888), p. 217

Unknown artist, in Edward A. Johnson, *A School History of the Negro Race in America* (Raleigh, NC: Edwards & Broughton, 1890), p. 84

Unknown artist, in I. Garland Penn, *The Afro-American Press and its Editors* (Springfield, IL: Willey & Co., 1891), p. 449

Unknown artist, *Boston Daily Globe*, January 8, 1893

Unknown artist, *Daily Inter Ocean* (Chicago), December 5, 1893

Unknown artist, *The Union and Advertiser* (Rochester, NY), February 21, 1895

Unknown artist, *Washington Evening Star*, February 21, 1895

Unknown artist, *Times* (Troy, NY), February 21, 1895

Unknown artist, *Chicago Daily News*, February 21, 1895

Unknown artist, *Boston Transcript*, March 2, 1895

Unknown artist, *The Appeal* (St. Paul, MN), March 23, 1895

Kurz and Allison's Art Studio Lithograph, Chicago, 1895

Unknown artist, Cotton States and International Exposition Medal, Atlanta, 1895

From Cat. #106

Unknown artist, *Atchison Daily Globe* (Kansas), April 23, 1887

Freeman Thorp, oil on canvas portrait, c. 1890 (Iowa State Historical Museum)

Edward H. Lee, *Indianapolis Freeman*, July 13, 1889, and February 9, 1895

Unknown artist, *The North American* (Philadelphia), August 18, 1891

Unknown artist, *Trenton Evening Times*, September 13, 1891

Unknown artist, *Indianapolis Freeman*, December 24, 1892

Unknown artist, *Daily Inter Ocean*, August 15, 1893

Unknown artist, *New York Press*, February 21, 1895

Unknown artist, *Budget* (Troy, NY), February 24, 1895

Unknown artist, *Post Express*, February 26, 1895

Unknown artist, *The Republican* (Seattle), March 23, 1895

Unknown artist, Washington High School Memorial Program cover, March 29, 1895 (Library of Congress)

S. Brainard's Sons Co. (Chicago), cover, "Frederick Douglass Funeral March," 1895 (Library of Congress)

Unknown artist, Frederick Douglass Monument Committee (Rochester, NY), souvenir spoon, 1896 (Beinecke Rare Book and Manuscript Library)

Autogravure Co., Chicago, Tennessee Centennial Exposition coin, 1896

Unknown artist, cover, *The Colored American Republican Text Book* (Washington, DC: The Colored American Publ. Co., 1899)

John Andrew & Son, frontispiece to Charles Chesnutt, *Frederick Douglass* (Boston: Small, Maynard, 1899)

ADDITIONAL CONTEMPORANEOUS ARTWORKS

Behnes, William. "Farewell Song of Frederick Douglass, on Quitting England for America—the Land of His Birth," London: Duff & Hodgson, 1847.

Bellew, Frank. "A Distinguished Turnout," *The Lantern*, May 29, 1852, p. 206.

Bouve, Ephraim W. "The Fugitive's Song," Boston: Henry Prentiss, 1845.

Bricktop [George G. Small]. Illustrations. *Fred Douglass and His Mule: A Story of the War.* 2nd ed., New York: M. J. Ivers & Co., 1886.

Clay, Edward Williams. "An Amalgamation Polka: Respectfully Dedicated to Miss Abby Kelly," New York: A. Donnelly, 1845.

———. "Experiments on the Tight Rope," New York: John Childs, 1852.

———. "Great Presidential Sweepstakes Over the Washington Course," New York: John Childs, 1852.

Cruikshank, George. "Douglass Flogged by Covey," *The Uncle Tom's Cabin Almanack; or, Abolitionist Memento for 1853.* London: J. Cassell, 1852, p. 23. Also published as "Douglas wird von Covey gezüchtigt," *Weber's Volks-Kalender.* Leipzig: Verlag von J. J. Weber, 1853, p.143.

Fassett, Cornelia. "The Florida Case before the Electoral Commission," 1879, U.S. Senate.

Hill, Cynthia. "Frederick Douglass Doll," c. 1858. New Bedford Whaling Museum.

Keppler, Joseph Ferdinand. "The Millennium at Last!" *Puck*, March 3, 1877: centerfold.

———. "Through Night to Light," *Puck*, October 25, 1882: centerfold.

———. "The Pyrrhic Victory of the Mulligan Guards in Maine," *Puck*, September 17, 1884: centerfold.

Lewis, Henry Jackson. "A Few Owl-Wise Sages," *The Freeman*, February 16, 1889, p. 8.

———. "The Candidates for the Recordership of Deeds," *The Freeman*, February 23, 1889, p. 8.

———. "President Harrison and the Office Seekers," *The Freeman*, March 9, 1889, p. 8.

———. "The Race Problem," *The Freeman*, March 30, 1889, p. 8.

———. "The Freeman's Political Horoscope," *The Freeman*, August 3, 1889, p. 8.

———. "Frederick Gets the 'Plum' (Haytian Mission)," *The Freeman*, July 20, 1889, p. 8.

Luks, George Benjamin. "The Great 'Human Rights' Movement," *Wild Oats Journal* (New York, NY), June 6, 1872, p. 9.

Rowse, Samuel. "The Resurrection of Henry Box Brown at Philadelphia," New York: A. Donnelly, 1850.

Taylor, James E. "The Santo Domingo Commission," *Frank Leslie's Illustrated Newspaper*, March 11, 1871, pp. 421, 437.

———. "The Commissioners, at their Headquarters in Santo Domingo City, taking Testimony from the neighboring Villagers," *Frank Leslie's Illustrated Newspaper*, March 18, 1871, p. 13.

———. "Fred. Douglass in the Lobby of the Grand Hotel, Counseling the Colored Delegates," *Frank Leslie's Illustrated Newspaper*, July 1, 1876, p. 276.

———. "Plantation Owners in Santo Domingo," unpublished drawing, 1871. National Park Service, Frederick Douglass National Historic Site.

Tucker, Moses. "An Opossum Dinner," *The Freeman*, December 21, 1889, p. 8.

Unknown artist. "The Irrepressible Conflict," *Frank Leslie's Illustrated Newspaper*, November 19, 1859, p. 398.

———. "Major-Glen Sheridan's Ride from Washington to Philadelphia," *Frank Leslie's Illustrated Newspaper*, October 12, 1867, p. 49.

———. "Back from Liberia," *Frank Leslie's Illustrated Newspaper*, December 6, 1879, p. 248.

———. "Our Artistic Correspondent Interviewing Frederick Douglass in the District Marshal's Office, Washington, D.C.; Illustrated Interviews with Eminent Public Men on Leading Topics of the Day," *Frank Leslie's Illustrated Newspaper*, December 13, 1879, p. 257.

———. "The Last Time He Saw His Mother," "Mrs. Auld Teaching Him to Read," "Found in the Woods by Sandy," and "Driven to Jail for Running Away," *Life and Times of Frederick Douglass.* Hartford, CT: Park Publ. Co., 1881, pp. 22, 70, 132, 168.

ARCHIVES AND COLLECTIONS CHECKED FOR PHOTOGRAPHS OF DOUGLASS

North America

African American Civil War Museum, Washington, DC

Albert S. Cook Library, Towson State University, MD

Allen County Public Library, Fort Wayne, IN

American Antiquarian Society, Worcester, MA

Amistad Research Center, Tulane University, New Orleans, LA

Anacostia Community Museum, Washington, DC

Annenberg Space for Photography, Los Angeles
Archives and Special Collections, Harvard University
Art Institute of Chicago
Atlanta History Center
Auburn Avenue Research Library, Atlanta
Avery Research Center, College of Charleston
Baltimore City Historical Society
Bancroft Library, University of California, Berkeley
Banneker-Douglass Museum, Annapolis, MD
Beinecke Rare Book and Manuscript Library, Yale University
Benson Ford Research Center, Dearborn, MI
Bibliothèque Schoelcher, Port-de-france, Martinique
Boston Athenæum
Boston Public Library
Canada National Archives, Ottawa
Charles H. Wright Museum of African American History, Detroit
Chester County Historical Society, PA
Chicago History Museum
Chris Webber Collection of African American Artifacts and Documents, Central Library, Sacramento Public Library System
Cincinnati Historical Society Library
Clark Atlanta University Art Collections
Connecticut Historical Society, Hartford
Connecticut State Library, Hartford
Cowan's Auctions Archives, Cincinnati
David M. Rubenstein Rare Book and Manuscript Library, Duke University
Department of Rare Books and Special Collections, Princeton University Library
District of Columbia Public Library
Division of Rare and Manuscript Collections, Cornell University
DuSable Museum of African American History, Chicago
Ethnic Heritage Center, New Haven
Fine Arts Museums of San Francisco
Frederick Douglass Memorial and Historical Association, Washington, DC
Frederick Douglass Museum & Caring Hall of Fame, Washington, DC
Frederick Douglass Museum and Cultural Center, Highland Beach, MD
Frederick Douglass Papers, Indiana University-Purdue University, Indianapolis
Frederick Douglass Papers, University of Rochester
Garrison Family Papers, Smith College, Northampton, MA
George Eastman House, Rochester
Gilder Lehrman Institute of American History, New York
Granger Collection, New York
Greg French Collection, Boston
Harry Ransom Center, University of Texas at Austin
High Museum of Art, Atlanta
Hillsdale College Archives, MI
Historical Society of Baltimore County
Historical Society of Pennsylvania, Philadelphia
Historical Society of Talbot County, MD
Huntington Library, San Marino, CA
Iowa State Historical Society, Des Moines
Isaac and Amy Post Family Papers, University of Rochester
Kansas State Historical Society, Topeka
Lavery Library Collection, St. John Fisher College, Rochester, NY
Levi Coffin State Historic Site, Fountain City, IN
Library Company of Philadelphia
Library of Congress
Louisiana State Museum, Baton Rouge
Lynn Museum and Historical Society, MA

Madison County Historical Society, Oneida, NY
Maine Historical Society, Portland
Maine State Archives, Augusta
Manuscript, Archives, and Rare Book Library, Emory University, Atlanta, GA
Maryland Historical Society, Baltimore
Maryland State Archives, Annapolis
Massachusetts Historical Society, Boston
McArthur Public Library, Maine, Biddeford, ME
Metropolitan Museum of Art, New York
Mississippi State Archives, Jackson
Missouri Historical Society, St. Louis
Missouri History Museum, St. Louis
Monroe County Public Library, Bloomington, IN
Moorland-Spingarn Research Center, Howard University, Washington, DC
Morgan Library and Museum, New York
Morgan State University, Baltimore
National Archives and Records Administration, Washington, DC
National Museum of African American History and Culture, Washington, DC
National Museum of American History, Washington, DC
National Park Service Museum Resource Center, Landover, MD
National Park Service, Frederick Douglass National Historic Site, Washington, DC
National Park Service, Maggie L. Walker National Historic Site, Richmond, VA
National Portrait Gallery, Washington, DC
Nazareth College, Rochester
Nebraska State Historical Society, Lincoln
Nelson-Atkins Museum of Art, Kansas City
New Bedford Whaling Museum, MA
New Haven Museum
New-York Historical Society, New York
New York State Museum, Albany
Newberry Library, Chicago
Ohio Historical Society, Columbus
Onondaga Historical Association, Syracuse, NY
Palmer Museum of Art, Pennsylvania State University
PBA Galleries Archives, San Francisco
Peabody Collection, Hampton University, VA
Peabody Essex Museum, Salem, MA
Pennsylvania Academy of the Fine Arts, Philadelphia
Philadelphia History Museum
Providence Public Library, RI
Quaker and Special Collections, Haverford College, PA
R. R. Auction Archives, Amherst, MA
Rare Book and Manuscript Library, Columbia University
Rare Book and Manuscript Library, University of Pennsylvania
Rhode Island Historical Society, Providence
Robert W. Woodruff Library, Atlanta University Center
Rochester Historical Society
Rochester Institute of Technology
Rochester Museum and Science Center
Rochester Public Library
St. Louis Art Museum
St. Louis Mercantile Library, University of Missouri–St. Louis
Schomburg Center for Research in Black Culture, New York Public Library
Special Collections, Alexandria Library, VA
Special Collections, Colby College, ME
Special Collections, University of Virginia Library, Charlottesville
Special Collections Research Center, Syracuse University Library
State Historical Society of Missouri, Columbia

Stephen A. Schwarzman Building, New York Public Library
Swann Auction Galleries Archive, New York
Tamiment Library, New York University
Tuskegee University Archives, AL
University of New Mexico Art Museum, Albuquerque
Virginia Historical Society, Richmond
Wadsworth Atheneum, Hartford, CT
Walter O. Evans Collection, Savannah, GA
White House Historical Association, Washington, DC
Whittier Public Library, CA
Wichita State University Library
Wilberforce University Library, OH
William L. Clements Library, University of Michigan, Ann Arbor
Wisconsin Historical Society, Madison
Women's Rights National Historical Park, Seneca Falls, NY

Europe
Aberdeen City and Aberdeenshire Archives, Scotland
Angus Archives, Scotland
Arbroath Library, Scotland
Ayrshire Archives, Scotland
Bantry House, County Cork, Ireland
Beauly Priory, Inverness, Scotland
Benwell Roman Temple, Tyne and Wear, UK
Bessie Surtees House, Newcastle upon Tyne, UK
Bibliothèque et des Archives du Sénat, Paris
Bibliothèque de l'Assemblée Nationale, Paris
Bibliothèque Historique de la Ville de Paris, Paris
Biblithécaire de la Maison de Victor Hugo, Paris
Bibliothèque Nationale de France, Paris
Bodleian Library of Commonwealth & African Studies at Rhodes House, University of Oxford
Bristol Record Office, UK
British Library, London
Burns Monument Centre, East Ayrshire, Scotland
Capheaton Hall, Northumberland, UK
Cathedral Church of St. Nicholas, Newcastle upon Tyne, UK
Centre for Local Studies, Darlington Library, UK
Cork City and County Archives, Ireland
Coventry History Centre, UK
Croxteth Hall, Liverpool, UK
Culloden House, Inverness, Scotland
Culver House, Exeter, UK
Cumbria Archive Centre, Carlisle, UK
Devon Record Office, Exeter, UK
Dr. Williams's Library, London
Dublin City Archives, Ireland
Dublin Friends' Historical Library, Ireland
Dumfries House, Ayrshire, Scotland
Durham County Record Office, UK
Eaton Hall, Cheshire, UK
Edinburgh City Archives
Fife Council Archive Centre, Scotland
Fort George, Highland, Scotland
Fota House, County Cork, Scotland
Fursdon House, Exeter, UK
Fyne Court, Somerset, UK
Glasgow Cathedral
Grand Orient de France, Paris

Greater Manchester County Record Office, UK
Halifax Reference Library, UK
Halsway Manor, Somerset, UK
Harewood House, Leeds, UK
Hestercombe Gardens, Taunton, UK
Highland Council Archive Service, Inverness, Scotland
House of Dun, Angus, Scotland
Howth Castle, Fingal County, Ireland
John Rylands Library, Manchester, UK
Killerton House, Exeter, UK
Kirkcaldy Library and Museum, Fife, Scotland
Knowsley Hall, Merseyside, UK
Lauriston Castle, Edinburgh
Library of the Religious Society of Friends in Britain, London
Limerick City Archives, Ireland
Liverpool Record Office, UK
Local and Family History Library, Leeds, UK
London Metropolitan Archives
Mitchell Library, Glasgow
Montrose Library, Scotland
Montrose Museum, Scotland
Musée de la Hardt, Fessenheim, France
Museum of Somerset, Taunton, UK
National Archives of Ireland, Dublin
National Archives of Scotland, Edinburgh
National Archives of the United Kingdom, Kew, Richmond, Surrey, UK
National Art Library, Victoria & Albert Museum, London
National Library of Ireland, Dublin
National Library of Scotland, Edinburgh
National Photographic Archive, Dublin
National Portrait Gallery, London
Newcastle Castle Garth, UK
Newcastle Castle Keep, UK
Newcastle City Library, UK
Nostell Priory, West Yorkshire, UK
North Ayrshire Heritage Centre, Scotland
North Devon Record Office, Exeter, UK
Paisley Central Library, Renfrewshire, Scotland
Paisley Museum, Renfrewshire, Scotland
Perth & Kinross Council Archive, Perth, Scotland
Plymouth and West Devon Record Office, UK
Plymouth Central Library, UK
Provost Skene's House, Aberdeen, Scotland
Public Record Office of Northern Ireland, Belfast, Northern Ireland
Raby Castle, County Durham, UK
Royal Photographic Society, London
St. Andrew's Library Photographic Archive, University of St. Andrews, Scotland
St. Mary's Episcopal Cathedral, Edinburgh
St. Neots Museum, Cambridgeshire, UK
Scottish National Portrait Gallery, Edinburgh
Sheffield Archives, UK
Sheffield Local Studies Library, UK
Somerset Heritage Centre, Taunton, UK
Stobhall Castle, Perthshire, Scotland
Temple Newsam Estate, Leeds, UK
Tyne & Wear Archives, Newcastle upon Tyne, UK
Urquhart Castle, Inverness, Scotland
Wakefield Learning and local Studies Library, UK

Warwickshire County Record Office, Warwick, UK
Westcountry Studies Library, Exeter, UK
West Yorkshire Archive Service, Wakefield, UK
Wortley Hall, Sheffield, UK

FURTHER READING

Baggett, Paul. "Transcending the Boundaries of Nation: Images and Imaginings of Frederick Douglass," *Process* 2 (2000): 103–13.

Baxter, Terry. *Frederick Douglass's Curious Audiences: Ethos in the Age of the Consumable Subject.* London: Routledge, 2004.

Bernier, Celeste-Marie. "'Arms Like Polished Iron': Representing the Black Slave Body in Narratives of a Slave Revolt," *Slavery and Abolition* 23.2 (2002): 91–106.

———. *Characters of Blood: Black Heroism in the Transatlantic Imagination.* Charlottesville: University of Virginia Press, 2012.

———. "'The Face of a Fugitive Slave': Representing and Reimagining Frederick Douglass in Popular Illustrations, Fine Art Portraiture and Daguerreotypes," in Magnus Brechkten, ed., *Political Memory.* Göttingen: Vandenhoeck & Ruprecht, 2012.

———. "A 'Typical Negro' or a 'Work of Art'? The 'Inner' via the 'Outer Man' in Frederick Douglass's Manuscripts and Daguerreotypes," *Slavery and Abolition* 33.2 (2012): 287–303.

———. "A Life in Art: The Case of Frederick Douglass," in Bill E. Lawson and Celeste-Marie Bernier, eds, *Imaging Frederick Douglass* (forthcoming, *African American Review*, 2016).

Blackwood, Sarah. "Fugitive Obscura: Runaway Slave Portraiture and Early Photographic Technology," *American Literature* 81.1 (2009): 93–125.

Blassingame, John W., and John R. McKivigan, eds. *The Frederick Douglass Papers: Series One, Two, and Three.* New Haven: Yale University Press, 1979–2012.

Blight, David W. *Frederick Douglass' Civil War: Keeping Faith in Jubilee.* Baton Rouge: Louisiana State University Press, 1991.

Brilliant, Richard. *Portraiture.* Cambridge, MA: Harvard University Press, 1991.

Brown, Joshua. *Beyond the Lines: Pictorial Reporting, Everyday Life, and the Crisis of Gilded-Age America.* Berkeley: University of California Press, 2002.

———. "Historians and Photography," *American Art* 21.3 (2007): 9–13.

Brunet, François. *Photography and Literature.* London: Reaktion, 2009.

Chaney, Michael. "Picturing the Mother, Claiming Egypt: *My Bondage and My Freedom* as Auto(bio)ethnography," *African American Review* 35.3 (2001): 391–408.

———. *Fugitive Vision: Slave Image and Black Identity in Antebellum Narrative.* Bloomington: Indiana University Press, 2009.

———. "Heartfelt Thanks to *Punch* for the Picture: Frederick Douglass and the Transnational Jokework of Slave Caricature," *American Literature* 82.1 (2010): 57–90.

Chesnutt, Charles W. *Frederick Douglass.* Boston: Small, Maynard & Co., 1899.

Cobb, Jasmine Nichole. *Picture Freedom: Remaking Black Visuality in the Early Nineteenth Century.* New York: New York University Press, 2015.

Davis, Keith F. *The Origins of American Photography, 1839–1885: From Daguerreotype to Dry-Plate.* Kansas City: Nelson-Atkins Museum of Art, 2007.

Dinius, Marcy. *The Camera and the Press: American Visual and Print Culture in the Age of the Daguerreotype.* Philadelphia: University of Pennsylvania Press, 2012.

———. "Seeing Ourselves As Others See Us: Frederick Douglass's Reflections on Daguerreotypy and Racial Difference," in Tanya Sheehan and Andres Zervignon. eds., *Photography and Its Origins.* London: Routledge, 2015.

Douglass' Monthly, Vols. 1–5, 1859–63. New York: Negro Universities Press, 1969.

DuBois Shaw, Gwendolyn. *Portraits of a People: Picturing African Americans in the Nineteenth Century.* Seattle: University of Washington Press, 2006.

Faisst, Julia. *Cultures of Emancipation: Photography, Race, and Modern American Literature.* Heidelberg: Universitätsverlag, 2012.

———. "Degrees of Exposure: Frederick Douglass, Daguerreotypes, and Representations of Freedom," *Philologie im Netz*, Supplement 5 (2012): 45–70.

Folsom, Ed. "Portrait of the Artist as a Young Slave: Douglass's Frontispiece Engravings," in James C. Hall, ed., *Approaches to Teaching Narrative of the Life of Frederick Douglass.* New York: Modern Language Association of America, 1999.

Foner, Philip S., ed., *The Life and Writings of Frederick Douglass.* 5 vols. New York: International Publishers, 1950–75.

Gikandi, Simon. *Slavery and the Culture of Taste.* Princeton, NJ: Princeton University Press, 2011.

Goldberg, Vicki. *The Power of Photography: How Photographs Changed Our Lives.* Expanded and updated, New York: Abbeville Publ., 1991.

Goodyear III, Frank H. *Red Cloud: Photographs of a Lakota Chief.* Lincoln: University of Nebraska Press, 2003.

Gougeon, Len. "Militant Abolitionism: Douglass, Emerson, and the Anti-Slave," *The New England Quarterly* 85.4 (December 2012): 622–57.

Hamilton, Charles, and Lloyd Ostendorf. *Lincoln in Photographs: An Album of Every Known Pose.* Dayton, OH: Morningside House, 1985.

Hill, Lena. *Visualizing Blackness and the Creation of the African American Literary Tradition.* Cambridge: Cambridge University Press, 2014.

Holzer, Harold. *Lincoln at Cooper Union: The Speech That Made Abraham Lincoln President.* New York: Simon & Schuster, 2004.

Humphreys, Hugh C. "'Agitate! Agitate! Agitate!' The Great Slave Law Convention and Its Rare Daguerreotype," *Madison County Heritage* 19 (1994): 1–64.

Katz, D. Mark. *Custer in Photographs.* New York: Bonanza Books, 1985.

———. *Witness to an Era: The Life and Photographs of Alexander Gardner; The Civil War, Lincoln, and the West.* New York: Viking, 1991.

Keenan, Thomas, and Eyal Weizman. *Mengele's Skull: The Advent of a Forensic Aesthetics.* Berlin: Sternberg Press, Portikus, 2012.

Lee, Julia Sun-Joo. *The American Slave Narrative and the Victorian Novel.* Oxford: Oxford University Press, 2012.

Lee, Maurice S., ed. *The Cambridge Companion to Frederick Douglass.* Cambridge: Cambridge University Press, 2009.

Levine, Robert. *Martin Delany, Frederick Douglass and the Politics of Representative Identity.* Durham: University of North Carolina Press, 1997.

———, and Samuel Otter, eds. *Frederick Douglass and Herman Melville: Essays in Relation.* Durham: University of North Carolina Press, 2008.

Linfield, Susie. *The Cruel Radiance: Photography and Political Violence.* Chicago: University of Chicago Press, 2010.

Lugo-Ortiz, Agnes, and Angela Rosenthal, eds. *Slave Portraiture in the Atlantic World.* Cambridge: Cambridge University Press, 2013.

Martin, Waldo. *The Mind of Frederick Douglass.* Durham: University of North Carolina Press, 1986.

Maxwell, Barry Frederick. "Douglass's Haven-Finding Art," *Arizona Quarterly* 48.4 (1992): 47–73.

McCandless, Barbara. "The Portrait Studio and the Celebrity: Promoting the Art," in Martha A. Sandweiss, ed., *Photography in Nineteenth-Century America.* New York: Harry N. Abrams, 1991.

McFeely, William. *Frederick Douglass.* New York: W. W. Norton & Co., 1995.

Meehan, Sean Ross. *Mediating American Autobiography: Photography in Emerson, Thoreau, Douglass and Whitman.* Columbia: University of Missouri Press, 2008.

Meltzer, Milton. *Mark Twain Himself: A Pictorial Biography.* New York: Thomas Y. Crowell Co., 1960.

Miller, Monica L. *Slaves to Fashion: Black Dandyism and the Styling of Black Diasporic Identity.* Durham: Duke University Press, 2009.

Mitchell, Mary Niall. *Raising Freedom's Child: Black Children and Visions of the Future After Slavery.* New York: New York University Press, 2008.

Molineux, Catherine. *Faces of Perfect Ebony: Encountering Atlantic Slavery in Imperial Britain.* Cambridge, MA: Harvard University Press, 2012.

Muller, John. *Frederick Douglass in Washington D.C.: The Lion of Anacostia.* New York: History Press, 2012.

Orvell, Miles. *The Real Thing: Imitation and Authenticity in American Culture, 1880–1940.* Chapel Hill: University of North Carolina Press, 1989.

Panzer, Mary. *Mathew Brady and the Image of History.* Washington, DC: Smithsonian Institution Press, 1997.

Peterson, Carl. "Nineteenth Century Photographers and Related Activity in Madison County, New York," *Madison County Heritage* 23 (1998): 15–25.

Plunkett, John. *Queen Victoria: First Media Monarch.* Oxford: Oxford University Press, 2003.

Powell, Richard J. *Cutting a Figure: Fashioning Black Portraiture.* Chicago: University of Chicago Press, 2009.

———. "Sator Africanus," in Susan Fillin-Yeh, ed., *Dandies: Fashion and Finesse in Art and Culture.* New York: New York University Press, 2001.

Quarles, Benjamin. *Frederick Douglass.* New York: Da Capo Press, 1997.

Rice, Alan, and Martin Crawford, eds. *Liberating Sojourn: Frederick Douglass and Transatlantic Reform.* Athens: University of Georgia Press, 1999.

Severa, Joan. *Dressed for the Photographer: Ordinary Americans & Fashion, 1840–1900.* Kent, OH: Kent State University Press, 1995.

Shumard, Ann M. *A Durable Memento: Portraits by Augustus Washington, African American Daguerreotypist.* Washington, DC: National Portrait Gallery, Smithsonian Institution, 2000.

Smith, Shawn Michelle. *American Archives: Gender, Race, and Class in Visual Culture.* Princeton, NJ: Princeton University Press, 1999.

Stauffer, John. "Daguerreotyping the National Soul: The Portraits of Southworth and Hawes," *Prospects* 22 (1997): 69–107.

———. "Race and Contemporary Photography: Willie Robert Middlebrook and the Legacy of Frederick Douglass," *21st: Journal of Contemporary Photography: Culture and Criticism* 1 (1998): 55–60.

———. *The Black Hearts of Men: Radical Abolitionists and the Transformation of Race.* Cambridge, MA: Harvard University Press, 2001.

———. "Frederick Douglass and the Aesthetics of Freedom," *Raritan* 25.1 (2005): 114–36.

———. *Giants: The Parallel Lives of Frederick Douglass and Abraham Lincoln.* New York: Twelve, 2008.

———. "Creating an Image in Black: The Power of Abolition Pictures," in W. Fitzhugh Brundage, ed., *Beyond Blackface: African Americans and the Creation of American Popular Culture, 1890–1930.* Chapel Hill: University of North Carolina Press, 2011.

———. "The 'Terrible Reality' of the First Living-Room Wars," in Anne Wilkes Tucker and Will Michels, eds., *War/Photography: Images of Armed Conflict and Its Aftermath.* Houston: Museum of Fine Arts, 2012.

Sundquist, Eric, ed. *Frederick Douglass: New Literary and Historical Essays.* Cambridge: Cambridge University Press, 1993.

Sweeney, Fionnghuala. *Frederick Douglass and the Atlantic World.* Liverpool: Liverpool University Press, 2007.

———. "Visual Culture and Fictive Technique in Frederick Douglass's *The Heroic Slave*," *Slavery and Abolition* 33.2 (2012): 305–20.

Taft, Robert. *Photography and the American Scene: A Social History, 1839–1899.* 1938; New York: Dover Publications, 1964.

Trachtenberg, Alan. *Reading American Photographs: Images as History, Mathew Brady to Walker Evans.* New York: Hill & Wang, 1989.

———. "Mirror in the Marketplace: American Responses to the Daguerreotype, 1839–1851," in John Wood, ed., *The Daguerreotype: A Sesquicentennial Celebration.* Iowa City: University of Iowa Press, 1989.

———. *Lincoln's Smile and Other Enigmas.* New York: Hill & Wang, 2007.

Trodd, Zoe. "The Spaces Left: Resistance and Erasure in Frederick Douglass's Palimpsestic Narratives," in Darby Lewes, ed., *Double Vision: 18th and 19th Century Literary Palimpsests.* New York: Rowman & Littlefield, 2008.

———. "A Hid Event, Twice Lived: The Post-War Narrative Sub-Versions of Douglass and Melville," *Leviathan: A Journal of Melville Studies* 10:2 (2008): 51–68.

———. "The After-Image: Frederick Douglass in Visual Culture," in Celeste-Marie Bernier and Hannah Durkin, eds., *Visualising Slavery and Reimaging Memory: Art Across the Black Diaspora.* Liverpool: Liverpool University Press, 2015.

———. "The Abolitionist and the Camera: Frederick Douglass's Half-Century of Photographs," in Lawson and Bernier, eds., *Imaging Frederick Douglass.*

Voss, Frederick S. *Majestic in His Wrath: A Pictorial Life of Frederick Douglass.* Washington, DC: Smithsonian Institution Press, 1995.

Wallace, Maurice O., and Shawn Michelle Smith, eds. *Pictures and Progress: Early Photography and the Making of African American Identity.* Durham: Duke University Press, 2012.

Wells, Donna M. "Visual History and African American Families of the Nineteenth Century," *Negro History Bulletin* 59.4 (1996): 19–21.

———. "Pictures and Progress: Frederick Douglass and the Beginnings of an African American Aesthetic in Photography," in Ida E. Jones and Elizabeth Clark Lewis, eds., *Emerging Voices and Paradigms.* Silver Spring, MD: Assoc. of Black Women Historians, 2008.

Westerbeck, Colin. "Frederick Douglass Chooses His Moment," *Art Institute of Chicago Museum Studies* 24.2 (1999): 144–61.

Wexler, Laura. "'A More Perfect Likeness': Frederick Douglass and the Image of the Nation," *Yale Review* 99.4 (2011): 145–69.

Willis, Deborah. *J.P Ball: Daguerrean and Studio Photographer.* New York: Garland Publishing, 1993.

———, ed. *Picturing Us: African American Identity in Photography.* New York: New Press, 1994.

———, and Barbara Krauthamer. *Envisioning Emancipation: Black Americans and the End of Slavery.* Philadelphia: Temple University Press, 2012.

Wood, John. "The American Portrait," in Wood, ed., *America and the Daguerreotype.* Iowa City: University of Iowa Press, 1991.

Wood, Marcus. *Blind Memory: Visual Representations of Slavery in England and America 1780–1865.* Manchester: Manchester University Press, 2000.

———. *Black Milk: Imagining Slavery in the Visual Cultures of Brazil and America.* Oxford: Oxford University Press, 2013.

Notes

INTRODUCTION

1 Douglass, "Pictures and Progress," n.d. (c. November 1864–March 1865); see p. 161 in this volume.

2 Holmes's three essays on photography are: "The Stereoscope and the Stereograph," *Atlantic Monthly* (June 1859): 738–48; "Sun-Painting and Sun-Sculpture; With a Stereoscopic Trip Across the Atlantic," *Atlantic Monthly* (July 1861): 13–29; and "Doings of the Sunbeam," *Atlantic Monthly* (July 1863): 1–16, although the last two are supplements to his 1859 essay. See Mark Durden, ed., *Fifty Key Writers on Photography* (New York: Routledge, 2013), p. 125; Alan Trachtenberg, ed., *Classic Essays on Photography* (New Haven, CT: Leete's Island Books, 1980), p. 71; and Alan Trachtenberg, *Reading American Photographs: Images as History, Mathew Brady to Walker Evans* (New York: Hill & Wang, 1989), pp. 17–20, 90–93.

Douglass probably delivered more than four lectures on photography—one lecture for each speech he wrote—but we have not yet been able to identify when he gave them. The editors of the Frederick Douglass Papers suggest that he delivered "Pictures and Progress" (originally titled "Lecture on Pictures") on December 3, 1861, in Boston, and again on November 15 in Syracuse, retitled as "Life Pictures"; but "Life Pictures" is substantially different from "Lecture on Pictures." See John W. Blassingame, ed., *The Frederick Douglass Papers* (New Haven: Yale University Press, 1979–2012, cited hereafter as *TFDP*) *Series 1*, Vol. 3, pp. 452, 619–20; and pp. 124, 126–41 in this volume.

3 Circumstantial evidence suggests that there are many more than 160 separate poses of Douglass. For starters, we have not uncovered a single photograph taken of Douglass in Europe. That's a shocking fact, given how frequently he sat for his portrait in the United States—on average once every sixteen weeks from 1845 to 1895. He spent three and a half years in Europe (two years in 1845–47, six months in 1859–60, and a year from 1886 to 1887, mostly in Britain). It thus seems odd, given how much he loved photography, that he would not once sit for his portrait while in Europe.

There are two likely reasons for this absence of images in European archives. First, digitization and documentation of holdings in European archives lags behind the United States "Finding aids" or their equivalent, common in United States archives often do not exist in Europe. As a result, scholars and even archivists have no idea what is in an archive until they look at each item.

Second, photography was far less popular in Britain than in the United States. Storefront photo galleries were rare, as were daguerreotypes, tintypes, ambrotypes, and cartes-de-visite, the most popular formats among the masses. In Britain, the calotype (or talbotype) was the preferred medium, and owing to cost and labor, it did not cater to the masses. More significantly, unlike in the United States, many if not most British photographers and their societies came from the upper class.

Douglass befriended aristocrats and elites, and there is evidence from his correspondence that he sat for his portrait while in England, even though we have not found any images. In 1859 he wrote a letter to Mrs. Cash in Huddersfield, referring to a photograph her daughter had taken

of him in 1846: "Please, if you are seeing or writing to your daughter Ellenor, remember me kindly to her, tell her I am as much like the picture she took of me as the wear and tear of thirteen years will permit me to be"—Douglass to Mrs. Cash, December 1859, in Philip S. Foner, ed., *The Life and Writings of Frederick Douglass* (cited hereafter as *LWFD),* Vol. V (New York: International Publishers, 1975), p. 459.

Every critic, collector, dealer, and historian of British photography we contacted felt as we do: that it seems strange that Douglass would not have sat for his portrait while in Britain.

The second piece of circumstantial evidence suggesting that Douglass sat for many more than 160 portraits is that the archives of his rivals (Custer, Red Cloud, and Lincoln) reveal many clusters of five to seven or more photographs, all quite similar, which stemmed from a single photo shoot. These clusters are rare in the Douglass archive, suggesting that many more photographs exist than have been collected or archived. This is understandable, since photographs of Douglass did not become collectors' items among whites until the late twentieth century. Finally, it is likely that many photographs were lost in the fire that destroyed Douglass's Rochester home in 1872.

During the research for this book, we sometimes encountered claims that other photographs were of Douglass. For example, the collector Jackie Napoleon Wilson claimed in *Hidden Witness: African-American Images from the Dawn of Photography to the Civil War* (New York: St. Martin's Press, 1999), which is the catalog accompanying an exhibition of the same title held at the J. Paul Getty Museum, that a photograph of two men is the "earliest known" depiction of Douglass and was made in the early 1840s. But the daguerreotype, held by the Chrysler Museum of Art and taken by the white Virginian William A. Pratt, is actually titled "Freemen of Color" and is dated 1850. Neither man in the photograph is Douglass.

In two instances, we include recently lost photographs. The Chicago History Museum holds a photograph of Douglass by Charles Delevan Mosher and another by Alfred Brisbois. As of 2013, the two cabinet cards—still listed in the museum's holdings—have been misplaced. After consulting with the museum's curators, we believe that these missing images constitute two additional separate poses of Douglass, since they are the only known photos of Douglass by Mosher and Brisbois. We thus include them in the Catalogue Raisonné as blank spaces (cat. #88, #134), with estimated dates based on when the photographers were active and when Douglass visited their cities.

We also include in the Catalogue Raisonné six engravings (cat. #9, #31, #99, #108, #122, #132); one drawing (cat. #121); one print (cat. #136); and one bust (cat. #56). Each of these images is clearly based on a photograph, owing to its detail. Since none match the extant photos of Douglass, we have concluded that they, too, are separate poses from lost photographs.

In May 2015 we also identified two additional photographs of Douglass. Since they closely resemble other images from the same sittings and this book was already in production, they do not appear here.

4 D. Mark Katz, *Custer in Photographs* (New York: Bonanza Books, 1985); Frank H. Goodyear III, *Red Cloud: Photographs of a Lakota Chief* (Lincoln: University of Nebraska Press, 2003), p. 1; Charles Hamilton and Lloyd Ostendorf, *Lincoln in Photographs: An Album of Every Known Pose* (Dayton, OH: Morningside House, 1985), p. ix; the Walt Whitman Archive, online at www .whitmanarchive.org/multimedia/gallery.html.

The Walt Whitman Archive includes 128 portraits of Whitman, but one (from 1860) is an engraving after an oil portrait. Katz's book includes every known photograph of Custer. In Katz's preface, Lloyd Ostendorf says there are "in excess of 150 pictures" of Custer and notes that Custer was never daguerreotyped (Douglass frequently was). Katz argues that his book includes 158 known photographs of Custer, but we counted only 155 separate poses. In any given sitting, there are often several (5–7) images, suggesting that most of the photographs taken of Custer were saved and archived—privately or publicly. By contrast, individuals, libraries, and museums made little effort to collect Douglass's photographs during his lifetime and for much of the twentieth century.

5 Harold Holzer is planning a book on the photographs of Grant. Although he has not yet analyzed and added up how many separate photographs there are, he estimates "about 150"—Holzer to Stauffer in conversation, Lincoln Forum, Gettysburg, PA, November 17, 2013.

6 George Eastman, "The Kodak Manual," George Eastman House, Rochester, NY, quoted in Beaumont Newhall, *The History of Photography, From 1839 to the Present,* rev. ed. (New York:

Museum of Modern Art, 1988), p. 129; Buffalo Bill Museum Image Archive, online at http://images.buffalobill.org/; J. R. LeMaster and James D. Wilson, eds., *The Mark Twain Encyclopedia* (New York: Garland Publishing 1993), pp. 575–77; and Milton Meltzer, *Mark Twain Himself: A Pictorial Biography* (New York: Thomas Y. Crowell, 1960). After examining the online archive of the Buffalo Bill Museum, we counted 262 separate photographic poses of Cody. Although many are undated, most of them appear to have been taken after 1900.

The *Mark Twain Encyclopedia* says there are approximately 650 photographs of Twain, but it does not state whether or not these are total photographs or distinct poses. It notes that as "Kodaking" became popular in the 1890s, Twain "was photographed over 40 times in a series of more than 120 pictures taken by James B. Pond on a trip in the summer of 1895" (pp. 575–76).

7 John Plunkett, *Queen Victoria: First Media Monarch* (Oxford: Oxford University Press, 2003), p. 160, Table 1: Photographs registered at Stationer's Hall, 1862–1901. It is unclear from Plunkett's book whether his numbers are total photographs or separate poses of the royal family.

8 See Further Reading in our bibliography for the existing scholarship.

9 On Douglass transforming the genre of autobiography, see William L. Andrews, *To Tell a Free Story: The First Century of Afro-American Autobiography, 1760–1865* (Urbana: University of Illinois Press, 1986), pp. 97–144, 167–76, 184–88, 214–39; John Stauffer, *Giants: The Parallel Lives of Frederick Douglass and Abraham Lincoln* (New York: Twelve, 2008), pp. 72, 310; Henry Louis Gates, Jr., *Figures in Black: Words, Signs, and the "Racial" Self* (New York: Oxford University Press, 1987), chs. 3–4; Robert B. Stepto, *A Home Elsewhere: Reading African American Classics in the Age of Obama* (Cambridge, MA: Harvard University Press, 2010), ch. 1; Robert B. Stepto, *From Behind the Veil: A Study of Afro-American Narrative* (1979; Urbana: University of Illinois Press, 1991), pp. 16–41, 153–57, 184–90; David W. Blight, Introduction, *Narrative of the Life of Frederick Douglass*, 2nd ed. (Boston: Bedford/St. Martin's, 2003), pp. 1–26; and John Stauffer, Introduction, *Narrative of the Life of Frederick Douglass, an American Slave* (New York: Library of America, 2014), pp. ix–xxi.

10 Douglass, "Lecture on Pictures" (1861) and "Pictures and Progress," n.d. (ca. November 1864–March 1865), pp. 127, 164 in this volume.

11 On Douglass celebrating September 3, 1838, the day he reached freedom in the free states, in place of his unknown birthday, see Douglass, *My Bondage and My Freedom*, ed. John Stauffer (New York: Modern Library, 2003), pp. 257–58; James McCune Smith, "Frederick Douglass in New York," *Frederick Douglass' Paper*, February 2, 1855; and John Stauffer, *The Black Hearts of Men: Radical Abolitionists and the Transformation of Race* (Cambridge, MA: Harvard University Press, 2001), p. 114.

On portraits constituting over 90 percent of American photographs in the early years, see Robert A. Sobieszek and Odette M. Appel, *The Daguerreotypes of Southworth and Hawes* (1976; New York: Dover Publications, 1980), p. x; Keith F. Davis, *The Origins of American Photography, 1839–1885: From Daguerreotype to Dry-Plate* (Kansas City: The Nelson-Atkins Museum of Art, 2007), pp. 173–74; and Roger Watson and Helen Rappaport, *Capturing the Light: The Birth of Photography* (New York: St. Martin's Press, 2013).

12 *Gleason's Pictorial* became *Ballou's Pictorial Drawing-Room Companion* in 1855 and lasted until 1859. On the birth of visual culture and the popularity of photography in America, see Newhall, *History of Photography*, pp. 27–39; Miles Orvell, *American Photography* (New York: Oxford University Press, 2003), pp. 13–14; Robert Taft, *Photography and the American Scene: A Social History, 1839–1899* (1938; New York: Dover Publications, 1964), pp. 46–166; Trachtenberg, *Reading American Photographs*, pp. 3–20; Alan Trachtenberg, "Photography: The Emergence of a Keyword," and Barbara McCandless, "The Portrait Studio and the Celebrity: Promoting the Art," both in *Photography in Nineteenth-Century America*, ed. Martha A. Sandweiss (New York: Harry N. Abrams, 1991), pp. 16–47, 48–75; John Stauffer, "Daguerreotyping the National Soul: The Portraits of Southworth and Hawes," *Prospects* 22 (1997): 69–97; Stauffer, *Black Hearts of Men*, pp. 55–56; Mary Panzer, *Mathew Brady and the Image of History* (Washington, DC: Smithsonian Institution Press, 1997), pp. 23–38, 71–92; Joshua Brown, *Beyond the Lines: Pictorial Reporting, Everyday Life, and the Crisis of Gilded-Age America* (Berkeley: University of California Press,

2002), pp. 1–59; and Vicki Goldberg, *The Power of Photography, Expanded and Updated: How Photographs Changed Our Lives* (New York: Abbeville Publ., 1991), pp. 7–17.

13 On the comparative paucity of photography in the slave states, see Davis, *The Origins of American Photography*, pp. 48, 174; Brown, *Beyond the Lines*, p. 50; and John Stauffer, "The 'Terrible Reality' of the First Living-Room Wars," in *War/Photography: Images of Armed Conflict and Its Aftermath*, ed. Anne Wilkes Tucker and Will Michels (Houston: Museum of Fine Arts, 2012), pp. 84–85, 88 n 42.

14 Douglass, "Which Greeley Are We Voting For? An Address Delivered in Richmond Virginia on 24 July 1872," *TFDP* 1:4, pp. 303; Douglass, letter to Louis Prang, June 14, 1870, published in *Prang's Chromos: A Journal of Popular Art* (September 1870), reprinted in Katherine Morrison McClinton, *The Chromolithographs of Louis Prang* (New York: Clarkson N. Potter, 1973; cited hereafter as letter to Louis Prang), p. 37. Douglass also applied the language of photography more broadly. In a letter to Gerrit Smith on April 15, 1852, he noted that although he had met someone, the room was dark and "I did not get a very good daguerreotype of the man" (meaning strong visual image)—*TFDP* 3:1, pp. 529.

15 Douglass, "Pictures and Progress," pp. 164–165 in this volume; Stauffer, *Black Hearts of Men*, pp. 51–52; Nancy Armstrong, *Fiction in the Age of Photography: The Legacy of British Realism* (Cambridge, MA: Harvard University Press, 1999), pp. 1–74, 248–49.

16 Douglass, "Pictures and Progress," p. 166 in this volume; Aristotle, *Poetics*, trans. Malcolm Heath (New York: Penguin Books, 1996), pp. 6–7 (3.1: "The Anthropology and History of Poetry, Origins."); W. J. T. Mitchell, "Representation," in Frank Lentricchia and Thomas McLaughlin, eds., *Critical Terms for Literary Study*, 2nd ed. (Chicago: University of Chicago Press, 1995), pp. 11–17; Thomas Carlyle, *On Heroes and Hero Worship and the Heroic in History* (1842; repr., London: Oxford University Press, 1951); and Ralph Waldo Emerson, *Representative Men: Seven Lectures* (1950; repr., Cambridge, MA: Harvard University Press, 1996).

17 Douglass, letter to Louis Prang, p. 37.

18 Douglass, "Pictures and Progress," p. 167 in this volume; Douglass, "Claims of the Negro Ethnologically Considered" (1854), *TFDP*, 1:2, pp. 497–524. On Douglass's limited success at attacking ethnologists on their own terms, and his awakening to the philosophical power of photography, see Catherine Kistler's superb essay, "Countering Ethnographic Racism with Rhetoric and Photography," in "English 90fd: The Rhetoric of Frederick Douglass and Abraham Lincoln," Harvard University (Fall 2013). On the ethnologists' arguments, see George M. Fredrickson, *The Black Image in the White Mind: The Debate on Afro-American Character and Destiny, 1817–1914* (1971; Middletown, CT: Wesleyan University Press, 1987), pp. 71–96; William Stanton, *The Leopard's Spots: Scientific Attitudes Toward Race in America, 1815–59* (Chicago: University of Chicago Press, 1960), pp. 24–112; Stephen Jay Gould, *The Mismeasure of Man* (New York: W. W. Norton & Co., 1996), pp. 62–104; and Ann Fabian, *The Skull Collectors: Race, Science, and America's Unburied Dead* (Chicago: University of Chicago Press, 2010), pp. 79–120.

19 Douglass, "Pictures and Progress," p. 171 in this volume; Carlyle, *On Heroes and Hero Worship and the Heroic in History*; Stauffer, *Black Hearts of Men*, pp. 50, 302 n6; Carl Peterson, "19th Century Photographers and Related Activity in Madison County, New York," *Madison County Heritage* 23 (1998): 15–25; Alan Trachtenberg, "The Daguerreotype: American Icon," in *American Daguerreotypes from the Matthew R. Isenburg Collection* (New Haven: Yale University Art Gallery, 1989), p. 16; John Wood, "Silence and Slow Time: An Introduction to the Daguerreotype," and Alan Trachtenberg, "Mirror in the Marketplace: American Responses to the Daguerreotype, 1839–1851," both in *The Daguerreotype: A Sesquicentennial Celebration*, ed. John Wood (Iowa City: University of Iowa Press, 1989), pp. 1–29, 60–73; John Wood, "The American Portrait," in *America and the Daguerreotype*, ed. John Wood (Iowa City: University of Iowa Press, 1991); and Panzer, *Mathew Brady*, pp. 23–38, 71–92.

20 James Russell Lowell, "The Prejudice of Color," February 13, 1846, in Lowell, *Anti-Slavery Papers*, Vol. 1 (Boston: Houghton Mifflin & Co., 1902), pp. 21–22.

21 Frederick S. Voss, *Majestic in His Wrath: A Pictorial Life of Frederick Douglass* (Washington, DC: Smithsonian Institution Press, 1995). On Douglass photographing and writing himself into the public sphere, see *Frederick Douglass' Paper*, August 3, 1855; Gates, *Figures in Black*, pp. 98–124; Blassingame, Introduction, *TFDP* 1:1, pp. xxi–lxix; and Stauffer, *Black Hearts of Men*, p. 46. On Douglass's preeminence as an orator, see Stauffer, *Giants*, pp. 67–96, 131–66.

22 Frederick Douglass Papers, Library of Congress (cited hereafter as FDP-LC), General Correspondence, 1863. See also Douglass enclosing a photograph with a letter on March 31, 1894, noting: "it will probably be the last occasion I may have to have a photograph taken, as I am fast approaching the sunset of life"—FDP-LC, General Correspondence, 1894, Mar. Douglass was wrong about this photograph being his last, going on to sit for several more in May and October that year. He also requested photographs from others. For one request, see Florence Blackall, March 31, 1894, FDP-LC, General Correspondence, 1894, Mar.

23 Josephine T. Washington, "Know Thyself!" *Pittsburgh Courier*, December 18, 1937, p. 19.

24 Henry Jackson Lewis, unpublished drawing, 1889, DuSable Museum of African American History, uncatalogued; Lewis, "The Race Problem," *Indianapolis Freeman*, March 30, 1889; Moses Tucker, "An Opossum Dinner," *Indianapolis Freeman*, December 21, 1889.

25 See, e.g., *The New National Era*, December 25, 1873.

26 "Twelfth National Anti-Slavery Bazaar," *The Liberator*, January 23, 1846, 14; *TFDP* 3:1, 330; FDP-LC, General Correspondence, 1894, Nov.–Dec. and Undated. Reed likely refers to Booker T. Washington's Tuskegee Institute in Alabama, to which Douglass would sometimes encourage friends to donate in the 1890s. See, e.g., Louis R. Harlan, ed., *The Booker T. Washington Papers: 1889–95* (Urbana: University of Illinois Press, 1974), p. 396.

27 Douglass, "A Tribute for the Negro," *The North Star*, April 7, 1849, reprinted in Foner, ed., *LWFD* 1, pp. 379–84, quotation at p. 380.

28 Stauffer, *Black Hearts of Men*, p. 51.

29 Stauffer, "'Terrible Reality,'" p. 81; Goldberg, *Power of Photography*, p. 21; Brown, *Beyond the Lines*, pp. 49, 54–55.

30 Two photographs by William W. Core (cat. #90 and #91) may include some of Douglass's family members—possibly Anna or his adult children and grandchildren. But Core photographed Douglass's home from a distance, and although Douglass is recognizable, the other subjects are not, and they lack facial detail. In addition, cat. #156 shows Douglass with Charles Satchell Morris, who had worked as Douglass's secretary and married Douglass's granddaughter Annie Rosine Sprague in 1892. Annie had died in 1893. So although it doesn't depict a grandchild, the photograph does depict Douglass with his widowed grandson-in-law.

31 Douglass, "Lecture on Pictures," p. 129 in this volume. Lincoln uses the term "fatally fixed for life" in critiquing slavery and racism; see Roy Basler, ed., *The Collected Works of Abraham Lincoln* (New Brunswick, NJ: Rutgers University Press, 1953), Vol. 3, p. 478.

32 Like most Americans, Douglass seems to have been especially taken with daguerreotypes.

33 James M. Gregory, *Frederick Douglass The Orator. Containing an Account of His Life; His Eminent Public Services; His Brilliant Career as Orator; Selections from His Speeches and Writings* (Springfield, OH: Wiley & Co., 1893), pp. 46–48.

34 Taft, *Photography and the American Scene*, pp. 46–122; Trachtenberg, *Reading American Photographs*, pp. 21–30.

35 We have also identified Douglass in the crowd at the National Equal Rights Convention meeting of December 9, 1873 (cat. #78)—on the balcony, third from the left; at the inauguration of President Garfield on March 4, 1881 (cat. #104)—behind and to the left of Garfield, directly beneath the second window from the left, lifting his top hat; and at John Greenleaf Whittier's funeral on September 10, 1892 (cat. #128)—in the tenth row at the far right end of the center block.

36 On Ball, see especially Deborah Willis, ed., *J. P. Ball: Daguerrean and Studio Photographer* (New York & London: Garland Publishing, 1993). There were other black artists who represented Douglass in his lifetime via drawings and cartoons rather than photographs: Edward H. Lee, Henry Jackson Lewis, Jacob C. Strather, and Moses L. Tucker.

37 "Daguerrian Gallery of the West," *Gleason's Pictorial Drawing-Room Companion* 6:13 (April 1854), p. 208; Joseph D. Ketner, *The Emergence of the African American Artist: Robert S. Duncanson, 1821–1872* (Columbia: University of Missouri Press, 1993), pp. 101–03; Stauffer, "Creating an Image," *Beyond Blackface*, pp. 80–81.

38 "Ball's Great Daguerrian Gallery of the West," *Frederick Douglass' Paper*, May 5, 1854; "Daguerrian Gallery of the West," *Gleason's Pictorial*, p. 208; Stauffer, "Creating an Image," *Beyond Blackface*, pp. 80–81.

39 Douglass, "Self-Made Men," *TFDP* 1:3, p. 291.

40 Walt Whitman, "Pictures," Sculley Bradley and Harold W. Blodgett, eds., *Leaves of Grass* (New York: W. W. Norton & Co., 1973), p. 642. On Whitman and photography, see Ed Folsom, *Walt Whitman's Native Representations* (New York: Cambridge University Press, 1994), pp. 99–126; Miles Orvell, *The Real Thing: Imitation and Authenticity in American Culture 1880–1940* (Chapel Hill: University of North Carolina Press, 1989), pp. 6–20; Trachtenberg, *Reading American Photographs*, pp. 60–70; and Sean Ross Meehan, *Mediating American Autobiography: Photography in Emerson, Thoreau, Douglass, and Whitman* (Columbia: University of Missouri Press, 2008), pp. 181–216.

41 Douglass, "Lecture on Pictures," p. 128 in this volume.

42 See Douglass, letter of March 31, 1894, FDP-LC, General Correspondence, 1894, Mar.; John Muller, *Frederick Douglass in Washington, D.C.: The Lion of Anacostia* (Charleston: History Press, 2012).

43 For the varied angles, see cat. #18–20, 23–24, 33–34, 61–62, 76–77, 84–87, 92–93, 96–97, 100–103. For different clothing in a single sitting, see cat. #71–75, where Douglass sat for Hurn both with and without his overcoat on. For varied gestures, see the pointing finger which is only present in cat. #28 of the photographs from the Samuel Fassett sitting of 1864. As Douglass sought the right angles for his face and body in photographs, others described that face as one of his strengths. William G. Allen, a black professor, observed in *The Liberator* of Douglass: "there is no actor living, whether he be tragedian or comedian, who would not give the world for such a face as his"—William G. Allen, "Orators," *The Liberator*, October 29, 1852: 176.

44 The two "imperfect" photographs exist only at George Eastman House, which holds Kent's own files, and at the Douglass National Historic Site, which holds Douglass's personal collection.

45 Ottilie Assing to her sister Ludmilla, Hoboken, N.J., October 29, 1870, Karl August Varnhagen von Ense Papers at the Jagiellonian Library, Jagiellonian University, Krakow, Poland. We are grateful to David Blight for sharing this letter with us and to Leigh Fought, who put it into a pdf file.

46 Douglass, "American Slavery is America's Disgrace: An Address Delivered in Sheffield England on 25 March 1847," *TFDP* 1:2, 10.

47 Henry H. Snelling, *The History and Practice of the Art of Photography; or, the Production of Pictures Through the Agency of Light* . . . (New York: G. P. Putnam, 1849), p. 41; Trachtenberg, *Reading American Photographs*, p. 46.

48 In the engraving of the 1843 daguerreotype by John C. Buttre, Douglass's eyes are wide open. It's as though Buttre has corrected the "flaw" in the daguerreotype, perhaps with Douglass's encouragement. Compare the daguerreotype and engraving here, plates 2 & 2.a.

49 Douglass to Ruth Cox, May 16, 1846, *TFDP* 3:1, p. 124.

50 *My Bondage and My Freedom* sold about 15,000 copies in the first two months of publication, which were very high sales for a book, and it remained a bestseller through the Civil War. By contrast, *Harper's Weekly* and *Frank Leslie's Illustrated* each enjoyed circulations of over 100,000, at times reaching 200,000, until after the Civil War. See Henry Louis Gates Jr., ed., *Frederick Douglass, Autobiographies* (New York: Library of America, 1994), pp. 1079–80; Brown, *Beyond the Lines*, pp. 25–30; Frank Luther Mott, *A History of American Magazines*, Vol. 2, *1850–1865* (Cambridge, MA: Harvard University Press, 1957), pp. 45, 452–65, 468–87; Frank Luther Mott, *American Journalism: A History of Newspapers in the United States Through 260 Years: 1690 to 1950*, rev. ed. (New York: Macmillan, 1950), p. 269; and Stauffer, "'Living-Room War,'" p. 91.

51 Douglass betrays a slight smile in several cabinet cards during his May 10, 1894, sitting for Denis Bourdon (cat. #148–150) and in a photograph with his second wife Helen and her sister in 1884 (see plate 49). Douglass, with his sense that black leaders must counteract with solemn dignity the racist representations of African Americans as comic, undignified clowns, would perhaps have been pleased by Barack Obama's official presidential portrait in 2008. President Obama was the first president since Nixon to be photographed not smiling broadly in his official portrait. Even Nixon was an exception. Aside from Nixon, Obama is the only president to be photographed not grinning—open-mouthed, baring teeth in a full smile—since Eisenhower.

52 Douglass may have developed the clenched-fist pose from his reading of the *Columbian Orator*, which advised: "The hands should generally be open; but in expressions of compunction and anger, they may be closed"—Caleb Bingham, *The Columbian Orator: Containing a Variety of Original and Selected Pieces; Together with Rules, Calculated to Improve Youth and Others in the Ornamental and Useful Art of Eloquence* (Baltimore: Philip H. Nicklin & Co., 1811), p. 24.

53 Joan L. Severa, *Dressed for the Photographer: Ordinary Americans and Fashion, 1840–1900* (Kent, OH: Kent State University Press, 1995), pp. 18–19, 21–23, 57, 84–85, 106, 118–19, 137, 176–77, 180, 210, 214, 223, 229, 239, 248–49, 256, 258, 268, 279, 314, 341, 345, 350, 387–88, 397–98, 411, 419, 424, 429, quotations at pp. 23, 419. As evidence that Douglass was thinking carefully about his hairstyle, he apparently told his friend Richard Greener that he imitated Alexandre Dumas, who "wore his hair . . . long and conspicuously" and was "not ashamed of 'fleecy locks and dark complexion.' . . . They did not 'forfeit nature's claim.'" See Richard Greener, "Reminiscences of Frederick Douglass," *Champion Magazine* (February 1917): 291–95.

54 James McCune Smith, Introduction to Frederick Douglass, *My Bondage and My Freedom*, ed. John Stauffer (1855; New York: Modern Library, 2003), p. xlix; John Eaton, quoted from *In Memoriam: Frederick Douglass*, ed. Helen Douglass (1897; Freeport, NY: Books for Libraries Press, 1971), p. 71; *LWFD* 3, p. 45.

55 "Training Their Youth," *Washington Post*, May 10, 1897 (with thanks to Jay Roberts for the information about the John Hay Industrial School); *Cleveland Gazette*, May 9, 1896, p. 1; "Henry Stanley Newman on Warnersville," in Stafford Allen Warner, *Yardley Warner, The Freedman's Friend: His Life and Times with His Journal and Letters Reproduced in an Appendix* (Didcot, UK: Wessex Press, 1957), pp. 211, 212. Paintings and drawings of Douglass also adorned the walls of people's homes into the twentieth century. John Edward Bruce observed to John Wesley Cromwell in December 1899 that in "nearly all the houses of the blue bloods I visited I saw either an oil painting or crayon of Douglass, Dr Bartol in Boston has a large oil painting of Douglass

in his 'parlor' and a crayon portrait of him at head of first landing"—Adelaide M. Cromwell, *Unveiled Voices, Unvarnished Memories: The Cromwell Family in Slavery and Segregation, 1692–1972* (Columbia: University of Missouri Press, 2007), p. 248.

56 Douglass, letter to Louis Prang, p. 37.

PART II: CONTEMPORANEOUS ARTWORK

1 Ezra Greenspan, *William Wells Brown* (New York: W. W. Norton & Co., 2014), pp. 151–53.

2 Douglass, "Last Will and Testament," in folder titled "Wills" (p. 34 of holograph), FDP-LC.

3 *Abolition Fanaticism in New York. Speech of a Runaway Slave from Baltimore, at an Abolition Meeting in New York, Held May 11, 1847* (Baltimore, 1847), p. 2.

4 Douglass, Review of *A Tribute for the Negro*, *The North Star*, April 7, 1849, republished in *LWFD*, Vol. I (New York International Publishers, 1950), p. 380; Charles Dickens, "To W.C. Macready," 17 March 1848, on *The Letters of Charles Dickens*, ed. Madeline House, Graham Storey, and Kathleen Tillotson, vol. 5 (New York: Oxford University Press, 1965–2002), p. 262; Julia Sun-Joo Lee, *The American Slave Narrative and the Victorian Novel* (New York: Oxford University Press, 2010), p. 3.

5 Frederick Douglass to Richard D. Webb, Glasgow, Scotland, mid-January 1846, *TFDP*, 3:1 , p. 79.

6 "World Temperance Convention," *The Illustrated London News*, August 15, 1846, p. 109.

7 *Uncle Tom's Cabin Almanack; or, Abolitionist Memento for 1853* (New York: Bunnell & Price, 1852), pp. 4, 7.

8 *Frank Leslie's Illustrated Newspaper*, November 12, 1859, p. 382.

9 *Frank Leslie's Budget of Fun*, January 1, 1860, p. 8.

10 "Charles Sumner," *Harper's Weekly*, April 4, 1874, front page.

11 Frederick Douglass to Sylvester Betts, October 30, 1881, FDP-LC, Correspondence Subject File.

12 Marvin D. Jeter and Mark Cervenka, "H. J. Lewis, Free man and Freeman Artist," *Common-Place* 7:3 (April 2007); also available at www.common-place.org/vol-07/no-03/jeter-cervenka/.

PART IV: DOUGLASS'S WRITINGS ON PHOTOGRAPHY

1 Harold Holzer, *Lincoln at Cooper Union: The Speech That Made Abraham Lincoln President* (New York: Simon & Schuster, 2005), pp. 88–100, quotation from Lincoln on p. 100; Goldberg, *Power of Photography*, pp. 76–78.

2 James Buchanan, "Fourth Annual Message to Congress," December 3, 1860, in John Bassett Moore, ed., *The Works of James Buchanan*, Vol. XI: *1860–1868* (Philadelphia: J.B. Lippincott, 1910), pp. 7–8; "Those Pictures Again," *Douglass' Monthly* (January 1861).

3 John Stauffer, "The 'Terrible Reality' of the First Living-Room Wars," in *War/Photography: Images of Armed Conflict and Its Aftermath*, ed. Anne Wilkes Tucker and Will Michels (Houston: Museum of Fine Arts, 2012), pp. 80–93.

4 "Frederick Douglass in Boston," *Douglass' Monthly* (January 1862); "Frederick Douglass in Boston," *The Liberator*, December 3, 1861; Warrenton [William Stevens Robinson], "From Boston," *Springfield Republican*, December 7, 1861.

5 The prestigious Fraternity Course lecture series began in 1858 to honor the life and teachings of Theodore Parker, the Unitarian minister and militant abolitionist who died in May 1860. According to one reviewer, these lectures constituted a "legacy left to humanity" and a "monument to his memory." In this fourth annual series (1861–62), Douglass was the fourth of nine lecturers. The other speakers were Ralph Waldo Emerson (Nov. 12), William Alger (Nov. 19), Henry Ward Beecher (Nov. 26), Daniel Dickinson (Dec. 10), Edwin Chapin (Dec. 17), Ezra Heywood (Dec. 24), William Studley (Dec. 31), and Wendell Phillips (Jan. 7). See "Frederick Douglass in Boston," *The Liberator*, December 13, 1861; "Fraternity Lectures. Fourth Series," *The Liberator*, November 8, 1861.

6 When Douglass began lecturing professionally in 1841, he prepared only a brief outline, and then later supplemented his outline by reading passages from published sources that he brought with him to the lectern. But in 1854 he began lecturing on the lyceum circuit, and started to write out his speeches. Lyceums expected formal, intellectual addresses, and he was paid up to $200 per lecture, more than he made in one year lecturing for the American Anti-Slavery Society. Often these formal addresses were then published.

 Even on the lyceum circuit, when he commanded one of the highest speaking fees in the country, Douglass sometimes began his speech with a show of humility. See John Blassingame, "Introduction to Series One," *TFDP* 1:1, pp. lxiii–lxv.

7 Douglass refers to famous inventors. Sir Richard Arkwright (1732–1792), a self-made Englishman, developed the factory system for processing cotton. James Watt (1736–1819), the Scottish entrepreneur, patented the first efficient steam engine. The American Robert Fulton (1765–1815) designed the first commercially viable steamboat. Benjamin Franklin (1706–1790) pioneered experiments with electricity. And Samuel Morse (1791–1872), an accomplished American painter, patented the telegraph in 1847.

8 Like most Americans, Douglass credited Louis Daguerre as having invented photography in 1839, even though the Englishman Henry Fox Talbot developed the calotype, a negative-to-positive form of photography, the same year. Fox Talbot's invention was not popular in America, however.

9 The daguerreotype was a unique, one-of-a-kind process in which a copper plate was coated with silver oxide and produced a laterally inverted positive image, which was then housed under glass in a leather case. Viewers opened and "read" daguerreotypes. The ambrotype, invented in 1851, resembled a daguerreotype in that it was fitted in a case under glass and viewers read it like a book. But instead of using copper, a wet-plate glass negative was lightly exposed, bleached, and fitted onto a black backing to produce a laterally inverted positive image. Ambrotypes were less expensive than daguerreotypes, but they did not sparkle in light with the same intensity. Douglass uses the term "photograph" to refer to cartes-de-visite or albumen prints, which became popular in 1860. In these processes, a wet-plate glass negative was exposed and then normally contact-printed onto an albumen print, known for its sepia tones and strong blacks. The electrotype transformed a daguerreotype into an intaglio print. The unexposed silver on the copper plate was etched out, and the exposed silver oxide was etched out and then the highlights were built up with an electric current. The plate could then hold ink and be used for printing. See Richard Benson, *The Printed Picture* (New York: Museum of Modern Art, 2008).

10 With Louis Daguerre's invention of the daguerreotype in 1839, photography became the most democratic form of portraiture, cheaper than sitting for a painted portrait or miniature. Daguerreotypes, along with subsequent formats, from tintypes and ambrotypes to cartes-de-visite, cost as little as one dollar and were affordable even among the working classes—"the humblest servant girl," as Douglass notes. See Robert Taft, *Photography and the American Scene: A Social History, 1839–1889* (1938; New York: Dover Publications, 1964), pp. 76–101; Alan Trachtenberg, *Reading American Photographs: Images as History, Mathew Brady to Walker Evans* (New York: Hill & Wang, 1989), ch. 1.

11 Douglass crosses out the following sentence, which he has used earlier in the paragraph: "Daguerre might have been forgotten but for incorporating his name with his wonderful discovery."

12 Adam Smith popularized the phrase "demand regulates supply," in his *Wealth of Nations* (1776).

13 George Gordon Lord Byron (1788–1824) was one of the most popular poets in antebellum America and one of Douglass's favorites. Douglass probably refers to the stanzas in Byron's *Don Juan*: "'Tis strange the mind, that very fiery particle / Should let itself be snuffed out by an article" (canto 11, stanza 60).

14 Douglass invokes a popular legend about Oliver Cromwell (1599–1658), Lord Protector of England, Scotland, and Ireland after Charles I was executed during the English civil wars. The source of the legend is from Horace Walpole, who quoted Cromwell's purported instructions to the portraitist Peter Lely: "I desire you would use all your skill to paint my picture truly like me, and not flatter me at all; but remark all these roughnesses, pimples, warts, and every thing as you see me, otherwise I never will pay a farthing for it."
 Walpole's quote was shortened to "Paint me as I am," and became a popular aphorism. In 1856, the *Lowell (Mass.) Daily Citizen and News* defended itself against a rival paper, the *Boston Telegraph*, by invoking the aphorism: "'Paint me as I am,' said Cromwell to the artist. We respectfully suggest that, whenever the *Boston Telegraph* undertakes to paint the position of this paper, to follow Cromwell's advice." The aphorism was also used in an 1863 article on Jane Austen in the *Atlantic Monthly*. See Horace Walpole, *Anecdotes of Painting in England; with Some Account of the Principal Artists; and Incidental Notes on Other Arts*, 5 vols. (London, 1796), Vol. 3, p. 30; "Paint Me As I Am," *Lowell (Mass.) Daily Citizen and News*, August 21, 1856, issue 98, col. A; Mrs. R. C. Waterson, "Jane Austen," *Atlantic Monthly* 11:64 (February 1863): 236.

15 Douglass is probably referring to John Weeks Moore, who published a popular *Encyclopaedia of Music* in 1854. In his description of the ballad, Moore quotes the Scottish essayist Andrew Fletcher, "who once said, 'Give me the making of the songs of a nation, and I care not who makes the laws'"—John W. Moore, *Complete Encyclopaedia of Music, Elementary, Technical, Historical, Biographical, Vocal, and Instrumental* (Boston: Oliver Ditson & Co., 1854), p. 87.

16 *Punch*, the influential British weekly devoted to humor and satire, was famous for its caricatures.

17 Austria, like South Carolina, vigorously censored political dissent.

18 John Bull was a famous symbol for England.

19 Douglass is probably referring to Lincoln's recent election. Mathew Brady's portrait of Lincoln, taken a few hours before Lincoln's Cooper Institute address in February 1860, was the first photograph to depict Lincoln as presidential—"dignified, resolute, and powerful." After Lincoln won the Republican nomination, Brady's portrait "introduced Lincoln's image to the public." Woodcut engravings based on Brady's Lincoln appeared on the cover of *Harper's Weekly* and in *Frank Leslie's Illustrated*, among the two most widely circulated papers in the country. Throughout the presidential campaign, Brady's Lincoln was ubiquitous, the basis of virtually all the images of Lincoln, prompting many observers to suggest, as Douglass does here, that it helped elect Lincoln. See Holzer, *Lincoln at Cooper Union*, pp. 88–100, quotations at pp. 98, 99; "Hon. Abram Lincoln, of Illinois," *Harper's Weekly*, May 26, 1860 (cover); "Abraham Lincoln, of Illinois," *Frank Leslie's Weekly*, October 20, 1860, p. 347; "Hon. Abraham Lincoln," *Harper's Weekly*, November 10, 1860 (cover); Francis B. Carpenter, *Six Months at the White House with Abraham Lincoln. The Story of a Picture* (New York: Hurd & Houghton, 1867), pp. 46–47; Harold Holzer, Gabor S. Boritt, and Mark E. Neely, Jr., *The Lincoln Image: Abraham Lincoln and the Popular Print* (New York: Scribner, 1984), p. 31; Panzer, *Mathew Brady*, pp. 17, 74–75; and Goldberg, *The Power of Photography*, pp. 75–80.

20 Thomas Whitson (1796–1864) was a Pennsylvania Quaker and veteran abolitionist. A member of the American Anti-Slavery Society from its founding in December 1833, he was an agent on the Underground Railroad in Lancaster County, PA.

21 The bottom of the holograph page has been torn, and the ending of this sentence appears to be missing, as the subsequent page begins a new paragraph.

22 In the mid-nineteenth century, American biologists, ethnologists, naturalists, and archeologists who studied humans were preoccupied with hierarchies of race. By 1860 most of these white scientists maintained that blacks were subhuman, and some, notably Louis Agassiz, embraced polygenism, arguing that blacks were a separate and distinctly inferior species. See George Fredrickson, *The Black Image in the White Mind* (1971; Middletown, CT: Wesleyan University Press, 1987), esp. chs. 3, 6; Bruce Dain, *A Hideous Monster of the Mind: American Race Theory in the Early Republic* (Cambridge, MA: Harvard University Press, 2002), esp. ch. 7.

23 Josiah Nott and George Glidden were ethnologists who published the popular work of pseudoscientific racism, *Types of Mankind* (1854), which went through multiple editions. In it they use illustrations to highlight their central thesis: that blacks are subhuman, more akin to apes than to whites. See Nott and Gliddon, *Types of Mankind; or, Ethnological Researches* (Philadelphia: Lippincott, Grambo & Co., 1855); Stephen Jay Gould, *The Mismeasure of Man* (1966; New York: W. W. Norton & Co., 1981); William Stanton, *The Leopard's Spots: Scientific Attitudes Toward Race in America, 1815–1819* (Chicago: University of Chicago Press, 1960), pp. 90–99; Frederickson, *Black Image in the White Mind*, pp. 71–164; and John Stauffer, *The Black Hearts of Men: Radical Abolitionists and the Transformation of Race* (Cambridge, MA: Harvard University Press, 2002), ch. 2.

24 Douglass refers to Revelation 21, in which John sees "a new heaven and a new earth" with twelve gates of pearl, "and the street of the city was pure gold"—Rev. 21:1–2, 21.

25 Douglass refers to the redemptive power of art and the correspondence between inner spiritual beauty manifested by external or sentient forms.

26 Here Douglass encapsulates the great power and beauty of self-making: the subjective consciousness or imagined self becomes real, palpable, and protean—like a creator among believers.

27 John Solomon Rarey (1827–1866) was a world-renowned horse trainer from Ohio. He wrote and lectured widely on the subject, and in 1861, as Douglass wrote this speech, he was touring the states demonstrating his training techniques. During the Civil War, the Union Army invited him to train its cavalry.

28 William Hogarth (1697–1764), the British painter, printmaker, and political satirist, was one of the most popular Anglo-American artists of the eighteenth century.

29 Manna was the breadlike food miraculously given to the Israelites in the wilderness—Exod. 16.

30 Douglass paraphrases Shakespeare's famous speech in *As You Like It*, Act II, scene vii, in which Jaques talks of

> . . . the whining school-boy, with his satchel
> And shining morning face, creeping like snail
> Unwillingly to school. And then the lover,
> Sighing like furnace, with a woeful ballad
> Made to his mistress' eyebrow. Then a soldier,
> Full of strange oaths and bearded like the pard [hairy as a leopard],
> Jealous in honour, sudden and quick in quarrel,
> Seeking the bubble reputation
> Even in the cannon's mouth . . .

31 In the first, 1790 U.S. Census, the population was 3.9 million; seventy years later, in 1860, the population was 31.4 million.

32 A reference to the revolutions of 1848, which began in France in February, spread to most of Europe and parts of Latin America, and affected over fifty countries.

33 Quoted from William Cowper's *The Task, Book II: A Time-Piece* (1785):

> Lands intersected by a narrow frith
> Abhor each other. Mountains interposed
> Make enemies of nations, who had else
> Like kindred drops been mingled into one.

Cowper (1731–1800) was a renowned British poet who remained popular especially in antebellum America.

34 Douglass paraphrases Amos 3:3: "Can two walk together, except they be agreed?"; quotes Matt. 6:24 and Luke 16:13; and paraphrases Matt. 12:25, Mark 3:24–25, Luke 11:17, and Lincoln's "House Divided" speech of 1858, which he read and admired.

35 Douglass paraphrases Matt. 19:6: "What therefore God hath joined together, let no man put asunder."

36 Douglass paraphrases II Sam. 12:12.

37 Douglass is referring to several incidents in which slaves, having reached Union lines, were returned to their masters.

38 General John C. Frémont, the Republican candidate for president in 1856, was stationed in Missouri in 1861, and on August 30 he issued the nation's first emancipation proclamation, which declared free all slaves of Rebel masters as well as putting an end to martial law in Missouri. Lincoln asked Frémont to amend his proclamation to conform to the First Confiscation Act, passed by Congress on August 6, 1861. The act authorized Union officers to confiscate, but not free, slaves of Rebel masters reaching Union lines, clothe and feed them, and put them to work as laborers. Frémont refused to amend his proclamation, and so Lincoln rescinded it and then fired him on November 2, a month before Douglass delivered this address in Boston.

Benjamin Butler, a prominent Massachusetts Democratic politician, became a Union general stationed at Fortress Monroe following Fort Sumter. In May 1861, Butler refused to return slaves of Rebel masters who had reached his fort; instead, he retained them and put them to work as "contrabands of war," prompting Congress to pass the First Confiscation Act. Douglass's reference to "the removal of General Butler" probably refers to Lincoln's removal of Butler from Virginia after he lost the battle of Big Nethel near Yorktown, Virginia. Lincoln transferred him to North Carolina and then to New Orleans, where he took control of the city and punished citizens who did not show respect toward his troops or the United States. Lincoln recalled him from New Orleans in December 1862.

Antislavery Flag Officer Silas Horton Stringham served under General Benjamin Butler in North Carolina. In August 1861, he captured two coastal forts near Cape Hatteras without loss. His success prompted Admiral David Porter to say that it was "our first naval victory, indeed our first victory of any kind, and ultimately one of the most important events of the war." Yet Stringham was falsely criticized for not enforcing the Union blockade, prompting his resignation in the summer of 1861, which Douglass refers to as "The removal of Commodore Stringham."

General Thomas Sherman was sympathetic to Southerners. After participating in the capture of Port Royal, South Carolina, in October 1861, he issued a placating proclamation to the people of South Carolina: "we have come amongst you with no feelings of personal animosity; no desire to harm your citizens, destroy your property, or interfere with any of your lawful rights or your social and local institutions."

39 This line is probably a note Douglass wrote for himself to extemporize on Lincoln's response to Frémont's emancipation proclamation.

40 General Andrew Jackson, in his campaign against the British in New Orleans in 1816, used blacks as soldiers, as did George Washington and other patriot generals during the Revolutionary War.

41 Lincoln's proclamation had declared that September 26 be set aside as a day of public fasting and prayer for a Union victory and the restoration of peace.

42 Matt. 3:10: "And now also the axe is laid unto the root of the trees: therefore every tree which bringeth not forth good fruit is hewn down, and cast into the fire."

43 John Brown, Jr., the eldest son of John Brown, did not participate in Brown's raid on Harpers Ferry, and during the Civil War he recruited and captained a company of Kansas soldiers.

44 Douglass quotes from "The Present Crisis," by James Russell Lowell. See *The Writings of James Russell Lowell*, Vol. 7: *Poems*, 1 (Boston: Houghton, Mifflin & Co., 1890), p. 183.

45 Boston was known as the "Athens of America." See Thomas H. O'Connor, *The Athens of America, 1825–1845* (Amherst: University of Massachusetts Press, 2006).

46 A reference to the commemoration of John Brown on the anniversary of his death. On December 3, 1860, Douglass and other abolitionists held a large meeting at Tremont Temple in Boston and were attacked by a mob.

47 The popular ballad "John Brown's Body" was created in mid-1861 by Massachusetts soldiers garrisoning Fort Warren in Boston Harbor. See John Stauffer and Benjamin Soskis, *The Battle Hymn of the Republic: A Biography of the Song That Marches On* (New York: Oxford University Press, 2013).

48 Senator James Mason of Virginia interviewed John Brown the day after his capture and presided over the Senate investigation of the Harpers Ferry raid. He became a Confederate officer during the Civil War and was captured and sent to Fort Warren in Boston, which became a Union prisoner-of-war camp.

49 Douglass describes a pre-naturalist sensibility, a Darwinian world of competition and the struggle for survival, in which war is a metaphor for life itself.

50 Possibly a reference to Richard Westall's famous portrait of Lord Byron (1813).

51 A lightning coire (or coir) is an early form of lightning rod.

52 "Free Speech Maintained in Syracuse," *Douglass' Monthly* (December 1861), p. 567. This review probably refers to "Life Pictures." *TFDP* 1:3, pp. 619–20.

53 The word "photography" means light-writing, and early photographers often acknowledged their debt to the sun as the source of their art.

54 In 1830, few books included frontispiece engravings; by 1860 most did, and they were typically portraits of the author. This shift reflected the rise of visual culture.

55 Douglass again invokes the popular legend about Oliver Cromwell (cf note 14 to part IV, pp. 261–262).

56 Douglass again refers to Mathew Brady's portrait of Lincoln, taken a few hours before Lincoln's Cooper Institute address in February 1860 (cf note 19 to part IV, p. 262).

57 Douglass probably is referring here to Lincoln's divisive First Inaugural. Reactions to that speech broke along party, sectional, and ideological lines. Southerners, most Northern Democrats, and most abolitionists disliked it, but centrist Republicans greatly admired it. Douglass was so upset by it that he considered moving to Haiti and encouraging other blacks to emigrate there. In the wake of Fort Sumter, he abandoned his plans to go to Haiti, because he viewed the war a golden opportunity to end slavery.

Douglass may also be referring to Lincoln's having grown a beard shortly after his election in November 1860. Lincoln's new look was partly inspired by a letter from Grace Bedell, an eleven-year-old girl from Westfield, New York, who had seen a campaign poster of Lincoln based on Brady's photograph. She wrote to Lincoln in October 1860, saying: "you would look a great deal better [if you grew a beard,] for your face is so thin. All the ladies like whiskers and they would tease their husbands to vote for you and then you would be President." The inaugural was the first major address in which Lincoln wore a beard. See Harold Holzer, *Lincoln, President-Elect: Abraham Lincoln and the Great Secession Winter* (New York: Simon & Schuster, 2008), pp. 459–63; John Stauffer, *Giants: The Parallel Lives of Frederick Douglass and Abraham Lincoln* (New York: Twelve, 2008), ch. 4; Roy P. Basler, ed., *The Collected Works of Abraham Lincoln*, Vol. IV (New Brunswick, NJ: Rutgers University Press, 1953), p. 130; Holzer, Boritt, and Neely, eds., *The Lincoln Image*, pp. 70–72; Holzer, *Lincoln at Cooper Union*, p. 99; and Goldberg, *The Power of Photography*, pp. 76–81.

58 Walt Whitman, another lover of photography, also suggested that pictures (photography in particular) could transpose into physical form "the inner life of the soul." In a self-review of his first (1855) edition of *Leaves of Grass*, he explained the purpose of having his half-length engraved portrait, based on a daguerreotype, as the frontispiece rather than his name: "Its author," he says, "is Walt Whitman and his book is a reproduction of the author. His name is not on the frontispiece, but his portrait, half-length, is. The contents of the book form a daguerreotype of his inner being, and the title page bears a representation of its physical tabernacle." The frontispiece portrait depicted the soul transposed into living form. In an earlier notebook, Whitman said that the soul "makes itself visible only through matter." Whitman's 1855 *Leaves of Grass* was quoted in the *Anglo-African Magazine*, which Douglass regularly read. See "Review of Whitman's *Leaves of Grass*," *Brooklyn Eagle*, September 15, 1855; Walt Whitman, *Notebooks and Unpublished Prose Manuscripts*, ed. Edward F. Grier (New York: New York University Press, 1984), Vol. 1, p. 58; Miles Orvell, *The Real Thing: Imitation and Authenticity in American Culture, 1880–1940* (Chapel Hill: University of North Carolina Press, 1989), p. 8; Whitman, "I Sing the Body Electric" quoted from "A Statistical View of the Colored Population of the United States—From 1790 to 1850," *Anglo-African Magazine* 1:4 (April 1859; New York: Arno Press, 1968), p. 99.

59 Douglass borrows again from Revelation 21, in which John sees "the holy city," a "new Jerusalem," "a new heaven and a new earth," with twelve gates of pearl, "and the street of the city was pure gold"—Rev. 21:1–2, 21.

60 Charlotte Brontë's *Jane Eyre* (1847) and Harriet Beecher Stowe's *Uncle Tom's Cabin* (1852) were influential social protest novels when published and are now part of the nineteenth-century canon.

61 Ole Bornemann Bull (1810–1880), known as "Ole Bull," was a well-known Norwegian violinist and composer. Jenny Lind, the "Swedish Nightingale," was a popular Swedish opera singer. Both toured the United States in the 1850s and were received with great acclaim.

62 The lyceum lecture circuit began in the antebellum era and became especially popular in the Northeast and Midwest. Douglass delivered this speech as a lyceum lecture.

63 The Lightning Express was a fast-moving locomotive that appeared in the 1850s. In 1863, Currier and Ives produced a hand-colored lithograph, *The Lightning Express*.

64 An English proverb that emerged in the seventeenth century: "They who live in glass houses should not throw stones."

65 In *Democracy in America*, Alexis de Tocqueville described a similar restlessness among Americans: "In the United States a man builds a house in which to spend his old age, and he sells it before the roof is on; he plants a garden and lets it just as the trees are coming into bearing; he brings a field into tillage and leaves other men to gather the crops; he embraces a profession and gives it up; he settles in a place, which he soon afterwards leaves to carry his changeable longings

elsewhere. . . . Death at length overtakes him, but it is before he is weary of his bootless chase of that complete felicity which forever escapes him." Douglass may have been familiar with Francis Bowen's popular 1862 translation. See Tocqueville, *Democracy in America*, trans. Francis Bowen, a retranslation of Francis Reeve's translation of 1840, Vol. 2, ch. 13 (1862; repr., New York: Vintage Books, 1990), pp. 136–37.

66 P. T. Barnum (1810–1891), the American showman who founded Barnum's American Museum in New York City (and later the Barnum & Bailey Circus), attracted enormous crowds by creating hoaxes as sources of amusements. He became known as "Humbug." See Neil Harris, *Humbug: The Art of P. T. Barnum* (Chicago: University of Chicago Press, 1973).

67 Douglass paraphrases the start of the speech quoted earlier from *As You Like It*, Act II, scene vii:

> All the world's a stage,
> And all the men and women merely players.
> They have their exits and their entrances,
> And one man in his time plays many parts,
> His acts being seven ages . . .

68 Alexander von Humboldt (1769–1859) was the Prussian naturalist and explorer.

69 Douglass is referring to Sir Isaac Newton (1642–1727), the natural philosopher whose work helped establish physics as a discipline and calculus in mathematics. Newton allegedly compared his scientific investigations to a boy "playing on the seashore" and gathering pebbles and shells "whilst the great ocean of truth lay all undiscovered before me." The anecdote first appeared in print in Joseph Spence, *Anecdotes, Observations and Characters, of Books and Men* (1820). Lord Byron, one of Douglass's favorite writers, referred to the anecdote in *Don Juan* (1822), Seventh Canto, 5th stanza:

> Newton, (that proverb of the mind,) alas!
> Declared, with all his grand discoveries recent,
> That he himself felt only "like a youth
> Picking up shells by the great ocean—Truth."

The physicist David Brewster also invoked the anecdote in his 1855 biography of Newton. See Spence, *Anecdotes, Observations and Characters, of Books and Men* (1858 edn), p. 40; David Brewster, *Memoirs of the Life, Writings, and Discoveries of Sir Isaac Newton*, Vol. II (Edinburgh: Thomas Constable & Co., 1855), p. 407.

70 Douglass summarizes a central theme of Theodore Parker's sermons, especially "The Transient and Permanent in Christianity" (1841), "Three Chief Safeguards of Society" (1851), and "The Law of God and the Statutes of Men" (1854), although we have not been able to find Douglass's quote in Parker's *Collected Works*. Possibly he obtained it from Ezra Heywood, who lectured on Parker after his death and quoted Parker as saying: "all the space between man's mind and God's mind is crowded with truths waiting to be discovered." See Ezra H. Heywood, "Mrs. Hatch and Theodore Parker," *The Liberator*, October 2, 1863; "Fraternity Lectures," *The Liberator*, November 8, 1861; *The Collected Works of Theodore Parker*, 14 vols. (London: N. Trübner & Co., 1863–76); Dean Grodzins, *American Heretic: Theodore Parker and Transcendentalism* (Chapel Hill: University of North Carolina Press, 2002); and Conrad Wright, *Three Prophets of Religious Liberalism: Channing—Emerson—Parker* (Boston: Unitarian Universalist Assoc., 1986).

71 A reference to the Calvinist tenet of predestination, in which all human beings are foreordained for eternal damnation or salvation and lack any ability to change their destiny. On Calvinism in the context of American religious history, see, e.g., Sydney E. Ahlstrom, *A Religious History of the American People* (New Haven: Yale University Press, 1972), chs. 8–10, 18–19.

72 Romans 9:13: "As it is written, Jacob have I loved, but Esau have I hated."

73 The religious concept of "equal benevolence" was traditionally understood as one in which God treated all humans as equal, with heaven compensating for earthly inequalities. Scottish Enlightenment *philosophes* led the way in revising the terms of "compensation" by advocating equality on earth. If humans were equal in God's eyes, then reformers should heed God's will "on earth as it is in heaven" and treat people as equals.

 This radical revision in compensating for inequalities fueled the political and philosophical idea of equality. It led Adam Smith, Henry MacKenzie, and other writers to reinterpret the Golden Rule as empathy. And it prompted Emerson to publish "Compensation" (1841), in which he emphasizes that an individual's soul can compensate "for the inequalities of condition" on earth. Emerson embraces the kind of radical self-making embodied by Douglass, a "metamorphosis" that vindicates the "law of compensation":

> in some happier mind they [changes within an individual] are incessant, and all worldly relations hang very loosely about him, becoming, as it were, a transparent fluid membrane through which the living form is seen, and not, as in most men, an indurated heterogeneous fabric of many dates, and of no settled character, in which the man is imprisoned. . . . And such should be the outward biography of man in time, a putting off of dead circumstance day by day, as he renews his raiment day by day.

 Douglass is alluding to "Compensation." He met Emerson in 1844; the two men shared a mutual respect, and influenced each other. See Emerson, "Compensation," *Essays and Poems* (1841; New York: Library of America, 1996), pp. 301, 302; Stauffer, *Black Hearts of Men,* pp. 35–39; Lawrence Buell, *Emerson* (Cambridge, MA: Harvard University Press, 2003), pp. 251, 255–57; Robert D. Richardson, Jr., *Emerson: The Mind on Fire* (Berkeley: University of California Press, 1995), pp. 322–23; David Brion Davis, *The Problem of Slavery in Western Culture* (New York: Oxford University Press, 1966), pp. 348, 355, 360–61, 367, 375–80, 385–87, 410–11; Kevin J. Vanhoozer, ed., *Nothing Greater, Nothing Better: Theological Essays on the Love of God* (Grand Rapids, MI: Wm. B Eerdmans, 2001), pp. 179, 181; and T. E. Cliffe Leslie, "The Political Economy of Adam Smith," *Fortnightly Review,* Nov. 1, 1870.

74 In the Civil War era John Milton, William Shakespeare, and Francis Bacon were considered among the three greatest writers and thinkers in Western culture: Milton for his epic poem, *Paradise Lost* (1667), Shakespeare for his plays and sonnets, and Bacon for developing and disseminating an inductive or empirical method for scientific research.

75 When Phaedrus asked Socrates about mythical figures, Socrates allegedly responded that he had no time for mythology, adding: "The proper study of mankind is man." Some critics argue that Socrates coined the maxim. Alexander Pope invokes it in his poem *An Essay on Man* (1733), at the beginning of Epistle II. See *Life, Teachings, and Death of Socrates. From Grote's History of Greece* (New York: Stanford & Delisser, 1859), p. 46; William Ellery Leonard, *Socrates, Master of Life* (Chicago: Open Court Publ. Co., 1915), p. 72; and Humphrey Davy Findley Kitto, *The Greeks* (1951; New Brunswick, NJ: Transaction Publishers, 2009), p. 193.

76 The opening of this paragraph, "Man to man," was possibly influenced by Robert Burns, whose "A Man's a Man for a' That" was one of Douglass's favorite poems. He frequently quoted the ending:

> For a'that, an' a' that,
> It's coming yet for a'that,
> That Man to Man, the world o'er,
> Shall brothers be for a'that.

 Burns (1759–1796), who rose up from humble farmer to become Scotland's unofficial national bard, was one of Douglass's favorite poets. See Stauffer, *Black Hearts of Men,* pp. 150–52. Burns's poem is also titled "Is There, for Honest Poverty."

77 Elisha Kent Kane (1820–1857), physician and explorer, joined an expedition in 1850 to search for Sir John Franklin and his men, who had disappeared in the Canadian Arctic while seeking

a legendary trade route to Asia known as the Northwest Passage. The 1850 expedition did not find Franklin, and three years later Kane led a second expedition. His ship got trapped in ice and snow, and he and his crew survived two winters in the Arctic by trading with the local Inuit and eating the ship's rats. Kane also saved the lives of starving mutineers by sending them food. Although he never found Franklin, his escape, coupled with his charting of an American route to the North Pole, made him famous, the nation's first Arctic hero. He lectured widely and published a best-selling book of his second expedition, to which Douglass refers. When Kane died in 1857, his funeral procession was a national phenomenon, surpassed only by those of Abraham Lincoln and Robert Kennedy. See Jeannette Mirsky, *Elisha Kent Kane and the Seafaring Frontier* (Boston: Little, Brown, 1954).

78 Douglass quotes from John 4, in which Jesus meets a Samarian woman at Jacob's well. The woman realizes that he is the Saviour and bears witness to him. She "went her way into the city, and saith to the men, Come, see a man, which told me all things that ever I did: is not this the Christ?" John 4:28–29.

79 South Carolina, the first state to secede, was known as the "Palmetto state," and its flag depicted a palmetto tree. During the secession crisis, several Southern states also created rattlesnake flags, inspired by the Gadsden flag of 1775, designed by the American general Christopher Gadsden, with the words: "Don't tread on me."

80 Daniel O'Connell (1775–1847) was known as the Liberator of Ireland. An Irish lawyer and member of Parliament, he led the movements to repeal the Act of Union that joined Great Britain and Ireland, and to abolish civil restrictions on Catholics. A staunch opponent of slavery, O'Connell obtained enough Irish votes needed to pass the Emancipation Act of 1833, which outlawed slavery throughout the British West Indies beginning August 1, 1834. The incident Douglass describes probably occurred between the end of August and early October 1845, during his Dublin lecture tour. He gave at least seven orations, twice at the Dublin Music Hall to thousands, and also to inmates of the prison where O'Connell had been confined. See *TFDP* 1:1, pp. xcvi, 34. "Making the welkin ring" means shouting or singing as if to heaven.

81 In *Hamlet,* Act V, scene ii, Hamlet says: "There's a divinity that shapes our ends, / Rough-hew them how we will." Douglass quoted this line to account for his destiny; so did Lincoln. See Douglass, *My Bondage and My Freedom,* p. 70; Stauffer, *Giants,* p. iii.

82 A reference to Psalm 139, in which David laments and prays for deliverance from his enemies. Douglass quotes from line 14: "I will praise thee; for I am fearfully and wonderfully made." The psalm and this paragraph evoke a deterministic or naturalist world. Douglass describes the "essence of the universe" as all-powerful: "on it goes, creating, unfolding, renewing, changing, perpetually taking on new forms, issuing new sounds," creating and destroying life. We ourselves are living and dying anew—with every moment. Here is the downside of a universe and self in constant flux and continual change. People are at the mercy of the universe. Free will has given way to coercion, and choice has been replaced by chance.

 In the midst of war, Douglass seems to understand the costs of war. He anticipates Stephen Crane's short poem in *War Is Kind* (1899):

> A man said to the universe:
> "Sir, I exist!"
> "However," replied the universe,
> "The fact has not created in me
> A sense of obligation."

The difference is that for Douglass the universe retains a sense of obligation toward its creatures. See Stephen Crane, "War Is Kind," *Prose and Poetry* (New York: Library of America, 1984), p. 1335. For other examples of naturalism in the 1850s and 1860s, see John Burt, *Lincoln's Tragic Pragmatism: Lincoln, Douglas, and Moral Conflict* (Cambridge, MA: Harvard University Press, 2013), p. 177; John Stauffer, "12 Years Between Life and Death," *American Literary History* 26:2 (2014): 318.

83 "Of what is to be . . . both are now." This sentence seems inspired by Ecclesiastes 1:9: "The thing that hath been, it is that which shall be; and that which is done is that which shall be done: and there is no new thing under the sun."

84 Douglass lectured throughout England, Ireland, and Scotland from August 1845 to April 1847. He returned twelve years later, lecturing in England and Scotland from November 1859 to April 1860.

85 Douglass quotes from Deuteronomy 8:3 and Matthew 4:4. In Deuteronomy, Moses tells the Israelites that God "might make thee know that man doth not live by bread only, but by every word that proceedeth out of the mouth of the LORD doth man live." In Matthew, Jesus tells the devil, "It is written, Man shall not live by bread alone, but by every word that proceedeth out of the mouth of God."

86 Douglass paraphrases Matthew 16:25, Mark 8:35, and Luke 9:24 and 17:33, in which Jesus says: "For whosoever will save his life shall lose it: but whosoever will lose his life for my sake, the same shall save it" (Matt. 16:25).

87 Douglass quotes from *Festus*, an epic poem by Philip James Bailey (1816–1902). Born and bred in Nottingham, England, Bailey first published *Festus* in 1838, and then expanded it. Partly inspired by Goethe's *Faust* (1808), it explores the relationship between God and man and postulates a gospel of faith and reason. The poem was immensely popular and widely quoted, especially among reformers; Douglass's audience probably recognized it.

88 Douglass is referring to the 1864 Democratic presidential candidate George B. McClellan. In late May 1862, the Chickahominy River in eastern Virginia had flooded, splitting McClellan's army in two, and Confederate general Joseph Johnston attacked. McClellan staved off the attack, but he was criticized for not counterattacking and possibly marching on Richmond. McClellan's enemies began satirically calling him the "Chickahominy hero." During the 1864 election, he ran on a platform of compromise. His party demanded an end to the war and a negotiated settlement with the Confederacy, which probably would have left slavery intact. See Stephen W. Sears, *George B. McClellan: The Young Napoleon* (New York: Da Capo Press, 1988), pp. 192–95; George B. McClellan, *McClellan's Own Story* (New York: Charles L. Webster & Co., 1887), pp. 363–409; Gary L. Bunker, "The 'Campaign Dial': A Premier Lincoln Campaign Paper, 1864," *Journal of the Abraham Lincoln Assoc.* 25:1 (Winter 2004): 42; "Little Mac Inaugurated," *New York Times*, January 16, 1878.

89 Maximilian I of Austria schemed with Napoleon III to rule Mexico after Napoleon invaded it in 1861. Maximilian declared himself Emperor of Mexico in April 1864, even though republican forces there had not surrendered. The United States refused to recognize Maximilian's reign, and in 1867 he was captured and executed. In referring to Maximilian's family as "detestable," Douglass alludes to widespread but unfounded rumors that Maximilian was the offspring of an illicit affair between his mother Sophie and his first cousin Napoleon II.

90 During the Civil War, England sold over $100 million worth of supplies, including arms, to the Confederacy. This was despite the Union blockade and opposition to slavery by most British people. In 1862 England came close to recognizing the Confederacy, which could have resulted in a Confederate victory. England's sympathies with the Confederacy were economic: over 80 percent of its cotton came from the United States. Seymour Drescher, *Abolition: A History of Slavery and Antislavery* (New York: Cambridge University Press, 2009), pp. 245–48; James M. McPherson, *Crossroads of Freedom: Antietam* (New York: Oxford University Press, 2002), pp. 37–60, 143–55.

91 By 1861 slavery had been abolished everywhere in South America except Brazil. It was the only country on the continent to declare neutrality in the Civil War, and the only one to extend rights to Confederate vessels. Every other South American country treated the Confederacy as a belligerent state, though they did not treat Confederate ships as "pirates," as Secretary of State William Seward demanded. In August 1864, Union captain Collins of the *Wachusett* captured the

Confederate ship *Florida* in Brazilian waters, provoking Brazilian outrage at America's refusal to respect Brazilian neutrality. See Nathan L. Ferris, "The Relations of the United States with South America During the American Civil War," *Hispanic American Historical Review* 21:1 (February 1941): 52–58; Drescher, *Abolition*, pp. 348–57.

92 Douglass refers to Copperhead "peace" Democrats, who opposed Emancipation and sought a negotiated settlement with the Confederacy. There were two groups of Copperheads: those who wanted the Union "as it was," reunited and with slavery as it had previously existed; and those who favored the Confederacy remaining a separate, slave nation. The Copperheads, these "tempters at home," constituted one of the greatest threats to a Union victory. See Jennifer L. Weber, *Copperheads: The Rise and Fall of Lincoln's Opponents in the North* (New York: Oxford University Press, 2006).

93 Douglass invokes a central tenet of Judeo-Christian thought: salvation; redemption; from lost to being found.

94 A reference to the legend that Nero, Rome's unpopular emperor, allegedly "fiddled while Rome burned" during a great fire in AD 64 that destroyed most of the city.

95 Douglass's phrase may be "the test of all books" rather than "the text of all books." It is unclear in the manuscript.

96 John B. Gough (1817–1886), a reformed drunkard, was the nation's most popular temperance lecturer and the author of three autobiographies (1846, 1870, 1880), the first two bestsellers. In many respects Gough was Douglass's counterpart in the temperance crusade.

97 Sojourner Truth (1797–1883), born Isabella Baumfree, was an eloquent orator and one of the best known African American women in the Civil War era.

98 In September 1864, William Tecumseh Sherman (1820–1891) and his army took Atlanta, thus salvaging Lincoln's reelection. In early November he began his famous March through Georgia, to Savannah, and then in early 1865 he marched through the Carolinas. He and his troops lived off the land while destroying property in a "scorched earth" campaign to break Confederates' will to fight.

99 Samuel Morse patented the telegraph in 1847. Antebellum Americans, especially Northerners, believed they were living in a new age of discovery and invention. See Daniel Walker Howe, *What Hath God Wrought: The Transformation of America, 1815–1848* (New York: Oxford University Press, 2007).

100 A paraphrase of the line from Robert Burns's poem "To a Louse, On Seeing One on a Lady's Bonnet at Church" (1786): "O would some Power the giftie gie us / To see oursels as others see us!"

101 Prompted in part by photographers such as Gustave Le Gray, French painters in the 1850s left their studios to paint from reality, depicting everyday subjects in their natural settings, or *en plein air*; in so doing, they inaugurated pictorial realism. See Kimberly Jones, et al., *In the Forest of Fontainebleau: Painters and Photographers from Corot to Monet* (New Haven: Yale University Press & Washington, DC: National Gallery of Art, 2008); Sylvie Aubenas, *Gustave Le Gray: 1820–1884* (Los Angeles: J. Paul Getty Museum, 2002); Alan Trachtenberg, *The Incorporation of America: Culture and Society in the Gilded Age* (1982; New York: Hill & Wang, 2007), ch. 6; and Linda Nochlin, *Realism* (New York: Penguin Books, 1972).

102 Through photography, Douglass suggests, one can see Paris or the Basilica of St. Peter in Rome without ever going there.

103 In emphasizing imagination over reason, Douglass champions the union of all humanity. In arriving at this conception, he was influenced by Aristotle's *Poetics*, Emerson's *Essays* and *Representative Men*, and Carlyle's *On Heroes and Hero-Worship*.

104 Douglass refers to scientists of race, particularly Louis Agassiz, Josiah Nott, and George R. Glidden, who argued that blacks were subhuman or a separate species. He attacked them in his 1854 speech, "Claims of the Negro Ethnologically Considered."

105 Douglass borrows from Aristotle's *Poetics* to refute the pro-slavery ideal articulated in Aristotle's *Politics*, along with contemporary racist and "proto-racist" justifications for slavery. See Aristotle, *Poetics*, trans. Malcolm Heath (New York: Penguin Books, 1996), pp.6–7; Aristotle, *The Politics*, trans. T.A. Sinclair (New York: Penguin Books, 1981), pp. 67, 58; Thomas Wiedemann, *Greek and Roman Slavery* (London: Routledge, 1994), pp. 18–20; David Brion Davis, *In the Image of God: Religion, Moral Values, and Our Heritage of Slavery* (New Haven: Yale University Press, 2001), pp. 128–29; Benjamin H. Isaac, *The Invention of Racism in Classical Antiquity* (Princeton: Princeton University Press, 2004); and John Stauffer, "Frederick Douglass and the Aesthetics of Freedom," *Raritan* 25:1 (Summer 2005): 114–36. See also W. J. T. Mitchell, "Representation," in Frank Lentricchia and Thomas McLaughlin, eds., *Critical Terms for Literary Study, 2nd ed.* (Chicago: University of Chicago Press, 1995), pp. 11–17.

106 Another reference to Alexander von Humboldt (1769–1859) whose *Personal Narrative of Travels to the Equinoctial Regions of the New Continent, During the Years 1799–1804*, translated into English and first published in the United States in 1815, reached a wide English-speaking public. In it Humboldt describes how some natives imitated European clothes by painting their skins. He also argued that all humans form one "great family," a "single organic type, modified by circumstances." See Alexander von Humboldt, *Personal Narrative of a Journey to the Equinoctial Regions of the New Continent* (New York: Penguin Classics, 1996), p. 275; Laura Dassow Walls, *The Passage to Cosmos: Alexander von Humboldt and the Shaping of America* (Chicago: University of Chicago Press, 2009), pp. 6, 76, 170, 318.

107 The quote is from the opening of "Swedenborg; or, the Mystic," in Emerson's *Representative Men* (1850, 1996), p. 53.

108 Luke 4:4 and Matthew 4:4: "It is written, That man shall not live by bread alone, but by every word of God."

109 In launching his raid, Brown believed that he was heeding God's will. See John Stauffer and Zoe Trodd, *The Tribunal: Responses to John Brown and the Harpers Ferry Raid* (Cambridge, MA: Harvard University Press, 2012); David S. Reynolds, *John Brown, Abolitionist: The Man Who Killed Slavery, Sparked the Civil War, and Seeded Civil Rights* (New York: Vintage, 2006).

110 Jan Hus (often referred to as John Huss in English) was a fourteenth-century Czech priest and reformer, whose writings influenced the rise of Protestantism a century later. Hus was convicted of heresy against Catholic doctrines and burned at the stake. As more wood was thrown upon the fire, Hus purportedly shouted out: "Sancta Simplicitas" (Holy Simplicity).

111 Douglass borrows again from Rev. 21:1–2, 21.

112 See Shakespeare's *As You Like It*, Act II, scene i, when Duke Senior declares:

> And this our life, exempt from public haunt,
> Finds tongues in trees, books in the running brooks,
> Sermons in stones, and good in every thing.

113 "This truth . . . ": In this paragraph, Douglass builds upon Aristotle's *Poetics* and especially Catholic conceptions of the role of art.

114 This is an original conceptualization by Douglass on the relationship between art and reform. He was inspired by and revised Carlyle's analysis of heroes in *On Heroes, Hero-Worship, and the Heroic in History* (1841). Carlyle refers to poets, prophets, and seers as reformers; but he emphasizes that ideals can never be realized and that great men should not strive to realize them, lest they promote disorder, anarchy, and revolution. Douglass seeks to "remove the contradiction"

between ideals and reality, between "what is" and "what ought to be." He probably read Carlyle's *On Heroes* soon after it was published. See Thomas Carlyle, *On Heroes, Hero-Worship and the Heroic in History* (1841; Lincoln: University of Nebraska Press, 1966), pp. 45, 78, 104–06, 152–53, 202–03. On Douglass probably having read Carylyle's *On Heroes*, see Douglass, *My Bondage and My Freedom*, ed. Stauffer, p. 211.

115 Cf note 27 of part IV, p. 263.

116 The quotation is from Hamlet's speech to the Players, Act III, scene ii: "Suit the action to the word, the word to the action; with this special observance, that you [o'erstep] not the modesty of nature."

EPILOGUE

1 W. E. B. Du Bois, "Photography," *Crisis* 26, no. 6 (October 1923): 247–48 (quoted); David Levering Lewis and Deborah Willis, *A Small Nation of People: W. E. B. Du Bois and African American Portraits of Progress* (New York: Amistad, 2003); Eugene F. Provenzo, Jr., *W. E. B. Du Bois's Exhibit of American Negroes: African Americans at the Beginning of the Twentieth Century* (Lanham, MD: Rowman & Littlefield, 2013).

2 Minor White, *Zone System Manual: Previsualization, Exposure, Development, Printing* (Hastings -on-Hudson, NY: Morgan & Morgan, 1968).

3 In 1841 exposure times lasted several minutes; a decade later they were several seconds, owing to improvements in lenses and the chemical used to develop the images. Despite this dramatic reduction in exposure times, many studios continued to use head- and body rests to stabilize their subjects through the 1850s, and a few were still using them at the end of the century. See Beaumont Newhall, *The History of Photography: From 1839 to the Present*, rev. ed. (New York: Museum of Modern Art, 1982), ch. 5; "Experiments in Photograph," *Harper's New Monthly Magazine*, 13:75 (August 1856), pp. 429–30; and Michel Frizot, *A New History of Photography* (Cologne: Könemann, 1998), p. 104.

4 Phone conversation with John Stauffer, March 16, 2015.

5 Frederick Douglass, *Narrative of the Life of Frederick Douglass, an American Slave. Written by Himself* (Boston: Anti-Slavery Office, 1845), pp. 65–66.

6 Henry Louis Gates, Jr., *Figures in Black: Words, Signs, and the "Racial" Self* (New York: Oxford University Press, 1989), chs. 3–4.

7 Douglass, *Narrative*, pp. 65–66.

8 Karl Marx, "From *The German Ideology*." In Jon Elster, ed., *Karl Marx: A Reader* (Cambridge: Cambridge University Press, 1986), p. 27.

9 Todd Gustavson, *The Camera: A History of Photography from Daguerreotype to Digital* (Toronto: Sterling Publishing, 2009), chs. 8–10; Lewis and Willis, *A Small Nation of People*, ch. 1.

10 *The Journals and Miscellaneous Notebooks of Ralph Waldo Emerson*, ed. William H. Gilman, et al., 16 vols. (Cambridge, MA: Harvard University Press, 1960–82), vol. 9, p. 125.

11 Emerson, "The Poet," *The Collected Works of Ralph Waldo Emerson*, ed. Alfred R. Ferguson, et al., 7 vols. to date (Cambridge: Harvard University Press, 1971–), vol. 2, p. 4.

12 Douglass, *My Bondage and My Freedom* (New York and Auburn: Miller, Orton & Mulligan, 1855), p. 52; Douglass, *Narrative*, pp. 2–5, quotation from p. 2.

13 James McCune Smith, Introduction, *Frederick Douglass, My Bondage and My Freedom*, p. xxv.

14 Emerson refers to "the old indecent nonsense about the nature of the negro" in "An Address . . . On . . . the Emancipation of the Negroes in the British West Indies." See Len Gougeon and Joel Myerson, eds., *Emerson's Antislavery Writings* (New Haven: Yale University Press, 1995), p. 31.

15 Harriet Jacobs, *Incidents in the Life of a Slave Girl. Written by Herself*, ed. L. Maria Child (Boston: Published for the Author, 1861), p. 175. The artist Ellen Driscoll reproduced Jacobs's garret as a work of installation art, *The Loophole of Retreat*. The small hole that Jacobs had made in her garret in order to see her children became in Driscoll's rendering a camera obscura, emitting light that projected an inverted image on the wall opposite the pinhole—Ellen Driscoll, "The Loophole of Retreat," http://www.ellendriscoll.net/ins_loophole.htm.

16 Emerson, "Emancipation of the Negroes," *Emerson's Antislavery Writings*, p. 31.

17 Len Gougeon, "Militant Abolitionism: Douglass, Emerson, and the Anti-Slave," *New England Quarterly*, 85:4 (December 2012), pp. 622–23.

18 Emerson, "Emancipation of the Negroes," *Emerson's Antislavery Writings*, pp. 30–31.

19 David Bromwich, email to the author, March 18, 2015.

20 Gougeon, "Militant Abolitionism," pp. 622–57, quotation at p. 639.

21 Emerson, "Emancipation of the Negroes," *Emerson's Antislavery Writings*, p. 29.

22 Ibid., p. 31.

23 Ibid., pp. 31–32.

24 Emerson, "The Fugitive Slave Law," *Emerson's Antislavery Writings*, p. 83; *The Complete Works of Ralph Waldo Emerson*, ed. Edward Waldo Emerson, 12 vols. (Boston: Houghton Mifflin, 1903–04), p. 198.

25 Douglass, *My Bondage and My Freedom*, pp. 246–47.

26 Werner Sollors, *Neither Black Nor White Yet Both: Thematic Explorations of Interracial Literature* (New York: Oxford University Press, 1997), pp. 15–16; Charles W. Chesnutt, "Self-Made Men," "What Is a White Man," and "The Future American." In *Essays & Speeches*, ed. Joseph R. McElrath, Jr., Robert C. Leitz III, and Jesse S. Crisler (Stanford, CA: Stanford University Press, 1999), pp. 33–40, 68–74. 121–36; Frederick Douglass, "The Future of the Colored Race," *LWFD* 4, p. 195.

27 Emerson, "Uses of Great Men," *Representative Men: Seven Lectures* (1850; Cambridge, MA: Harvard University Press, 1996), p. 7.

28 Ibid., pp. 5, 15; Emerson, "Kansas Relief Meeting, 10 September 1856," *Emerson's Antislavery Writings*, p. 113.

29 McCune Smith, Introduction, *Frederick Douglass, My Bondage and My Freedom*, p. xxix.

30 Emerson, "Uses of Great Men," *Representative Men*, p. 6.

31 Ibid., p. 7.

32 Ibid., pp. 9, 15–16, 19.

33 H. G. Adams, ed., *God's Image in Ebony . . .* (London: Partridge & Oakey, 1854).

34 Douglass, "Claims of the Negro Ethnologically Considered," *The Frederick Douglass Papers*, vols. 1–5 (New Haven: Yale University Press, 1979–92), vol. 2, pp. 497–524.

35 Douglass, "A Tribute for the Negro," *The North Star*, April 7, 1849. For other examples of Douglass attacking racist caricatures, see "Which Greeley Are We Voting For? An Address Delivered in Richmond Virginia on 24 July 1872," *The Frederick Douglass Papers, Series 1: Speeches, Debates, and Interviews*, 5 vols., ed. John W. Blassingame (New Haven: Yale University Press, 1979–92), vol. 4, p. 303, and "Douglass, letter to Louis Prang," June 14, 1870, in *Prang's Chromos: A Journal of Popular Art* (September 1870), reprinted in Katherine Morrison McClinton, *The Chromolithographs of Louis Prang* (New York: Clarkson N. Potter, 1973), p. 37.

36 W. J. T. Mitchell, email to the author, March 13, 2015.

37 Molly Rogers, *Delia's Tears: Race, Science, and Photography in Nineteenth-Century America* (New Haven: Yale University Press, 2010), pp. 233–35; M. Susan Barger and William B. White, *The Daguerreotype: Nineteenth-Century Technology and Modern Science* (Baltimore: Johns Hopkins University Press, 1991), pp. 80–81; Yxta Maya Murray, "From Here I Saw What Happened and I Cried: Carrie Mae Weems' Challenge to the Harvard Archive," *8 Unbound: Harvard Journal of the Legal Left*, 1 (2013): 2, http://www.legalleft.org/wp-content/uploads/2013/09/Murray.pdf; Alan Trachtenberg, *Reading American Photographs: Images as History, Mathew Brady to Walker Evans* (New York: Hill & Wang, 1989), pp. 52–60; Keith F. Davis, *The Origins of American Photography, 1839–1885: From Daguerreotype to Dry-Plate* (Kansas City, MO: Nelson-Atkins Museum of Art, 2007), p. 49.

38 Douglass, *My Bondage*, p. 247.

39 Douglass, "Pictures and Progress," p. 163.

40 Ibid., p. 163.

41 Ibid., pp. 166, 167.

42 Ibid., pp. 166–168.

43 Ibid., p. 170.

44 Ibid., p. 170.

45 Ibid., p. 171.

46 Ibid., p. 171.

47 W. E. B. Du Bois, *The Souls of Black Folk: Essays and Sketches* (Chicago: A. C. McClurg & Co., 1903), pp. 1–12.

48 Barbara Johnson, *The Critical Difference: Essays in the Contemporary Rhetoric of Reading* (Baltimore: Johns Hopkins University Press, 1980), p. 3; Julia Faisst, *Emancipation: Photography, Race, and Modern American Literature* (Heidelberg: Universitätsverlag Winter, 2012), ch. 1. For another approach to Douglass and photography, see Sarah Lewis, *Black Sea, Black Atlantic: Frederick Douglass and the "Thought Pictures" of the Caucasus* (Cambridge, MA: Harvard University Press, forthcoming).

AFTERWORD

1 Frederick Douglass to Ruth Cox, May 16, 1846, in *TFDP*, 3:1, p. 124.

2 For "storm, whirlwind, and earthquake," see Douglass, "What to the Slave is the Fourth of July? An Address Delivered in Rochester, New York on 5 July 1852," in *TFDP*, 1:2, pp. 359–88 (371).

3 That said, I hope my cousins on the other branches of the family tree don't read this, or I may find myself in a bit of hot water!

4 For more on modern slavery and human trafficking, see Kevin Bales, *Disposable People: New Slavery in the Global Economy* (rev. ed., Berkeley: University of California Press, 2012); Bales, *Ending Slavery: How We Free Today's Slaves* (Berkeley: University of California Press, 2007); Bales, Zoe Trodd, and Alex Kent Williamson, *Modern Slavery: The Secret World of 27 Million People* (Oxford: Oneworld Press, 2009); and Louise Shelley, *Human Trafficking: A Global Perspective* (Cambridge: Cambridge University Press, 2010).

5 For more on the work of FDFI, see www.fdfi.org.

Acknowledgments

For their generous and invaluable help with archives and images, we thank Mike Antonioni, Abby Battis, Lori Birrell, Joanne Bloom, Richard D. Brennan, Randall K. Burkett, Jeff Cabral, Adrienne Cannon, Jay Hall Carpenter, Sean Casey, Joan Cavanagh, Phillip Chardon, Courtney Chartier, Amanda Claunch, Tabitha Pryor Corradi, Stanley Ellis Cushing, Maya Davis, Maria Day, Tim Detweiler, Geoff De Verteuil, Tina Dunkley, Joellen ElBashir, Frank Faragasso, Nancy Finlay, Roy L. Flukinger, Brandon Fortune, Sara Georgini, Jordan Goffin, Frank Goodyear, Erika Gottfried, Ruth Morris Graham, Christopher Haley, Will Hansen, Lauren B. Hewes, Josh Hogan, Richard Jenkins, Lauren Johnson, Ida E. Jones, Marybeth Kavanagh, Sally Leahey, Clayton Lewis, Jack Lufkin, Eric Lutz, Ka'mal McClarin, Michelle McKinney, Melissa S. Mead, Frank Mitchell, Jennifer Morris, AnnaLee Pauls, Byron Peck, Jesse Peers, Kenvi C. Phillips, Dianne Pizzo, Michelle Price, William Rasmussen, Anna Roelofs, Robert C. Sonderman, Aaron P. Spelbring, Joe R. Struble, Emily Oland Squires, Jennifer Tonkovich, Jack von Euw, Jennifer A. Watts, Robert Weible, Conrad Wright, Laura Wulf, and Mary Yacovone.

For their intellectual interventions and engagement, we thank Peter Accardo, Steve Albahari, Matthew Amato, Kevin Bales, David Blight, James Brookes, Steven Brown, Lonnie Bunch, Keith Davis, Scott Davis, Walter O. Evans, Leigh Fought, Greg French, Paul Gardullo, Henry Louis Gates, Jr., Vicki Goldberg, Lilian Handlin, Bill E. Lawson, Robert S. Levine, Peter Ling, Amy Lippert, George Lipsitz, Joe Lockard, Philip Marino, Jack McKivigan, Sharon Monteith, Jessie Morgan-Owens, Kenneth B. Morris, Jr., John H. Muller, Hannah Rose Murray, Judie Newman, Sarah O'Hara, John Oldfield, Sally Pierce,

Alan Rice, Jay Roberts, Yael Schacher, William Stoneman, Wendy Strothman, Fionnghuala Sweeney, Garland Taylor, Phyllis Thompson, Anne Tucker, Robert Weil, Deborah Willis, John and Carol Wood, and Marcus Wood. For their expert research assistance, we thank Hannah Durkin, Benjamin Hoare, and Melissa Walker. For generous research support and fellowships that enabled work on this book, Zoe Trodd thanks the British Academy; the Arts and Humanities Research Council; Santander; the Gilder Lehrman Center for the Study of Slavery, Resistance, and Abolition at Yale University; and the American Council of Learned Societies. And for their careful, patient, insightful, and collaborative editing work on this book, we thank Philip Marino, Anna Oler, Nancy Palmquist, and Anna Mageras.

We also thank our supportive family and friends: Erik and Nicholas Stauffer, Deborah Cunningham, William and Jean Stauffer, Mark and Becky LaFavre, Jim Lawson and Rachel Stauffer, Kevin Parks, Wendell Gibson, Casey King, and Andrew Fairbairn; Graham Thompson, Lyn and Geoff Trodd, Gabe Trodd, Bee Trodd, Anthea Trodd and John Proops, Karen Astle, Tom Rob Smith, Phyllis Thompson, and Aoife Nolan; and Andy Green.

Our greatest debt is to the three people to whom we dedicate this book: Nettie Washington Douglass, the great-great-granddaughter of Frederick Douglass and a twenty-first-century abolitionist herself, whose Frederick Douglass Family Initiatives (FDFI) works to end the enslavement of more than 35 million people around the world today; Alan Trachtenberg, a founder of visual studies, whose writing, mentoring, generosity, and curiosity has inspired us and countless others; and the memory of Donna Wells, for her path-breaking scholarship on Douglass and photography.

About the Authors

JOHN STAUFFER is Professor of English, American Studies, and African American Studies at Harvard University. He is the author or editor of thirteen books and over ninety articles, including two books that were national bestsellers: *Giants: The Parallel Lives of Frederick Douglass and Abraham Lincoln* (2008); and *State of Jones* (2009), co-authored with *Washington Post* columnist Sally Jenkins. *The Black Hearts of Men* (2002) was the co-winner of the Frederick Douglass Book Prize and the Lincoln Prize 2nd Place winner. *The Battle Hymn of the Republic: A Biography of the Song That Marches On* (2013), co-authored with Benjamin Soskis, was a Lincoln Prize finalist. His essays and reviews have appeared in *Time, The Wall Street Journal, The New York Times, The Washington Post,* and *Huffington Post.* He has lectured throughout the United States and Europe, and was an adviser for three movies: *Django Unchained* (2012), *The Abolitionists* (2013), and *The African Americans: Many Rivers to Cross* (2013), and for the exhibition *War/Photography* (2012–14).

ZOE TRODD is Professor of American Literature in the Department of American and Canadian Studies at the University of Nottingham. She has a PhD from Harvard University and has written over fifty academic articles. Her eleven books include *A Reusable Past: Abolitionist Memory in the Long Civil Rights Movement* (2016); *The Tribunal: Responses to John Brown and the Harpers Ferry Raid* (2012); *Modern Slavery: The Secret World of 27 Million People* (2009); *To Plead Our Own Cause: Personal Stories by Today's Slaves* (2008); *American Protest Literature* (2006); and *Meteor of War: The John Brown Story* (2004). She has curated an exhibition of murals featuring Frederick Douglass and currently holds a large grant from the British Arts and Humanities Research Council

called The Antislavery Usable Past, which translates the lessons of past antislavery movements, including their imagery, into effective tools for policy makers, civil society groups, and citizens working against contemporary global slavery.

CELESTE-MARIE BERNIER is Professor of African American Studies at the University of Nottingham and co-editor of the *Journal of American Studies*. She is the recipient of the Philip Leverhulme Prize in Art History, the British Association for American Studies Book Prize, and the American Studies Network Book Prize. She has written more than thirty articles and her eleven books include *Stick to the Skin: A History of Contemporary African American Art* (2017); *Inside the Invisible: Slavery and Memory in the Works of Lubaina Himid* (2016); *Imaging Resistance: Representing the Body, Memory and History in Fifty Years of African American and Black British Visual Arts 1960–2010* (2015); *Suffering and Sunset: World War I in the Art and Life of Horace Pippin* (2015); *Visualizing Slavery: Art Across the Black Diaspora* (2015); *Characters of Blood: Black Heroism in the Transatlantic Imagination* (2012); *Public Art, Memorials and Atlantic Slavery* (2009); and *African American Visual Arts: From Slavery to the Present* (2008).

Index

Page numbers in *italics* refer to illustrations.